FREDERIC
REMINGTON'S
OWN WEST

FREDERIC REMINGTON'S OWN WEST

Written and Illustrated by
FREDERIC REMINGTON

Edited and with an Introduction by
HAROLD McCRACKEN

PROMONTORY PRESS
NEW YORK 10016

Published by Promontory Press, a division of A & W Promotional Book
Corporation, 95 Madison Avenue, New York, N.Y. 10016, by arrangement
with The Dial Press, 245 East 47th Street, New York, N.Y. 10017.

Library of Congress Catalog Card No.: 60-13432
ISBN: 0-88394-005-1

DESIGNED BY HAROLD MC CRACKEN

Manufactured in the United States of America

Contents

Introduction 7
 PART ONE: In The Old Southwest
 I Soldiering in the Southwest 17
 II On The Indian Reservations 27
 III A Desert Romance 35
 IV How an Apache War Was Won 49
 V A Scout with the Buffalo-Soldiers 65
 VI Natchez's Pass 81
 VII Massai's Crooked Trail 91
 VIII Horses of the Plain 99
 IX How the Law Got Into the Chaparral 111
 X The Honor of the Troop 123
 XI A Failure of Justice 129
 XII An Outpost of Civilization 137
 XIII A Rodeo at Los Ojos 147
 XIV Artist Wanderings Among the Cheyennes 157

 PART TWO: On The Northern Plains
 XV The Story of the Dry Leaves 175
 XVI How Order No. 6 Went Through 183
 XVII Thanksgiving Dinner for the Ranch 191
 XVIII The Strategy of the Blanket Pony 195
 XIX The Buffalo Dance 203
 XX When a Document is Official 205
 XXI Order of the Blackfeet Sun Dance 213
 XXII The Trouble Brothers 219
 XXIII A Quarrel Over Cards 223
 XXIV Chasing a Major General 227
 XXV Lieutenant Casey's Last Scout 237
 XXVI The Sioux Outbreak in South Dakota 251

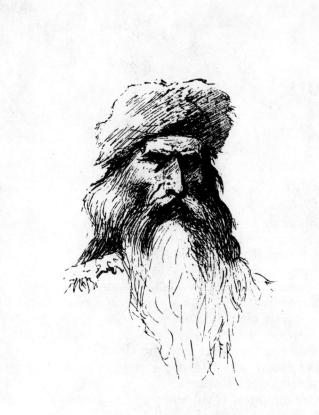

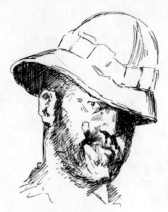

the official correspondent.

Introduction

Frederic Remington — Writer
by Harold McCracken

The name of Frederic Remington has become synonymous with the realistic portrayal of our Old West. His impressive paintings, drawings and works of sculpture of the early day frontiersmen, cowboys and Indians are today well established as pictorial documentations of the most colorful and virile, as well as the most popular chapter in American history. Remington's subject was the length and breadth of the Old West, both geographically and historically—from Mexico to Canada and from the early Spanish explorers to the last of the Indian wars. Certainly no other artist ever devoted his God-given talents with more dedication to a single era, or was marked by more prodigious accomplishment. His work as a pictorial documentarian has stood the test of time and ever increasing recognition has put him well in the forefront of the most distinguished in the field.

Frederic Remington was a writer as well as an artist—although his accomplishments with the journalist's pen have virtually been lost in the brightness of his paint brush. In both fields he was strictly a documentarian. In art he was the master of every medium. Although literally self-taught, he turned with equal facility from oil to watercolor, pen and ink, etching, or sculpture. The same was true of writing—he was equally at home with fact or fiction. In whatever he did, "pretty pictures" and subservience to popular taste were somebody else's field. A contemporary critic once characterized his art as *"hard as nails."* To Remington that was high praise—for the men and the deeds he portrayed were in real life *"hard as nails."* The same realism is found in his writings—they do not form a historian's chronological tome, but rather sharp vignettes of human beings making history amid rough surroundings. Remington gives an understanding of the white men and red men of our Old West enacting one of the most dramatic stories in the world-wide migrations of the white race. And now, as that chapter of our national past can be seen in its real perspective, Remington's stature as an artist increases, and his work as a writer finds a new importance.

7

We should remember that Remington was primarily an artist and in his time universally considered one both by the public and by editors—and that it is usually very difficult for an individual who is so firmly pegged in one field to find acceptance in another, particularly in the fields of arts and letters. Furthermore, as a writer, he faced extraordinary competition, for at the time a particularly accomplished school of Western writers was in full bloom—such men as Owen Wister, Emerson Hough, Bret Harte, George Bird Grinnell, Alfred Henry Lewis, Joaquim Miller, Richard Harding Davis, and a good many more. These men were devoting their talents exclusively to writing and had popular followings among both readers and editors. Remington was turning out a great number of pictures, many of which were used to illustrate the articles, stories and books of these same authors. He was also turning out as many works of sculpture as most men who devote themselves to that art alone. In addition he spent a part of practically every year adventuring in some out-of-the-way part of the West (or in the wars in Cuba, Europe, Russia, North Africa, and Asia). And yet, in spite of these circumstances, Remington's writings, both fact and fiction, appeared regularly in the best magazines of the day—*Century*, *Harper's*, *Collier's*, *Cosmopolitan* and others.

Theodore Roosevelt, one of our most respected authorities on the West, in a letter signed Secretary of the Navy and dated November 28, 1897, gave Frederic Remington the following unsolicited estimate of the artist's accomplishments as a writer: "You come closer to the real thing with the pen than any other man in the western business. And I include Hough, Grinnell, and Wister. . . . Somehow you get close not only to the plainsman and soldier, but to the half-breed and Indian, in the same way Kipling does to the British Tommy and the Gloucester codfisher. Literally innumerable short stories and sketches of cowboys, Indians and soldiers have been, or will be written. Even if very good they will die like mushrooms, unless they are the very best, but the very best will live and will make the cantos in the last epic of the Western Wilderness. . . . Now, I think you are writing this 'very best'. . . . You have struck a note of grim power . . . to deserve characterization by that excellent but much abused adjective, weird. Without stopping your work [in art], I do hope you will devote more and more time to the pen."

Frederic Remington was among the last of the important documentarians to see the Old West pass into the limbo of an era gone but not forgotten. Born in the little college town of Canton, in upstate New York, on October 1, 1861, he was to follow a career that was in many respects far removed from the influences of his childhood. The only touch of adventurous background was that Frederic's father distinguished himself as a cavalry officer in the Civil War. Fred was well-educated. He was sent to a private school. But after less than two years at Yale, he went West in 1880 out of a desire to find ad-

venture and perchance a quick fortune. He was only nineteen years old at the time, and it was then, while knocking about in Montana, that he was inspired to become a documentarian of the Old West.

By all the influences of legacy and early circumstances, Frederic Remington should have become a writer rather than an artist. His father was a newspaper publisher, and his grandfather a clergyman with a deep interest in literature. There was no heritage of artistic talent, and no evidence of youthful encouragement of his latent inclination toward drawing. Whatever dream of the future he may have had is perhaps set forth best in a letter Fred wrote as a teen-age student at Highland Military Academy, dated May 27, 1878. It confides to his favorite uncle, Horace D. Sackrider, the following: "I am going to try to get into Cornell College this coming June and if I succeed will be a Journalist. I mean to study for an artist anyhow, whether I ever make a success of it or not." Why he failed to get into Cornell and study to be a journalist, or what influence sent him to Yale, is not known. Even when he went to Yale, ostensibly to attend the Art School, he quickly decided he would have absolutely no part of it—instead, he gained inter-collegiate distinction as a heavyweight boxer and as a star on the famous football team that was captained by Walter Camp.

A serious leaning toward writing is evident throughout Remington's early career. His art was the latent talent and stamp of destiny—seemingly the more difficult than writing, for a self-taught aspirant. Reared in a journalistic atmosphere, it is quite natural that Fred should have been an avid reader. His interest lay in books of history and true adventure. According to his own statement, his early favorites were the journals of George Catlin and Lewis and Clark, and his copies of Parkman's works are finger-stained and marked with marginal notes. He was blessed with a good journalist's instinct for getting deep into the facts and details pertinent to a story—the solid foundation of both the documentary artist and the writer.

Interested in horses from boyhood, when the nineteen-year-old adventurer went West he quickly became as expert as an old cowhand in a western saddle. But unlike most cowboys, Remington delved deep into the history of the western pony, from the days when the earliest Spanish explorers introduced the horse to the Southwestern Plains, up through its adoption and breeding by the tribesmen of the various regions of the West. It was this research and study that taught him the difference in characteristics between the horses of the Indians of the arid regions of Arizona Territory and those of the wintry regions of Montana. As early as January, 1889 *Century Magazine* published his comprehensive article "Horses of the Plain," which is included in this book. So great was Remington's interest that several years after the publication of the article he made a trip to North Africa to study and paint the blue-blooded ancestors of the horses which the early Spanish introduced to our West.

Remington's art and writing had much in common. One of the most characteristic of the parallels was his consistent disposition to portray the "little people" of history-in-the-making. Although he held as close friends most of the big names among both white and red men, it was the rank and file who were the principal subjects of his drawings and writings.

By 1888, just two years after the first Remington picture appeared in any national magazine, *Century* commissioned him to make a trip into his former adventuring ground in the Southwest, not only to make a series of documentary pictures of conditions of the Indians on the reservations, but also to accompany these with articles on the subject. The editor of *Century* was apparently the first to recognize Remington's potential as a writer. In another letter sent to the same Uncle Sackrider by Mrs. Remington early in 1889, she says: "The *Century* people tell him [Fred] that he is quite a literary man. He weighs 230 pounds and thinks he will get a riding horse [for use in Central Park]." Three author-illustrated articles from that trip appeared in *Century*. This reporting was the real beginning of his career as a writer.

His by-line began appearing in top periodicals with increasing regularity. While his work, both artistic and literary, was documentary, he had a natural flair for the dramatic—although he always strove for accuracy, and was never guilty of a willful attempt to garnish with any tinge of the sensational, sentimental or the pretty.

Progress in his writing kept pace with progress in painting. He ventured into the field of fiction. In 1897 *Harper's Monthly* published a story in which Remington introduced a character called Sun-Down La Flare. Further Sun-Down stories like "How Order No. 6 Went Through" followed and they later constituted his first book of fiction, published in 1889. Sun-Down was presented by his author as fiction, and yet Sun-Down actually lived. In the present writer's research for the biography *Frederic Remington—Artist of the Old West* (1947), he found a number of snap-shots of Sun-Down among the artist's personal records in the Remington Art Memorial at Ogdensburg, New York. These were easily recognizable as the same person who was portrayed in the illustrations for the stories. There were also some letters from Sun-Down, in which the interesting vernacular was plainly evident. It is safe to assume that every incident that Remington wove into the Sun-Down stories was also as carefully drawn from his life and from the lives of others whom the writer had known or learned about from unimpeachable sources. The same was undoubtedly true of the others of Remington's writings which he presented in the form of "fiction." Reading his beautiful "Story of the Dry Leaves" should convince almost anyone that its stark realism could only have been drawn from a real tragedy which had been intimately observed by the writer.

The same was true of his first novel *John Ermine of the Yellow-stone*, which was published by Macmillan in 1902. This was a marked success, going into a number of editions. It was also produced as a play, opening at the new Globe Theatre, Weber and Fields' playhouse in Boston, on September 14, 1903. It was played in Chicago and was then brought into the Manhattan Theatre in New York City; later it was periodically "road-showed" for several years. Another of his book-length works of fiction was *The Way of An Indian*, which appeared serially in *Cosmopolitan*, November 1905 to March 1906, before being published as a book the latter year.

Frederic Remington's enormous output becomes even more amazing as one surveys the catalog of his accomplishments in the arts and letters and realizes that it was all achieved in less than half a century of life. How unfortunate it is that he died at the early age of forty-eight, on December 26, 1909, just as he had reached his prime in all his abilities.

It is unfortunate, too, that Frederic Remington did not live to write either an autobiography, or a book of his own observations of the passing of the Old West. Either of these books would have added greatly to our understanding of that important period of transition. It would also have helped to date more accurately some of the episodes Remington did put into the written record. Remington always avoided injecting his own personality into anything he did. Even when interviewed by newspaper reporters, as he frequently was after success came to him, he consistently refused to answer questions about himself and his own experiences, and took the firm attitude, "Don't write about me, just write about my pictures."

This present book is an anthology of the writings of Frederic Remington illustrated with the artist's own drawings. It does not include all that he wrote, but what this editor regards as the best of the vignettes, both fact and fiction, relating to the Old West and its transition into the New. Furthermore, the material has been selected and arranged to form as nearly as it can an autobiographical sequence. What we have here is the nearest approach to an autobiography of this extraordinary Western artist-writer that can ever be assembled. To date all the individual episodes accurately is not possible. Most were written in retrospect, at various periods of his life. As pointed out above, it is safe to assume that virtually all were written from personal observation and with careful attention to factual documentation. All the gallery of individuals who are presented, whether in fact or fiction, were real life people who made the history of our Old West.

In his pictures and his writings, Frederic Remington left for the benefit of the generations that follow him, what is beyond doubt one of the most comprehensive documentary records of our Old West and its transition into the limbo of history—and for this alone he deserves our everlasting gratitude.

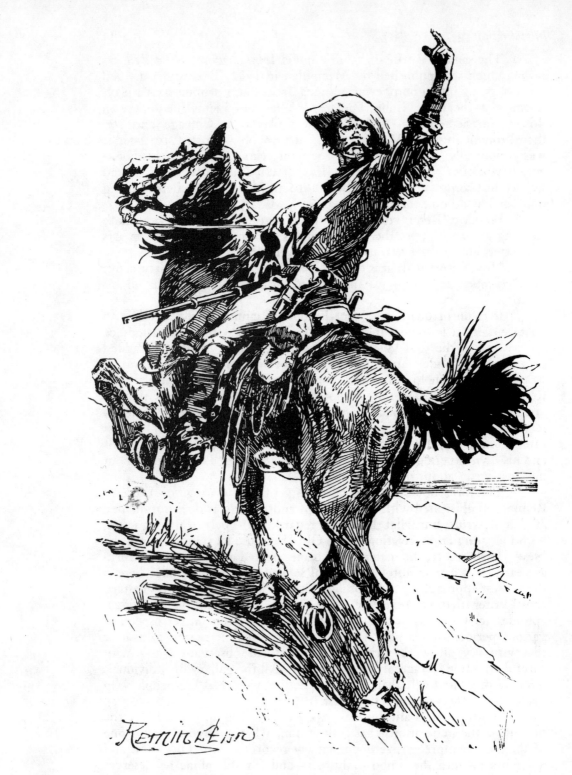

THE OPENER OF THE TRAIL

PART ONE

In The Old Southwest

In The
Old Southwest

Frederic Remington knew and loved the whole West, from the arid regions of Arizona Territory to the rolling prairies and rugged Rockies of Montana. In the story of the Old West, the Southwest and the Northern Plains stand out as the two broadly defined regions each with characteristics distinctly its own. The former spilled over into Old Mexico, and the latter extended into the adjoining Rocky Mountains and up into Canada. The Southwest was marked with blistering heat and waterless deserts, cactus and drab Apaches; the Northern Plains was a vast expanse of grassy buffalo range, timbered hills, beautifully garbed Sioux and Blackfeet, and freezing winter blizzards. The white men who roamed the wilderness areas of both regions took on different characteristics. The trappers and the cowboys were different, and even the Army had to learn a whole new catechism of service, combat and survival when they were moved from one region to the other. Years of association brought some men to love one area and hate the other. The great herds of buffalo migrated from one area to the other to avoid the intense heat or bitter cold. It might almost be said that only white men and rattlesnakes adapted themselves with equal facility to making a home of both regions.

During the first couple of years after Remington went West in 1880 as a nineteen-year-old adventure seeker, he roamed the overland and cattle trails through the back country from the Canadian to the Mexican borders. In spite of his comfortable and even aristocratic family background, and his sophisticated days at Yale, something very deeply rooted in his nature made him intensely devoted to the roughest aspects of frontier life. In both the north and the south he made his friends in the cattle country saloons and the other rendezvous of the white man and Indians who had given character to the earlier days, and he acquired their strong distaste for the passing of the Old West.

The story of the Old West is also the story of one of the longest and most extraordinary conquests by the white race of another race for

the possession of a national homeland. Historically it is very important. The last thirty years of the nineteenth century were the most intensive of the transition period, in both the north and south. Remington came early enough to become intimately familiar with the lingering vestiges of what had gone before, and he was an eye witness to the grand finale. In his pictures he covered it all—for he was fundamentally an artist. Although the articles and stories he wrote are frequently difficult and sometimes impossible to pin-point as to date or chronology, they all have the one basic theme of the passing of the Old West, and they easily fall into the categories of the Southwest and the Northern Plains. It is for these reasons that they have been grouped in two parts —and arranged in as nearly a chronological order as possible.

The first pictures that Remington published were of the Southwest and there seem to have been few years between the beginning of the 1880's and the end of the century that Remington did not spend some time in that region. What he wrote can be taken as soundly documentary, and it represents what is probably as clear-cut an impression of the people and the period as any historical treatise can convey. Here is drama, the struggle and bitterness of two races amid heat and thirst and sweat—the one striving in their own way to retain an ancestral homeland, and the other waging a war of subjugation to make a national homeland for his own people. Here is the Southwest, in transition from the old to the new. Here is Frederic Remington's own account of that struggle.

—H. McC.

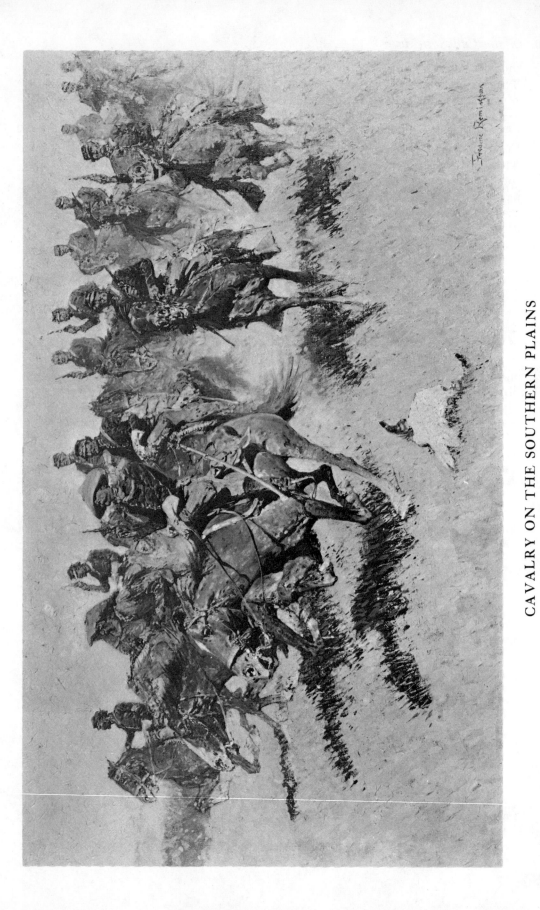

CAVALRY ON THE SOUTHERN PLAINS

I

Soldiering in the Southwest

(An unpublished manuscript)

In any historic recounting of the Apache war, the soldiers must come in for their share, although there are some folks who say, "these soger-chaps is hired to do thirteen dollars' worth of fighting per month and I'll be blanked if I think they earn their money." No man earns his wages half so hard as the soldier doing campaign work on the Southwestern frontier. He may not do thirteen dollars' worth of fighting every month, but he does marching which under special contract he might agree to furnish for $5,000 per turn of the moon. Altogether, the duties imposed on the troops of General Miles [foremost of the U.S. Army leaders in the Indian wars in the West] are as onerous and unprofitable as any within the category of military operations. They cannot end their campaign by a battle, trusting to their god of war for the result. They are fighting a mountain people in their own mountains, who have no base, no objective point of attack, nor any false idea of military glory or even comity to defend.

Today [1889] the Indian is mounted fresh, and tomorrow night he is remounted on stolen stock; he can subsist himself in competition with the coyote on the desert; he has an abundance of ammunition; and at his back is a mountain stronghold known only to himself and all but impassable to his enemies, from which he sallies out, dealing a demoralizing guerrilla warfare on the defenseless white inhabitants of the valleys. Before the news reaches the soldiers, he has stretched miles of desolate desert behind the flying feet of his pony. Still, realizing the obstinate pursuit, he pricks on his flagging horse until the heaving flanks and faltering gait show inability to keep the terrible pace, when, with an ungrateful stab of the knife, he takes to his heels and leaves the poor panting, bleeding pony to die on the trail. Thus is he rewarded for his gallant effort by his fiendish rider and thus is the Apache at war with even the beasts of the fields.

The tired cavalry horse plods along in the hopeless pursuit, spurred and goaded to the utmost limit of his endurance. Poor beast,

17

while in his humble way he bears the brunt, the marching, and the suffer-
ing of all cavalry war, no report mentions him, no pension awaits, no
one knows, no one cares.

Much of this is also true of the trooper rider, whose identity
never gets beyond his orderly-sergeant. His heroism is called duty,
and it probably is. On the long march it is his task to nerve his tired
muscles and keep in place. It is his duty to eat the scanty fare and per-
chance to carry off a vicious bullet wound or be buried in the sands of
Mexico. It is his duty to do many things that stretch that word to its
good Old English tension. And, after all, who are these lowly wearers
of the blue? Oh, very matter-of-fact persons, with no sense of the heroic,
with a lack of moral fiber perhaps, rude of manners and soldiers because
of circumstances once and force of habit now. For instance, the tall
young fellow with the smooth face on the roan horse is Jack Hazard—
lived somewhere in Connecticut, got broke in New York City, and
enlisted. That bronzed and grizzled old pirate with the black mustache
and goatee, good type of the "army in Flanders," is serving his fifth
enlistment and couldn't get a living out of the Army. The red-faced
chap with the yellow mustache has served King William as a hussar;
and Mike O'Malley there is a worthy descendant of the old stock—his
kind are in every army, in every clime. These are the "crows"; Natchez's
men are the "kites"; the dark canyons and lofty peaks of the Sierra
Madres, the Santa Ritas, the Whetstones, the Dragoons, and the Santa
Catairinas are the battlegrounds. Official reports bear no romance in
their lines, and the half that these rocks have witnessed will never be
known.

As this is a soldier's scrape, we naturally look him over more
closely. Indeed, he is a strange soldier. His brass *sans* glitter, his accou-
terments unblacked, he is covered with dust and much that was dust
once but is a firmer deposit now, all plainly saying "the regulations
be hanged!" His boots are red, one spur is gone, his pants are reinforced
with buckskin and worn to a state of impropriety; his shirt is open at
the neck, his blue coat is a dull mauve color, his hat, a battered ruin,
and his skin, burned carmine or swarthily tanned, while a good stubble
of beard completes all that is lacking to metamorphose our soldier into
a veritable buccaneer.

Once I met a young officer some two months out from Gov-
ernors Island, full of the books and much more knowledge begotten of
the confidence of youth, who informed me after I had expatiated on
the delightfully vagabond types these soldiers presented to an artist "that
all soldiers look alike, you see one, you see all." While this is the theory
and passes for true in the Atlantic garrisons, in General Miles's depart-
ment the practice is at a wondrous variance. Pipe-clay elements are
dropped for want of time to attend to them. Some of the men have not
been in garrison for a year, and at times their ingenuity is taxed to appear
decent.

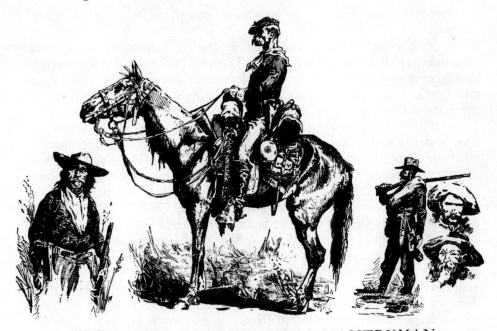

THE SCOUT, TROOPER AND INFANTRYMAN

The infantryman in his brown canvas clothes has more the look of a navvy than the smart military character, and frequently a toe has worked through a shoe until it much resembles a mud-turtle, imparting to its wearer the social air of a tramp. The villainous knives issued to the "doughboys" complete a sinister aspect, for they would look a part and parcel of the Genghis Khan; still, they have their use in the domestic affairs of the soldier while serving in place of the discarded bayonet. Another exponent of the foot soldier, the knapsack, is also gone, while the ammunition belt has relegated the cartridge box to the arsenals. A big tin cup flaps from its fastenings on the haversack, and the "set" of the pantaloons, tucked and wrinkled in the service boots, is far from fashionable.

The scouts, packers, and teamsters add artistic qualities in their strongly molded faces and businesslike get-up that the most casual onlooker could not but perceive. It readily occurs to one that he would not care to meet them in the dark, but the proof of the pudding shows them to be exceptionally honest, pleasant men in their way—only their lives are earnest and altogether discouraging to the dandy tendencies. Should one be disposed to ferret out strange characters, here is his "feast of reason"; for these men have not followed their dangerous callings and made personal histories rivaling the yellow-novel heroes without a mind peculiar, a character sturdy, and a training far from matter of fact. They will greet you roughly, with a thorough lack of conventionality, in the dialect of the frontier; and if you *sabe* [understand] them they are no end of friends; and spreading your blanket beside them, you may feel

fortunate if you never sleep in worse company in your Western rambles.

The Indian scouts employed as trailers will certainly attract attention. They are San Carlos and Tonto Apaches, wild and savage as any race of men who ever lived; lithe and sinewy, with sharp eyes and quick, bright ways; quite different from their stolid brethren of the north. They wear the usual garments made of cotton cloth, with a colored fabric wound round their heads, allowing their manes to flow about their face and shoulders. In walking, they move off smartly, working from the hips, running with ease uphill, and as the saying goes, "they rest while coming down." The tales of their endurance in traveling are almost incredible. That they are cruel, one does not have to look a second time to guess; he does not have to see them torture a rabbit as a pastime, for the subdued ferocity of the tiger is in their eyes and gleams out savagely at times, beyond their will to suppress. A villainous-looking Mexican named José Marie is their interpreter. He has spent his life among them, having been captured when a child and since adopted into the tribe, where he doubtless is considered a very fair Apache for a Yaqui mongrel. He shouts his interpretations at them after the manner of a Mississippi River mate in the boating days of old. Truly as heterogeneous a combination of soldier elements as the reign of war can bring together, and certainly interesting to observe, is this phase of life so important in American history, which is fast passing away.

In following the fortunes of Miles's troopers, the first impression is the beautiful simplicity of camp life. Robin Hood is outdone, for he had the forest trees above his head. Where the saddle is taken from the horse's back and thrown upon the ground is camp, without more ado or advancing. The aspect of a tented field is entirely missing.

In the early morning, as the night grows pale with coming light, the horse herd comes up from its night on the range at a good round trot, unconsciously keeping in the form of a column, showing the impress of a military life on the equine nature. The Apaches' chosen ground not being made for the echoes of a trumpet, no bugles blare; but the simple calls of the sergeant summon the men. "Catch your horses," comes the command amid the hurrying of many feet as the herd rounds up. The horses are caught and picketed, the breakfast eaten, the saddlebags rationed, because this is a warm trail and before the command "Halt" is given, sleep will be more necessary than eating.

"Come boys, get a motion on, that air mu-el will just naturally die of old age if you don't rustle," shouts the boss packer to his assistants. The ropes fly in the mystic circles of the "diamond hitch" as the big packs are bound on the *apperajos* [saddlebags]. The mule strains, lays his ears back, and grunts a little as, with an "All tight now," the two packers surge back on the ropes. As the "poor mule," so called in comparison with his more lusty fellows, goes back to the train with

a light but bulky load of camp kettles jangling at his sides, "All right, Sarg" comes from the pack train, followed by the sharp soldierly tones of "Saddle up."

Each trooper stands to his horse and proceeds to that artful process, the dilettante effort of a cavalryman's life. A galled horse is his curse. It means punishment and jeers and loss of caste, so he arranges his blankets as a mother would smooth the coverlets on a sleeping babe, and swinging on his saddle, he straightens the girths and "cinches" up all snug and tight. The blanket and overcoat are nicely rolled and buckled on, the full canteens strapped, the carbine socketed, and all being ready, comes the command, "Fall in!" "Count fours!—Prepare to mount!—Mount!—Fours right! March!" follows fast, and the column breaks on its march.

The scouts take up the interminable trail, the troops string out, and the packers keep the mules closed up. Across a wide valley lead the flying footprints, evidently making for the mountains on the other side. A fine dust rises under the many hoofs, enveloping the column and settling in a fine sifting over all below. Higher and higher goes the sun into the heavens, and pouring down in blistering streams, it bites the shadows sharply on the ground and is reflected up again from the glittering white of the sands. From the south the sirocco freshens and comes like a blast from a hot-air register against the cheeks. The perspiration starts on the flanks of the beasts and the foreheads of the men, and runs in grimy streaks toward the centers of gravitation. The water in the canteens is now a sickening draught.

Still on and on leads the hostile trail. Here they ran their horses, as is seen by the hoofbeats on the sand, and the droppings would indicate that the passage was made many hours before. That the Indian horses were tired can be seen by the jerky fall of the feet, long strides shortening gradually, then long again as urged on by the cruel knife. They also passed in the night, for here they have run into a mesquite bush instead of going around it. Then, too, they deemed themselves safe from immediate pursuit, as no scouts have lain back on the trail. All this and much more do the footmarks tell the experienced eyes that follow.

Presently the edge of the mesa is reached and the trail leads into the bottoms. Water is there, we hope; but no, the white sands of the dried river have greedily drunk the last drop and now lie dry and hot in the bed. But there is water somewhere on the Indian trail, and probably somewhere in those mountains whose blue is warming into browns as we approach. Off to the right appears a calm and brimming lake, beautiful to longing eyes; but too well do the men know the mirage and that their parched lips cannot be moistened there.

The horses, too, are in need of water, but they have needed it many times since they left the cool pastures of Missouri and can do an astonishing amount of waiting until they get a chance to drink. But the flesh and good condition is gone, their bones show sharp against the

skin, and the play of the muscles is perfectly seen. Their necks have lost the arch, the eyes their sharpness, and the ears flap much as do those of their quasi-brothers, the mules. Trust not to appearances, for your elegant steeds of Central Park could not follow these veterans until they, too, had gone through a case-hardening by long marching, soft feed, and suffocating heat.

Traveling on the mesa is a recess to the soldiers on an Apache trail. At the base of the mountains their trials begin. Up, straight up over the last place in the world to travel, the wild warriors lead, and there must the troopers follow. Dismounting, they urge the horses up and over the mountain peaks, where no well-regulated equine mind would ever think of going except at the instigation of his friendly enemy, man. Here a horse gives out, lies down on the trail; but there is no time to wait, the column passes on and he is abandoned. The trail may be lost in the rocks. Obstacles insurmountable may be met, or perhaps a shower of bullets greets it from the rocks above.

Everything is possible except a square stand-up-fight, because the Apache war code contemplates everything but that. Still, they will fight when cornered, as Colonel García's command of Mexican troops can testify after their fight at the water hole in Sonora. Hand to hand the Apaches engaged him, drinking and fighting almost at the same time, with the loss of many men on both sides. Indefatigable and aggressive, they turned upon Hatfield after being driven off with loss, and ambushed his command in a box-canyon near Santa Cruz. Though Lebo's "black buffaloes" demonstrated that they cannot whip our troops, even with the advantage of position. But at racing across the mountains the men or animals do not live that can equal them. As Private Kelly remarked while mopping the perspiration from his brow, "sure un a blind mon might as well chase a burd." The soldier avails himself of his only prerogative, grumbling; he cannot know the General's purpose in marching him so rapidly and constantly up and down the face of the earth. But the unceasing pursuit will wear out human endurance at last, even though it be of the marvelous Apache kind. Meanwhile, the duties are developing both officers and men. It is the finest imaginable place to round off a West Pointer, as he learns acuteness in his operations against the wily enemy and his muscles become iron. The men here cannot straggle. The wild defiles of the Sierras offer no temptations to stay behind.

As a whole the operations are confined to the rapid maneuvering of petty commands, while each has its quota of incident. The history of the campaign will probably not be written for some time to come. The exploits of Natchez's banditti may never form a printed page. The dread solitudes of that desolate land alone know where lie the bones of the murdered inhabitants of Arizona and Sonora.

What officer of the Army will pluck the final laurels is yet to be seen, but many have deserved great credit; and for personal heroism, none surpass young Lieutenant Clark of the Tenth colored Cavalry.

A TROOPER'S FATE IN APACHE-LAND

In Lebo's fight he gallantly rescued, under fire, the wounded Corporal Scott, and this incident demonstrates how men appreciate a brave and generous officer. "Dat 'ar Lieutenant Clark is a —— ——fighting man, you'd better believe," said a sergeant in his company to me as we discussed the fight. My information of the lieutenant's exploit is from a vivid explanation of Corporal Scott himself, as he lay on his cot in the Fort Huachuca hospital, convalescing from an amputation of the leg. The corporal added in the soft rippling of his native dialect, "dat when he jumped fo' me as I lay dar in de open, dem Inguns, dey jus' done plowed de groun' round dar, and mister, ef dat lieutenant warn't a right brave man, he'd 'a' done dusted out and lef' me as I tole him to." The dusky hero who aided the lieutenant's noble effort will go down to posterity in allegory as it were, for I presume that he, like Attila and numerous other men of war, had no time to hunt up stray historians.

I talked also with the men of Captain Hatfield's action, and one bearded veteran seemed more impressed with the poetic burial of the dead under the old adobe wall at Frontares than the circumstances of the strife; for in his expressive narrative he apostrophized that "you can bet your neck, she was a funeral. It sort of struck the boys that way anyhow, and the howling of them greaser women, 'long with the

EARNING HIS $13. A MONTH

glare of the torches, didn't ease her any; and the boys, they just stood round and looked as solemn as a hen roost." Undoubtedly they did look solemn as they rendered the bullet-torn forms of their comrades back to their parent clay and brooded over the time when their turns might come to be swallowed in the sands of Mexico, mourned by their comrades but left forever behind as they marched away.

Here, too, I met many men whose names are associated with the border wars. General "Sandy" Forsyth, the sturdy commander at Beacher's Island in '68, an action which stands without a peer in modern heathen wars. . . . He carries three bullet wounds as mementos of that affair . . . and all as lightly as a buffalo would a charge of swan shot . . . and he is willing to absorb more lead in the interest of the American Army.

The tall gentleman in civilian clothes who talks with every old rancher as familiarly as though he were not a major general, is Miles. From his calm, thoughtful face one might think all this concern rested on some other person's shoulders; but do not attempt to follow his jinni flights, or you will miss many hours of sleep. Here today and miles away tomorrow, with his headquarters in his gripsack. Organizing an expedition, directing there and encouraging here, he knows all that goes on over a vast territory. The people all know him, like him personally, and have confidence. Miles is a fighting Army officer, and that always commands respect. But the tall general, with all his democracy, has little levity in his mental make-up; and should you desire to occupy his time, guard well your speech, or with pointed remarks, he may make you regret an indiscretion.

In my journeying I also met that young gentlemen of the Army Lieutenant Dasher of the Staff, bred to the acme of military formalities; and I sat on the ground in the shade of an adobe wall and chatted with Captain Dogged, of marching and fighting, and in my imagination followed him through the stormy times along the Potomac, thence into Texas and Kansas among the Cheyennes and Arapahoes, up into the frosty trails of Montana made by the Sioux; and then we dwelt on the present, and that seemed, as always, the worst of all. I could not help noting how Dasher's prompt air and faultless attire contrasted with Dogged's dull boots and his "rear elevation," made prominent by saddle-worn buckskin. The silvered head, too, of old Colonel Highlist tells of a life spent in the service, and the limp in his gait makes one wonder on what field he was wounded; and young Hudson, fresh from the "Point," has it all before him and . . . wishes Uncle Sam's moods were more warlike.

Here all these men have their interest, for the only place we can admire a duck is in the water, likewise a soldier in war. In the humdrum of civil life, with the Almighty Dollar as the gauge of every phase, brass buttons rank as a baser metal; but when well tarnished by exposure to a long campaign, they grace the dusty trooper on his jaded mount, appeal to every sentiment, and shine as gold.

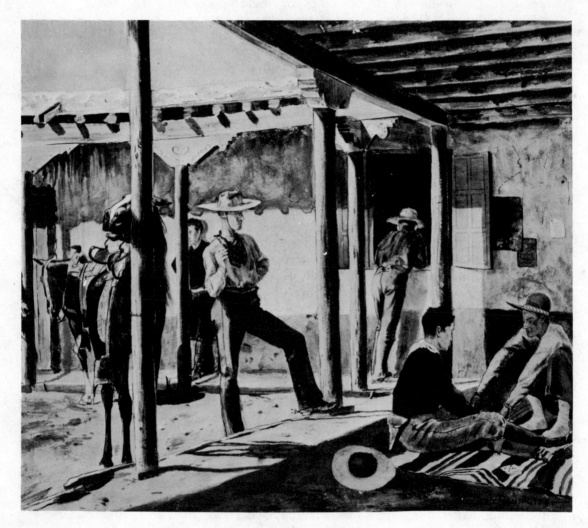

SAN CARLOS, ARIZONA TY. — 1885

II

On The Indian Reservations

I was camping with a couple of prospectors one night some years ago [in 1885] on the south side of the Pinal Range in Arizona Territory. We were seated beside our little cooking fire about nine o'clock in the evening, engaged in smoking and drowsily discussing the celerity of movement displayed by Geronimo, who had at last been heard of down in Sonora, and might be already far away from there, even in our neighborhood. Conversation lapsed at last, and puffing our pipes and lying on our backs, we looked up into the dark branches of the trees above. I think I was making a sluggish calculation of the time necessary for the passage of a far-off star behind the black trunk of an adjacent tree when I felt moved to sit up. My breath went with the look I gave, for to my unbounded astonishment and consternation, there sat three Apaches on the opposite side of our fire with their rifles across their laps. My comrades also saw them, and old, hardened frontiersmen as they were, they positively gasped in amazement.

"Heap hungry," ejaculated one of the savage apparitions, and again relapsed into silence.

As we were not familiar with Mr. Geronimo's countenance, we thought we could see the old villain's features in our interlocutor's, and we began to get our artillery into shape.

The savages, in order to allay the disturbance which they had very plainly created, now explained.

"We White Mountain people. No want fight—want flour."

They got the flour in generous quantities, it is needless to add, and although we had previously been very sleepy, we now sat up and entertained our guests until they stretched themselves out and went to sleep. We pretended to do the same. During that night I never closed my eyes, but watched, momentarily expecting to see more visitors come gliding out of the darkness. I should not have been surprised even to see an Apache drop from a branch above me.

They left us in the morning, with a blessing couched in the

style of forcible speech that my Rocky Mountain friends affected on unusual occasions. I mused over the occurrence; for while it brought no more serious consequences than the loss of some odd pounds of bacon and flour, yet there was a warning in the way those Apaches could usurp the prerogatives of ghosts, and ever after that I used to mingle undue proportions of discretion with my valor.

Apaches are wont to lurk about in the rocks and chaparral with the stealth of coyotes, and they have always been the most dangerous of all the Indians of the Western country. They are not at all valorous in their methods of war, but are nonetheless effective. In the hot desert and vast rocky ranges of their country no white man can ever catch them by direct pursuit. Since railroads and the telegraph have entered their territory and military posts have been thoroughly established, a very rigorous military system has kept them in the confines of the San Carlos reservation, and there is no longer the same fear that the next dispatches may bring news of another outbreak. But the troopers under General Miles always had their cartridge belts filled and their saddle pockets packed, ready at any hour of the day to jump out on a hostile trail.

The affairs of the San Carlos agency are administered at present by an Army officer, Captain Bullis of the Twenty-fourth Infantry. As I have observed him in the discharge of his duties, I have had no doubt that he pays high life-insurance premiums. He does not seem to fear the beetle-browed pack of murderers with whom he has to deal, for he has spent his life in command of Indian scouts, and not only understands their character, but has gotten out of the habit of fearing anything. If the deeds of this officer had been done on civilized battlefields instead of in silently leading a pack of savages over the desert waste of the Rio Grande or the Staked Plain, they would have gotten him his niche in the temple of fame. Alas! they are locked up in the gossip of the Army messroom, and end in the soldiers' matter-of-fact joke about how Bullis used to eat his provisions in the field, opening one can a day from the packs, and whether it was peaches or corned beef, making it suffice. The Indians regard him as almost supernatural, and speak of the "Whirlwind" with many grunts of admiration as they narrate his wonderful achievements.

The San Carlos reservation, over which he has supervision, is a vast tract of desert and mountain, and near the center of it, on the Gila River, is a great flat plain where the long, low adobe buildings of the agency are built. Lines of white tents belonging to the cantonment form a square to the north. I arrived at this place one evening, after a hot and tiresome march, in company with a cavalry command. I found a good bunk in the tent of an Army officer whose heart went out to the man in search of the picturesque, and I was invited to destroy my rations that evening at the long table of the officers' mess, wondering much at the culinary miracles performed by the Chinaman who presided

over its destinies. The San Carlos is a hotter place than I ever intend to visit again. A man who is used to breathing the fresh air of New York Bay is in no condition to enjoy at one and the same time the dinner and the Turkish bath which accompanies it. However, Army officers are as entertaining in their way as poets, and I managed to be both stoical and appreciative.

On the following morning I got out my sketchbook, and taking my host into my confidence, I explained my plans for action. The captain discontinued brushing his hair and looked me over with a humorous twinkle in his eyes. "Young man," he said, "if you desire to wear a long gray beard, you must make away with the idea that you are in Venice."

I remembered that the year before a Blackfoot upon the Bow River had shown a desire to tomahawk me because I was endeavoring to immortalize him. After a long and tedious course of diplomacy it is at times possible to get one of these people to gaze in a defiant and fearful way down the mouth of a camera; but to stand still until a man draws his picture on paper or canvas is a proposition which no Apache will entertain for a moment. With the help of two officers, who stood up close to me, I was enabled to make rapid sketches of the scenes and people; but my manner at last aroused suspicion, and my game would vanish like a covey of quail.

From the parade in front of our tent I could see the long lines of horses, mules, and burros trooping into the agency from all quarters. Here was my feast. Ordinarily the Indians are scattered for forty miles in every direction; but this was ration day, and they all were together. After breakfast we walked down. Hundreds of ponies, caparisoned in all sorts of fantastic ways, were standing around. Young girls of the San Carlos tribe flitted about, attracting my attention by the queer ornaments which, in token of their virginity, they wear in their hair. Tall Yuma bucks galloped past with their long hair flying out behind. The squaws crowded around the exit and received the great chunks of beef which a native butcher threw to them. Indian scouts in military coats and armed with rifles stood about to preserve order. Groups of old women sat on the hot ground and gossiped. An old chief, with a very respectable amount of adipose under his cartridge belt, galloped up to our group and was introduced as Esquimezeu. We shook hands.

These Indians have natural dignity, and it takes very little knowledge of manners for them to appear well. The Apaches have no expression for a good-by or a greeting, and they never shake hands among themselves; but they consider handshaking an important ceremony among white men, and in their intercourse with them, attach great importance to it. I heard an officer say that he had once seen an Apache come home after an absence of months: he simply stepped into the room, sat down without a word, and began rolling a cigarette.

The day was very hot, and we retired to the shade of Captain

Bullis's office. He sat there with a big sombrero pulled over his eyes and listened to the complaints of the Indians against one another. He relegated certain offenders to the guardhouse, granted absolute divorces, and probated wills with a bewildering rapidity. The interpreter struggled with his English; the parties at law eyed one another with villainous hate, and knives and rifles glistened about in a manner suggestive of the fact that the court of last resort was always in session. Among these people men are constantly killing one another, women are carried off, and feuds are active at all times. Few of these cases come before the agent if the parties think they can better adjust their own difficulties by the blood-atonement process, but the weak and the helpless often appeal.

After leaving the office and going some distance, we were startled by a gunshot from the direction of the room we had just left. We started back. The Negro soldiers of the guard came running past; the Indians became excited; and everyone was armed in a minute. A giant officer of infantry, with a white helmet on his head, towered above the throng as he forced his way through the gathering mass of Indians. Every voice was hushed, and everyone expected anything imaginable to happen. The Indians began to come out of the room, the smoke eddying over their heads, and presently the big red face and white helmet of the infantry officer appeared. "It's nothing, boys—only an accidental discharge of a gun." In three minutes things were going on as quietly as before.

Captain Bullis sauntered up to us, and tipping his hat on one side, meditatively scratched his head as he pointed to an old wretch who sat wrapped in a sheet against the mud wall of the agency.

"There's a problem. That old fellow's people won't take care of him any longer, and they steal his rations. He's blind and old and can't take care of himself." We walked up and regarded the aged being, whose parchment skin reminded us of a mummy. We recoiled at the filth, we shuddered at his helplessness, and we pitied this savage old man so steeped in misery; but we could do nothing. I know not how the captain solved his problem. Physical suffering and the anguish of cast-off old age are the compensations for the self-reliant, savage warrior who dozes and dreams away his younger days and relegates the toil to those within his power.

We strolled among the horses and mules. They would let me sketch them, though I thought the half-wild beasts also shrank away from the baleful gaze of the white man with his bit of paper. Broncos, mules, and burros stood about with bags of flour tied on their saddles and great chunks of meat dripping blood over their unkempt sides. These woebegone beasts find scant pasture in their desert home, and are banged about by their savage masters until ever-present evils triumph over equine philosophy. Fine navy blankets and articles of Mexican manufacture were stretched over some of the saddles, the latter probably

over its destinies. The San Carlos is a hotter place than I ever intend to visit again. A man who is used to breathing the fresh air of New York Bay is in no condition to enjoy at one and the same time the dinner and the Turkish bath which accompanies it. However, Army officers are as entertaining in their way as poets, and I managed to be both stoical and appreciative.

On the following morning I got out my sketchbook, and taking my host into my confidence, I explained my plans for action. The captain discontinued brushing his hair and looked me over with a humorous twinkle in his eyes. "Young man," he said, "if you desire to wear a long gray beard, you must make away with the idea that you are in Venice."

I remembered that the year before a Blackfoot upon the Bow River had shown a desire to tomahawk me because I was endeavoring to immortalize him. After a long and tedious course of diplomacy it is at times possible to get one of these people to gaze in a defiant and fearful way down the mouth of a camera; but to stand still until a man draws his picture on paper or canvas is a proposition which no Apache will entertain for a moment. With the help of two officers, who stood up close to me, I was enabled to make rapid sketches of the scenes and people; but my manner at last aroused suspicion, and my game would vanish like a covey of quail.

From the parade in front of our tent I could see the long lines of horses, mules, and burros trooping into the agency from all quarters. Here was my feast. Ordinarily the Indians are scattered for forty miles in every direction; but this was ration day, and they all were together. After breakfast we walked down. Hundreds of ponies, caparisoned in all sorts of fantastic ways, were standing around. Young girls of the San Carlos tribe flitted about, attracting my attention by the queer ornaments which, in token of their virginity, they wear in their hair. Tall Yuma bucks galloped past with their long hair flying out behind. The squaws crowded around the exit and received the great chunks of beef which a native butcher threw to them. Indian scouts in military coats and armed with rifles stood about to preserve order. Groups of old women sat on the hot ground and gossiped. An old chief, with a very respectable amount of adipose under his cartridge belt, galloped up to our group and was introduced as Esquimezeu. We shook hands.

These Indians have natural dignity, and it takes very little knowledge of manners for them to appear well. The Apaches have no expression for a good-by or a greeting, and they never shake hands among themselves; but they consider handshaking an important cere- mony among white men, and in their intercourse with them, attach great importance to it. I heard an officer say that he had once seen an Apache come home after an absence of months: he simply stepped into the room, sat down without a word, and began rolling a cigarette.

The day was very hot, and we retired to the shade of Captain

Bullis's office. He sat there with a big sombrero pulled over his eyes and listened to the complaints of the Indians against one another. He relegated certain offenders to the guardhouse, granted absolute divorces, and probated wills with a bewildering rapidity. The interpreter struggled with his English; the parties at law eyed one another with villainous hate, and knives and rifles glistened about in a manner suggestive of the fact that the court of last resort was always in session. Among these people men are constantly killing one another, women are carried off, and feuds are active at all times. Few of these cases come before the agent if the parties think they can better adjust their own difficulties by the blood-atonement process, but the weak and the helpless often appeal.

After leaving the office and going some distance, we were startled by a gunshot from the direction of the room we had just left. We started back. The Negro soldiers of the guard came running past; the Indians became excited; and everyone was armed in a minute. A giant officer of infantry, with a white helmet on his head, towered above the throng as he forced his way through the gathering mass of Indians. Every voice was hushed, and everyone expected anything imaginable to happen. The Indians began to come out of the room, the smoke eddying over their heads, and presently the big red face and white helmet of the infantry officer appeared. "It's nothing, boys—only an accidental discharge of a gun." In three minutes things were going on as quietly as before.

Captain Bullis sauntered up to us, and tipping his hat on one side, meditatively scratched his head as he pointed to an old wretch who sat wrapped in a sheet against the mud wall of the agency.

"There's a problem. That old fellow's people won't take care of him any longer, and they steal his rations. He's blind and old and can't take care of himself." We walked up and regarded the aged being, whose parchment skin reminded us of a mummy. We recoiled at the filth, we shuddered at his helplessness, and we pitied this savage old man so steeped in misery; but we could do nothing. I know not how the captain solved his problem. Physical suffering and the anguish of cast-off old age are the compensations for the self-reliant, savage warrior who dozes and dreams away his younger days and relegates the toil to those within his power.

We strolled among the horses and mules. They would let me sketch them, though I thought the half-wild beasts also shrank away from the baleful gaze of the white man with his bit of paper. Broncos, mules, and burros stood about with bags of flour tied on their saddles and great chunks of meat dripping blood over their unkempt sides. These woebegone beasts find scant pasture in their desert home, and are banged about by their savage masters until ever-present evils triumph over equine philosophy. Fine navy blankets and articles of Mexican manufacture were stretched over some of the saddles, the latter probably

obtained in a manner not countenanced by international law.

The Apaches have very little native manufacture. They rely on their foraging into Mexico for saddlery, serapes, and many other things. Their squaws make wickerwork, some of which I have never seen surpassed. *Allas*, or water jars, of beautiful mold and unique design, are sold to anyone who desires to buy them at a price which seems absurdly mean when the great labor expended on them is considered. But Apache labor is cheap when Apaches will work at all. The women bring into the cantonment great loads of hay on their backs, which is sold to the cavalry. It is all cut with a knife from bunches which grow about six inches apart, and is then bound up like wheat and carried for miles.

By evening all the Indians had betaken themselves to their own rancherias and the agency was comparatively deserted for another week.

I paused for a day on the Gila, some miles from the agency, to observe the methods of agriculture practiced by the San Carlos Indian tribe. The Gila River bottoms are bounded on each side by bluffs, and on these the Indians build their brush jacals. High above the stifling heat of the low ground the hot winds from the desert blow through the leafy bowers which they inhabit. As they wear no clothing except breechcloth and moccasins, they enjoy comparative comfort. The squaws go back and forth between their jacals and the river, carrying wicker *allas* filled with muddy water, and the whole people seek the river and the system of irrigating ditches at evening time to

turn the water over the parched ground and nourish the corn, wheat and vegetables which grow there.

Far up the valley the distant *stump* of a musket shot reaches our ears; then another comes from a nearer point, and still another. Two or three women begin to take away the boards of an *acequia* dam near as the water rises to their knees, and with a final tug, the deepening water rushes through. "*Bang!*" goes the Springfield carbine of an Indian standing at my elbow, and after some moments another gunshot comes to our ears from below. As the minutes pass, the reports come fainter, until we are just conscious of the sounds far off down the valley.

The pile of straw round which a mounted Indian has been driving half a dozen horses all day in order to stamp out the grain has lowered now until he will have but an hour's work more in the morning. He stops his beasts and herds them off to the hills to graze. The procession of barefooted men and of women bearing jars comes winding over the fields toward their humble habitations on the bluffs. The sun sinks behind the distant Sierras, and the beautiful quiet tones of the afterglow spread over the fields and the water. As I stand there watching the scene, I can almost imagine that I see Millet's peasants; but alas! I know too well the difference.

My companion, a lieutenant of cavalry, and I bethink ourselves to go back to the camps of these people to spend an evening; so, leaving the troopers about their fires, we take our way in company with an old Government Indian scout to his own jacal. The frugal evening meal was soon disposed of, and taking our cigarettes, we sat on the bluffs and smoked. A traveler in the valley, looking up at the squatting forms of men against the sky, would have remembered the great strength of chiaroscuro in some of Doré's drawings and to himself have said that this was very like it.

I doubt if he would have discerned the difference between the two white men who came from the bustling world so far away and the dark-skinned savages who seemed a sympathetic part of nature there, as mute as any of its rocks and as incomprehensible to the white man's mind as any beast which roams its barren wastes.

It grew dark, and we forbore to talk. Presently, as though to complete the strangeness of the situation, the measured "*thump, thump, thump*" of the tom-tom came from the vicinity of a fire some short distance away. One wild voice raised itself in strange discordant sounds, dropped low, and then rose again, swelling into shrill yelps, in which others joined. We listened, and the wild sounds to our accustomed ears became almost tuneful and harmonious. We drew nearer, and by the little flickering light of the fire discerned half-naked forms huddled with uplifted faces in a small circle around the tom-tom. The fire cut queer lights on their rugged outlines, the waves of sound rose and fell, and the "*thump, thump, thump, thump*" of the tom-tom kept a binding

time. We grew in sympathy with the strange concert, and sat down some distance off and listened for hours. It was more enjoyable in its way than any trained chorus I have ever heard.

The performers were engaged in making medicine for the growing crops, and the concert was a religious rite which, however crude to us, was entered into with a faith that was attested by the vigor of the performance. All savages seem imbued with the religious feeling, and everything in nature that they do not comprehend is supernatural. Yet they know so much about her that one often wonders why they cannot reason further.

The one thing about our aborigines which interests me most is their peculiar method of thought. With all due deference to much scientific investigation which has been lavished upon them, I believe that no white man can ever penetrate the mystery of their mind or explain the reason of their acts.

The red man is a man of glaring incongruities. He loves and hates in such strange fashions, and is constant and inconstant at such unusual times, that I often think he has no mental process, but is the creature of impulse. The searching of the ethnologist must not penetrate his thoughts too rapidly, or he will find that he is reasoning for the Indian, and not with him.

KIOWA BUCK

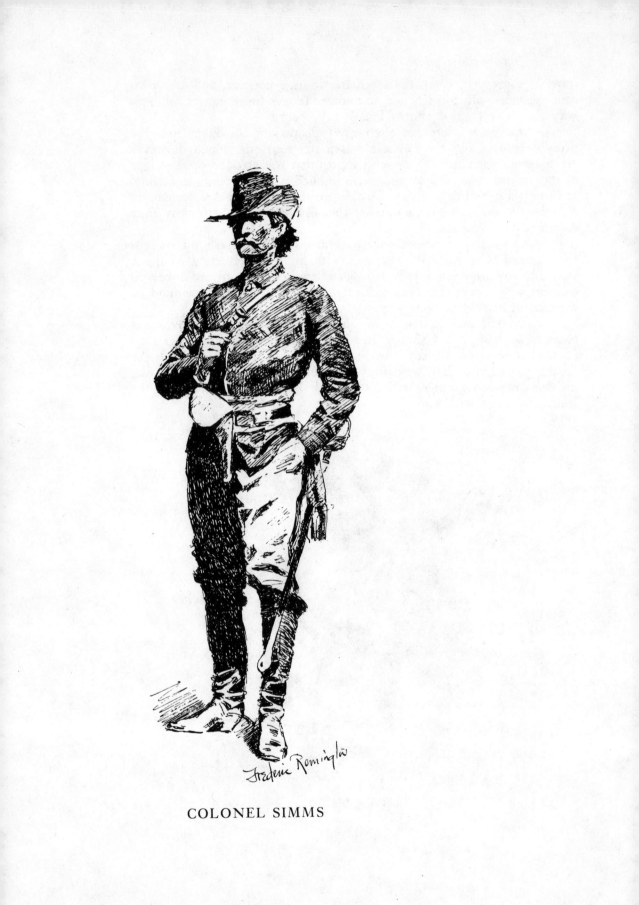

COLONEL SIMMS

III

A Desert Romance

I

Ochoa water hole is in no way remarkable, and not regarded as such by people in Arizona, but if the waters could speak and tell about what happened at their sides in the long ago, men would listen. Three generations of white men and Mexicans have fought Apaches since then, and one generation of Apaches has walked in the middle of the big road. There have been stories enough in the meantime. Men have struggled in crowds over similar water holes throughout the Southwest, and Ochoa has been forgotten.

With the coming of the great war [the Civil War] the regular soldiers were withdrawn to participate in it. The Apaches redoubled their hostilities. This was in Cochise's day, and he managed well for them.

Volunteers entered the United States service to take the places of the departed soldiers, to hold the country, and to protect the wagon trains then going to California. A regiment of New Mexican volunteer infantry, Colonel Simms commanding, was stationed at Fort Bowie, and was mostly engaged in escorting the caravans. There was a military order that such trains should leave the posts only on the first of every month, when the regular soldier escort was available; but in enterprising self-reliance the pioneers often violated this.

One lazy summer day a Texan came plodding through the dust to the sentries at Bowie. He was in a state of great exhaustion, and when taken to Colonel Simms, he reported that he had escaped from a Texas emigrant caravan which was rounded up by Apaches at Ochoa water hole, about forty-five miles east and south of this point, and that they were making a fight against great odds. If help was not quickly forthcoming, it was death for all.

Immediately the colonel took what of his command could be spared, together with a small cavallard of little hospital mules, and began the relief march.

These Americo-Mexican soldiers were mountain men and strong

35

travelers. All during the remainder of the day they shuffled along in the dust—brown blue-bearded men, shod in buckskin moccasins of their own construction, and they made the colonel's pony trot. There are many hills and many plains in forty-five miles, and infantry is not a desert whirlwind. Night settled over the command, but still they shuffled on. Near midnight they could hear the slumping of occasional guns. The colonel well knew the Apache fear of the demons of the night, who hide under the water and earth by day, but who stalk at dark, and are more to be feared than white men, by long odds. He knew that they did not go about except under stress, and he had good hope of getting into the beleaguered wagons without much difficulty. He knew his problem would come afterward.

Guided by the guns, which the white men fired more to show their wakefulness than in hopes of scoring, the two companies trod softly in their buckskin footgear; but the mules struck flinty hard against the wayside rocks, and then one split the night in friendly answer to the smell of a brother mule somewhere out in the dark. But no opposition was encountered until occasional bullets came whistling over there from the wagons. "Hold on, pardners!" shouted the colonel. "This is United States infantry; let us in."

This noise located the command, and bullets and arrows began to seek them out in the darkness from all sides, but with a rush they passed into the packed wagons and dropped behind the entrenchments. The poor people of the train were greatly cheered by the advent. By morning the colonel had looked about him, and he saw a job of unusual proportions before him. They were poor emigrants from Texas, their wagons piled with common household goods and with an unusual proportion of women and children—dry, careworn women in calico dresses, which the clinging wind blew close about their wasted and unlovely frames. In the center stood a few skeletons of horses, destined to be eaten, and which had had no grass since the train had been rounded up. What hairy, unkempt men there were lay behind their bales, long rifles in hand, bullets and powderhorn by their elbows—tough customers who would sell out dearly.

Presently, a very old man came to the colonel, saying he was the head person of the train, and he proposed that the officer come to his wagon, where they could talk over the situation seriously.

The colonel was at the time a young man. In his youth he had been afflicted with deskwork in the great city of New York. He could not see anything ahead but a life of absolute regularity, which he did not view complacently. He was book-taught along the lines of construction and engineering, which in those days meant anything from a smokehouse to a covered bridge. Viewed through the mist of years he must, in his day, have been a fair prospect for feminine eyes. The West was fast eating up the strong young men of the East, and Simms found his way with the rest to the uttermost point of the unknown

lands, and became a vagrant in Taos. Still, a man who knew as much as he did and who could get as far West as Taos did not have to starve to death. There were merchants there who knew the fords of the Cimarron and the dry crossings of the Mexican customhouse, but who kept their accounts by cutting notches on a stick. So Simms got more writing to do, a thing he had tried to escape by the long voyage and muling of previous days. Being young, his gaze lingered on the long-haired buckskin men of Taos, and he made endeavor to exchange the quill for the rifle and the trap, and shortly became a protégé of Kit Carson. He succeeded so well that in the long years since he has been no nearer a pen than a sheep corral would be.

He succumbed to his Mexican surroundings, and was popular with all. When the great war came, he remembered New York and declared for the Union. Thus by hooks which I do not understand he became a colonel in the situation where I have found him.

As he approached the old man's part of the train, he observed that he was richer and much better equipped than his fellows. He had a tremendous Conestoga and a spring-wagon of fine workmanship. His family consisted of a son with a wife and children and a daughter who looked at the colonel until his mind was completely diverted from the seriousness of their present position. The raw, wind-blown calico women had not seemed feminine to the officer, but this young person began to make his eyes pop and his blood go charging about in his veins.

She admitted to the officer in a soft Southern voice that she was very glad he had gotten in, and the colonel said he was very glad indeed that he was there, which statement had only become a fact in the last few seconds. Still, a bullet-and-arrow-swept wagon park was quite as compelling as the eyes of Old Man Hall's daughter, for that was her father's name. The colonel had a new interest in rescue. The people of the train were quite demoralized and had no reasonable method to suggest as a way out, so the colonel finally said "Mr. Hall, we must now burn all this property to prevent its falling into the hands of the enemy. I will take my hospital mules and hook them up to a couple of your lightest wagons, on which will be loaded nothing but provisions, old women, small children, and what wounded we have, and then we will fight our way back to the post."

Mr. Hall pleaded against this destruction, but the officer said that the numbers of the investing enemy made it imperative that they go out as lightly as possible, as he had no more mules and could spare no more men to guard the women. It seemed hard to burn all that these people had in the world, but he knew of no other way to save their lives.

He then had two wagons drawn out, and after a tussle got his unbroken pack mules hooked up. Then the other stuff was piled into the remaining wagons and set on fire. The soldiers waited until the flames were beyond human control, when they sprang forward in

skirmish formation, followed out of bow-shot by the wagons and women. A rear guard covered the retreat.

As the movement began, Colonel Simms led his pony up to the daughter of Mr. Hall and assisted her to mount. Simms was a young man, and it seemed to him more important that a beautiful young woman should be saved than some sisters who carried the curbs and collar marks of an almost spent existence. This may not be true judgment, but Simms had little time to ponder the matter.

Now the demons of the Arizona deserts began to show themselves among the brush and rocks, and they came in boldly, firing from points of vantage at the moving troops. A few went down, but the discipline told, and the soldiers could not be checked. Scurrying in front ran the Indians, on foot and on horseback. They had few guns, and their arrows were not equal to the muzzle-loading muskets of the troops or the long rifles of the Texans. A few of the savages were hit, and this caused them to draw off. The wounded soldiers were loaded into the wagons, which were now quite full.

What with having to stop to ram the charges home in their guns and with the slow progress of the women on foot, the retreat dragged its toilsome way. There were bad places in the back trail—places which Simms knew the Apaches would take advantage of; but there was nothing for it but to push boldly on.

After a couple of hours the command drew near a line of bluffs up which the trail led. There was no way around. Simms halted his wagons at the foot of the coulee leading up and sent his men in extended order on each flank to carry the line of the crest, intending to take the wagons and women up afterward. This they did, encountering some opposition, and when just in the act of reaching the level of the mesa, a score of mounted warriors dashed at the line and rode over it, down the coulee in a whirl of dust, and toward the women, who had no protection which could reach them in time to save. The men on the hill, regardless of the enemy in front, turned their muskets on the flying bunch, as did the rear guard; but it was over with a shot, and the soldiers saw the warriors ride over the women and wagons, twanging their bows and thrusting with their lances. The mules turned, tangled in their harness, and lay kicking in a confused heap. The women ran scurrying about like quail. The cloud of dust and racing ponies passed on, receiving the fire of the rear guard again, and were out of range. With them went the colonel's horse and Old Man Hall's daughter, stampeded—killed by the colonel's kindness. No arm could save.

When the dust settled, several women and children lay on the sand, shot with arrows or cut by lances. The mules were rearranged, the harness patched, and the retreat was resumed.

Old Man Hall was hysterical with tears, Simms was dumb beyond speech as they marched along beside the clanking wagons with their moaning loads. On all sides strode the gallant New Mexicans and

Texans, shooting and loading. The Apaches, encouraged by success, plied them with arrows and shots from every arroyo which afforded safe retreat. The colonel ran from one part of the line to another, directing and encouraging his men. By afternoon everyone was much exhausted, Colonel Simms particularly so from his constant activity and distress of mind.

Old Man Hall had calmed down and had become taciturn, except for the working of his hollow jaws as he talked to himself. Going to the rear wagon, he took out a cotton bag, which he swung across his shoulders, and trudged along with it. "Some valuables he cherishes," thought Simms; "but to add such weight in the trying march seems strange. Demented by the loss of his daughter, probably."

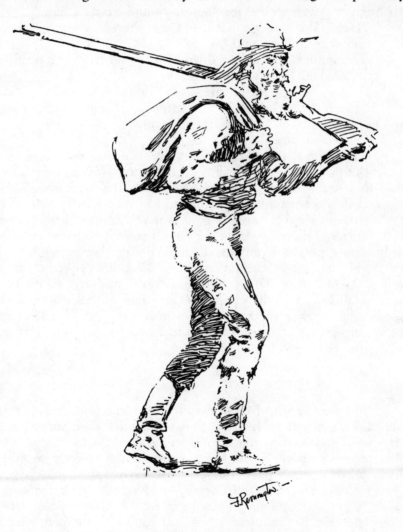

THE OLD MAN WITH HIS SACK

Slower and slower moved the old man with his sack, falling back until he mingled with the rear guard, and then even dropping behind that.

"Come, come, *camarada*, stir yourself! The *Indios* are just behind!" they called.

"I don't care," he replied.

"Throw away the sack. Why do you carry that? Is your sack more precious than your blood?"

"Yes, it is now," he said almost cheerfully.

"What does it contain, *señor?* Paper money, no doubt."

"No; it is full of pinole and pemochie and strychnine—for the wolves behind us"; and Old Man Hall trod slower and slower, and was two hundred yards in the rear before Simms noticed him.

"Halt! We will go back and get the old man, and have him put in the wagons," he said.

The soldiers turned to go back, when up from the brush sprang the Apaches, and Hall was soon dead.

"Come on; it is of no use now," signaled Simms.

"The old man is loco," said a soldier. "He had a sack of poisoned meal over his shoulder. He is after revenge."

"Poisoned meal!"

"Yes, *señor;* that is as he said," replied the soldier.

But under the stress Simms's little column toiled along until dusk, when they were forced to stop and entrench in a dry camp. There was no water in those parts, and the Indians had no doubt drawn off for the night—gone to the Ochoa spring, it was thought, and would be back in the morning. By early dawn the retreat started on its weary way, but no Indians appeared to oppose them. All day they struggled on, and that night camped in the post. They had been delivered from their peril: at little cost, when the situation was considered, so men said—all except Hall's son and the young commanding officer. The caravan had violated the order of the authorities in traveling without escort and had been punished. Old Man Hall, who had been responsible, was dead, so the matter rested.

II

The people who had so fortunately come within the protecting lines of Fort Bowie were quite exhausted after their almost ceaseless exertions of the last few days, and had disposed themselves as best they could to make up their lost sleep. Some of the soldiers squeezed the tequila pigskin pretty hard, but they had earned it.

Colonel Simms tossed uneasily on his rude bunk for some time before he gained oblivion. Something in the whole thing had been incomplete. He had soldiers killed and soldiers wounded—that was a part of the game. Some emigrants had suffered—that could not be helped.

It was the good-looking girl, gone swirling off into the unknown desert, in the dust of the Apache charge, which was the rift in the young colonel's lute, and he had begun to admit it to himself. What could be done? What was his duty in the matter? His inclination was to conduct an expedition in quest of her. He knew his Apache so well that hope died out of his mind. Even if she could get away on the colonel's swift pony, an Apache on foot could trail and run down a horse. But the tired body and mind gave over, and he knew nothing until the morning light opened his eyes. Sitting opposite him on a chair was the brother of Hall's daughter, with his chin on his hands and his long rifle across his knees.

"Good morning, Mr. Hall," he said.

"Mornin', Colonel," replied Hall. "Ah'm goin' back after my sista, Colonel. Ah'm goin' back, leastwise, to whar she was."

"So am I," spoke up Simms, like a flash, as he swung himself to his feet, "and right now." With men like Simms, to think was to act.

He was refreshed by his rest and was soon bustling about the post. The day before two companies of his regiment had come into the post on escort duty. They were pony-mounted, despite their being infantry, and were fresh. These he soon rationed, and within an hour's time had them trailing through the dust on the back track. Hall's sad-faced son rode by his side, saying little, for both felt they could not cheer each other with words.

Late in the afternoon, when coming across the mesa which ended at the bluff where the misfortune had overtaken the girl, they made out mounted figures at the very point where they had brought up the wagons.

"If they are Apaches, we will give them a fight now; they won't have to chase us to get it, either," said the colonel as he broke his command into a slow lope.

Steadily the two parties drew together. More of the enemy showed above the bluffs. They formed in line, which was a rather singular thing for Apaches to do, and presently a horseman drew out, bearing a white flag on a lance.

"Colonel, those are *lanceros* of Mexico," spoke up the orderly sergeant behind the officer.

"Yes, yes; I can see now," observed Simms. "Trot! March! Come on, bugler." Saying which, the colonel, attended by his man, rode forth rapidly, a white handkerchief flapping in his right hand.

So they proved to be, the irregular soldiers of distracted Mexico —wild riders, gorgeous in terra-cotta buckskin and red serapes, bent on visiting punishment on Apache Indians who ravaged the valleys of Chihuahua and Sonora, and having, therefore, much in common with the soldiers on this side of the line.

In those days the desert scamperers did not know just where

the international boundary was. It existed on paper, no doubt, but the bleak sand stretches gave no sign. Every man or body of men owned the land as far on each side of them as their rifles would carry, and no farther. Both Mexico and the United States were in mighty struggles for their lives. Neither busied themselves about a few miles of cactus or the rally and push of their brown-skinned irregulars.

Shortly the *comandante* of the lancers came up. He was a gay fellow with a brown face, set with liquid black eyes, and togged out in the rainbows of his national costume. Putting out his hand to Simms, he spoke: "*Buenos días, señor*. Is it you who have killed all the Apaches?"

"*Si, capitan*," replied Simms. "I had the honor to command, but I do not think we killed so many."

"*Madre de Dios!* You call that not many! Ha, you are a terrible soldier!" And the lancer slapped him on the back. "I saw the battle-ground; I rode among the bodies as far as I could make my horse go. I saw all the burned wagons, and the *Indios* lying around the water hole, as thick as flies in a kitchen. It smelled so that I did not stop to count them; they were as many as a flock of sheep. I congratulate you. Did you lose many *soldados*?"

"No, *capitan*. I did not lose many men, but I lost a woman—just down below the bluffs. Did you see her body there?"

In truth, the poisoned sack of meal had come only slowly into Simms's mind when he thought of the dead Indians about the water hole, and he did not care to enlighten a foreign officer in a matter so difficult of explanation.

"No," answered the Mexican; "they were all naked Apaches—I made note of that. We looked for others, but there were none. You are a terrible soldier. I congratulate you; you will have promotion, and go to the great war in the East."

"Oh, it is nothing, I assure you," grunted Simms as he trotted off to get away from his gruesome glories. "Come, *señor;* we will look at the girl's trail below the bluffs."

"Was she mounted well?" inquired the lancer, full of a horseman's instinct.

"Yes, she had a fast horse, but he had been ridden far. He was my own."

"She was of your family?"

"No, no; she was coming through with the wagon train from Texas."

"She was a beautiful *señorita?*" ventured the lancer, with a sharp smile.

"Prettiest filly from Taos to New Orleans," spoke our gallant in his enthusiasm, and then they dismounted at the wagon place, which was all beaten up with the hoofmarks of the lancers.

The best trailers among the mountain men of the command

THE TRACKERS FOLLOWED THE TRAIL

were soon on the track of the horsed Indians who had driven off the girl, and this they ran until quite dark. The enemy had gone in full flight.

Simms made his camp, and the Mexican lancer pushed on ahead, saying he would join him again in the morning.

By early light Simms had his troops in motion; but the trail was stamped up by the lancer command, and he could follow only this. He was in a broken country now, and rode far before he began to speculate on seeing nothing of his friends of yesterday. Some three hours later he did find evidence that the lancers had made a halt, but without unsaddling. Simms had run the trail carefully, and had his flankers out on the side, to see that no one cut out from the grand track. Soon he was summoned by a flanker who waved his hat, and toward him rode the officer. Nearing, he recognized the man, who was a half-breed American, well known as a trailer of great repute.

"Colonel, here are the prints of the Apache ponies; I know by their bare feet and the rawhide shoes. Your pony is not among them; he was shod with iron. These ponies were very tired; they step short and stumble among the bushes," said the man, as he and the colonel rode along, bending over in their saddles. "See that spot on the ground. They had run the stomachs out of their horses. They stopped here and talked. They dismounted." Both the colonel and the trailer did the same. "There is no print of her shoe here," the trailer continued slowly. "See where they walked away from their horses and stood here in a bunch.

They were talking. Here comes a pony track back to them from the direction of the chase. This pony was very tired. His rider dismounted here and walked toward the group. The moccasins all point toward the way they were running. They were talking. Colonel, the girl got away. I may be mistaken, but that is what the trail says. All the Indians are here. I have counted twenty ponies."

There is nothing to do in such places but believe the trail. It often lies, but in the desert it is the only thing which speaks. Taking his command again, the colonel pushed on as rapidly as he dared, while feeling that his flanking trailers could do their work. They found no more sign of the Indians, who had evidently given up the chase, thinking, probably, the wagons more important than the fast horse-girl.

All day long they progressed, the colonel wondering why he did not come up with the lancer command. Why was the Mexican in such a hurry? He did not relish the idea of this man's rescuing the girl, if that was to be fate. Long he speculated, but time brought only more doubt and suspicion. At places the Mexican had halted, and the ground was tramped up in a most meaningless way. Again the trailer came to him.

"Colonel," he said, "these people were blinding a trail. It's again' nature for humans to walk around like goats in a corral. I think they have found where the girl stopped, but I can't run my eye on her heel."

The colonel thought hard, and being young, he reached a rapid conclusion. He would follow the Mexican to the end of his road. Detailing a small body of picked trailers to follow slowly on the sides of the main trail, he mounted, and pushed on at a lope. Darkness found the Mexicans still going. While his command stopped to feed and rest, the colonel speculated. He knew the Mexicans had a long start; it was unlikely that they would stop. He thought, "I will sleep my command until midnight, and follow the trail by torchlight. I will gain the advantage they did over me last night."

After much searching on the mountainside in the gloom, some of his men found a pitch tree, which they felled and slivered. At the appointed time the command resumed its weary way. Three hundred yards ahead, a small party followed the trail by their firelight. This would prevent, in a measure, an ambuscade. A blanket was carried ahead of the flaming stick—a poor protection from the eyes of the night, but a possible one. So, until the sky grayed in the east, the soldiers stumbled bitterly ahead on their relentless errand. It was a small gain, perhaps, but it made for success. When the torches were thrown away, they grazed for an hour, knowing that horses do not usually do that in the dark, and by day they had watered and were off. The trail led straight for Mexico.

Whatever enthusiasm the poor soldiers and horses might have, we know not, but there was a fuel added to Simms's desire, quite as

great as either the pretty face of Adele Hall of his chivalric purpose kindled—it was jealousy of the lancer officer. When hate and love combine against a young man's brain, there is nothing left but the under jaw and the back of his head to guide him. The spurs chugged hard on the lathering sides as the pursuers bore up on the flying wake of the treacherous man from Mexico.

At an eating halt which the lancers made, the trailers sought carefully until, standing up together, they yelled for the colonel. He came up, and pointing at the ground, one of the men said, "*Señor*, there is the heel of the white girl."

Bending over, Simms gazed down on the telltale footprint, saying, "Yes, yes; it is her shoe—I even remember that. Is it not so, Hall?" The girl's brother, upon examination, pronounced it to be his sister's shoe. Simms said, "We will follow that lancer to hell. Come on."

There were, in those days, few signs of human habitation in those parts. The hand of the Apache lay heavy on the land. The girl-stealer was making in the direction of Magdalena, the first important Mexican town en route. This was a promise of trouble for Simms. Magdalena was populous and garrisoned. International complications loomed across Simms's vision, but they grew white in the shadow of the girl, and come what would, he spurred along, the brother always eagerly at his side.

By midafternoon they came across a dead horse, and soon another. The flat-soled *tegua* [buckskin boot] tracks of the dismounted riders ran along in the trail of the lancer troop. The country was broken, yet at times they could see long distances ahead. Shortly the trailers found the *tegua* prints turned away from the line of march, and men followed, and found their owners hidden in the mesquite bush. These, being captured, were brought to Colonel Simms, who dismounted and interrogated them as he gently tapped their lips with the muzzle of his six-shooter to break their silence. He developed that the enemy was not far ahead; that the girl was with them, always riding beside Don Gomez, who was making for Magdalena. Further, the prisoners said they had found the white woman asleep beside her worn-out pony, which they had taken aside and killed.

This was enough. The chase must be pushed to a blistering finish. As they drew ahead, they passed exhausted horses standing head down by the wayside, their riders being in hiding, doubtless. On a rise they saw the troop of lancers jogging along in their own dust, not three hundred yards ahead, while in the valley, a few miles beyond, was an adobe ranch, for which they were making. With a yell from the United States soldiers, they broke into the best run to be got out of their jaded ponies. The enemy, too, spurred up, but they were even more fatigued, and it was not many minutes before the guns began to go. A few of the enemy's horses and men fell out, wounded, and were ridden over, while the rest fled in wild panic. They had doubtless

thought themselves safe from pursuit, and they would have been had their booty been anything less than Adele Hall. Many lancers turned and surrendered when the tired horses could do no more. The commands tailed out in a long line, the better horses of the Americans mixing gradually with the weaker ones of the lancers. Still well ahead rode Don Gomez and his reluctant companion. These drew up to the blue walls of the long adobe ranch (for it was now sunset) and were given admittance, some dozen men in all, when the heavy doors were swung together and barred, just as the American advance drew rein at their portals.

Finally having all collected—both Americans and prisoners—and having carefully posted his men around the ranch, Simms yelled in Spanish: "Come to the wall, *Capitan* Gomez. I am Colonel Simms. I would speak a word with you." Again he spoke to the walls, now blackening against the failing light. From behind the adobe battlements came excited voices; the inhabitants were trying to digest the meaning of this violence, but no one answered Simms.

Turning, he gave an order. Instantly a volley of musketry started from near him, and roared about the quiet ranch.

Once more Simms raised his angry voice: "Will you come on the roof and talk to me now, Don Gomez?"

At length a voice came back, saying, "There are no windows; if I come on the roof, I will be shot."

"No, you will not be shot, but you must come on the roof."

"You promise me that?"

"Yes, I promise you that no soldier of mine will shoot at you," and in loud military language Simms so gave the order.

Slowly a dark figure rose against the greenish light of the west.

"Don Gomez, I ask you truly, has one hair of that girl's head been harmed? If you lie to me, I swear on the Cross to burn you alive."

"I swear, my colonel; she is the same as when you last saw her. I did not know you were coming. I was trying to save her. I was taking her to my commander at Magdalena."

"You lie!" was the quick response from Simms, followed by a whiplike snap peculiar to the long frontier rifles. The dark form of Don Gomez turned half round, and dropped heavily out of sight on the flat roof of the adobe.

"Who fired that shot?" roared Simms.

"Ah did, sah," said Hall, stepping up to the colonel and handing him his rifle: "Ah am not one of yer soldiers, sah—Ah am Adele Hall's brother, and Mr. Gomez is dead. You can do what you please about it, sah."

While this conversation was making its quick way, a woman sprang up through the hole in the roof and ran to the edge, crying, "Help, Colonel Simms! Oh, help me!"

"Cover the roof with your guns, men," ordered Simms, and

both he and the brother sprang forward, followed by a general closing in of the men on the building.

 As they gained the side wall, Simms spoke. "Don't be scared, Miss Hall; jump. I will catch you," and he extended his arms. The girl stepped over the foot-high battlement, grasped one of the projecting roof timbers, and dropped safely into Colonel Simms's arms. She was sobbing, and Simms carried her away from the place. She was holding tightly to the neck of her rescuer, with her face buried in a week's growth of beard.

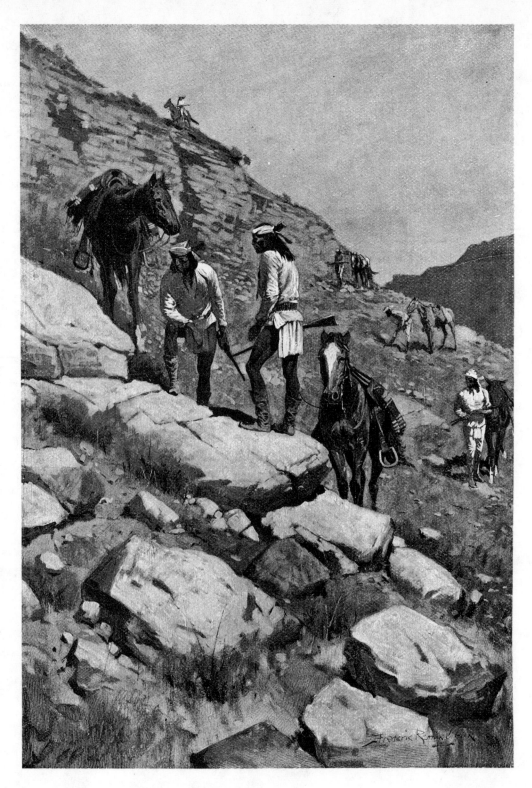

SCOUTS

IV

How An Apache War Was Won

(An unpublished manuscript)

We were sitting in Captain Watson's quarters before a log fire when he dropped a crumpled newspaper on the floor beside him, saying, "That's funny."

"What's funny?"

"Here is an obituary of old Major Lothrop. It says he was a great Indian fighter. He wasn't—that's all. I doubt if he was ever in an Indian fight, but any man who was out West in the old days is popularly supposed to be an Indian fighter."

"How absurd," went on the captain, "I have lived with Indians for years and years at a time, and I suppose if I died, the papers would say, 'He was a great Indian fighter.' In reality I have been in only a few small affairs of that character, but I have done a power of Indian-thinking for which I will receive no credit. It would often be better and more truthful to call us 'Indian-thinkers' rather than 'fighters.'

"When I was commanding Apache Indian scouts at San Carlos in Arizona, I did thinking enough to make a lawyer's head buzz. If you will stand for it—I will unhook a long story for you which will show how a bunch of Indians can keep you guessing if you are riding herd.

"In the first place—I had one of the best Indian men who ever lived, for chief of scouts—one Al Seiber, a stern, modest man who had been in a hundred fights, but who was an Indian-thinker besides. He could tell what an Indian was going to do under given circumstances, whether by telepathy, by the impulse of the moon, or by cutting a deck of cards, I cannot say; but to help us out, he organized an Indian secret service. After much care and consultation we selected certain men who were unknown to anyone else except the interpreter-of-scouts, and were unknown to each other. Their operations being carried on in the strictest secrecy, they were terribly effective for their particular work. Being under the exclusive control of Seiber and myself, they would generally make their reports and receive their orders in the dead of night. Certain assassination waited on discovery.

49

"About 1888 occurred what is known as the Kid Outbreak. This band of renegades consisted at first of sixteen Apaches, headed by Gon-E-Shay. After they had been out a short time they surrendered to General Miles. Some were tried by court-martial—some by civil courts. Some were convicted and some were acquitted. Of those convicted, some, owing to a question of jurisdiction, were kept in prison to be retried; others were pardoned and came back to the reservation. Gon-E-Shay, the leader, was convicted on his own evidence. He had able lawyers appointed by the court to defend him, and although they urged him to plead, 'Not guilty,' and keep silent, he persisted in making his statement. He said to the court—referring to the ranchman for whose murder he was being tried, 'I saw this man up in a gulch, half a mile from his house. He was on his knees cutting down a small piñon tree. I shot him and he rolled over. He commenced to struggle. I ordered Say-Es to go down and kill him, but Say-Es refused to go. I went down myself. He was lying on the ground, covered with blood, but his eyes were open. I said to him, 'Your race has had my race down for a long time; now I have got you down and I am going to keep you there. Then I took out my pistol and killed him. That's all.'

"Those who were pardoned were living quietly on the reservation when suddenly they were arrested and tried again—this time by the civil authorities. They received sentences of imprisonment and were being taken to the Yuma penitentiary when they rose against their guards, killed the sheriff—Glen Reynolds—and his deputy Holmes—and supposed they had killed the other guard—Eugene Middleton. Middleton was badly shot in the neck, but his great coolness in pretending that he was dead saved his life, and he is now alive, well, and prosperous, living in the town of Globe, Arizona.

"Immediately after this murder, Kid and his brother murderers were pursued by Captain Wilder of the Fourth Cavalry, accompanied by Lieutenant Hardeman of the Tenth Cavalry and myself. Captain Wilder probably gave Kid the closest race he ever had, and I think would undoubtedly have bagged the whole outfit then and there if one of my best scouts—Rowdy—had not got drunk just at the wrong time. The leaders among the Apache scouts threw off on us and purposely lost the trail, when, as I found out afterward, Kid and his followers were hiding, exhausted and completely broken down, not four hundreds yards from us.

"After the murder of the sheriff, Kid and his band were irrevocably committed to the warpath, and then it was that they began to be a terror to Arizona. They were joined by some others who had also committed murders and put themselves outside the pale of the law. The band consisted of Kid, Bee-Chu-Om-Dath, and Say-Es, the leaders; Has-Tin-Du-To-Dy, Miguel, Tonto B60 (that is, No. 60 of B band of Tontos), Good-Boy (so named by himself), Capitan Chiquita, and Curly (who were persuaded and forced to go on the warpath by the

leaders), and a tall young fellow whose face I remember well but whose name I cannot just now recall. Previous to joining the outlaws, Capitan Chiquita and Curly lived near each other in the San Pedro Valley, on Aravaipa Creek. This locality was a great resort for the outlaws, and their presence undoubtedly overawed these two Indians and caused them to take to the warpath with the others—mainly for their own safety.

"This band of desperate outlaws was proving a veritable scourge to the country. More than two regiments of U.S. troops were in the field, attempting to capture or destroy them. These troops performed wonders in the way of hard and long marches, and their efforts, if they had been directed against any civilized opponents, would have accomplished great results, but they were utterly ineffectual against the Kid Band. They could not capture or kill a single one of them, and it is not at all to their discredit that they could not, because no human beings restricted as the U.S. Cavalry almost necessarily were by laws and regulations, could cope with the free and unfettered movements of the outlaws. If a cavalryman's horse broke down, he could pursue no longer. On the contrary, an outlaw would ride his horse to death, covering an amazing distance in twelve to twenty-four hours, then steal or take another fresh horse, repeat the same ride, and so on continuously. In this way they would appear at some point and do their murderous work when they were supposed to be hundreds of miles away. All the Indian scouts in the Department—the most effective of all troops in rough mountain warfare—were used against the outlaws, but they failed for the same reason that the troops did. When their ponies broke down, they could not seize fresh ones as did the outlaws.

"At this time I was in command of the Indian scouts at San Carlos—about seventy-five in all. Of these, about twenty were secret-service men. These secret-service men were very effective when they had anything tangible to work on, but the outlaws would not stay long enough in one place for the secret-service men to get in their work.

"Large rewards were offered. More than ten thousand dollars was set on Kid's head. Some old frontiersmen took to the mountains in the hope of getting the reward, but they soon tired out or became terror-stricken at the murders committed around them and came back to the towns.

"In reality, Kid was not the worst of the gang. The most implacable, bloodthirsty, and vindictive were Bee-Chu-Om-Dath and Say-Es. But the band got the name of the Kid Band at first, and all the murders and atrocities were naturally saddled on Kid.

"The raids and ravages of these outlaws extended through Arizona and New Mexico and down into the states of Chihuahua and Sonora in Old Mexico. It is hardly possible to convey in words an accurate idea of the panic and terror spread throughout the country by Apaches on the warpath. I have seen a hostile army enter a town;

have been in towns when yellow fever and cholera were first announced and have seen the panic-stricken flight of the people; but have never seen anything so terrify and paralyze people as the near approach of these bloodthirsty outlaws. I once saw a lady who had heart trouble drop dead on learning that the Kid Band had just passed within two hundred yards of her house. People acted as if bereft of reason and common sense. I have known them to leave their houses with doors open, dinner cooking on the stove, dogs, horses, and poultry loose in the yard, and fly in terror without knowing where they were going. I have seen home after home in this deserted condition, and have seen a house full of armed men—strong men and brave men, too—their faces white and blanched with terror, who would hardly open their doors wide enough for one to speak with them from the outside. And they had good cause for their terror, for the outlaws spared neither man, woman, child, nor sex.

"The appalling feature of these Apache raids was no doubt due to the fact that their attacks were always from ambush and entirely unexpected. Their murder strokes came like thunderbolts from a clear sky. A ranchman would be riding along on horseback, would hear a low whistle or some unusual noise near him, and would check his horse to see what it was. The stop would give his hidden enemy opportunity for deadly aim, and the next moment he would be dead—a bullet through the father, the old gray-haired mother, the grown boys and girls, the young children—a happy group enjoying their meal at the close of the day's work—when *bang! bang! bang!* and all who were capable of any resistance would be shot dead in their places, and the savage outlaws, entering, would save their ammunition by dashing the children's heads against the walls of the house. That country was in a terrible plight in those days.

"In addition to the Kid Band there was a small band of Chiricahuas, but their ravages were confined mainly to Old Mexico. There was also a small band of White Mountain Apaches out from Fort Apache. This latter band consisted of No-sey, Josh, and an old man, their relative. They had not killed any whites, but made a pretty big killing in an Apache camp, and in consequence had taken to the mountains, where they were stealing horses and killing cattle.

"It was dangerous to travel anywhere through the outlaw-infested country. People wondered where the next stroke of murder would fall. When it did come, its effect was startling and, like all others, entirely unexpected. The question above all others in the minds of the people was, how can these Apache outlaws be destroyed? Having charge of the police force of the reservation at San Carlos, *i.e.* the Indian scouts and secret-service men, it was my special duty to apprehend all lawbreakers, and the question was therefore one which interested me particularly. Many nights, after going to bed, I had lain awake trying to think out some solution to the problem, but it was insoluble.

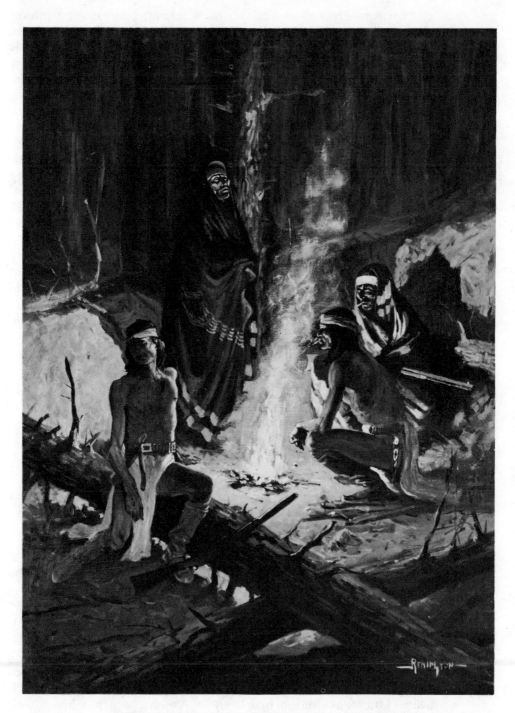

STEALTHY AND CRUEL AS WOLVES

"I was in my tent at San Carlos, working, I think, on a muster roll. It was about twelve o'clock at night, and excepting the sentinels, I was probably the only man awake in the camp. There was a gentle rap on the door, and being used to such midnight calls, I said in a low voice, 'Come in.' The rapper opened the door cautiously and came in. He was one of my Apache secret-service men. He came tiptoeing toward me, his eyes glistening, a smile on his face and his finger to his lips. These secret-service men often risked death if they were found out, and they were therefore extremely careful. Although I had as many as twenty-five at one time, they were unknown to each other as secret-service men. He knelt down about two feet from me, and looking carefully all around the tent, whispered, 'I know where No-sey is.' It will be remembered No-sey was chief of one of the outlaw bands. A conversation then commenced which lasted perhaps an hour. After having him locate for me the hiding place of No-sey and his band, I asked him, 'Do you think you could kill No-sey and Josh and bring their heads in?' The other member of the band, the old man, did not count. He had not committed any murder and was merely a friend of the other two. The secret-service man replied, 'Yes, but I would not like to do that, because they are friends of mine. I can do it, though, if you say so.'

" 'Did you talk to them?'

" 'Yes.'

" 'How long were you with them?'

" 'I stayed with them all night.'

" 'Have they killed any white people yet?'

" 'No.'

" 'Have they killed any more Indians?'

" 'No.'

" 'What have they been doing all this time?'

" 'Moving around—they don't stay long in one place—they kill deer and beef—they play cards and make moccasins.'

" 'What did No-sey talk about?'

" 'He is tired of being out. He can't sleep at night. He is afraid of those White Mountain Apaches. He would like to come in, but he is afraid to.'

" 'Suppose,' said I, 'No-sey and Josh are promised complete pardon for all their crimes if they go to work with us and help us kill the Kid Band—will they do it?' His eyes glittered. 'Yes,' said he, 'they will do it—and will be glad to.'

"Nothing more could be done that night, but I told him to see the interpreter the next day and pick out a good time to come back with him. Our conversation had been in Apache, which I knew well enough for ordinary talk, but I found from experience that when I wished to be sure of having my ideas conveyed accurately, or to receive

accurately what Indians said, it was always best to have a good interpreter.

"I did not sleep a wink that night. Here was at last a chance to hit the outlaws a staggering blow. Three plans occurred to me. To make a night march, surprise and capture or kill No-sey's band; to have this done by the secret-service man; to use No-sey and his band against the outlaws. I chose the last plan as the best in every way.

"The warpath is not always an easy road to travel. It gets so exceedingly tiresome at times that the war party is willing to surrender on any terms short of death. The outlaws realize that they are outside the pale of all law—that everyone is their deadly enemy, free to shoot them down like the prowling coyote. Their nerves and faculties are kept at the highest tension, with a sudden and violent death looked forward to sooner or later. I reasoned that all exertion, all effort, is proportionate to the *motive* that causes it, and that ordinarily a man will do more to save his life than for any other motive. Here were No-sey and Josh, outlawed murderers, with death or capture to look forward to, and capture meant death by hanging. It was very plain that they would do all in their power to be assured of complete pardon. Also, they were known to be outlaws by the Kid Band, outside the pale of law just like themselves. For this reason they would not be suspected by the Kid Band.

"Apaches have a way of signaling at long distances, and there would be no trouble in getting into communication with the Kid Band. The idea occurred to me to have No-sey and Josh get the Kid Band and the Chiricahuas into one outfit, then to lead them together into ambush in someplace where the whole bunch could be cleaned up. I was very much tempted to try this plan because it would give such brilliant results if it worked all right. The checkerboard would be cleared at one jump and leave me in addition Josh and No-sey, who would make rattling good scouts. But after a good deal of floor-walking and consideration of every point of view, the difficulties in the way were too many and there seemed too many chances of failure. I concluded to go to work against the Kid Band.

"Next morning I had the plan fully matured and got it approved by the commanding officer and the U.S. Indian agent. In the forenoon the secret-service man came to my tent, and soon afterward, the interpreter, when the scheme was thoroughly explained and discussed, we three being the only ones present.

"It took two days for the secret-service man to get to No-sey's hiding place and back again to San Carlos, and it required two of these trips—four days—before the arrangement was completely made, agreed upon, and settled between us. The final arrangement was this, as thoroughly understood as if it had been in writing: No-sey, Josh, and the old man between them were to kill Kid, Bee-Chu-Om-Dath, and Say-Es; Capitan Chiquita and Curly they were not to kill; any of the others

they *could* kill, *provided* it did not interfere with the main object, which was getting the leaders. In consideration of this service and when they presented satisfactory evidence of the fact, they were to be pardoned for all past offenses, and in addition to this I promised to enlist them as scouts and to look out for all their interests as long as I stayed at San Carlos.

"They were to start out for Mexico, where the Kid Band was then, or was supposed to be, as if regularly on the warpath, killing cattle, stealing horses, etc. Anyone they came across they were to shoot at, being careful to miss, however. They were cautioned particularly to kill none of the people. In this way they were to get in with the Kid Band and do their work when opportunity offered. I sent No-sey three new carbines and belts and one hundred and fifty cartridges. He said the rifles he had were old and inaccurate. I also sent him eight dollars and something—all the money I had in my pocket—to buy coffee and sugar down in Mexico. I knew from experience how coffee restored one when one is tired out, and this would help him to do his work.

"On the fourth day after the secret-service man told of No-sey's hiding place—on the day when he was making his final trip to No-sey—an Apache boy came into San Carlos and reported that he had just seen three of the Kid Band up in the foothills of Mount Trumbull, not more than twenty miles distant. He said that he had talked with them, and that they were up to get new followers and steal squaws. They told him the route they would take that day and said they would be at a certain place that night, where they would have a talk with the reservation Apaches. They also told him that if he should go into San Carlos, he could tell all there what he had seen, and if any of them wanted a fight, they could come out and have it. This was the boldest move they had ever made. And here was a new development and a new point to be considered. If they were telling the truth and would be that night where they said they would be, why not prepare an ambush for them that night? After thinking the matter over for some time, I concluded it was not possible they would be so foolish as to give their plans away to a boy. I believed the boy but did not believe them. I concluded to stick to the arrangement with No-sey and to do nothing that would interfere with it. It was apparently working finely.

"That it is the best laid schemes of mice and men aft gang a' glee recurred to me very frequently during the next few days. The next morning I went out with six scouts. I wanted to verify the boy's story. I had not gone five miles before I met the secret-service man. This was the day No-sey should have been on his way to Mexico. I let the scouts ride on, and I stopped behind to talk to the secret-service man. He said he had taken out the wrong-sized cartridges by mistake and was going in to get the right size. No-sey had not started, but would start the next day. I told him the boy's story and told him to go back to No-sey as soon as possible and warn him to be on the lookout for the three Kid

outlaws. I added I was very sure the boy had told the truth, but I was going out to see anyway. He asked me where I was going to camp that night. 'I think it will be at the subagency,' I replied, figuring on where the day's trip would take me. *Camp* was a word used to designate any stopping place for the night, although it was a misnomer, for we never carried anything in the way of tents except the very small shelter tents, which were only large enough to cover one man curled up, and this was used only in case of rain. One blanket behind the saddle was all we generally carried in addition to the saddle blanket. The subagency was an old deserted building on the Gila River.

"He then said, 'It will be a good thing to take the scouts out of this part of the country over into the San Pedro Valley so they would not interfere with No-sey. He is afraid of them.'

" 'All right,' said I, 'I will do this.'

"He hesitated for a while, then, counting on his fingers, he said, 'Four nights from now, where will you camp then?' I had not figured this far ahead and did not know where I would camp.

"Before I could answer, he said, 'I will tell you a good place,' and named one of the roughest and most inaccessible spots in all that rough country.

" 'Do you know the place?' he said. 'There is water there.'

" 'Yes,' I answered, 'I know it. All right—four nights from now —I will camp there.'

"The scouts were getting some distance ahead, and I did not take time to ask him why he wanted me to camp at this particular spot, but supposed he wanted to select some out-of-the-way place, and he had certainly done so. I overtook the scouts, found the trail of the three outlaws, and followed it all that day. I found the boy had told the truth, and more than this I found, much to my surprise—the outlaws had told *him* the truth. They had gone exactly the way they said they would go, and the trail led back to the very spot where they said they would have a talk with the other reservation Apaches the night before. There were a great many pony tracks around this place, but whether they were made by loose ponies coming down to water or by mounted Apaches, I could not make out. Also, the trail as it approached this place had been joined by a good many other pony tracks, and whether these were loose pony tracks or not I could not tell. I did not know what to think. Was this a new war party gathering, and was the country on the verge of a new and large outbreak? If so, my little bunch of scouts and myself were not in a very safe place. Things did not look at all right.

"I camped at the old subagency. The boy lived only about half a mile from the place. That night I got him to come over to camp and questioned him to see if I could get any further light on the situation. I asked him if the outlaws had told him the names of those they were to meet the night before. He said they had named some. 'Who

were they?' I asked. He called over some names on his fingers. At the last name called my heart seemed to stop beating for about ten seconds. I was literally struck dumb with amazement. *It was the name of my secret-service man.*

"What was up now? Was the secret-service man going on the warpath with the rest of them—No-sey, Josh, and the new war party? And why did he want me to camp in that out-of-the-way place *on the fourth night* with only six scouts and sixty miles from any assistance? Things looked ominous.

"I told the scouts we had better be careful that night. There was no telling what danger was gathering around us. We were in the midst of Apache Indian camps and the troops were miles away. We all slept in the old adobe building, each with his loaded carbine at his side. There would be no danger that night, because Apaches never attack then, but we would have to be on the lookout about daylight the next morning. I could not sleep much. I was thinking of what a mess I had got myself and the scouts into, and more than that, I was thinking of how to get out of it. I thought of all my past life, and wished I could have it to lead over again. I regretted I had not taken up with the law, or medicine, or the ministry—preaching the gospel in some civilized community *east* of the Mississippi. *That camping place for the fourth night*—was it chosen as a good place to kill all of us at one treacherous blow? And I had sent No-sey three new Springfield carbines! I wondered to myself what the Chief of Ordnance would say about those three carbines. I pictured to myself the letter I would get. 'This officer will explain *why* he issued three (3) new carbines, cal. .45, without obtaining proper receipts for the same.' And all these thoughts were not conducive to sleep.

"It was indeed a most trying situation. I looked at it from every point of view and sized up matters about this way. The secret-service man and No-sey and Josh and possibly, but not probably, the old man, would join the Kid outlaws on the warpath, and would have the three new carbines. This sudden visit of the three Kid outlaws had probably been prearranged for some time with No-sey's band. Most of the disaffected young warriors would join, and I counted up over the whole reservation about twenty-four that would probably go out, thus swelling the new war party to about thirty in all, these people all being in that immediate locality at this time. Such a large party would sweep like a perfect storm of devastation and bloodshed over the country.

"I did some very hard studying that night. The first act in their bloody drama would be to take in my six scouts and myself and get our carbines and ammunition. Right at this point in my train of thought I made up my mind I would not camp at that place on the fourth night. The best thing to do was to go back to San Carlos under cover of the darkness, and I was about to tell the scouts to saddle up when an idea suddenly occurred to me and I saw what a tremendous mistake I would

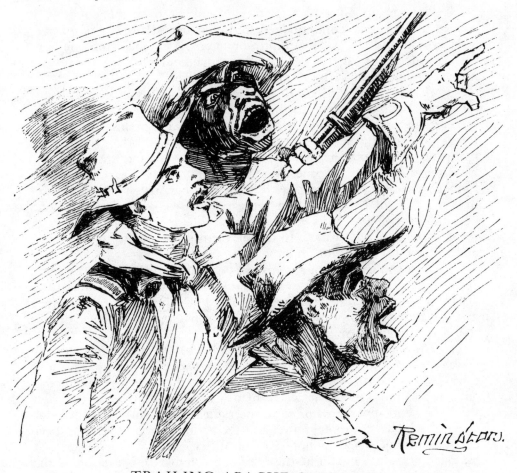

TRAILING APACHE OUTLAWS

have made if I had gone back to San Carlos. I determined on what to do—which you will understand later on.

"The night passed without incident and the coast was all clear the next morning. We pulled out for the San Pedro country, which was in a directly opposite direction and one hundred miles away from the scene of operations of No-sey and the outlaws, and camped there. Having nothing particular to do, we put in the next day hunting wild hogs and black-tail deer. These wild hogs, or Arizona peccaries, live only in the most inaccessible peaks where human beings rarely come. At least that is the only kind of place I have ever seen them, and I infer they select such places. That night we had a great deal of venison hanging up, and a tremendous mountain lion walked into camp, attracted by its scent. He got out before anyone could get a shot at him. Early the day set, we went to the place the secret-service man had selected for us as such a desirable camping place.

"It was up on a high plateau. Looking over the country, it seemed to be a wide continuous plain, but if one attempted to go over it, he would find it was cut up into innumerable chasms from one hundred to one thousand feet deep, with perpendicular walls. They were not very wide, though they might be very deep.

"It was impossible to go more than a short distance in any one direction without coming to one of these impassable chasms. There were some cliff dwellings and other abodes of prehistoric people. Imagine an egg cut in two and the half-egg resting on the ground with its tip up. Then imagine this half-egg about twelve feet high and you have the appearance of one of these dwellings. It was of limestone formation, hollow of course, with walls proportionately much thicker than the shell of an egg. There were two, three, or four round holes near the ground for doors and windows. There were half a dozen or so of these near the water. Inside of them were many arrows, some not finished, toy bows for children.

"I put in the day riding around the place and made up my mind *again* not to camp there. It was a regular death trap, with no way to get out except the way we came in. We got supper late in the afternoon, watered our horses, filled our canteens, and went back on the trail a distance of a mile.

"And here is what I determined to do. At this point the trail which led up into this country, and which was the only possible way to get into or out of it, passed between two of these deep perpendicular chasms, and the distance between them was not more than seventy-five yards. Twenty-five yards or so to the right of the trail was a small hill of rock, which, by disintegration and the action of the water, had been cut out into all shapes. There was no other hill anywhere near. We hid our horses in some bushes near by and clambered to the top of this rock. It was a perfect Gibraltar of strength for a small party. Ten men could easily stand off one hundred.

"We knew that as soon as the outbreak took place they would hear it almost at once at San Carlos, and the troops from there and Fort Thomas would pursue the renegades. The first act of the latter, as I have said, would be to wipe us out of existence and get our carbines and ammunition, when they would proceed on their raid of murder and destruction down into Old Mexico. And now we were ready for them, and the surprisers would be surprised. *We would let them get in the death trap which they had prepared for us, and hold them there until the troops came.*

"About dark we got into our stronghold. The stillness of death pervaded everything. No animals came into the country—nothing but birds. An hour later we heard a noise. It grew plainer. We listened intently. It was a pony coming slowly on the rocky trail, but still a good distance off. Some of the scouts went out and threw themselves flat on the ground to catch the first view of the approaching object.

Soon one of them whispered, 'It's somebody—it's an Apache'—though I could not see even the pony myself. It was no doubt the secret-service man, but was he coming to get us located for others, or what was he coming for?

"We were all now down on the trail. Twenty steps from us the pony stopped still. He had scented us.

"'Who are you?' called out one of the scouts in Apache.

"'*She!*' came back the answer through the darkness.

"We all went up to the pony, which was staggering in its tracks from exhaustion. I recognized the voice at once. *She* is Apache for *I*, and he was one of my scouts. He had been riding for twenty-four hours. He gave me a letter which I read while a scout held a lighted match. It was from the commanding officer at San Carlos, and read substantially as follows: '*No-sey and Josh have come in and surrendered. Head of Bee-Chu-Om-Dath brought in. Say-Es brought in badly wounded. Curly also captured unhurt.*'

"When we got back to San Carlos, I found Say-Es and Curly in the guardhouse, heavily ironed. The former was as much an object of curiosity as a zebra. No-sey and Josh having got their men, had come in and surrendered. I had never seen either of them before, though I had been trying pretty hard for three years to do so. No-sey was making some official and social calls preliminary to entering upon his new and un-outlaw kind of life, and was dressed up for the occasion. He had on moccasins, a pair of drawers, a brigadier general's full-dress coat, and a straw hat. I immediately enlisted him and Josh as scouts, and the old man as a secret-service man. It is true they had not got the Kid, but they had done their best and had done remarkably well, and had well earned pardon and reward. No-sey gave me a beautiful Navajo blanket to cement our newly formed friendship.

"The passing of Say-Es and Bee-Chu-Om-Dath was a shocking affair—quite characteristic of Apache treachery. The outlaws, with No-sey, Josh, and the old man, had been raiding together, killing horses and cattle and terrifying the settlers along Eagle Creek. About sunset they were getting supper—each, as was their invariable custom, with his rifle in his hand. Josh was sitting on a ledge of rock to the left of Bee-Chu-Om-Dath, and very close to him. While busied in cleaning his rifle he got it pointed at the heart of Bee-Chu-Om-Dath, and pulled the trigger. The latter rolled over, dead, and then all three fired at Say-Es. Curly was so rattled, though they did not fire at him, that he never stopped running until he got into the camps near San Carlos, where he surrendered to my first sergeant, Tony.

"No-sey—as soon as possible—came into the agency. The officers of the troops stationed at San Carlos, Arizona, were at supper in their mess tent. It was in summer, at the height of the watermelon season. The Indians there used to raise fine watermelons, and would carry them in sacks around the camp to sell. While the supper with its talk,

jokes, and laughter was going on, an Indian walked into the tent. He came with a smile on his face and a sack over his shoulder. With all that dignity which only an Indian chief can assume, he shook hands with the commanding officer, bowed smilingly to the captains, paid no attention to the lieutenants, and pushed the Chinese cook out of his way.

"The officer in charge of the mess called out to him, 'Good! You are just in time. Bring us out a watermelon.'

"The Indian took the sack from his shoulders, and from it rolled out on the floor—*a ghastly human head, with its long black hair matted with blood.*

"As soon as the shock of first surprise was over, an examination showed to those acquainted with Indian characteristics that it was the head of an Apache, but no one of all present knew anything of the mystery of that bloody head except the commanding officer.

"The main leaders out of the way, the remainder of the band soon went to pieces, and most of them fell an easy prey to the secret-service men.

"One night I got in late from a trip, and on looking up Acting-Assistant Surgeon Mann, found him holding post-mortem on what was left of Has-Tin-Du-To-Dy. Tonto B60 was brought in alive. The tall young fellow, whose name I now remember as Lah-Kone, was killed about thirty miles north of San Carlos. Miguel was killed in a fight with the Mexicans down in Old Mexico. Good-Boy was killed by his brother outlaws because he had a very sore leg and could not keep up with them. Say-Es was his executioner. This soreness was an abscess about the knee. I often used to doctor him for it before he ever thought of going on the warpath. Capitan Chiquita became terror-stricken, and hurried in so fast to give himself up that although I was right behind him with scouts and doing my best to overtake him, he beat me in and surrendered before I could take him. Kid was the only one who escaped.

"Gon-E-shay received the death sentence. One day the sheriff came around and told him and three other Apaches to get ready to be hanged the next morning at six o'clock. 'I don't have any getting ready to do,' replied Gon-E-shay, 'I am ready now.'

"When the sheriff came next morning, he found Gon-e-shay and two others dead. Each had torn a strip of cloth from his breech-clout, and then, tieing this in a knot around his neck, had pulled at each end, thus choking himself to death. They were found in this position, the strips of cloth still taut from the strength of the pull. Their necks and the palms of their hands, when the fingers were pried open, were found bloody where the strips had cut into the flesh. Such had been their fierce determination to cheat the white man's law and the gallows of their victims. And it had been done without a groan or a struggle. The other Apache, who was in the same cell with them, knew nothing of it until the sheriff came, and he was as much surprised as the sheriff.

"Soon after this I saw the secret-service man whom I had employed in communicating with No-sey, and asked him why he had wanted us to camp at that place on the fourth night. 'Oh,' said he, 'if we hadn't got those Kid fellows up there in this part of the country, they would have wanted to go down to Capitan Chiquita's old place. No-sey would have been along with them, and I wanted to get the scouts up there so they couldn't get over the country to bother No-sey.' Our camping place the fourth night was up on a high plateau near Capitan Chiquita's old place, which was in a bottom, but there was no way to get over the intervening cut-up country.

"'And did you hear where we *did* camp?' I asked him.

"'Yes,' said he, laughing heartily, 'that's all right. You can't always tell. Apache sometime all the same coyote.'

"So you see—when they write my obituary, I wish they would say he was a great Indian thinker and let it go at that."

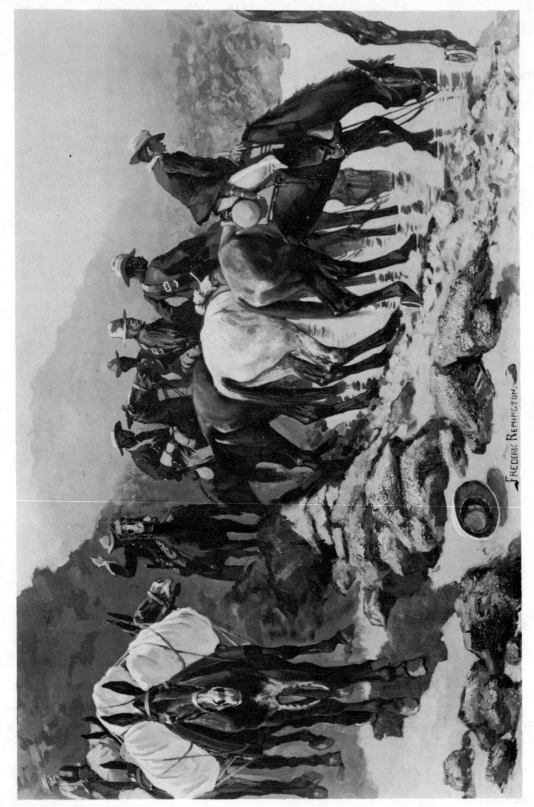

A POOL IN THE DESERT

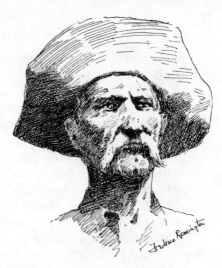

V

A Scout with
the Buffalo-Soldiers

I sat smoking in the quarters of an Army friend at Fort Grant, and
through a green latticework I was watching the dusty parade
and congratulating myself on the possession of this spot of com-
fort in such a disagreeably hot climate as Arizona Territory offers in
the summer, when in strode my friend the lieutenant, who threw his
cap on the table and began to roll a cigarette.

"Well," he said, "the C.O. has ordered me out for a two-weeks'
scouting up the San Carlos way, and I'm off in the morning. Would
you like to go with me?" He lighted the cigarette and paused for my
reply.

I was very comfortable at that moment, and knew from some
past experiences that marching under the summer sun of Arizona was
real suffering and not to be considered by one on pleasure bent. I was
also aware that my friend the lieutenant had a reputation as a hard
rider and would in this case select a few picked and seasoned cavalry-
men and rush over the worst possible country in the least possible time.
I had no reputation as a hard rider to sustain, and, moreover, had not
backed a horse for the year past. I knew, too, that Uncle Sam's beans,
black coffee, and the bacon which every old soldier will tell you about
would fall to the lot of anyone who scouted with the Tenth Dragoons.
Still, I very much desired to travel through the country to the north,
and in a rash moment said, "I'll go."

"You quite understand that you are amenable to discipline,"
continued the lieutenant, with mock seriousness, as he regarded me with
that soldier's contempt for a citizen which is not openly expressed but
is tacitly felt.

"I do," I answered meekly.

"Put you afoot, citizen; put you afoot, sir, at the slightest prov-
ocation, understand," pursued the officer, in his sharp manner of giving
commands.

I suggested that after I had chafed a Government saddle for a

day or two, I should undoubtedly beg to be put afoot, and, far from being a punishment, it might be a real mercy.

"That being settled, will you go down to stable call and pick out a mount? You are one of the heavies, but I think we can outfit you," he said; and together we strolled down to where the bugle was blaring.

At the adobe corral the faded coats of the horses were being groomed by the black troopers in white frocks; for the Tenth United States Cavalry is composed of colored men. The fine alkaline dust of that country is continually sifting over all exposed objects, so that grooming becomes almost as hopeless a task as sweeping back the sea with a house broom. A fine old veteran cavalry horse, detailed for a sergeant of the troop, was selected to bear me on the trip. He was a large horse of a pony build, both strong and sound, except that he bore a healed-up saddle gall, gotten, probably, during some old march upon an endless Apache trail. His temper had been ruined, and a grinning soldier said as he stood at a respectful distance, "Leouk out, sah. Dat ole hoss shore kick youh head off, sah."

The lieutenant assured me that if I could ride that animal through and not start the old gall, I should be covered with glory; and as to the rest, "What you don't know about cross-country riding in these parts, that horse does."

Well satisfied with my mount, I departed. That evening numbers of rubber-muscled cavalry officers called me and drew all sorts of horrible pictures for my fancy, which greatly amused them and duly filled me with dismal forebodings. "A man from New York comes out here to trifle with the dragoons," said one facetious chap, addressing my lieutenant; "so now, old boy, you don't want to let him get away with the impression that the cavalry don't ride." I caught the suggestion that is was the purpose of those fellows to see that I was "ridden down" on that trip; and though I got my resolution to the sticking point, I knew that "a pillory can outpreach a parson," and that my resolutions might not avail against the hard saddle.

On the following morning I was awakened by the lieutenant's dog-rubber [a soldier detailed as officer's servant] and got up to array myself in my field costume. My old troop horse was at the door, and he eyed his citizen rider with malevolent gaze. Even the dumb beasts of the Army share that quiet contempt for the citizen which is one manifestation of the military spirit, born of strength, and as old as when the first man went forth with purpose to conquer his neighbor man.

Down in front of the post trader's was gathered the scouting party. A tall sergeant, grown old in the service, scarred on battlefields, hardened by long marches—in short, a product of the camp—stood by his horse's head. Four enlisted men, picturesquely clad in the cavalry soldier's field costume, and two packers, mounted on diminutive bronco mules, were in charge of four pack mules loaded with *apperajos* [saddle-bags] and packs. This was our party. Presently the lieutenant issued

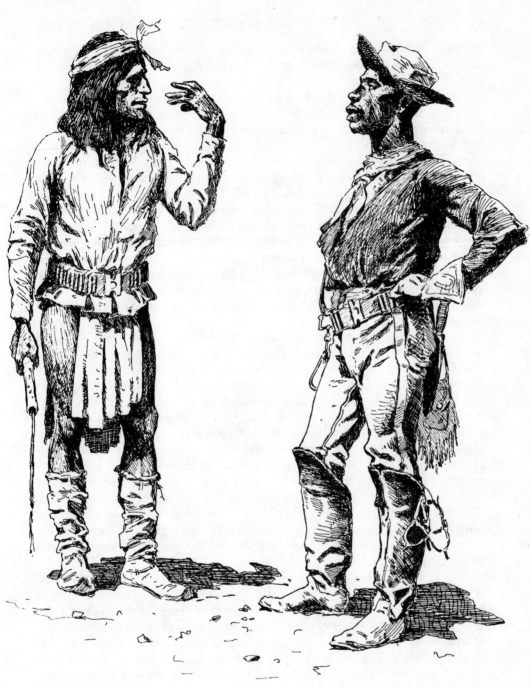

THE SIGN LANGUAGE

from the headquarters' office and joined us. An orderly led up his horse. "Mount," said the lieutenant; and swinging himself into his saddle, he started off up the road.

Out past the groups of adobe houses which constitute a frontier military village, or post, we rode, stopping to water our horses at the little creek, now nearly dry—the last water for many miles on our trail —and presently emerged upon the great desert. Together, at the head of the little cavalcade, rode the lieutenant and I, while behind, in single file, came the five troopers, sitting loosely in their saddles with the long stirrup of the United States cavalry seat, forage hats set well over their eyes, and carbines, slickers, canteens, saddle pockets, and lariats rattling at their sides. Strung out behind were the four pack mules, now trotting demurely along, now stopping to feed, and occasionally making a solemn and evidently well-considered attempt to get out of line and regain the post which we were leaving behind. The packers brought up the rear, swinging their "blinds" and shouting at the lagging mules in a manner which evinced a close acquaintance with the character and peculiarities of each beast.

The sun was getting higher in the heavens and began to assert its full strength. The yellow dust rose about our horses' hoofs and settled again over the dry grass and mesquite bush. Stretching away on our right was the purple line of the Sierra Bonitas, growing bluer and bluer until lost in the hot scintillating atmosphere of the desert horizon. Overhead stretched the deep blue of the cloudless sky. Presently we halted and dismounted to tighten the packs, which work loose after the first hour. One by one the packers caught the little mules, threw a blind over their eyes, and, "Now, Whitey! Ready! eve-e-e-e— gimme that loop," came from the men as they heaved and tossed the circling ropes in the mystic movements of the diamond hitch. "All fast, Lieutenant," cries a packer, and mounting, we move on up the long slope of the mesa toward the Sierras. We enter a break in the foothills and the grade becomes steeper and steeper, until at last it rises at an astonishing angle.

The lieutenant shouts the command to dismount and we obey. The bridle reins are tossed over the horses' heads, the carbines thrown butt upward over the backs of the troopers, a long drink is taken from the canteens, and I observe that each man pulls a plug of tobacco about a foot long from one of the capacious legs of his troop boots and wrenches off a chew. This greatly amused me, and as I laughed, I pondered over the fertility of the soldier mind; and while I do not think that the original official military board which evolved the United States troop boot had this idea in mind, the adaptation of means to an end reflects great credit on the intelligence of someone.

Up the ascent of the mountain we toiled, now winding among trees and brush, scrambling up precipitous slopes, picking a way across a field of shattered rock, or steadying our horses over the smooth sur-

face of some boulder, till it seemed to my uninitiated mind that cavalry was not equal to the emergencies of such a country. In the light of subsequent experiences, however, I feel confident that any cavalry officer who has ever chased Apaches would not hesitate a moment to lead a command up the Bunker Hill Monument. The slopes of the Sierra Bonitas are very steep, and since the air became more rarified as we toiled upward, I found that I was panting for breath. My horse —a veteran mountaineer—grunted in his efforts and drew his breath in a long and labored blowing; consequently I felt as though I was not doing anything unusual in puffing and blowing myself. The resolutions of the previous night needed considerable nursing, and though they were kept alive, at times I reviled myself for being such a fool as to do this sort of thing under the delusion that it was an enjoyable experience. On the trail ahead I saw the lieutenant throw himself on the ground. I followed his example, for I was nearly "done for." I never had felt a rock that was as soft as the one I sat on. It was literally downy. The old troop horse heaved a great sigh, and dropping his head, went fast asleep, as every good soldier should do when he finds the opportunity. The lieutenant and I discussed the climb, and my voice was rather loud in pronouncing it "beastly." My companion gave me no comfort, for he was "a soldier, and unapt to weep," though I thought he might have used his official prerogative to grumble. The Negro troopers sat about, their black skins shining with perspiration, and took no interest in the matter in hand. They occupied such time in joking and in merriment as seemed fitted for growling. They may be tired and they may be hungry, but they do not see fit to augment their misery by finding fault with everybody and everything. In this particular they are charming men with whom to serve. Officers have often confessed to me that when they are on long and monotonous field service and are troubled with a depression of spirits, they have only to go about the campfires of the Negro soldier in order to be amused and cheered by the clever absurdities of the men. Personal relations can be much closer between white officers and colored soldiers than in the white regiments without breaking the barriers which are necessary to Army discipline. The men look up to a good officer, rely on him in trouble, and even seek him for advice in their small personal affairs. In barracks, no soldier is allowed by his fellows to "cuss out" a just and respected superior. As to their bravery: "Will they fight?" That is easily answered. They have fought many, many times. The old sergeant sitting near me, as calm of feature as a bronze statue, once deliberately walked over a Cheyenne rifle pit and killed his man. One little fellow near him once took charge of a lot of stampeded cavalry horses when Apache bullets were flying loose and no one knew from what point to expect them next. These little episodes prove the sometimes doubted self-reliance of the Negro.

After a most frugal lunch we resumed our journey toward the clouds. Climbing many weary hours, we at last stood on the sharp

ridge of the Sierra. Behind us we could see the great yellow plain of the Sulphur Spring Valley, and in front, stretching away, was that of the Gila, looking like the bed of a sea with the water gone. Here the lieutenant took observations and busied himself in making an itinerary of the trail. In obedience to an order of the Department commander, General Miles, scouting parties like ours are constantly being sent out from the chain of forts which surround the great San Carlos reservation. The purpose is to make provision against Apache outbreaks which are momentarily expected, by familiarizing officers and soldiers with the vast solitude of mountain and desert. New trails for the movement of cavalry columns across the mountains are threaded out, water holes of which the soldiers have no previous knowledge are discovered, and an Apache band is at all times liable to meet a cavalry command in out-of-the-way places. A salutary effect on the savage mind is then produced.

Here we had a needed rest, and then began the descent on the other side. This was a new experience. The prospect of being suddenly overwhelmed by an avalanche of horseflesh as the result of some unlucky stumble makes the recruit constantly apprehensive. But the trained horses are sure of foot, understand the business, and seldom stumble except when treacherous ground gives way. On the crest, the prospect was very pleasant, as the pines there obscured the hot sun; but we suddenly left them for the scrub mesquite which bars your passage and reaches forth for you with its thorns when you attempt to go around.

We wound downward among the masses of rock for some time, when we suddenly found ourselves on a shelf of rock. We sought to avoid it by going up and around, but after a tiresome march we were still confronted by a drop of about a hundred feet. I gave up in despair; but the lieutenant, after gazing at the unknown depths which were masked at the bottom by a thick growth of brush, said, "This is a good place to go down." I agreed that it was if you once got started; but personally I did not care to take the tumble.

Taking his horse by the bits, the young officer began the descent. The slope was at an angle of at least sixty degrees and was covered with loose dirt and boulders, with the mask of brush at the bottom concealing awful possibilities of what might be beneath. The horse hesitated a moment, then cautiously put his head down and his leg forward and started. The loose earth crumbled, a great stone was precipitated to the bottom with a crash, the horse slid and floundered along. Had the situation not been so serious, it would have been funny, because the angle of the incline was so great that the horse actually sat on his haunches like a dog.

"Come on!" shouted the redoubtable man of war; and as I was next on the ledge and could not go back or let anyone pass me, I remembered my resolutions. They prevailed against my better judgment, and I started. My old horse took it unconcernedly, and we came down

all right, bringing our share of dirt and stones and plunging through the wall of brush at the bottom to find our friend safe on the lower side. The men came along without so much as a look of interest in the proceeding, and then I watched the mules. I had confidence in the reasoning powers of a pack mule, and thought that he might show some trepidation when he calculated the chances; but not so. Down came the mules without turning an ear, and then followed the packers, who, to my astonishment, rode down. I watched them do it, and know not whether I was more lost in admiration or eager in the hope that they would meet with enough difficulty to verify my predictions.

We then continued our journey down the mountains through a box canyon. Suffice it to say that, as it is a cavalry axiom that a horse can go wherever a man can if the man will not use his hands, we made a safe transit.

Our camp was pitched by a little mountain stream near a grassy hillside. The saddles, packs, and *apperajos* [saddlebags] were laid on the ground, and the horses and mules herded on the side of the hill by a trooper, who sat perched on a rock above them, carbine in hand. I was thoroughly tired and hungry, and did my share in creating the

SADDLING UP IN THE MORNING

famine which it was clearly seen would reign in that camp ere long. We sat about the fire and talked. The genial glow seems to possess an occult quality; it warms the self-confidence of a man; it lulls his moral nature; and the stories which circulate about a campfire are always more interesting than authentic. One old packer possessed a wild imagination, backed by a fund of experiences gathered in a life spent in knocking about everywhere between the Yukon River and the City of Mexico, and he rehearsed tales which would have staggered Baron Munchausen.

The men got out a pack of Mexican cards and gambled at a game called "Coon-can" for a few nickels and dimes and that other soldier currency—tobacco. Quaint expressions came from the card party. "Now I'se agoin' to scare de life outen you when I show down dis hand," said one man after a deal.

The player addressed looked at his hand carefully and quietly rejoined, "You might scare *me*, pard, but you can't scare de cards I'se got yere."

The utmost good-nature seemed to prevail. They discussed the little things which make their lives. One man suggested that "De big jack mule, he behavin' hisself pretty well dis trip; he hain't done kick nobody yet." Pipes were filled, smoked, and returned to that cavalry man's gripsack, the bootleg, and the game progressed until the fire no longer gave sufficient light.

Soldiers have no tents in that country, and we rolled ourselves in our blankets, and gazing up, saw the weird figure of the sentinel against the last red gleam of the sunset, and beyond that, the great dome of the sky, set with stars. Then we fell asleep.

When I awoke the next morning, the hill across the canyon wall was flooded with a golden light, while the gray tints of our camp were steadily warming up. The soldiers had the two black camp pails over the fire and were grooming the horses. Everyone was good-natured, as befits the beginning of the day. The tall sergeant was meditatively combing his hair with a currycomb; such delightful little unconventionalities are constantly observed about the camp. The coffee steamed up in our nostrils, and after a rub in the brook, I pulled myself together and declared to my comrade that I felt as good as new. This was a palpable falsehood, as my labored movements revealed to the hard-sided cavalryman the sad evidence of the effeminacy of the studio. But our respite was brief, for almost before I knew it, I was again on my horse, following down the canyon after the black charger bestrided by the junior lieutenant of K Troop. Over piles of rocks fit only for the touch and go of a goat, through the thick mesquite which threatened to wipe our hats off or to swish us from the saddle, with the air warming up and growing denser, we rode along. A great stretch of sandy desert could be seen, and I foresaw hot work.

In about an hour we were clear of the descent and could ride

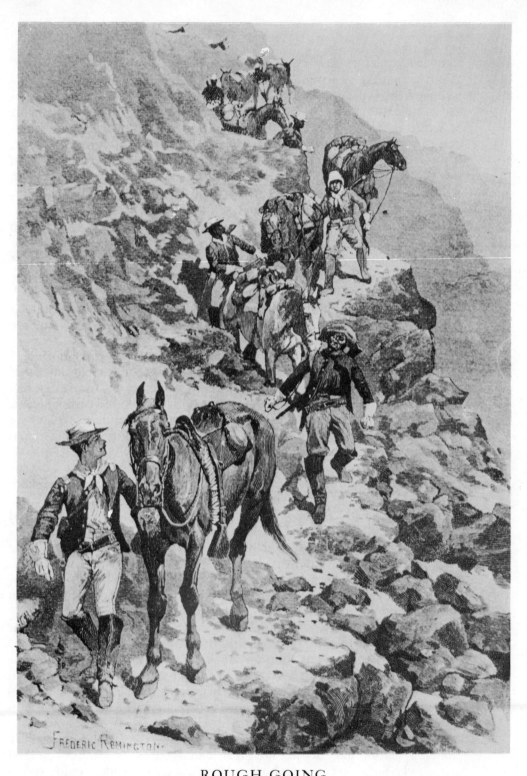

ROUGH GOING

along together, so that conversation made the way more interesting. We dismounted to go down a steep drop from the high mesa into the valley of the Gila, and then began a day warmer even than imagination had anticipated. The awful glare of the sun on the desert, the clouds of white alkaline dust which drifted up until lost above, seemingly too fine to settle again, and the great heat cooking the ambition out of us, made the conversation lag and finally drop altogether. The water in my canteen was hot and tasteless, and the barrel of my carbine, which I touched with my ungloved hand, was so heated that I quickly withdrew it. Across the hot-air waves which made the horizon rise and fall like the bosom of the ocean we could see a whirlwind or sandstorm winding up in a tall spiral until it was lost in the deep blue of the sky above. Lizards started here and there; a snake hissed a moment beside the trail, then sought the cover of a dry bush; the horses moved along with downcast heads and drooping ears. The men wore a solemn look as they rode along, and now and then one would nod as though giving over to sleep. The pack mules no longer sought fresh feed along the way, but attended strictly to business.

A short halt was made, and I alighted. Upon remounting, I threw myself violently from the saddle, and upon examination found that I had brushed up against a cactus and gotten my corduroys filled with thorns. The soldiers were overcome with great glee at this episode, but they volunteered to help me pick them from my dress. Thus we marched all day, and with canteens empty, we pulled into Fort Thomas that afternoon.

At the fort we enjoyed that hospitality which is a kind of freemasonry among Army officers. The colonel made a delicious concoction of I know not what, and provided a hammock in a cool place while we drank it. Lieutenant F—— got cigars that were past praise, and another officer had provided a bath. Captain B—— turned himself out-of-doors to give us quarters, which graciousness we accepted while our consciences pricked. But for all that, Fort Thomas is an awful spot, hotter than any other place on the crust of the earth. The siroccos continually chase each other over the desert, the convalescent wait upon the sick, and the thermometer persistently reposes at the figure of 125 degrees F. Soldiers are kept in the Gila Valley posts for only six months at a time before they are relieved, and they count the days.

On the following morning at an early hour we waved adieus to our kind friends and took our way down the valley. I feel enough interested in the discomforts of that march to tell about it, but I find that there are not resources in any vocabulary. If the impression is abroad that a cavalry soldier's life in the Southwest has any of the lawn-party element in it, I think the impression could be effaced by doing a march like that. The great clouds of dust choke you and settle over horse, soldier, and accouterments until all local color is lost and black man and white man wear a common hue. The "*chug, chug,*

chug" of your tired horse as he marches along becomes infinitely tire-
some, and cavalry soldiers never ease themselves in the saddle. That
is an Army axiom. I do not know what would happen to a man who
"hitched" in his saddle, but it is carefully instilled into their minds that
they must "ride the horse" at all times and not lounge on his back. No
pains are spared to prolong the usefulness of an Army horse, and every
old soldier knows that his good care will tell when the long forced
march comes someday, and when to be put afoot by a poor mount
means great danger in Indian warfare. The soldier will steal for his
horse, will share his camp bread, and will moisten the horse's nostrils
and lips with the precious water in the canteen. In garrison, the troop
horses lead a life of ease and plenty; but it is varied at times by a
pursuit of hostiles, when they are forced over the hot sands and up
over the perilous mountains all day long, only to see the sun go down
with the rider still spurring them on amid the quiet of the long night.

Through a little opening in the trees we see a camp and stop
in front of it. A few mesquite trees, two tents, and some sheds made
of boughs beside an *acequia* make up the background. By the cooking
fire lounge two or three rough frontiersmen, veritable pirates in ap-
pearance, with rough flannel shirts, slouch hats, brown canvas overalls,
and an unkempt air; but suddenly, to my intense astonishment, they
rise, stand in their tracks as immovable as graven images, and salute
the lieutenant in the most approved manner. Shades of that sacred book
the *Army Regulations*, then these men were soldiers! It was a camp
of instruction for Indians and a post of observation. They were nice
fellows, and did everything in their power to entertain the cavalry.
We were given a tent, and one man cooked the Army rations in such
strange shapes and mysterious ways that we marveled as we ate.

After dinner we lay on our blankets, watching the groups of
San Carlos Apaches who came to look at us. Some of them knew the
lieutenant, with whom they had served and whom they now addressed
as "Young Chief." They would point him out to others with great zest,
and babble in their own language. Great excitement prevailed when
it was discovered that I was using a sketchbook, and I was forced to
disclose the half-finished visage of one villainous face to their gaze. It
was straightway torn up, and I was requested, with many scowls and
grunts, to discontinue that pastime, for Apaches more than any other
Indians dislike to have portraits made. That night the "hi-ya-ya-hi-ya-
hi-yo-o-o-o-o" and the beating of the tom-toms came from all parts
of the hills, and we sank to sleep with this gruesome lullaby.

The following day as we rode we were never out of sight of
the brush huts of the Indians. We observed the simple domestic
processes of their lives. One naked savage got up suddenly from behind
a mesquite bush, which so startled the horses that quicker than thought
every animal made a violent plunge to one side. No one of the trained
riders seemed to mind this unlooked-for movement in the least, beyond

displaying a gleam of grinning ivories. I am inclined to think that it
would have let daylight upon some of the "English hunting seats" one
sees in Central Park.

All along the Gila Valley can be seen the courses of stone which
were the foundations of the houses of a dense population long since
passed away. The lines of old irrigating ditches were easily traced, and
one is forced to wonder at the changes in nature, for at the present
time there is not water sufficient to irrigate land necessary for the
support of as large a population as probably existed at some remote
period. We "raised" some foothills, and could see in the far distance
the great flat plain, the buildings of the San Carlos agency, and the
white canvas of the cantonment. At the ford of the Gila we saw a
company of doughboys wade through the stream as our own troop
horses splashed across. Nearer and nearer shone the white lines of tents
until we drew rein in the square, where officers crowded around to
greet us. The jolly post commander, the senior captain of the Tenth,
insisted upon my accepting the hospitalities of his "large hotel," as he
called his field tent. Right glad have I been ever since that I accepted
his courtesy, for he entertained me in the true frontier style.

Being now out of the range of country known to our command,
a lieutenant in the same regiment was detailed to accompany us beyond.
This gentlemen was a character. The best part of his life had been
spent in this rough country, and he had so long associated with Apache
scouts that his habits while on a trail were exactly those of an Indian.
He had acquired their methods and also that instinct of locality so
peculiar to red men. I jocosely insisted that Lieutenant Jim only needed
breechclout and long hair in order to draw rations at the agency. In
the morning, as we started under his guidance, he was a spectacle. He
wore shoes and a white shirt, and carried absolutely nothing in the
shape of canteens and other "plunder" which usually constitute a
cavalryman's kit. He was mounted on a little runt of a pony so thin
and woebegone as to be remarkable among his kind.

It was insufferably hot as we followed our queer guide up a dry
canyon, which cut off the breeze from all sides and was a veritable
human frying pan. I marched next behind our leader, and all day long
the patter, patter of that Indian pony, bearing his tireless rider, made
an aggravating display of insensibility to fatigue, heat, dust, and climb-
ing. On we marched over the rolling hills, dry, parched, desolate,
covered with cactus and loose stones. It was nature in one of her
cruel moods, and the great silence over all the land displayed her
mastery over man.

When we reached water and camp that night, our ascetic leader
had his first drink. It was a long one and a strong one, but at last he
arose from the pool and with a smile remarked that his "canteens were
full." Officers in the regiment say that no one will give Lieutenant
Jim a drink from his canteen, but this does not change his habit of not

A HALT TO TIGHTEN THE PACKS

carrying one; nevertheless, by the exercise of self-denial which is at times heroic, he manages to pull through. They say that he sometimes fills an old meat tin with water in anticipation of a long march, and stories which try credulity are told of the amount of water he has drunk at times.

Yuma Apaches, miserable wretches, come into camp, shake hands gravely with everyone, and then, in their Indian way, begin the inevitable inquiries as to how the coffee and flour are holding out. The campfire darts and crackles, the soldiers gather around it, eat, joke, and bring out the greasy pack of cards. The officers gossip of Army affairs, while I lie on my blankets, smoking and trying to establish relations with a very small and very dirty little Yuma Apache, who sits near me and gazes with sparkling eyes at the strange object which I undoubtedly seem to him. That "patroness of rogues," the full moon, rises slowly over the great hill while I look into her honest face and lose myself in reflections.

It seems but an instant before a glare of sun strikes my eyes and I am awake for another day. I am mentally quarreling with that insane desire to march which I know possesses Lieutenant Jim; but it is useless to expostulate, and before many hours the little pony constantly moving along ahead of me becomes a part of my life. There he goes. I can see him now—always moving briskly along, pattering over the level, trotting up the dry bed of a stream, disappearing into the dense chap-

arral thicket that covers a steep hillside, jumping rocks, and doing
everything but halt.

We are now in the high hills, and the air is cooler. The chap-
arral is thicker, the ground is broken into a succession of ridges, and
the volcanic boulders pile up in formidable shapes. My girth loosens
and I dismount to fix it, remembering that old saddle gall. The com-
mand moves on and is lost to sight in a deep ravine. Presently I resume
my journey, and in the meshwork of ravines I find that I no longer
see the trail of the column. I retrace and climb and slide downhill,
forcing my way through chaparral, and after a long time I see the
pack mules go out of sight far away on a mountain slope. The blue
peaks of the Pinals tower away on my left, and I begin to indulge
in mean thoughts concerning the indomitable spirit of Lieutenant
Jim, for I know he will take us clear over the top of that pale blue
line of far-distant mountains. I presume I have it in my power to
place myself in a more heroic light, but this kind of candor is good
for the soul.

In course of time I came up with the command, which had
stopped at a ledge so steep that it had daunted even these mountaineers.
It was only a hundred-foot drop, and they presently found a place
to go down where, as one soldier suggested, "there isn't footing for a
lizard." On, on we go, when suddenly, with a great crash, some sandy
ground gives way, and a collection of hoofs, troop boots, ropes, can-
teens, and flying stirrups goes rolling over in a cloud of dust and finds
a lodgment in the bottom of a dry watercourse. The dust settles and
discloses a soldier and his horse. They rise to their feet and appear
astonished, but as the soldier mounts and follows on, we know he is
unhurt. Now a coyote, surprised by our cavalcade and unable to get
up the ledge, runs along the opposite side of the canyon wall. "*Pop,
pop, pop, pop,*" go the six-shooters, and then follow explanations by
each marksman of the particular thing which made him miss.

That night we were forced to make a "dry camp," that is, one
where no water is to be found. There is such an amount of misery
locked up in the thought of a dry camp that I refuse to dwell upon it.
We were glad enough to get upon the trail in the morning, and in
time found a nice running mountain brook. The command wallowed
in it. We drank as much as we could hold and then sat down. We arose
and drank some more, and yet we drank again, and still once more,
until we were literally waterlogged. Lieutenant Jim became uneasy,
so we took up our march. We were always resuming the march when
all nature called aloud for rest. We climbed straight up impossible
places. The air grew chill, and in a gorge a cold wind blew briskly
down to supply the hot air rising from sands of the mesa far below.
That night we made a camp, and the only place where I could make
my bed was on a great flat rock. We were now among the pines, which
towered above us. The horses were constantly losing one another in

the timber in their search for grass, in consequence of which they whinnied while the mules brayed and made the mountain hideous with sound.

By another long climb we reached the extreme peaks of the Pinal range, and there before us was spread a view which was grand enough to compensate us for the labor. Beginning in "gray reds," range after range of mountains, overlapping each other, grow purple and finally lose themselves in pale blues. We sat on a ledge and gazed. The soldiers were interested, though their remarks about the scenery somehow did not seem to express an appreciation of the grandeur of the view, which impressed itself strongly upon us. Finally one fellow, less aesthetic than his mates, broke the spell by a request for chewing tobacco, so we left off dreaming and started on.

That day Lieutenant Jim lost his bearings and called upon that instinct which he had acquired in his life among the Indians. He "cut the signs" of old Indian trails and felt the course to be in a certain direction—which was undoubtedly correct, but it took us over the highest points of the Mescal range. My shoes were beginning to give out, and the troop boots of several soldiers threatened to disintegrate. One soldier, more ingenious than the rest, took out some horseshoe nails and cleverly mended his boot-gear. At times we wound around great slopes where a loose stone or the giving way of bad ground would have precipitated horse and rider a thousand feet below. Only the courage of the horses brings one safely through. The mules suffered badly, and our weary horses punched very hard with their foreparts as they went downhill.

We made the descent of the Mescals through a long canyon where the sun gets one in chancery, as it were. At last we reached the Gila, and nearly drowned a pack mule and two troopers in a quicksand. We began to pass Indian huts, and saw them gathering wheat in the river bottoms, while they paused to gaze at us and doubtless wondered for what purpose the buffalo-soldiers were abroad in the land. The cantonment appeared, and I was duly gratified when we reached it.

I hobbled up to the "Grand Hotel" of my host, the captain, who laughed heartily at my floundering movements and observed my nose and cheeks, from which the sun had peeled the skin, with evident relish at the thought of how I had been used by his lieutenant. At his suggestion I was made an honorary member of the cavalry, and duly admonished "not to trifle again with the Tenth Nubian Horse if I expected any mercy."

In due time the march continued without particular incident, and at last the scout "pulled in" to the home post, and I again sat in my easy chair behind the latticework, firm in the conviction that soldiers, like other men, find more hard work than glory in their calling.

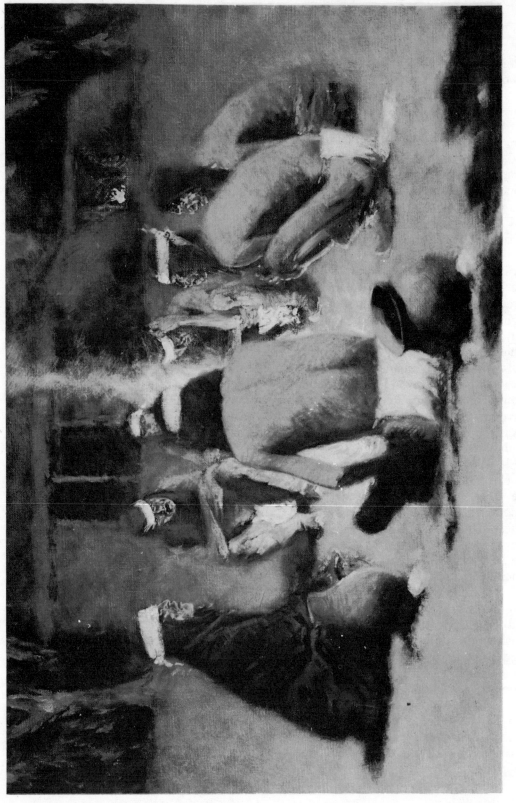

THE APACHE SONG OF DEATH

VI

Natchez's Pass

What I have in mind occurred in the days when the Government expected the Army to fight successfully both the wild Indians and the Department of the Interior. A military career thrives on opposition. It is the natural development of a soldier. Captain Bill Summers had buffeted through the great war, and all in all had sixteen years of formulation. He was rugged, red, fearless, and short-winded in his speech. He had found that the flag and Washington were often at odds, but he did not attempt to understand. The agency and Fort McDowell were as much at war as well could be.

There was at this time a demon in charge of the Apache agency whose name shall be Mr. Marshall East. He may have since died in a penitentiary or have gotten through the net which justice has always set across the dark waters of opportunity; I do not know. He was a well-looking man, educated and resourceful. Morally he liked a dirty dollar—even a bloody one, I think. He was a tool used by what was then called the "Indian Ring"—a scurvy band of political pirates, the thought of whom should always make Americans blush. Its reckless operations made a hell of the frontier. The Army protested, the settlers pleaded pathetically, but the Interior Department kept its mercenaries at their posts.

The politicians grew fat; the Army, the settlers, and the Indians grew thin. General Crook was in charge of the military operations against the Indians and the Interior Department. Savages constantly left the agencies on passes, when they murdered and stole. Crook's soldiers rode after them; and the Government had a real war on its hands, between two of its greatest departments.

One hot day Captain Bill Summers rode into the agency at the head of his troop. After making camp, he stalked into the office of Mr. Marshall East and opened fire. "Mr. Marshall East, we have found the dead bodies of three white men over on the Rio Verde— killed by Indians whose trail we have followed into this agency. What are you going to do about it?"

"Humph!—won't you sit down?" nodded the agent as he fumbled some papers before him on the table.

"No, thank you. I didn't come here to sit down. I came here to arrest murderers, and I demand your aid."

"Well—arrest murderers, and don't bother me," retorted the agent.

"See here, Mr. Marshall East, you know that it is your duty to assist me by the use of your Indian police to identify these outlaws. You know, or should know, what Indians are away from the agency, or have been away, with or without passes," rejoined the captain, now becoming alarmingly red in the face.

"I thought you came here to arrest murderers?"

"I did."

Coolly the man behind the table continued, "Well—what are you standing there for?"

The captain was no longer standing, but striding, heavy heeled, across the room and back to his place, where he slapped his sombrero on his head, pulling it down defiantly about his ears. "You are a scoundrel, Mr. Marshall East! You are accessory after the fact to murder!"

The agent in his turn took fire. He sprang to his feet. "You call me a scoundrel! What do you mean by coming into my office and calling me such a name? Get out of here instantly," and half turning to a long-haired sombreroed Indian factotum, he said, "Sanchez!" Sergeant McCollough's rifle came from an "order" to "carry" with a snap.

"Steady, Sergeant," muttered the captain. Thus the scene was arrested in its development and all in the room stood regarding each other nervously. Presently the captain's mustache spread and he burst into a loud laugh. "Oh, you old dog! I know you won't bite. You would abet murder, but you would not do it with your right arm. I am going to leave this room, but not until you sit down—if I have to get my striker to pitch my dog tent here."

Slowly the desk man resumed his chair. Continuing, the captain said, "Before going, I want to state carefully that you are one of the worst scoundrels I ever saw, and before I am through, I will burn the brand—*scoundrel*—on your thick hide." Going to the door, where he stopped with his hand on the knob, he half turned and said, "Sanchez," followed by a sneering laugh. Then he passed out, followed by the sergeant.

"I will make you pay for this!" came a muffled roar of the agent's voice through the closed door.

"Oh, I guess we will split even," mumbled the departing officer, though of a truth he did not see how.

Walking to the troop camp, the captain took possession of an abandoned *ramada* [thatched shelter] some little distance from his men;

and here he sat on his blankets, trying to soothe his disgusted thoughts with a pipe. The horses and mules and soldiers made themselves comfortable, and rested after their hard marching of the previous days. It was to ease his command that determined the officer to stay "one smoke" at the place.

Immediately after dark "Peaches," one of the Indian scouts of the command, slipped, ghostlike, to the opening of the *ramada*, saying, "Nan-tan!"

"What is it, Peaches?"

The ghost glided from the moonlight into the shadow, addressing his officer. "Say, Nan-tan—Injun bad—agent bad—no like you hombres. Say—me tink kill you. Tink you go make de vamoose. *Sabe?*"

"Oh, nonsense! Apaches won't attack me at night. Too many ghosts, Peaches."

Peaches replied, with a deprecatory turn of the hand, "No, no, Nan-tan—no *brujas*—too near agency. You vamoose—*sabe?*"

The captain had an all-abiding faith in Peaches's knowledge of villainy. He was just at present a friendly scout, but liable at any time to have a rush of blood to the head which would turn his hand against any man. He had been among the agency Indians all day, talking with them, and was responsive to their moods. It isn't at all necessary to beat an Indian on the head with a rock to impress his mind. He is possessed of a subtlety of understanding which is Oriental. So the captain said, "Go, Peaches—tell Sergeant McCullough to come here."

In a few minutes the alert noncom stood across the moonlight, saluting.

"Sergeant, Peaches here has heard some alarming talk among the Indians. I don't think there is anything in it, but 'Injuns is Injuns' you know. Tie and side-line your horses and have your men sleep, skirmish formation, twenty-five paces out from the horses. Double your sentries. You might send a man or two up here to divide a watch over me. I want a good sleep. Understand?"

"Yes, sir. May I be one of them? It ain't far to the troop, and I can see them in the moonlight well enough."

"You had better stay with the troop. Why do you want to come up here? You can manage some sleep?" queried Summers.

"Been sleeping all afternoon, sir. Been talking to Peaches. Don't quite make it all out. Like to come up, sir."

"Oh, well—all right, then—do as you please, but secure your horses well." Saying which, the captain turned on his blankets to sleep.

In a half hour's time the sergeant had arranged his troop to his satisfaction—told the old "bucks" to mind their eyes, judiciously scared the "shavetails" into wakefulness, and with Peaches and Trooper "Long Jack" O'Brien—champion fist-mixer of the command—he stole into the captain's *ramada*. The officer was snoring with honest, hard-going vigor.

"This do be a rale da-light," murmured Long Jack.

"Shut up—you'll wake the old man!" whispered the noncom. Silence becoming the moonlight and desert soon brooded over the plains of the agency. There was no sound save the snoring, stamping of horses on picket, and the doleful coyotes out beyond, baying the mysterious light.

Through long hours Long Jack and the sergeant nodded their heads by turns. The moon was well down in the west when Peaches came over and poked the sergeant in the back with his carbine. The punched one stood up in sleepy surprise, but comprehending, shook O'Brien awake, and stepped over to where Peaches was scanning through the dead leaves which draped the *ramada*.

"Injun," whispered Peaches, almost inaudibly.

For a long time they sat gazing out at the dusky blur of the sagebrush. The sergeant, with white man's impatience, had about concluded that the faculties of Peaches were tricking him.

"Humph!" he grunted. The hand of the Indian scout tightened like nippers of steel around his arm and opened his eyes anew. Presently he made out a sagebrush which had moved slowly several feet, when it stopped. The hand of Peaches gave another squeeze when the brush made farther progress toward the *ramada*. The sergeant stole over to the door and put a tourniquet on Long Jack's arm which brought him in sympathy with the mysterious situation. That worthy's heart began to thump in unison with the others. A man under such circumstances can hear his own heart beat, but it is so arranged that others cannot. The sergeant pulled Long Jack's ear to his mouth, as a mother might about to kiss her infant. "Don't shoot—give them the butt." Cautiously the two Springfields were reversed. Long Jack was afraid to spit on his hands, but in lieu, he ran his tongue over both before he bulldogged them about the carbine barrel. With feet spread, the two soldiers waited; and Peaches, like a black shadow, watched the brush. The minutes passed slowly, but the suspense nerved them. After ages of time had passed, they were conscious of the low rustle of a bush alongside the ramada—ever so faint, but they were coming. Slowly a sagebrush came around the corner, followed by the head of an Indian.

The eyes of the crawling assassin could not contract from moonlight to meet the gloom of the interior of the house of boughs. It is doubtless true that he never had a sense of what happened, but the silence was shattered by a crash, and the soldiers sprang outside.

"Then I broake both ye un me goon."

"What in hell is the matter?" came from the awakened captain as he made his way out of the blankets.

A little group formed around the body, while Peaches rolled it over on its back, face upward. "Sanchez," he said quietly. "Say, Nan-tan, maybeso you *sabe* Peaches. You go vamoose now?"

The captain scratched his bare head, he gave his breeches a

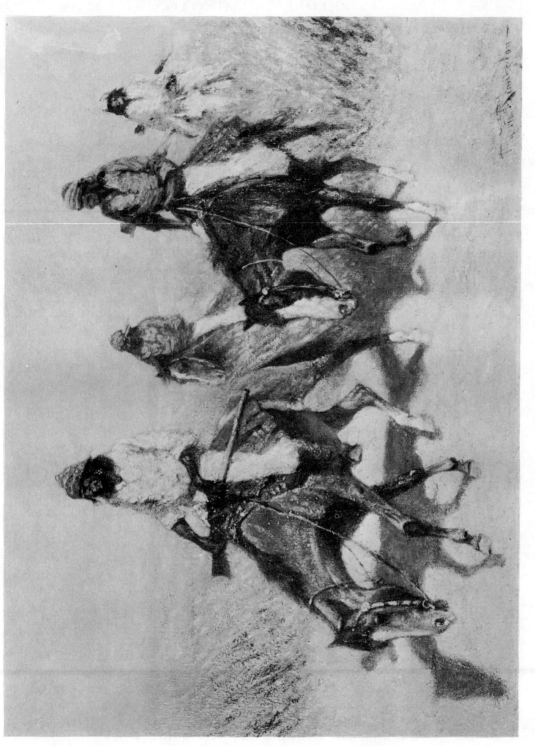

THE POOL IN THE DESERT

hitch, he regarded the moon carefully, as though he had never seen it before, then he looked at the dead Indian.

"Yes, Peaches, I think I *sabe*. Say, Sergeant, it's 'boots and saddles' on the jump. Don't say a word to the men, but bring a pack mule up here and we'll load this carrion on it. Peaches, you blind this man's trail. I reckon you are Injun enough to do that. O'Brien, don't leave the stock of that rifle lying there."

The camp was soon bustling. The horses were led out, blankets smoothed, and saddles swung across. A pack mule was led up to the captain's *ramada* by McCollough, O'Brien, and Peaches. All four men helped to wrap up their game in a canvas. Though the mule protested vigorously, he was soon under the gruesome burden, circled tight with the diamond hitch. Having finished, the captain spoke: "Promise me, men, that you won't talk about this. I want time to think about it. I don't know the proper course to take until I consult with the military authorities. If the Indians found this out now, there would be a fight right here. If they don't, one may be averted."

" 'Twas a foine bit av woork to me credit, which will be a dead loss to me, boot I promise," replied Long Jack, and so did the others.

"Have you blinded his trail, Peaches?"

"*Si*, Nan-tan; Injun no see a t'ing," said that imp of the night.

The little command took their thudding, clanking way over the ghostly hills, trotting steadily until the sun was high, when they made an eating halt. A few days brought them into McDowell, where the captain reported the affair. Officially, his comrades did not know what to do. Personally, they thought he did right. They expected nothing from the Indian Ring but opposition, and they were not as strong in Washington as the politicians. But shortly time served them, as it does many who wait.

A great drought had raged in the Southwest, and many sheep-men from San Diego were driving their flocks into the Tonto Basin. One day a Mexican Indian came into Fort McDowell, stark naked and nearly exhausted. He reported that the small sheep outfit to which he belonged had been attacked by Apaches and all murdered but himself. Captain Summers was again ordered out with his troop to the scene of the outrage. He made forty-five miles the first day, yet with such traveling it was ten days before he came in sight of the camp. There were three tents, wind blown and flapping. In front of the middle one lay three dead Indian bucks. The canvas walls were literally shot full of holes. As the captain pulled back the flap of the center tent, he saw a big blond-bearded white man, sitting bolt-upright on a bed made of poles, with one arm raised in the act of ramming down a charge in a muzzle-loading rifle. He was dead, having been shot through the head. He was the owner, and a fine-looking man. His herders lay dead in the other tents, and his flocks were scattered and gone. The story of that desert combat will never be known. It was a drawn

battle, because the Indians had not dared to occupy the field. The man who escaped was out in the hills, and fled at the firing.

On burying the dead, the troopers found passes signed "Marshall East, Agt." under the belts of the dead Apaches. At last here was something tangible. Identifying each head with its attendant pass, the Indian scouts decapitated them, stowing them in grain bags. Back to McDowell wound the command, where a council of war was held. This resulted in the captain's being sent to the agency, accompanied by four troops as safe escort.

Arriving, Summers again passed the unwelcome portals of the agent's office, followed by his staff, consisting of a lieutenant, Mc-Collough, Long Jack, and Peaches, bearing a grain bag.

"Good day, Mr. Marshall East. I come to reassure you that you are a great scoundrel," vouchsafed the sombreroed officer as he lined up his picturesque company. "I see Sanchez is not here today. Away on a pass, I presume."

"I don't know how that concerns you. I have other men here, and I will not be bulldozed by you. I want you to understand that. I intend to see if there are not influences in the world which will effectually prevent such a ruffian as you invading my office and insulting both myself and the branch of the Government to which I belong."

"My dear sir," quoth the captain, "you sign passes which permit these Indians of yours to go into white men's territory, where they every day murder women and men and run off stock. When we run them back to your agency, you shield and protect them because you know that if we were allowed to arrest them for their crimes, it might excite the tribe, send them on the warpath, resulting in a transfer of their responsibility to the War Department. That would interfere with your arrangements. A few dead settlers or soldiers count for little against that."

"Captain Summers, I am running this agency. I am responsible for this agency. Indians do go off this reservation at times, without doubt, but seldom without a pass from me; and then with a specific object. When Indians are found outside without passes, it then becomes the duty of the Army to return them to me."

In reply: "I suppose it is our duty to bring you tarantulas and Gila monsters also; it is our duty to wear our horses' shoes off in these mountains chasing your passes with their 'specific objects.' Would you give up an Indian whom we could prove had murdered, or who had tried to murder, a white man?"

"Yes—I might—under certain circumstances, with exceptional proofs," answered Mr. East.

Quickly asked the officer, "Where is Sanchez now?"

With a searching query in his eyes, the agent continued his defensive of not seeing how that concerned the captain.

The warrior's voice rose. "Yes, sir. I will tell you how it interests me. He tried to murder me, to stab me at night—right here on this agency. Will you send your Indian police to arrest him for me?"

"Humph!—rather startling. Pray where and when did he try to murder you? What proofs have you?"

"I have three men standing here before you who saw him crawl to my *ramada* in the night with a drawn knife."

"What became of him?" drawled the agent, betraying increasing interest.

"Will you arrest him?" insisted Summers, with his index finger elevated against the chair man.

"Not so fast, my dear captain. He might prove an alibi. Your evidence might not be conclusive."

The captain permitted his rather severe countenance to rest itself. McCollough and O'Brien guarded their "four aces" with a "deuce-high" lack of interest. Peaches might have been a splendid mummy from an aged tomb, standing there with the sack at his feet.

Again becoming sober of mien, the captain continued in a voice which might have been the slow beginning of a religious service: "You are a scoundrel—you are to blame for dozens of murders in this country! Men and even women are being butchered every day because you fear to lose the opportunity to steal the property which belongs to these poor savages. I have soldier comrades lying in desert graves who would be alive if you were not a coward and a thief. Only the other day Indians bearing your 'specific object' passes killed five sheepmen in the Tonto Basin."

"I have issued no passes lately."

Here the captain pulled out all the stops in his organ. "You are a liar, and I am going to prove it."

The agent, who had been sitting lazily behind his desk, leaned forward and made the ink bottles, pens, and erasers dance fast as he smote the table with his fist. "Leave the room—leave the room, or I will call my police!"

"Where is Sanchez?"

"I don't know," and the fist ceased to beat as he looked up sharply. "Do you?"

The captain turned rigidly. "Peaches, show the gentlemen where Sanchez is."

With a suggestion of that interest which a mender of cane-bottomed chairs might display in business, Peaches pawed in his grain sack—peered into its dark folds—until suddenly, having assured himself, he straightened up, holding in his right hand by its long locks a dead head depending therefrom. Taking it gingerly, the captain set it on the table directly before Mr. Marshall East and arranged it squarely.

With dropping jaw, the agent pushed himself back in his chair before the horrible sight.

"Yes—I know where Sanchez is. He is looking at you. Were you an accessory before the fact of his intentions? Does he seem to reproach you?" spoke the captain.

"God!" burst from the lips of the man as he eyeballed his attendant.

"Oh—well—you recognize him, then. Here also is one of your passes. It calls for Chief Natchez, a one-eyed man, who 'specifically murdered sheepherders with an object.' Peaches, produce Natchez!"

Again fumbling, the keeper of the bag got the desired head by the hair and handed it over. It was more recent and well preserved. The eyes were more human, and his grin not so sweet. This, too, was arranged to gaze on the author of the passes.

"You see he has one eye—he answers the pass. I suppose his 'specific object' was sheep."

The agent breathed heavily—not from moral shock, but at the startling exhibit. His chickens had come home to roost. His imagination had never taken him so far afield. The smooth amenities of the business world could not assert themselves before such unusual things. The perspiration rolled down his forehead. He held on to the table with both hands.

Again producing a dirty paper, the captain read, "Pass Guaca-lotes" (with some description). "Signed, Marshall East. Agt., etc." Peaches dug up the deceased from the sack, handing it solemnly to the Nan-tan.

"Now, you murderer, you see your work. I wish you could see the faces of the dead sheepherders too," and with hot impulse he rolled the head across the table. It fell into the agent's lap and then to the floor. With a loud exclamation of "Oh—o—o!" the affrighted man bolted for the door.

Turning with the quickness of a fish, the soldier said, "Peaches, *numero tres,*" and the third head came out of the bag like a shot.

"Murderer! Stop! Here is another 'specific object'!" but the agent was rapidly making for the door. With a savage turn the Captain hurled the dead head after him. It struck him on the back of the neck and fell to the floor.

With a cry of fear which cannot be interpreted on paper, the agent got through the door, followed by a chorus of "Murderer!" It was a violent scene—such as belonged to remote times, seemingly. No one knows what became of the agent. What I wonder at is why highly cultivated people in America seem to side with savages as against their own soldiers.

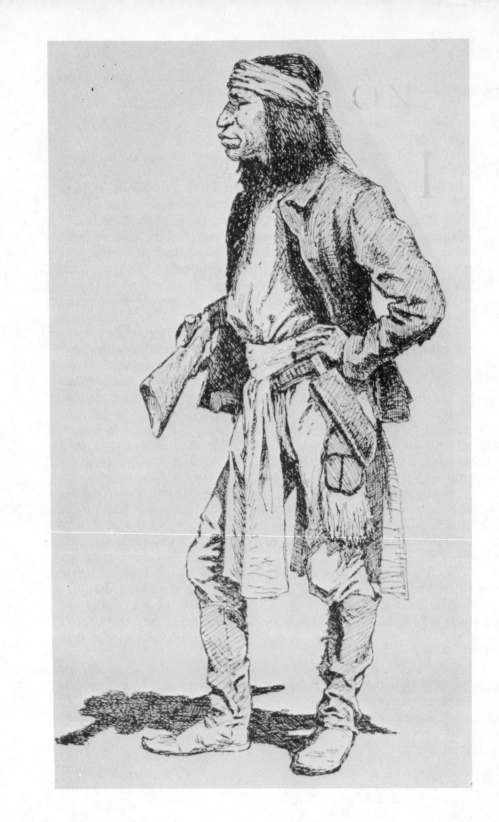

VII

Massai's Crooked Trail

It is a bold person who will dare to say that a wilder savage ever lived than Massai.

He was a *bronco* Chiricahua whose *tegua* tracks were so long and devious that all of them can never be accounted for. Three regiments of cavalry, all the scouts—both white and black—and Mexicans galore had their hack; but the ghostly presence appeared and disappeared from the Colorado to the Yaqui. No one can tell how Massai's face looks, or looked, though hundreds know the shape of his footprint.

The Seventh made some little killings, but they fear that Massai was not among the game. There surely is or was such a person as Massai. He developed himself slowly, as I will show by the Sherlock Holmes methods of the chief of scouts, though even he only got so far, after all. Massai manifested himself like the dust storm or the morning mist—a shiver in the air, and gone. The chief walked his horse slowly back on the lost trail in disgust, while the scouts bobbed along behind, perplexed. It was always so. Time has passed, and Massai indeed seems gone, since he appears no more. The hope in the breasts of countless men is nearly blighted; they no longer expect to see Massai's head brought into camp, done up in an old shirt and dropped triumphantly on the ground in front of the chief of scout's tent, so it is time to preserve what trail we can.

Three troops of the Tenth had gone into camp for the night, and the ghostly landscape hummed with the murmur of many men. Supper was over, and I got the old Apache chief of scouts behind his own ducking and demanded what he knew of an Apache Indian named Massai. He knew all or nearly all that any white man will ever know.

"All right," said the chief as he lit a cigar and tipped his sombrero over his left eye, "but let me get it straight. Massai's trail was so crooked, I had to study nights to keep it arranged in my head. He didn't leave much more trail than a buzzard, anyhow, and it took years to unravel it. But I am anticipating.

91

"I was chief of scouts at Apache in the fall of ninety when word was brought in that an Indian girl named Natastale had disappeared and that her mother was found under a walnut tree with a bullet through her body. I immediately sent Indian scouts to take the trail. They found the tracks of a mare and colt going by the spot, and thinking it would bring them to the girl, they followed it. Shortly they found a moccasin track where a man had dismounted from the mare, and without paying more attention to the horse track, they followed it. They ran down one of my own scouts in a *tiswin* [an intoxicating beverage made of corn] camp, where he was carousing with other drinkers. They sprang on him, got him by the hair, disarmed and bound him. Then they asked him what he had done with the girl and why he had killed the mother, to which he replied that 'he did not know.' When he was brought to me, about dark, there was intense excitement among the Indians, who crowded around, demanding Indian justice on the head of the murderer and ravisher of the women. In order to save his life I took him from the Indians and lodged him in the post guardhouse. On the following morning, in order to satisfy myself positively that this man had committed the murder, I sent my first sergeant, the famous Mickey Free, with a picked party of trailers back to the walnut tree with orders to go carefully over the trail and run down the mare and colt; or find the girl, dead or alive, wherever they might.

"In two hours word was sent to me that the trail was running to the north. They had found the body of the colt with its throat cut, and were following the mare. The trail showed that a man afoot was driving the mare, and the scouts thought the girl was on the mare. This proved that we had the wrong man in custody. I therefore turned him loose, telling him he was all right. In return he told me that he owned the mare and colt, and that when he passed the tree, the girl was up in its branches, shaking down nuts which her old mother was gathering. He had ridden along, and about an hour afterwards had heard a shot. He turned his mare loose and proceeded on foot to the *tiswin* camp, where he heard later that the old woman had been shot and the girl 'lifted.' When arrested, he knew that the other scouts had trailed him from the walnut tree; he saw the circumstances against him, and was afraid.

"On the night of the second day Mickey Free's party returned, having run the trail to within a few hundred yards of the camp of Alcashay in the Forestdale country, between whose band and the band to which the girl belonged there was a blood feud. They concluded that the murderer belonged to Alcashay's camp, and were afraid to engage him.

"I sent for Alcashay to come in immediately, which he did, and I demanded that he trail the man and deliver him up to me, or I would take my scout corps, go to his camp, and arrest all suspicious characters.

He stoutly denied that the man was in his camp, promised to do as I directed, and to further allay any suspicions, he asked for my picked trailers to help run the trail. With the body of men he proceeded on the track, and they found that it ran right around his camp, then turned sharply to the east, ran within two hundred yards of a stage ranch, thence into some rough mountain country, where it twisted

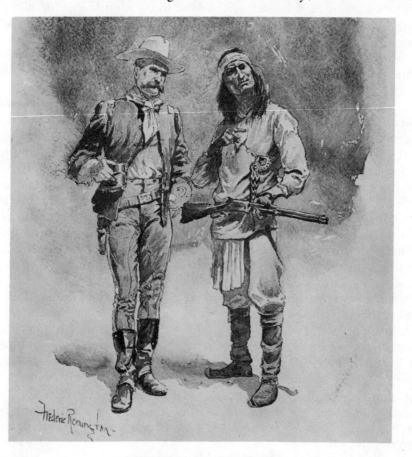

A CHIEF OF SCOUTS

and turned for forty miles. At this point they found the first camp the man had made. He had tied the girl to a tree by the feet, which permitted her to sleep on her back; the mare had been killed, some steaks taken out, and some meat 'jerked.' From thence they could find no trail which they could follow. At long intervals they found his moccasin mark between rocks, but after circling for miles, they gave it up. In this camp they found and brought to me a firestick—the first and only one I had ever seen—and they told me that the firestick had not been used by Apaches for many years. There were only a few old men in my camp who were familiar with its use, though one managed

to light his cigarette with it. They reasoned from this that the man was a *bronco* Indian who had been so long 'out' that he could not procure matches, and also that he was a much wilder one than any of the Indians then known to be outlawed.

"In about a week there was another Indian girl stolen from one of my hay camps, and many scouts thought it was the same Indian, who they decided was one of the well-known outlaws; but older and better men did not agree with them; so there the matter rested for some months.

"In the spring the first missing girl rode into Fort Apache on a fine horse, which was loaded down with buckskins and other Indian finery. Two cowboys followed her shortly and claimed the pony, which bore a CCC brand, and I gave it up to them. I took the girl into my office, for she was so tired that she could hardly stand up. She was haggard and worn to the last degree. When she had sufficiently recovered, she told me her story. She said she was up in the walnut tree when an Indian shot her mother, and coming up, forced her to go with him. He trailed and picked up the mare, bound her on its back, and drove it along. The colt whinnied, whereupon he cut its throat. He made straight for Alcashay's camp, which he circled, and then turned sharply to the east, where he made the big twisting through the mountains which my scouts found. After going all night and the next day, he made the first camp. After killing and cooking the mare, he gave her something to eat, tied her up by the feet, and standing over her, told her that he was getting to be an old man, was tired of making his own fires, and wanted a woman. If she was a good girl, he would not kill her, but would treat her well and always have venison hanging up. He continued that he was going away for a few hours and would come back and kill her if she tried to undo the cords; but she fell asleep while he was talking. After daylight he returned, untied her, made her climb on his back, and thus carried her for a long distance. Occasionally he made her alight where the ground was hard, telling her if she made any 'sign,' he would kill her, which made her careful of her steps.

"After some miles of this blinding of the trail they came upon a white horse that was tied to a tree. They mounted double and rode all day as fast as he could lash the pony, until, near nightfall, it fell from exhaustion, whereupon he killed it and cooked some of the carcass. The *bronco* Indian took himself off for a couple of hours, and when he returned, brought another horse, which they mounted, and sped onward through the moonlight all night long. On that morning they were in the high mountains, the poor pony suffering the same fate as the others.

"They stayed here two days, he tying her up whenever he went hunting, she being so exhausted after the long flight that she lay comatose in her bonds. From thence they journeyed south slowly, keep-

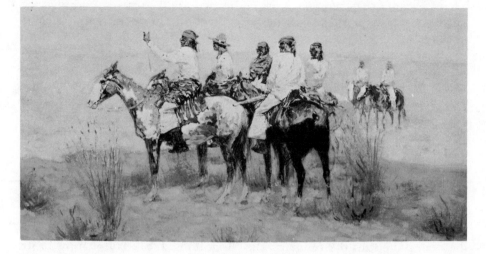

WILDER SAVAGES NEVER LIVED

ing to the high mountains, and only once did he speak, when he told
her that a certain mountain pass was the home of the Chiricahuas. From
the girl's account she must have gone far south into the Sierra Madre
of Old Mexico, though of course she was long since lost.

"He killed game easily, she tanned the hides, and they lived as
man and wife. Day by day they threaded their way through the deep
canyons and over the Blue Mountain ranges. By this time he had be-
come fond of the White Mountain girl, and told her that he was Massai,
a Chiricahua warrior; that he had been arrested after the Geronimo war
and sent East on the railroad over two years since, but had escaped
one night from the train and had made his way alone back to his native
deserts. Since then it is known that an Indian did turn up missing, but
it was a big band of prisoners and some births had occurred, which
made the checking off come straight. He was not missed at the time.
From what the girl said, he must have got off east of Kansas City and
traveled south and then west, till at last he came to the lands of the
Mescalero Apaches, where he stayed for some time. He was over a year
making this journey, and told the girl that no human eye ever saw him
once in that time. This is all he ever told the girl Natastale, and she was
afraid to ask him more. Beyond these mere facts, it is still a midnight
prowl of a human coyote through a settled country for twelve hun-
dred miles, the hardihood of the undertaking being equaled only by
the instinct which took him home.

"Once only while the girl was with him did they see sign of
other Indians, and straightway Massai turned away—his wild nature
shunning even the society of his kind.

"At times 'his heart was bad,' and once he sat brooding for a
whole day, finally telling her that he was going into a bad country to

kill Mexicans, that women were a burden on a warrior and that he had made up his mind to kill her. All through her narrative he seemed at times to be overcome with this blood-thirst, which took the form of a homicidal melancholia. She begged so hard for her life that he relented; so he left her in the wild tangle of mountains while he raided on the Mexican settlements. He came back with horses and powder and lead. This last was in Winchester bullets, which he melted up and recast into .50-caliber balls made in molds of cactus sticks. He did not tell how many murders he had committed during these raids, but doubtless many.

"They lived that winter through in the Sierras, and in the spring started north, crossing the railroad twice, which meant the Guaymas and the Southern Pacific. They sat all one day on a high mountain and watched the trains of cars go by; but 'his heart got bad' at the sight of them, and again he concluded to kill the girl. Again she begged off, and they continued up the range of the Mogollons. He was unhappy in his mind during all this journey, saying men were scarce up here, that he must go back to Mexico and kill someone.

"He was tired of the woman and did not want her to go back with him, so after sitting all day on a rock while she besought him, the old wolf told her to go home in peace. But the girl was lost and told him that either the Mexicans or Americans would kill her if she departed from him; so his mood softened, and telling her to come on, he began the homeward journey. They passed through a small American town in the middle of the night—he having previously taken off the Indian rawhide shoes from the ponies. They crossed the Gila near the Nau Taw Mountains. Here he stole two fresh horses, and loading one with all the buckskins, he put her on and headed her down the Eagle Trail to Black River. She now knew where she was, but was nearly dying from the exhaustion of his fly-by-night expeditions. He halted her, told her to 'tell the white officer that she was a pretty good girl, better than San Carlos woman, and that he would come again and get another.' He struck her horse and was gone.

"Massai then became a problem to successive chiefs of scouts, a bugbear to Arizona. If a man was killed or a woman missed, the Indians came galloping and the scouts lay on his trail. If he met a woman in the defiles, he stretched her dead if she did not please his errant fancy. He took potshots at the men plowing in their little fields, and knocked the Mexican bull-drivers on the head as they plodded through the blinding dust of the Globe Road. He even sat like a vulture on the rim rock and signaled the Indians to come out and talk. When two Indians thus accosted did go out, they found themselves looking down Massai's .50-caliber, and were tempted to do his bidding. He sent one in for sugar and coffee, holding the brother, for such he happened to be, as a hostage till the sugar and coffee came. Then he told them that he was going behind a rock to lie down, cautioning them not

to move for an hour. That was an unnecessary bluff, for they did not wink an eye till sundown. Later than this he stole a girl in broad daylight in the face of a San Carlos camp and dragged her up the rocks. Here he was attacked by fifteen or twenty bucks, whom he stood off until darkness. When they reached his lair in the morning, there lay the dead girl, but Massai was gone.

"I never saw Massai but once, and then it was only a piece of his G string flickering in the brush. We had followed his trail half the night, and just at daylight, as we ascended a steep part of the mountains, I caught sight of a pony's head looking over a bush. We advanced rapidly, only to find the horse grunting from a stab wound in the belly and the little camp scattered around about him. The shirttail flickering in the brush was all of Massai. We followed on, but he had gone down a steep bluff. We went down, too, thus exposing ourselves to draw his fire so that we could locate him, but he was not tempted. . . .

"Lieutenant Averill, after a forced march of eighty-six miles, reached a hostile camp near morning, after climbing his detachment since midnight in the almost inaccessible rocks, in hopes of surprising the camp. He divided his force into three parts, and tried as well as possible to close every avenue of escape; but as the camp was on a high rocky hill at the junction of four deep canyons, this was found impracticable. At daylight the savages came out together, running like deer and making for the canyons. The soldiers fired, killing a buck and accidentally wounding a squaw, but Massai simply disappeared.

"That's the story of Massai. It is not as long as his trail," said the chief of scouts.

FIRST OF HIS RACE

VIII

Horses
on the Plain

To men of all ages the horse of northern Africa has been the stand-
ard of worth and beauty and speed. It was bred for the purpose
of war and reared under the most favorable climatic conditions,
and its descendants have infused their blood into all the strains which
in our day are regarded as valuable. The Moors stocked Spain with
this horse, and the so-called Spanish horse is more Moorish than other-
wise. It is fair to presume that the lightly armored cavaliers of the
sixteenth century, or during the Spanish conquests in America, rode
this animal, which had been so long domesticated in Spain, in preference
to the inferior northern horse. To this day the pony of western America
shows many points of the Barbary horse to the exclusion of all other
breeding. His head has the same facial line; and that is a prime point
in deciding ancestry in horses. Observe, for instance, the great dis-
similarity in profile displayed by old plates of the Godolphin Arabian
and the Darley Arabian, two famous sires, kings of their races—the one
a Barb and the other an Arabian.

In contemplating the development of the horse, or rather his
gradual adjustment to his environment, no period more commends it-
self than that of the time from the Spanish invasion of Mexico to the
present day [1888]. The lapse of nearly four centuries and the great
variety of conditions have so changed the American "bronco" from his
Spanish ancestor that he now enjoys a distinctive individuality. This
individuality is also subdivided; and as all types come from a common
ancestry, the reasons for this varied development are sought with in-
terest, though I fear not always with accuracy. Cortes left Cuba on his
famous expedition with "sixteen horses," which were procured from
the plantations of that island at great expense.

As a matter of course these horses did not contribute to the stocking
of the conquered country, for they all laid down their lives to make
another page of military history in the annals of the Barbary horse.
Subsequent importations must have replenished the race. Possibly the

dangers and expense attendant on importation did not bring a very high grade of horses from Spain, though I am quite sure that no sane don would have preferred a coarse-jointed great Flemish weight-carrier for use on the hot sands of Mexico to a light and supple Barb, which would recognize in the sand and heat of his New World home an exact counterpart of his African hills. As the Spaniards worked north in their explorations, they lost horses by the adverse fortunes of war and by their straying and being captured by Indians.

At a very early date the wild horse was encountered on the plains of Mexico, but a long time elapsed before the horse was found in the north. La Salle found the Comanches with Spanish goods and also horses in their possession, but on his journey to Canada it was with great difficulty that he procured horses from the Indians farther north. In 1680, or contemporaneously with La Salle's experience in the south, Father Hennepin lived with the Sioux and marched and hunted the buffalo on foot. At a much later day a traveler heard the Comanches boast that they "remembered when the Arapahoes to the north used dogs as beasts of burden." That horses were lost by the Spaniards and ran in a wild state over the high, dry plains of Mexico and Texas at an early day is certain; and as the conditions of life were favorable, they must have increased rapidly. How many years elapsed before the northern Indians procured these animals, with which they are so thoroughly identified, is not easily ascertainable. Cheyenne Indians who were well versed in that tribal legend which is rehearsed by the lodge fire in the long winter nights have told me gravely that they always have had horses. I suspect that this assertion has its foundation in the vanity of their cavalier souls, for the Cheyenne legend runs very smoothly, and has paleface corroboration back to a period when we know that they could not have had horses.

Only on the Plains has the horse reached his most typical American development. The range afforded good grass, and they bred indiscriminately, both in the wild state and in the hands of the Indians, who never used any discretion in the matter of coupling the best specimens, as did the Indians of the mountains, because of the constant danger of their being lost or stolen, thus making it unprofitable. Wild stallions continually herded off the droves of the Indians of the southern Plains, thus thwarting any endeavor to improve the stock by breeding. It is often a question whether the "pinto," or painted pony of Texas, is the result of a pinto ancestry or of a general coupling of horses of all colors. The latter, I think, is the case, for the Barb was a one-color horse, and the modern horse-breeder in his science finds no difficulty in producing that color which he deems the best. The Comanches, Wichitas, and Kiowas hold that stallion in high esteem which is most bedecked and flared by blotches of white hair on the normal color of his hide. The so-called Spanish horse of northern Mexico is less apt to show this tendency toward a particolored coat, and his size, bone, and general

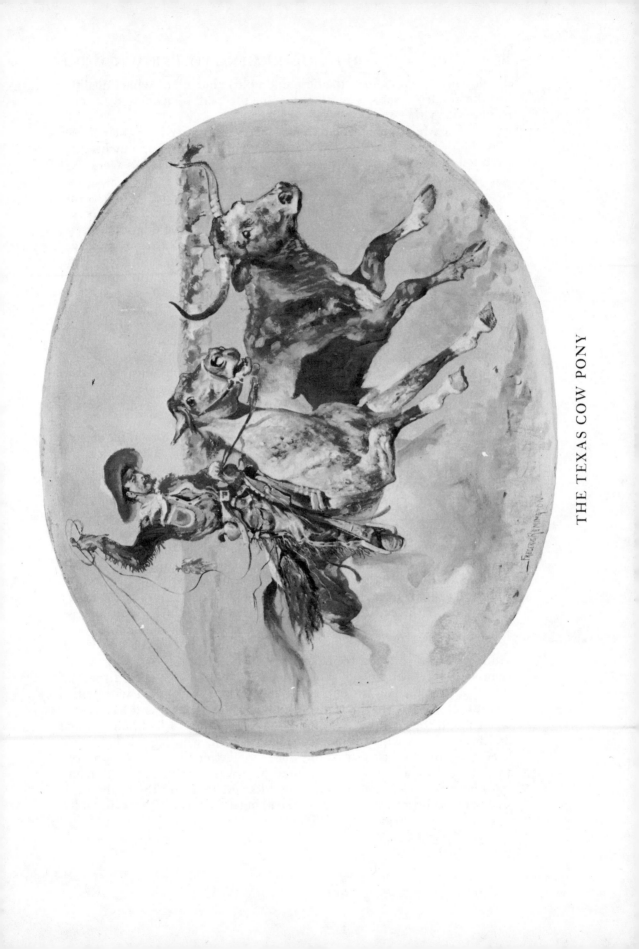

THE TEXAS COW PONY

development stamp him as the best among his kind, all of which qualities are the result of some consideration on the part of man with a view to improving the stock.

The Mexicans on their Indian-infested frontier kept their horses close herded; for they lived where they had located their ranches, desired good horses, and took pains to produce them. The sires were well selected, and the growing animals were not subjected to the fearful setbacks attendant on passing a winter on the cold plains, which is one of the reasons why all wild horses are stunted in size. Therefore we must look to the Spanish horse of northern Mexico for the nearest type to the progenitors of the American bronco. The good representatives of this division are about fourteen and a half hands in stature; of large bone, with a slight tendency to roughness; generally bay in color; flat-ribbed and of great muscular development; and, like all the rest, have the Barbary head, with the slightly oval face and fine muzzle.

Nearly identical with this beast is the mustang of the Pacific Coast—a misnomer which for a generation has been universally applied by fanciful people to any horse bearing a brand. This particular race of horses, reared under slightly less advantageous circumstances than the Spanish horse of Old Mexico, was famous in early days; but they are now so mixed with American stock as to lose the identity which, in the days of the Argonauts, was their pride.

The most inexperienced horseman will not have to walk around the animal twice in order to tell a Texas pony; that is, one which is full bred, with no admixture. He has fine deerlike legs, a very long body, with a pronounced roach just forward of the coupling, and possibly a "glass eye" and a pinto hide. Any old cowboy will point him out as the only creature suitable for his purposes. Hard to break, because he has any amount of latent devil in his disposition, he does not break his legs or fall over backward in the "pitching" process, as does the "cayuse" of the Northwest. I think he is small and shriveled up like a Mexican because of his dry, hot habitat, over which he has to walk many miles to get his dinner. But in compensation he can cover leagues of his native plains, bearing a seemingly disproportionately large man with an ease both to himself and to his rider which is little short of miraculous.

I tried on one occasion to regenerate a fine specimen of the southern Plains sort and to make a pretty little cob of the wild, scared bundle of nerves and bones which I had picked out of a herd. I roached his mane and docked his tail, and put him in a warm stall with half a foot of straw underneath. I meted out a ration of corn and hay which was enough for a twelve-hundred-pound workhorse. I had him combed and brushed and wiped by a good-natured man, who regarded the proceeding with as much awe as did the pony. After the animal found out that the corn was meant to be eaten, he always ate it; but after many days he was led out and to my utter despair, he stood there, the same shy perverse brute which he always had been. His paunch was distended

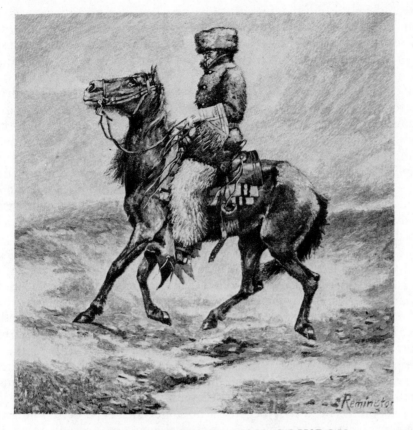

THE NORTHERN PLAINS COWBOY

to frightful proportions, but his cat hams, neck and thin little shoulders were as dry and hard as ever. Mentally he never seemed to make any discrimination between his newly found masters and the big timber wolves that used to surround him and keep him standing all night in a bunch of fellows. On the whole it was laughable, for in his perversity he resisted the regenerating process much as any other wild beast might. For all that, these animals are "all sorts of a horse" in their own particular field of usefulness, though they lack the power of the Spanish horse.

Once in Arizona I rode one of the latter animals, belonging to Chief Ascension Rios of the Papagoes, at a very rapid gallop for twenty-four miles during the middle of the day through the desert sand. The thermometer stood as high as you please in the shade, and the hot sun on the white sand made the heat something frightful. I am not noted for any of the physical characteristics which distinguish a fairy. At the end of the journey I was confirmed in the suspicion that he was a most magnificent piece of horseflesh for a ride like that, and I never expect to see another horse which can make the trip and take it so lightly to heart. He stood there like a rock, and was as good as at starting, having

sweated only a normal amount. The best test of a horse is not what he can do but how easily he can do it. Some of the best specimens of the horse and rider which I have ever had occasion to admire were Mexican *vaqueros*, and I have often thought the horses were more worthy than the men.

The golden age of the bronco was ended some twenty years ago [in the 1860's] when the great tidal wave of Saxonism reached his grassy plains. He was rounded up and brought under the yoke by the thousand, and his glories departed. Here and there a small band fled before man, but their freedom was hopeless. The act of subjugation was more implied than real, and to this day as the cowboy goes out and drives up a herd of broncos to the corral, there is little difference between the wild horse of old and his enslaved progeny. Of course the wild stallion is always eliminated, and he alone was responsible for the awe which a wild horse inspired.

The home of the Simon-pure wild horse is on the southern Plains, and when he appears elsewhere, he has been transported there by man and found his freedom later on. I have found food for reflection in tracing the causes of the varied development of these broncos under different conditions. A great many of the speculations in which I indulge may be faulty, as they deal with a subject not widely investigated by any more learned savants than one is apt to find about the fires of the cow camps in the far West. One must not forget, also, that the difficulty increases as years pass, because the horses are driven about from one section to another, and thus crossed with the stock of the country until in a very few years they became a homogeneous type. The solutions to these problems must always be personal views and in no sense final. One thing is certain: of all the monuments which the Spaniard has left to glorify his reign in America, there will be none more worthy than his horse. This proposition I have heard combated, however, by a person who had just been "bucked" violently from the back of a descendant of the Barbs. He insisted that the Spaniards had left little to glorify their reign in America, least of all their miserable scrubby ponies. Nevertheless, the Spaniard's horses may be found today [1888] in countless thousands, from the city of the Montezumas to the regions of perpetual snow; they are grafted into our equine wealth and make an important impression on the horse of the country.

There is a horse in the Indian Territory, Arkansas, and Missouri called the Cherokee pony, which is a peculiar animal. Of low stature, he is generally piebald, with a great profusion of mane and tail. He is close set, with head and legs not at all of the bronco type, and I know that his derivation is from the East, though some insist on classing him with our Western ponies; but he is a handsome little beast, easily adapts himself to surroundings, and is in much favor in the Eastern markets as a saddle pony for boys and for ladies' carts.

The most favorable place to study the pony is in an Indian camp,

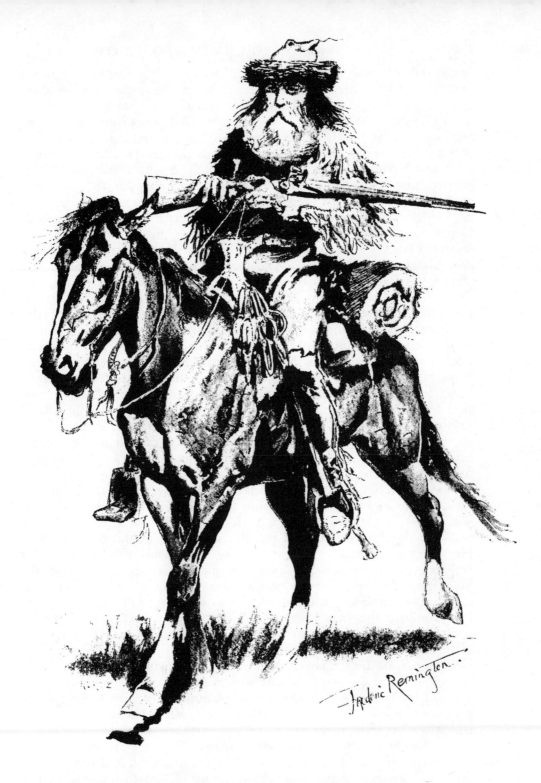

THE MOUNTAIN MAN AND HIS PONY

as the Indians rarely defeat the ends of nature in the matter of natural selection; and further, the ponies are allowed to eat the very greenest grass they can find in the summertime and to chew on a cottonwood sawlog during the winter, with perfect indifference on the part of their owners. The pony is thus a reflex of nature, and coupled with his surroundings, is of quite as much interest as the stretch of prairie grass, the white lodges, and the blanketed forms. The savage red man, in his great contest with nature, has learned not to combat nature but to observe her moods and to prepare a simple means of escape. He puts up no fodder for the winter, but relies on the bark of the cottonwood. Often he is driven to dire extremity to bring his stock through the winter. I have been told that in the Canadian Northwest the Blackfeet have bought grain for their ponies during a bad spell of weather, which act implies marvelous self-denial, as the cost of a bushel of oats would bring financial ruin on any of the tribe. Before the early grass starts in the spring, the emaciated appearance of one of these little ponies in the far Northwest will sorely try the feelings of an equine philanthropist should he look along the humpy ribs and withered quarters. But alack! when the young grass does shoot, the pony scours the trash which composes his winter diet, sheds his matted hair, and shines forth another horse. In a month "Richard's himself again," ready to fly over the grassy sward with his savage master or to drag the *travaux* and pack the buxom squaw. Yet do not think that at this time the Indian pony is the bounding steed of romance; do not be deluded into expecting the arched neck, the graceful lines, and the magnificent limbs of the English hunter; for, alas! they are not here. They have existed only on paper. He may be all that the wildest enthusiast may claim in point of hardihood and power, as indeed he is, but he is not beautiful. His head and neck join like the two parts of a hammer, his legs are as fine as a deer's, though not with the flat kneecap and broad cannonbone of the English ideal. His barrel is a veritable tun, made so by the bushels of grass which he consumes in order to satisfy nature. His quarters are apt to run suddenly back from the hips, and the rear view is decidedly mulish about the hocks. The mane and the tail are apt to be light, and I find that the currycomb of the groom has a good deal to do in deciding on which side of the horse's neck the mane shall fall; for on an Indian pony it is apt to drop on the right and the left, or stand up in the middle in perfect indecision. The Indian never devotes any stablework to his mount, although at times the pony is bedecked in savage splendor. Once I saw the equipment of a Blackfoot war pony, composed of a mask and bonnet gorgeous with red flannel, brass-headed tacks, silver plates, and feathers, which was art in its way.

As we go very far into the Canadian Northwest, we find that the interminable cold of the winters has had its effect, and the pony is small and scraggy, with a disposition to run to hair that would be the envy of a goat. These little fellows seem to be sadly out of their reckon-

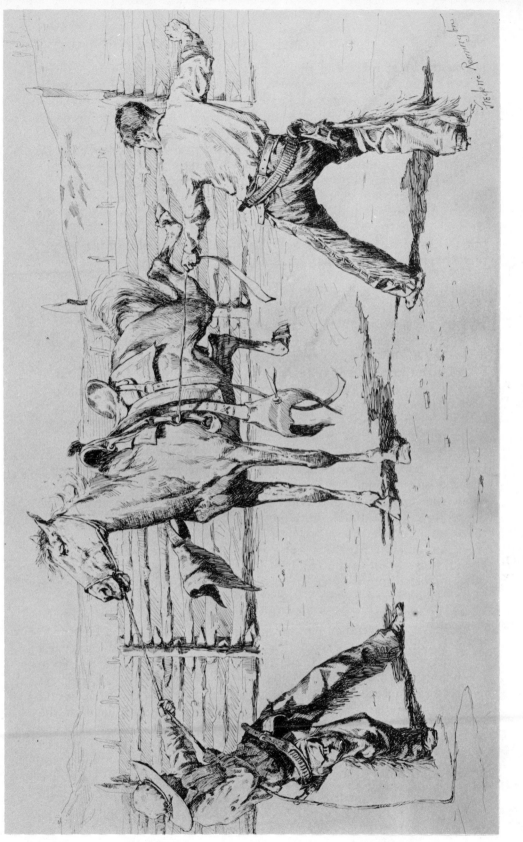

BRONCO BUSTERS SADDLING

ing, as the great reverse of the proposition is true, for the horses thrive after a fashion and demonstrate the toughness of the race. Unless he be tied up to a post, no one ever knew an Indian pony to die of the cold. With his front feet he will paw away the snow to an astonishing depth in order to get at the dry herbage, and by hook or by crook he will manage to come through the winter despite the wildest prophecies on the part of the uninitiated that he cannot live ten days in such a storm.

The Indian pony often finds to his sorrow that he is useful for other purposes than as a beast of burden, for his wild masters of the Rocky Mountains think him excellent eating. To the Shoshonees, the particular use of a horse was for the steaks and stews that were in him; but the Indian of the Plains had the buffalo and could afford, except in extreme cases, to let his means of transportation live.

The Apaches were never "horse Indians," and always readily abandoned their stock to follow the mountains on foot. In early times their stock-stealing raids into Mexico were simply foraging expeditions, as they ate horses, mules, cattle, and sheep alike.

In the grassy valleys of the northern Rocky Mountains, walled in as they are by the mountain ranges, horse-breeding was productive of good results and was followed. Thus the "cayuse," a fine strain of pony stock, took its name from a tribe, though it became disseminated over all that country. As it was nearly impossible for the Indians to steal each other's horses on every occasion, the people were encouraged to perpetuate the good qualities of their favorite mounts.

The cayuse is generally roan in color, with always a tendency this way, no matter how slight. He is strongly built, heavily muscled, and the only bronco which possesses square quarters. In height he is about fourteen hands; and while not possessed of the activity of the Texas horse, he has much more power. This native stock was a splendid foundation for the horse-breeders of Montana and the Northwest to work on, and the Montana horse of commerce rates very high. This condition is not all to the credit of the cayuse, but to a strain of horses early imported into Montana from the West and known as the Oregon horse, which breed had its foundation in the mustang.

In summing up for the bronco, I will say that he is destined to became a distinguished element in the future horse of the continent, if for no other reason except that of his numbers. All over the West he is bred into the stock of the country, and of course always from the side of the dam. The first one or two crosses from this stock are not very encouraging, as the blood is strong, having been bred in and in for so many generations. But presently we find an animal of the average size, as fine, almost, as a thoroughbred, with his structural points corrected and fit for many purposes. He has about the general balance of the French ponies of Canada or perhaps a Morgan, which for practical purposes were the best horses ever developed in America. At this stage of the development of the bronco he is no longer the little

narrow-shouldered cat-hammed brute of his native plains, but as round and square and arched as anybody's horse. In the Department of Arizona they have used many Californian horses, and while some officers claim that they are not as desirable as pure American stock, I venture to think that they would be if they were used by light cavalry and not by dragoons.

In intelligence the bronco has no equal, unless it is the mule. That hybrid has an extra endowment of brains, as though in compensation for the beauty which he lacks. I think that the wild state may have sharpened the senses of the bronco, while in domestication he is remarkably docile. It would be quite unfair to his fellows to institute anything like a comparison without putting in evidence the peculiar method of defense to which he resorts when he struggles with man for the mastery. Everyone knows that he "bucks," and familiarity with that characteristic never breeds contempt. . . .

His greatest good quality is the ease with which he stands any amount of hard riding over the trail; and this is not because of any particular power which he has over the thoroughbred, but because of his "hard stomach." He eats no grain in the growing stages of his life, and his stomach has not been forced artificially to supply a system taxed beyond the power of the stomach to fill. The same general difference is noted between an Indian and a white man. You may gallop the pony until your thoroughbred would "heave and thump" and "go wrong" in a dozen vital places, and the bronco will cool off and come through little the worse for the experience.

As a saddle animal simply, the bronco has no superior. The "lope" is a term which should never be applied to that motion in any other breed of horses. I have watched a herd of cow ponies being driven over the prairie where the undulations of the backs in the moving throng were as regular and easy as the rise and fall of the watery waves. The fox trot, which is the habitual gait of all Plainsmen, cowboys, and Indians, is easily cultivated in him, and his light supple frame accommodates itself naturally to the motion.

This particular American horse lays claim to another quality, which in my estimation is not least, and that is his wonderful picturesqueness. He graces the Western landscape not because he reminds us of the equine ideal but because he comes of the soil and has borne the heat and burden and the vicissitudes of all that pale of romance which will cling about the Western frontier. As we see him hitched to the plow or the wagon, he seems a living protest against utilitarianism, but unlike his red master, he will not go. He has borne the Moor, the Spanish conqueror, the red Indian, the mountain man, and the *vaquero* through all the glories of their careers; but they will soon be gone, with all their heritage of gallant deeds. The pony must meekly enter the new regime. He must wear the collar of the new civilization and earn his oats by the sweat of his flank. There are no more worlds for him to conquer; now he must till the ground.

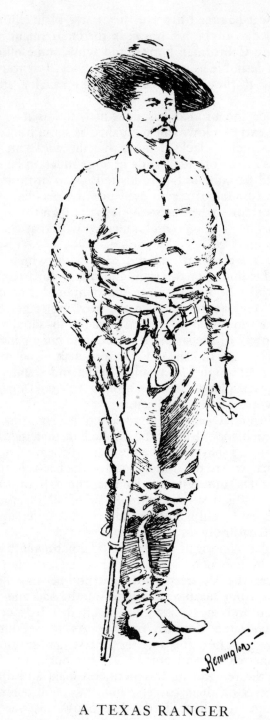

A TEXAS RANGER

IX

How the Law Got
Into the Chaparral

You have heard about the Texas Rangers?" said the Deacon to me one night, in the San Antonio Club. "Yes? Well, come up to my rooms and I will introduce you to one of the old originals —dates way back in the [18] thirties—there aren't many of them left now—and if we can get him to talk, he will tell you stories that will make your eyes hang out on your shirt front."

We entered the Deacon's cozy bachelor apartments, where I was introduced to Colonel "Rip" Ford, of the old-time Texas Rangers. I found him a very old man, with a wealth of snow-white hair and beard—bent, but not withered. As he sunk on his stiffened limbs into the armchair, we disposed ourselves quietly and almost reverentially while we lighted cigars. We began the approaches by which we hoped to loosen the history of a wild past from one of the very few tongues which could still wag on the days when the Texans, the Comanches, and the Mexicans chased one another over the plains of Texas, and shot and stabbed to find who should inherit the land.

Through the veil of tobacco smoke the ancient warrior spoke his sentences slowly, at intervals, as his mind gradually separated and arranged the details of countless fights. His head bowed in thought; anon it rose sharply at recollections, and as he breathed, the shouts and lamentations of crushed men—the yells and shots—the thunder of horses' hoofs—the full fury of the desert combats came to the pricking ears of the Deacon and me.

We saw through the smoke the brave young faces of the hosts which poured into Texas to war with the enemies of their race. They were clad in loose hunting frocks, leather leggings, and broad black hats; had powder horns and shot pouches hung about them; were armed with bowie knives, Mississippi rifles, and horse pistols; rode Spanish ponies, and were impelled by Destiny to conquer, like their remote ancestors, "the godless hosts of Pagan" who "came swimming o'er the Northern Sea."

"Rip" Ford had not yet acquired his front name in 1836, when he enlisted in the famous Captain Jack Hayes's company of Rangers, which was fighting the Mexicans in those days, and also trying incidentally to keep from being eaten up by the Comanches.

Said the old colonel: "A merchant from our country journeyed to New York, and Colonel Colt, who was a friend of his, gave him two five-shooters—pistols they were, and little things. The merchant in turn presented them to Captain Jack Hayes. The captain liked them so well that he did not rest till every man jack of us had two apiece.

"Directly," mused the ancient one, with a smile of pleasant recollection, "we had a fight with the Comanches—up here above San Antonio. Hayes had fifteen men with him—he was doubling about the country for Indians. He found 'sign,' and after cutting their trail several times, he could see that they were following him. Directly the Indians overtook the Rangers—there were seventy-five Indians. Captain Hayes —bless his memory!—said, 'They are fixin' to charge us, boys, and we must charge them.' There were never better men in this world than Hayes had with him," the colonel went on, with pardonable pride, "and mind you, he never made a fight without winning.

"We charged, and in the fracas killed thirty-five Indians—only two of our men were wounded—so you see the five-shooters were pretty good weapons. Of course they wa'n't any account compared with these modern ones, because they were too small, but they did those things. Just after that Colonel Colt was induced to make bigger ones for us, some of which were half as long as your arm.

"Hayes? Oh, he was a surveyor, and used to go out beyond the frontiers about his work. The Indians used to jump him pretty regular; but he always whipped them, and so he was available for a Ranger captain. About then—let's see"—and here the old head bobbed up from his chest, where it had sunk in thought—"there was a commerce with Mexico just sprung up, but this was later—it only shows what that man Hayes used to do. The bandits used to waylay the traders, and they got very bad in the country. Captain Hayes went after them—he struck them near Lavade, and found the Mexicans had more than twice as many men as he did; but he caught them napping, charged them afoot—killed twenty-five of them, and got all their horses."

"I suppose, Colonel, you have been charged by a Mexican lancer?" I inquired.

"Oh yes, many times," he answered.

"What did you generally do?"

"Well—you see—in those days I reckoned to be able to hit a man every time with a six-shooter at one hundred and twenty-five yards," explained the old gentleman—which no doubt meant many dead lancers.

"Then you do not think much of a lance as a weapon?" I pursued.

"No; there is but one weapon. The six-shooter when properly handled is the only weapon—mind you, sir, I say *properly*," and here the old eyes blinked rapidly over the great art as he knew its practice.

"Then of course the rifle has its use. Under Captain Jack Hayes sixty of us made a raid once after the celebrated priest-leader of the Mexicans—Padre Jarante—which same was a devil of a fellow. We were very sleepy—had been two nights without sleep. At San Juan every man stripped his horse, fed, and went to sleep. We had passed Padre Jarante in the night without knowing it. At about twelve o'clock next day there was a terrible outcry—I was awakened by shooting. The Padre was upon us. Five men outlying stood the charge, and went under. We gathered, and the Padre charged three times. The third time he was knocked from his horse and killed. Then Captain Jack Hayes awoke, and we got in a big *casa*. The men took to the roof. As the Mexicans passed, we emptied a great many saddles. As I got to the top of the *casa*, I found two men quarreling." (Here the colonel chuckled.) "I asked what the matter was, and they were both claiming to have killed a certain Mexican who was lying dead some way off. One said he had hit him in the head, and the other said he hit him in the breast. I advised peace until after the fight. Well—after the shooting was over and the Padre's men had had enough, we went out to the particular Mexican who was dead and, sure enough, he was shot in the head and in the breast; so they laughed and made peace. About this time one of the spies came in and reported six hundred Mexicans coming. We made an examination of our ammunition, and found that we couldn't afford to fight six hundred Mexicans with sixty men, so we pulled out. This was in the Mexican War, and only goes to show that Captain Hayes's men could shoot all the Mexicans that could get to them if the ammunition would hold out."

"What was the most desperate fight you can remember, Colonel?"

The old man hesitated; this required a particular point of view—it was quality, not quantity, wanted now; and, to be sure, he was a connoisseur. After much study by the colonel, during which the world lost many thrilling tales, the one which survived occurred in 1851.

"My lieutenant, Ed Burleson, was ordered to carry to San Antonio an Indian prisoner we had taken and turned over to the commanding officer at Fort McIntosh. On his return, while nearing the Nueces River, he spied a couple of Indians. Taking seven men, he ordered the balance to continue along the road. The two Indians proved to be fourteen, and they charged Burleson up to the teeth. Dismounting his men, he poured it into them from his Colt's six-shooting rifles. They killed or wounded all the Indians except two, some of them dying so near the Rangers that they could put their hands on their boots. All but one of Burleson's men were wounded—himself shot in the head with an arrow. One man had four 'dogwood switches'

[arrows] in his body, one of which was in his bowels. This man told me that every time he raised his gun to fire, the Indians would stick an arrow in him, but he said he didn't care a cent. One Indian was lying right up close, and while dying, tried to shoot an arrow, but his strength failed so fast that the arrow only barely left the bowstring. One of the Rangers in that fight was a curious fellow—when young he had been captured by Indians, and had lived with them so long that he had Indian habits. In that fight he kept jumping around when loading, so as to be a bad target, the same as an Indian would under the circumstances, and he told Burleson he wished he had his boots off, so he could get around good"—and here the colonel paused quizzically. "Would you call that a good fight?"

The Deacon and I put the seal of our approval on the affair, and the colonel rambled ahead.

"In 1858 I was commanding the frontier battalion of state troops on the whole frontier, and had my camp on the Deer Fork of the Brazos. The Comanches kept raiding the settlements. They would come down quietly, working well into the white lines, and then go back arunning—driving stolen stock and killing and burning. I thought I would give them some of their own medicine. I concluded to give them a fight. I took two wagons, one hundred Rangers, and one hundred and thirteen Tahuahuacan Indians, who were friendlies. We struck a good Indian trail on a stream which led up to the Canadian. We followed it till it got hot. I camped my outfit in such a manner as to conceal my force, and sent out my scouts, who saw the Indians hunt buffalo through spyglasses. That night we moved. I sent Indians to locate the camp. They returned before day and reported that the Indians were just a few miles ahead, whereat we moved forward. At daybreak, I remember, I was standing in the bull-wagon road leading to Santa Fe and could see the Canadian River in our front—with eighty lodges just beyond. Counting four men of fighting age to a lodge, that made a possible three hundred and twenty Indians. Just at sunup an Indian came across the river on a pony. Our Indians down below raised a yell —they always got excited. The Indian heard them—it was very still then. The Indian retreated slowly and began to ride in a circle. From where I was, I could hear him puff like a deer—he was blowing the bullets away from himself—he was a medicine man. I heard five shots from the Jagers with which my Indians were armed. The painted pony of the medicine man jumped ten feet in the air, it seemed to me, and fell over on his rider—then five more Jagers went off, and he was dead. I ordered the Tahuahuacans out in front, and kept the Rangers out of sight because I wanted to charge home and kind of surprise them. Pretty soon I got ready, and gave the word. We charged. At the river we struck some boggy ground and floundered around considerable, but we got through. We raised the Texas yell, and away we went. I never expect again to hear such a noise—I never want to hear it—what

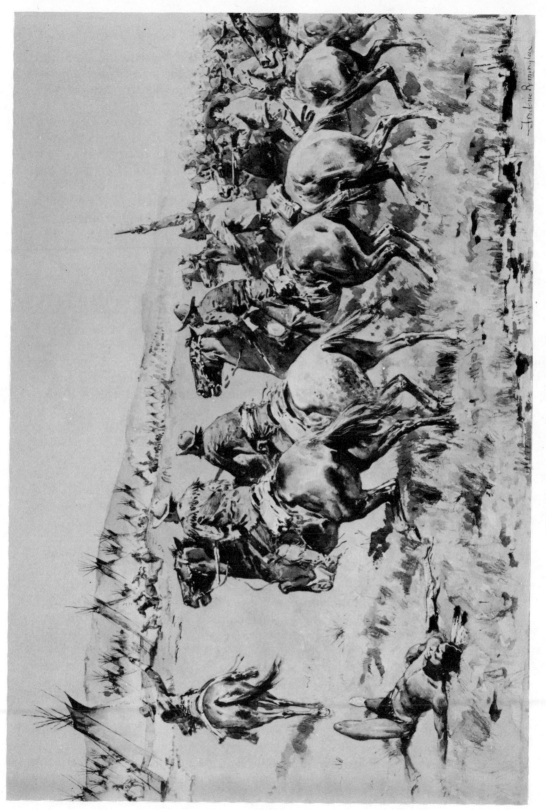

WE STRUCK BOGGY GROUND

with the whoops of the warriors—the screaming of the women and children—our boys yelling—the shooting, and the horses just amixin' up and astampeding around," and the colonel bobbed his head slowly as he continued.

"One of my men didn't know a buck from a squaw. There was an Indian woman on a pony with five children. He shot the pony— it seemed like you couldn't see that pony for little Indians. We went through the camp, and the Indians pulled out—spreading fanlike, and we arunning them. After a long chase I concluded to come back. I saw lots of Indians around in the hills. When I got back I found Captain Ross had formed my men in line. 'What time in the morning is it?' I asked.

" 'Morning, hell!' says he, 'it's one o'clock!'

"And so it was. Directly I saw an Indian coming down a hill near by, and then more Indians and more Indians—till it seemed like they wa'n't ever going to get through coming. We had struck a bigger outfit than the first one. That first Indian he bantered my men to come out single-handed and fight him. One after another he wounded five of my Indians. I ordered my Indians to engage them and kind of get them down in the flat, where I could charge. After some running and shooting, they did this, and I turned the Rangers loose. We drove them. The last stand they made they killed one of my Indians, wounded a Ranger, but left seven of their dead in a pile.

"It was now nearly nightfall, and I discovered that my horses were broken down after fighting all day. I found it hard to restrain my men, they had got so heated up; but I gradually withdrew to where the fight commenced. The Indian camp was plundered. In it we found painted buffalo robes with beads a hand deep around the edges—the finest robes I have ever seen—and heaps of goods plundered from the Santa Fe traders.

"On the way back I noticed a dead chief, and was for a moment astonished to find pieces of flesh cut out of him. Upon looking at a Tahuahuacan warrior, I saw a pair of dead hands tied behind his saddle. That night they had a cannibal feast. You see, the Tahuahuacans say that the first one of their race was brought into the world by a wolf. 'How am I to live?' said the Tahuahuacan. 'The same as we do,' said the wolf; and when they were with me, that is just about how they lived.

"I reckon it's necessary to tell you about the old woman who was found in our lines. She was looking at the sun and making incantations, acussing us out generally and elevating her voice. She said the Comanches would get even for this day's work. I directed my Indians to let her alone, but I was informed afterward that that is just what they didn't do."

At this point the colonel's cigar went out, and directly he followed; but this is the manner in which he told of deeds which

I know would fare better at the hands of one used to phrasing and capable also of more points of view than the colonel was used to taking. The outlines of the thing are strong, however, because the Deacon and I understood that fights were what the old colonel had dealt in during his active life, much as other men do in stocks and bonds or wheat and corn. He had been a successful operator, and only recalled pleasantly the bull quotations.

This type of Ranger is all but gone. A few may yet be found in outlying ranches. One of the most celebrated resides near San Antonio —"Big-foot" Wallace, by name. He says he doesn't mind being called "Big-foot," because he is six feet two in height and is entitled to big feet. His face is done off in a nest of white hair and beard, and is patriarchal in character. In 1836 he came out from Virginia to "take toll" of the Mexicans for killing some relatives of his in the Fannin Massacre, and he considers that he has squared his accounts; but they had him on the debit side for a while. Being captured in the Meir expedition, he walked as a prisoner to the city of Mexico and did public work for that country with a ball-and-chain attachment for two years. The prisoners overpowered the guards and escaped on one occasion, but were overtaken by Mexican cavalry while dying of thirst in a desert. Santa Anna ordered their "decimation," which meant that every tenth man was shot, their lot being determined by the drawing of a black bean from an earthen pot containing a certain proportion of white ones. Big-foot drew a white one.

He was also a member of Captain Hayes's company, afterward a captain of Rangers and a noted Indian-fighter. Later he carried the mails from San Antonio to El Paso through a howling wilderness, but always brought it safely through—if safely can be called lying thirteen days by a water hole in the desert waiting for a broken leg to mend, and living meanwhile on one prairie wolf, which he managed to shoot. Wallace was a professional hunter, who fought Indians and hated greasers; he belongs to the past, and has been "outspanned" under a civilization in which he has no place, and is today living in poverty.

The Civil War left Texas under changed conditions. That and the Mexican wars had determined its boundaries, however, and it rapidly filled up with new elements of population. Broken soldiers, outlaws, poor immigrants living in bull-wagons, poured in. "Gone to Texas" had a sinister significance in the late sixties. When the railroad got to Abilene, Kansas, the cow men of Texas found a market for their stock, and began trailing their herds up through the Indian country. Bands of outlaws organized under the leadership of desperadoes like Wes Hardin and King Fisher. They rounded up cattle regardless of their owners' rights, and resisted interference with force. The poor man pointed to his brand in the stolen herd and protested. He was shot. The big owners were unable to protect themselves from loss. The property right was established by the six-shooter, and honest men were forced to the wall.

In 1876 the property-holding classes went to the legislature, got it to appropriate $100,000 a year for two years, and the Ranger force was reorganized to carry the law into the chaparral. At this time many judges were in league with the bandits; sheriffs were elected by the outlaws, and the electors were cattle-stealers.

The Rangers were sworn to uphold the laws of Texas and the United States. They were deputy sheriffs, United States marshals—in fact, were often vested with any and every power, even to the extent of ignoring disreputable sheriffs. At times they were judge, jury, and executioner, when the difficulties demanded extremes. When a band of outlaws was located, detectives or spies were sent among them, who openly joined the desperadoes and gathered evidence to put the Rangers on their trail. Then, in the wilderness, with only the soaring buzzard or prowling coyote to look on, the Ranger and the outlaw met to fight it out, with tigerish ferocity, to the death. Shot, and lying prone, they fired until the palsied arm could no longer raise the six-shooter, and justice was satisfied as their bullets sped. The captains had the selection of their men and the right to dishonorably discharge at will. Only men of irreproachable character who were fine riders and dead shots were taken. The spirit of adventure filled the ranks with the most prominent young men in the state, and to have been a Ranger is a badge of distinction in Texas to this day. The display of anything but a perfect willingness to die under any and all circumstances was fatal to a Ranger, and in course of time they got the *moral* on the bad man. Each one furnished his own horse and arms, while the state gave him ammunition, grub, one dollar a day, and extra expenses. The enlistment was for twelve months. A list of fugitive Texas criminals was placed in his hands, with which he was expected to familiarize himself. Then, in small parties, they packed the bedding on their mule, they hung handcuffs and leather thongs about its neck, saddled their riding ponies, and threaded their way into the chaparral.

On an evening I had the pleasure of meeting two more distinguished Ranger officers—more modern types—Captains Lea Hall and Joseph Shely, both of them big, forceful men and loath to talk about themselves. It was difficult to associate the quiet gentlemen who sat smoking in the Deacon's rooms with what men say; for the tales of their prowess in Texas always ends, "and that don't count Mexicans, either." The bandit never laid down his gun but with his life; so *la ley de fuga* [Mexican law of shooting escaped or resisting prisoners] was in force in the chaparral, and the good people of Texas were satisfied with a very short account of a Ranger's fight.

The most distinguished predecessor of these two men was a Captain McNally, who was so bent on carrying his raids to an issue that he paid no heed to national boundary lines. He followed a band of Mexican bandits to the town of La Cueva, below Ringgold, once, and surrounding it, demanded the surrender of the cattle which they

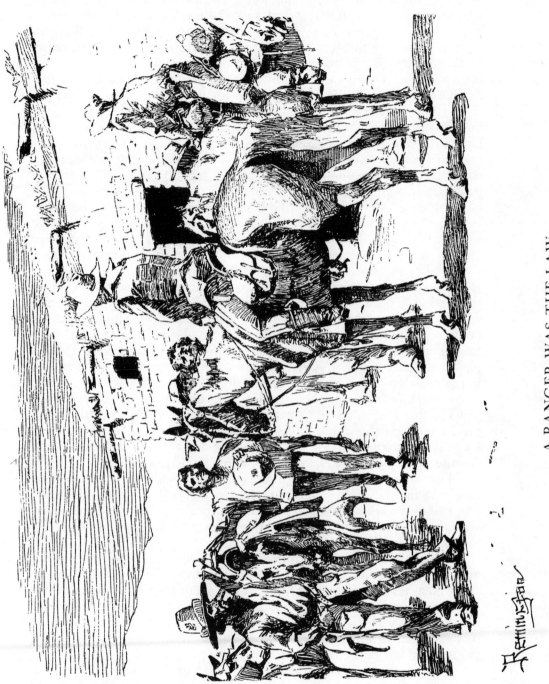

A RANGER WAS THE LAW

had stolen. He had but ten men, and yet this redoubtable warrior surrounded a town full of bandits and Mexican soldiers. The Mexican soldiers attacked the Rangers and forced them back under the riverbanks, but during the fight the *jefe politico* was killed. The Rangers were in a fair way to being overcome by the Mexicans when Lieutenant Clendenin turned a Gatling loose from the American side and covered their position. A parley ensued, but McNally refused to go back without the cattle, which the Mexicans had finally to surrender.

At another time McNally received word through spies of an intended raid of Mexican cattle thieves under the leadership of Cammelo Lerma. At Resaca de la Palma McNally struck the depredators with but sixteen men. They had seventeen men and five hundred head of stolen cattle. In a running fight for miles McNally's men killed sixteen bandits, while only one escaped. A young Ranger by the name of Smith was shot dead by Cammelo Lerma as he dismounted to look at the dying bandit. The dead bodies were piled in ox carts and dumped in the public square at Brownsville. McNally also captured King Fisher's band in an old log house in Dimmit County, but they were not convicted.

Showing the nature of Ranger work, an incident which occurred to my acquaintance Captain Lea Hall will illustrate. In De Witt County there was a feud. One dark night sixteen masked men took a sick man, one Dr. Brazel, and two of his boys, from their beds, and despite the imploring mother and daughter, hanged the doctor and one son to a tree. The other boy escaped in the green corn. Nothing was done to punish the crime, as the lynchers were men of property and influence in the country. No man dared speak above his breath about the affair.

Captain Hall, by secret-service men, discovered the perpetrators, and also that they were to be gathered at a wedding on a certain night. He surrounded the house and demanded their surrender, at the same time saying that he did not want to kill the women and children. Word returned that they would kill him and all his Rangers. Hall told them to allow their women and children to depart, which was done; then, springing on the gallery of the house, he shouted, "Now, gentlemen, you can go to killing Rangers; but if you don't surrender, the Rangers will go to killing you." This was too frank a willingness for midnight assassins, and they gave up.

Spies had informed him that robbers intended sacking Campbell's Store in Wolfe City. Hall and his men lay behind the counters to receive them on the designated night. They were allowed to enter, when Hall's men, rising, opened fire—the robbers replying. Smoke filled the room, which was fairly illuminated by the flashes of the guns—but the robbers were all killed, much to the disgust of the lawyers, no doubt, though I could never hear that honest people mourned.

The man Hall was himself a gentleman of the romantic Southern-soldier type, and he entertained the highest ideals, with which it would be extremely unsafe to trifle, if I may judge. Captain Shely, our other

visitor, was a Herculean black-eyed man, fairly fizzing with nervous energy. He was also exceedingly shrewd, as befits the greater concreteness of the modern Texas law, albeit he too had trailed bandits in the chaparral and rushed in on their campfires at night, as two big bullet holes in his skin will attest. He it was who arrested Polk, the defaulting treasurer of Tennessee. He rode a Spanish pony sixty-two miles in six hours and arrested Polk, his guide, and two private detectives, whom Polk had bribed to set him over the Rio Grande.

When the land of Texas was bought up and fenced with wire, the old settlers who had used the land did not readily recognize the new regime. They raised the rally cry of "free grass and free water"—said they had fought the Indians off and the land belonged to them. Taking nippers, they rode by night and cut down miles of fencing. Shely took the keys of a county jail from the frightened sheriff, made arrests by the score, and lodged them in the big new jail. The countryside rose in arms, surrounded the building, and threatened to tear it down. The big Ranger was not deterred by this outburst, but quietly went out into the mob, and with mock politeness delivered himself as follows:

"Do not tear down the jail, gentlemen—you have been taxed for years to build this fine structure—it is yours—do not tear it down. I will open the doors wide—you can all come in—do not tear down the jail; but there are twelve Rangers in there, with orders to kill as long as they can see. Come right in, gentlemen—but come fixed."

The mob was overcome by his civility.

Texas is today [1896] the only state in the Union where pistol-carrying is attended with great chances of arrest and fine. The law is supreme even in the lonely jacals out in the rolling waste of chaparral, and it was made so by the tireless riding, the deadly shooting, and the indomitable courage of the Texas Rangers.

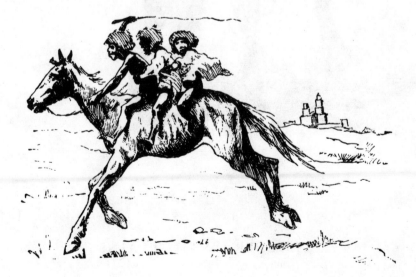

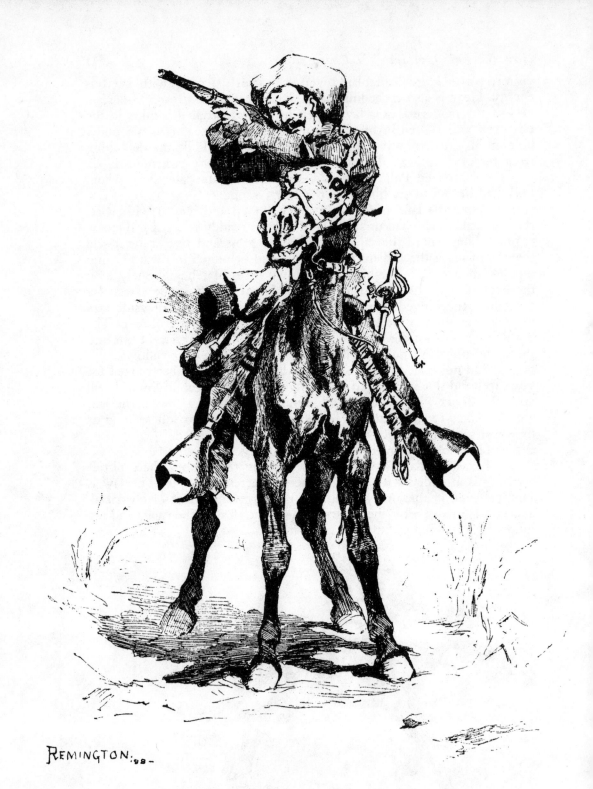

REMINGTON '88 -

TROOPER OF THE PLAINS

X

The Honor
of the Troop

L Troop in a volunteer regiment might be an unadulterated fight-
ing outfit; but at first off, to volunteers, it would not be the letter
L which they would fight for, so much as the mere sake of fight-
ing; and they would never regard the letter *L* as of more importance
than human life. Indeed, that letter would not signify to them any more
than the squads or the regimental bass drum. Later on it certainly
would, but that would take a long time. In the instance of the L Troop
of which I speak, it had nearly one hundred years to think about, when
anyone in the troop cared to think about the matter at all. They were
honorable years, and some of the best men living or dead have at one
time or another followed that guidon. It had been through the "rifle"
and "dragoon" periods of our history, and was now part of the regular
cavalry establishment; and its operations had extended from Lake Erie
to the City of Mexico.

Long lists of names were on its old rolls—men long since dead,
but men who in the snow and on the red sands had laid down all they
had for the honor of L Troop guidon. Soldiers—by which is meant the
real long-service military type—take the Government very much as a
matter of course; but the number of the regiment, and particularly the
letter of their troop, are tangible, comparative things with which they
are living every day. The feeling is precisely that one has for the alma
mater or for the business standing of an old commercial house.

The "old man" had been captain of L for years and years, and
for thirty years its first sergeant had seen its rank and file fill up and
disappear. Every tenth man was a "buck" soldier, who thought it only
a personal matter if he painted a frontier town up after pay day, but
who would follow L Troop guidon to hell or thump anyone's nose
in the garrison foolish enough to take L in vain, and I fear they would
go further than this—yes, even further than men ought to go. Thus the
"rookies" who came under the spell of L Troop succumbed to this
veneration through either conventional decorum or the mailed fist.

123

In this instance L Troop had been threading the chaparral by night and by day on what rations might chance, in hopes to capture for the honor of the troop sundry greasers, outlawed and defiant of the fulminations of the civil order of things. Other troops of the regiment also were desirous of the same thing and were threading the desolate wastes far on either side. Naturally L did not want any other troop to round up more "game" than they did; so their horses were ridden thin and the men's tempers were soured by the heat, dust, poor diet, and lack of success.

The captain was an ancient veteran, gray and rheumatic, near his retirement, and twenty-five years in his grade, thanks to the silly demagogues so numerous in Congress. He had been shot full of holes, bucketed about on a horse, immured in mud huts, frozen and baked and soaked until he should have long since had rank enough to get a desk and a bed or retirement. Now he was chasing human fleas through a jungle—boys' work—and it was admitted in ranks that the old man was about ready to "throw a curb." The men liked him, even sympathized with him, but there was that d—— G Troop in the barrack next, and they would give them the merry ha-ha when they returned to the post if L did not do something.

And at noon—mind you, high noon—the captain raised his right hand; up came the heads of the horses, and L Troop stood still in the road. Pedro, the Mexican trailer, pointed to the ground and said, "It's not an hour old," meaning the trail.

"Dismount," came the sharp order.

Toppling from their horses, the men stood about, but the individuals displayed no noticeable emotion. They did what L Troop did. One could not imagine their thoughts by looking at their red set faces.

They rested quietly for a time in the scant shade of the bare tangle, and then they sat up and listened, each man looking back up the road. They could hear a horse coming, which meant much to people such as these.

The men forced to the rear would come first or fire a shot, but with a slow pattering came a cavalry courier into view—a dusty soldier on a tired horse which stepped stiffly along, head down, and if it were not for the dull kicking of the inert man, he would have stopped anywhere. The courier had ridden all night from the railroad, seventy-five miles away. He dismounted and unstrapped his saddle pocket, taking therefrom a bundle of letters and a bottle, which he handed to the old man with a salute.

The captain now had a dog-tent set up for himself, retiring into it with his letters and the bottle. If you had been there, you would have seen a faint ironical smile circulate round the faces of L Troop.

A smart lieutenant, beautifully fashioned for the mounted service and dressed in field uniform, with its touches of the border on the regulations, stepped up to the dog-tent, and stooping over, saluted, saying,

"I will run this trail for a few miles if the captain will give me a few men."

"You will run nothing. Do you not see that I am reading my mail? You will retire until I direct you——"

The lieutenant straightened up with a snap of his lithe form. His eyes twinkled merrily. He was aware of the mail, he realized the bottle, and he had not been making strategic maps of the captain's vagaries of four years to no purpose at all; so he said, "Yes, sir," as he stepped out of the fire of future displeasure.

But he got himself straightway into the saddle of a horse as nearly thoroughbred as himself, and riding down the line, he spoke at length with the old first sergeant. Then he rode off into the brush. Presently six men whose horses were fit followed after him. They all trotted along a trail which bore back of the captain's tent, and shortly they came back into the road.

Then Pedro Zacatin ran the trail of three ponies—no easy matter through the maze of cattle paths, with the wind blowing the dust into the hoofmarks. He only balked at a turn, more to see that the three did not retreat than at any fault of his own. In an opening he stopped, and pointing, said in the harsh gutturals which were partly derived from an Indian mother and partly from excessive cigarette-smoking, "They have stopped and made a fire. Do you see the smoke? You will get them now if they do not get away."

The lieutenant softly pulled his revolver, and raising it over his head, looked behind. The six soldiers opened their eyes wide and yanked out their guns. They raised up their horses' heads, pressed in the spurs, and as though at exercise in the riding hall, the seven horses broke into a gallop. Pedro stayed behind. He had no further interest in L Troop than he had already displayed.

With a clattering rush the little group bore fast on the curling wreath of the campfire. Three white figures dived into the labyrinth of thicket, and three ponies tugged hard at their lariats; two shots rang, one from the officer's revolver, one from a corporal's carbine, and a bugler boy threw a brass trumpet at the fleeting forms.

"Ride 'em down! Ride 'em down!" sang out the officer as through the swishing brush bounded the aroused horses, while the bullets swarmed on ahead.

It was over as I write, and in two minutes the three bandits were led back into the path, their dark faces blanched.

The lieutenant wiped a little stain of blood from his face with a very dirty pocket handkerchief, a mere swish from a bush; the corporal looked woefully at a shirt sleeve torn half off by the thorns, and the trumpeter hunted up his instrument; while a buck soldier observed, "De old man 'ull be hotter'n chili 'bout dis."

The noble six looked at the ignoble three half scornfully, half curiously, after the manner of men at a raffle when they are guessing the weight of the pig.

"Tie them up, Corporal," said the lieutenant as he shoved fresh shells into his gun; "and, I say, tie them to those mesquite trees, Apache fashion—*sabe?*—Apache fashion, Corporal; and three of you men stay here and hold 'em down." With which he rode off, followed by his diminished escort.

The young man rode slowly with his eyes on the ground, while at intervals he shoved his campaign hat to one side and rubbed his right ear, until suddenly he pulled his hat over his eyes, saying, "Ah, I have it." Then he proceeded at a trot to the camp.

Here he peeped cautiously into the old man's dog-tent. This he did ever so carefully; but the old man was in a sound sleep. The lieutenant betook himself to a bush to doze until the captain should bestir himself. L Troop was uneasy. It sat around in groups, but nothing happened until five o'clock.

At this hour the old man came out of his tent, saying, "I say, Mr. B——, have you got any water in your canteen?"

"Yes, indeed, captain. Will you have a drop?"

After he had held the canteen between his august nose and the sky for a considerable interval, he handed it back with a loud "Mount!" and L Troop fell in behind him as he rode away, leaving two men, who gathered up the dog-tent and the empty bottle.

"Where is that —— greaser? Have him get out here and run this trail. Here, you tan-colored coyote, kem up!" and the lieutenant winked vigorously at that perturbed Pedro and patted his lips with his hand to enjoin silence.

So Pedro ran the trail until it was quite dusk, being many times at fault. The lieutenant would ride out to him, and together they would bend over it and talk long and earnestly. L Troop sat quietly in its saddles, grinned cheerfully, and poked each other in the ribs.

Suddenly Pedro came back, saying to the captain, "The men are in that bush—in camp, I think. Will you charge, sir?"

"How do you know that?" was the petulant query.

"Oh, I think they are there; so does the lieutenant. Don't you, Mr. B——?"

"Well, I have an idea we shall capture them if we charge," nervously replied the younger officer.

"Well—right into line! Revolvers! Humph!" said the captain, and the brave old lion plowed his big bay at the object of attack. It did not matter what was in front—and L Troop followed fast. They all became well tangled up in the dense chaparral, but nothing more serious than the thorns stayed their progress, until three shots were fired some little way in the rear and the lieutenant's voice was heard calling, "Come here; we have got them."

In the growing dusk the troop gathered around the three luckless greasers, now quite speechless with fright and confusion. The captain looked his captives over softly, saying, "Pretty work for L Troop;

sound very well in reports. Put a guard over them, lieutenant. I am going to try for a little sleep."

The reflections of L Troop were cheery as it sat on its blankets and watched the coffee in the tin cups boil. Our enterprising lieutenant sat apart on a low bank, twirling his thumbs and indulging in a mighty wonder if that would be the last of it, for he knew only too well that trifling with the old man was no joke.

Presently he strolled over and called the old first sergeant—their relations were very close. "I think L had best not talk much about this business. G Troop might hear about it, and that wouldn't do L any good. *Sabe?*"

"Divel the word kin a man say, sir, and live till morning in L Troop."

Later there was a conference of the file, and then many discussions in the ranks, with the result that L Troop shut its mouth forever.

Some months later they returned to the post. The canteen rang with praise of the old man, for he was popular with the men because he did not bother them with fussy duties, and loud was the paean of the mighty charge over the big insurgent camp where the three great chiefs of the enemy were captured. Other troops might be very good, but L was "it."

This hard rubbing of the feelings of others had the usual irritating effect. One night the burning torch went round and all the troopers gathered at the canteen, where the wag of G Troop threw the whole unvarnished truth in the face of L members present. This, too, with many embellishments which were not truthful. A beautiful fight ensued and many men slept in the guardhouse.

After dark L Troop gathered back of the stables, and they talked fiercely at each other; accusations were made and recrimination followed. Many conferences were held in the company room, but meanwhile G men continued to grind it in.

Two days later the following appeared in the local newspaper:

". : . Pedro Zacatin, a Mexican who served with troops in the late outbreak, as found hanging to a tree back of the post. There was no clue, since the rain of last night destroyed all tracks of the perpetrators of the deed. It may have been suicide, but it is thought at the post that he was murdered by sympathizers of the late revolution who knew the part he had taken against them. The local authorities will do well to take measures against lawless Mexicans from over the border who hang about this city," etc.

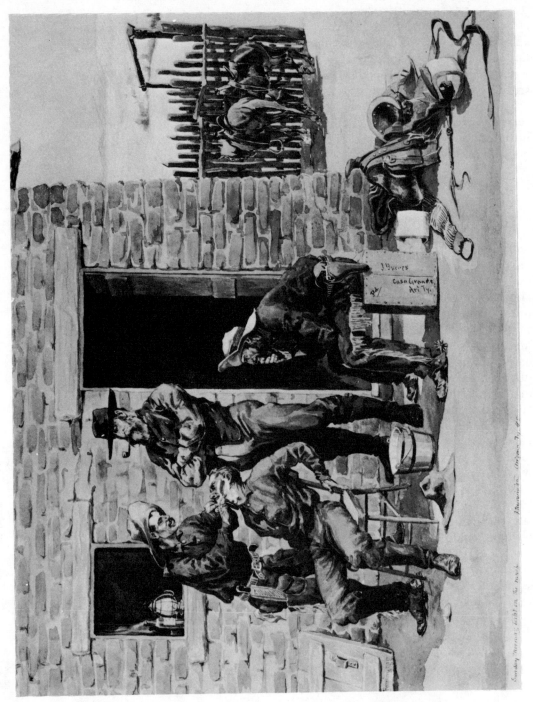

SUNDAY MORNING SPRUCE-UP

XI

A Failure of Justice

Captain Halleran of the dragoons stepped off the way freight at Alkali Flat, which sort of place has been well described as a "roaring board and canvas city"; only in justice to certain ancient adobe huts I should mention their presence.

He was on Government business connected with the Indian war then raging in the territory, and Alkali Flat was a temporary military depot piled high with crackers, bacon, cartridges, and swarming with mules, dusty men, and all the turmoil which gathers about a place where Uncle Sam dispenses dollars to his own.

The captain was a gentleman and a scholar, but he didn't look the part. What sweat and alkali dust won't do to a uniform, sleeping on the ground in it for a month or two will do, and then he was burned like a ripe peach. This always happens to American soldiers in wars. The captain's instincts, however, had undergone no change whatever, and the dust-blown plaza did not appeal to him as he sauntered across toward the long row of one-storied shanties. There was a dismal array of signs—"The Venus," "The Medicine Queen," "The Beer Spring," "The Free and Easy"—but they did not invite the captain. There were two or three outfitting stores which relieved the business aspect, but the simple bed and board which the captain wanted was not there, unless with its tin-pan piano or gambling-chip accompaniment.

He met a man who had the local color, and asked if there was not in the town a hotel run somewhat more on the ancient lines.

"Sure there is, Cap, right over to the old woman's," said he, pointing. "They don't have no hell round the old woman's. That's barred in this plaza; and she can cook jes' like mother. That's the old woman's over thar whar yu see the flowers in front and the two green trees—jes' nex' the Green Cloth Saloon."

The captain entered the place, which was a small barroom with a pool table in the center, and back of this, a dining room. Behind the bar stood a wholesome-looking woman in a white calico dress, far

enough this side of middle age to make the "old woman" libelous as applied to her.

"Good-evening, madam," ventured the captain, feeling that such a woman could not escape matrimony at the Flat.

"Good evening, Captain. Want some supper?"

"Yes, indeed, and I guess I will take a drink—a cocktail, if you please," as he leaned on the bar.

"Captain, the boys say I am a pretty bad bartender. I'll jes' give you the stuff, and you can fix it up to your taste. I don't drink this, and so I don't know what men like. It's grub and beds I furnish mostly, but you can't exactly run a hotel without a bar. My customers sort of come in here and tend bar for themselves. Have a lemon peel, Captain?"

The captain comprehended, mixed and drank his cocktail, and was ushered into the dining room. It was half full of picturesque men in their shirt sleeves or in canvas and dusty boots. They were mostly red-faced, bearded, and spiked with deadly weapons. They were quiet and courteous.

Over his bottle the American is garrulous, but he handles his food with silent earnestness.

Chinamen did the waiting, and there was no noise other than the clatter of weapons, for the three-tined fork must be regarded as such. The captain fell to with the rest, and found the food an improvement on field rations. He presently asked a neighbor about the hostess —how she managed to compete with the more pretentious resorts. Was not the Flat a hard place for a woman to do business?

"Yes, pard, yu might say it is rough on some of the ladies what's sportin' in this plaza, but the old woman never has no trouble." And his new acquaintance leaned over and whispered, "She's on the squar, pard; she's a plumb good woman, and this plaza sort of stands for her. She's as solid as a brick church here."

The captain's friend and he, having wrestled their ration, adjourned to the sidewalk, and the friend continued, "She was wife to an old sergeant up at the post who went and died. The boys here wanted a eatin' joint, bein' tired of the local hash, which I honest can tell yu was most damn bad; so they gets her down here to ride herd on this bunch of Chinamen top-side. She does pretty well for herself, gives us good grub and all that, but she gets sort of stampeded at times over the goin's on in this plaza, and the committee has to go out and hush 'em up. Course the boys gets tangled up with their irons, and then they are packed in here, and if the old woman can't nurse 'em back to life, they has to go. There is a little bunch of fellows here what she has set up with nights, and they got it put up that she is about the best damn woman on the earth. They sort of stand together when any alcoholic patient gets to yellin' round the old woman's or some sportin' lady goes after the old woman's hair. About every loose feller round yer has asked the old woman to marry him, which is why she ain't popular

A FIGHT IN THE STREET

with the ladies. She plays 'em all alike, and don't seem to marry much, and this town makes a business of seein' she always lands feet first, so when anyone gets to botherin', the committee comes round and runs him off the range. It sure is unhealthy fer any feller to get loaded and go jumpin' sideways round this 'dobie. *Sabe?*"

The captain did his military business at the quartermaster's, and then repaired to the old woman's barroom to smoke and wait for the down freight. She was standing behind the bar, washing the glasses.

A customer came in, and she turned to him.

"Brandy, did you say, John?"

"Yes, madam; that's mine."

"I don't know brandy from whisky, John; you jes' smell that bottle."

John put the bottle to his olfactories, and ejaculated, "Try again; that ain't brandy, fer sure."

Madam produced another bottle, which stood the test, and the man poured his portion and passed out.

Alkali Flat was full of soldiers, cow men, prospectors who had been chased out of the hills by the Apaches, Government freighters who had come in for supplies, and the gamblers and whisky-sellers who kindly helped them to sandwich a little hilarity into their business trips.

As the evening wore on, the blood of Alkali Flat began to circulate. Next door to the old woman's the big saloons were in a riot. Glasses clinked, loud-lunged laughter and demoniac yells mixed with the strained piano, over which untrained fingers banged and pirouetted. Dancers bounded to the snapping fiddle tones of "Old Black Jack." The chips on the faro table clattered, the red-and-black man howled, while from the streets at times came drunken whoops, mingled with the hawhaws of mules over in the quartermaster's corral.

Madam looked toward the captain, saying, "Did you ever hear so much noise in your life?"

"Not since Gettysburg," replied the addressed. "My tastes are quiet, but I should think Gettysburg the more enjoyable of the two. But I suppose these people really think this kind of thing is great fun."

"Yes, they live so quiet out in the hills that they like to get into this bedlam when they are in town. It sort of stirs them up," explained the hostess.

"Do they never trouble you, madam?"

"No—except for this noise. I have had bullets come in here, but they wasn't meant for me. They get drunk outside and shoot wild sometimes. I tell the boys plainly that I don't want none of them to come in here drunk, and I don't care to do any business after supper. They don't come around here after dark much. I couldn't stand it if they did. I would have to pull up."

A drunken man staggered to the door of the little hotel, saw the madam behind the bar, received one look of scorn, and backed out again with a muttered, " 'Scuse me, lady; no harm done."

Presently in rolled three young men, full of the confidence which far too much liquor will give to men. They ordered drinks at the bar roughly. Their derby hats proclaimed them Easterners; Railroad tramps or some such rubbish, thought the captain. Their conversation had the glib vulgarity of the big cities, with many of their catch phrases, and they proceeded to jolly the landlady in a most offensive way. She tried to brave it out, until one of them reached over the bar and chucked her under the chin. Then she lifted her apron to her face and began to cry.

The wise mind of the captain knew that society at Alkali Flat worked like a naphtha-engine—by a series of explosions. And he saw a fearful future for the small barroom.

Rising, he said, "Here, here, young men, you had better behave yourselves, or you will get killed."

Turning with a swagger, one of the hobos said, "Ah! whose'll kill us, youse—— ——?"

"No, he won't!" This was shouted in a resounding way into the little room, and all eyes turned to the spot from which the voice came. Against the black doorway stood Dan Dundas—the gambler who ran the faro layout next door, and in his hands were two Colts leveled

A CITIZEN WITH THE BARK ON

at the toughs, while over them gleamed steadily two bright blue eyes, like planetary stars against the gloom of his complexion. "No, he won't kill yu; he don't have to kill yu. I will do that."

With a hysterical scream, the woman flew to her knight errant. "Stop—stop that, Dan! Don't you shoot—don't you shoot, Dan! If you love me, Dan, don't don't!"

With the quiet drawl of the Southwest, the man in command of the situation replied, "Well, I reckon I'll sure have to, little woman. Please don't put your hand on my guns. Maybeso I won't shoot, but, Helen—but I ought to, all right. Hadn't I, Captain?"

Many heads lighted up the doorway back of the militant Dan, but the captain blew a whiff of smoke toward the ceiling and said nothing.

The three young men were scared rigid. They held their ex-termites as the quick situation had found them. If they had not been scared, they would still have failed to understand the abruptness of things; but one of them found tongue to blurt, "Don't shoot! We didn't do nothin', Mister."

Another resounding roar came from Dan—"Shut up!" And the quiet was opaque.

"Yes," said the captain as he leaned on the billiard table, "you fellows have got through your talking. Anyone can see that"; and he knocked the ash off his cigar.

"What did they do, Helen?" And Dan bent his eyes on the woman for the briefest of instants.

Up went the apron to her face, and through it she sobbed, "They chucked me under the chin, Dan, and—and one of them said I was a pretty girl—and——"

"Oh, well, I ain't saying he's a liar, but he ain't got no call fer to say it. I guess we had better get the committee and lariat 'em up to a telegraph pole—sort of put 'em on the Western Union line—or I'll shoot 'em. Whatever you says goes, Helen," pleaded justice amid its perplexities.

"No, no, Dan! Tell me you won't kill 'em. I won't like you any more if you do."

"Well, I sure ought to, Helen. I can't have these yer hobos comin' round here insultin' of my girl. Now you allow that's so, don't yu?"

"Well, don't kill 'em, Dan; but I'd like to tell 'em what I think of them, though."

"Turn her loose, Helen. If yu feel like talkin', just you talk. You're a woman, and it does a woman a heap of good to talk; but if yu don't want to talk, I'll turn these guns loose, or we'll call the com-mittee without no further remarks—jes' as yu like, Helen. It's your play."

The captain felt that the three hobos were so taken up with Dan's guns that Helen's eloquence would lose its force on them. He also had a weak sympathy for them, knowing that they had simply

applied the low street customs of an Eastern city in a place where customers were low enough, except in the treatment of decent women.

While Dan had command of the situation, Helen had command of Dan, and she began to talk. The captain could not remember the remarks—they were long and passionate—but as she rambled along her denunciation, the captain, who had been laughing quietly and quizzically admiring the scene, became suddenly aware that Dan was being more highly wrought upon than the hobos.

He removed his cigar, and said in a low voice, "Say, Dan, don't shoot; it won't pay."

"No?" asked Dan, turning his cold wide-open blue eyes on the captain.

"No; I wouldn't do it if I were you; you are mad, and I am not, and you had better use my judgment."

Dan looked at the hobos, then at the woman, who had ceased talking, saying, "Will I shoot, Helen?"

"No, Dan," she said simply.

"Well, then," he drawled as he sheathed his weapons, "I ain't goin' to trifle round yer any more. Good night, Helen," and he turned out into the darkness.

"Oh, Dan!" called the woman.

"What?"

"Promise me that no one kills these boys when they go out of my place; promise me, Dan, you will see to it that no one kills them. I don't want 'em killed. Promise me," she pleaded out of the door.

"I'll do it, Helen, I'll kill the first man what lays a hand on the doggoned skunks," and a few seconds later the captain heard Dan, out in the gloom, mutter, "Well, I'll be d——!"

A more subdued set of young gentlemen than followed Dan over to the railroad had never graced Alkali Flat.

Dan came back to his faro game, and sitting down, shuffled the pack and meditatively put it in the box, saying to the casekeeper, "When a squar woman gets in a game, I don't advise any bets."

But Alkali Flat saw more in the episode than the mere miscarriage of justice; the excitement had uncovered the fact that Dan Dundas and Helen understood each other.

COWBOY FUN IN OLD MEXICO

XII

An Outpost of Civilization

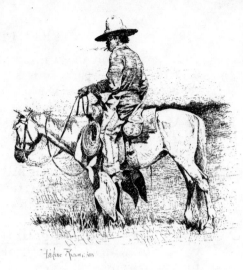

The hacienda of San José de Bavicora lies northwest from Chihua-
hua [in north central Mexico], 225 of the longest miles on the map.
The miles run up long hills and dive into rocky canyons; they
stretch over never-ending burnt plains and across the beds of tortuous
rivers thick with scorching sand. And there are three ways to make
this travel. Some go on foot—which is best, if one has time—like the
Tahuramaras; others take it ponyback, after the Mexican manner; and
persons with no time and a great deal of money go in a coach. At first
thought this last would seem to be the best, but the Guerrero stage has
never failed to tip over, and the company makes you sign away your
natural rights, and almost your immortal soul, before it will allow you
to embark. So it is not the best way at all, if I may judge from my own
experience. We had a coach which seemed to choose the steepest hill
on the route, where it then struck a stone, which heaved the coach,
pulled out the kingpin, and what I remember of the occurrence is full
of sprains and aches and general gloom. Guerrero, too, is only three-
fourths of the way to Bavicora, and you can only go there if Don
Gilberto, the *patron* of the hacienda—or, if you know him well enough,
"Jack"—will take you in the ranch coach.

After bumping over the stones all day for five days, through
a blinding dust, we were glad enough when we suddenly came out of
the tall timber in the mountain pass and espied the great yellow plain
of Bavicora stretching to the blue hills of the Sierra. In an hour's ride
more, through a chill wind, we were at the ranch. We pulled up at
the entrance, which was garnished by a bunch of cow punchers, who
regarded us curiously as we pulled our aching bodies and bandaged
limbs from the Concord and limped into the patio.

To us was assigned the room of honor, and after shaking our-
selves down on a good bed, with mattress and sheeting, we recovered
our cheerfulness. A hot toddy, a roaring fireplace, completed the effect.
The floor was strewn with bear- and wolf-skin rugs; it had pictures

and draperies on the walls, and in a corner a washbasin and pitcher—so rare in these parts—was set on a stand, grandly suggestive of the refinements of luxury we had attained to. I do not wish to convey the impression that Mexicans do not wash, because there are brooks enough in Mexico if they want to use them, but washbasins are the advance guards of progress, and we had been on the outposts since leaving Chihuahua.

Jack's man William had been ever present and administered to our slightest wish; his cheerful "Good-mo'nin', gemmen," as he lit the fire recalled us to life. After a rubdown I went out to look at the situation.

Jack's ranch is a great straggling square of mud walls enclosing two patios, with adobe corrals and outbuildings, all obviously constructed for the purposes of defense. It was built in 1770 by the Jesuits, and while the English and Dutch were fighting for possession of the Mohawk Valley, Bavicora was an outpost of civilization, as it is today. Locked in a strange language, on parchment stored in vaults in Spain, are the records of this enterprise. In 1840 the good fathers were murdered by the Apaches, the country devastated and deserted, and the cattle and horses hurried to the mountain lairs of the Apache devils. The place lay idle and unreclaimed for years, threatening to crumble back to the dust of which it was made. Near by are curious mounds on the banks of a dry arroyo. The punchers have dug down into these ruins and found adobe walls, mud plasterings, skeletons, and bits of woven goods. They call them the "Montezumas."

All this was to be changed. In 1882 an American cowboy—which was Jack—accompanied by two companions, penetrated south from Arizona; and as he looked from the mountains over the fair plain of Bavicora, he said, "I will take this." The Apaches were on every hand; the country was terrorized to the gates of Chihuahua. The stout heart of the pioneer was not disturbed, and he made his word good. By purchase, he acquired the plain and so much more that you could not ride round it in two weeks. He moved in with his hardy punchers and fixed up Bavicora so it would be habitable. He chased the Indians off his ranch whenever he "cut their sign." After a while the Mexican *vaqueros* from below overcame their terror when they saw the American hold his own with the Apache devils, and by twos and threes and half-dozens they came up to take service, and now there are two hundred who lean on Jack and call him *patron*. They work for him and they follow him on the Apache trail, knowing he will never run away, believing in his beneficence and trusting to his courage.

I sat on a mudbank and worked away at a sketch of the yellow sunlit walls of the mud ranch, with the great plain running away like the ocean into a violet streak under the blue line of the Pena Blanca. In the rear rises a curious broken formation of hills, like millions of ruins of Rhine castles. The *lobos* [wolves] howl by night, and the Apache

is expected to come at any instant. The old *criada*, or serving woman, who makes the beds saw her husband killed at the front door, and every man who goes out of the patio has a large assortment of the most improved artillery on his person. Old carts with heavy wooden wheels like millstones stand about. Brown people with big straw hats and gay serapes lean lazily against the gray walls. Little pigs carry on the contest with nature, game chickens strut, and clumsy puppies tumble over each other in joyful play; burros stand about sleepily, only indicating life by suggestive movements of their great ears, while at intervals a pony, bearing its lithe rider, steps from the gate, and breaking into an easy and graceful lope, goes away into the waste of land.

I rose to go inside, and while I gazed, I grew exalted in the impression that here, in the year 1893, I had rediscovered a Fort Laramie after Mr. Francis Parkman's well-known description. The foreman, Tom Bailey, was dressed in store clothes, and our room had bedsteads and a washbasin; otherwise it answered very well. One room was piled high with dried meat, and the great stomachs of oxen filled with tallow; another room is a store full of goods—calicoes, buckskin, *reatas*, yellow leather shoes, guns, and other quaint plunder adapted to the needs of a people who sit on the ground and live on meat and corn meal.

"Charlie Jim," the Chinese cook, has a big room with a stove in it, and he and the stove are a never-ending wonder to all the folks, and the fame of both has gone across the mountains to Sonora and to the south. Charlie is an autocrat in his curious Chinese way, and by the dignity of his position as Mr. Jack's private cook and his unknown antecedents, he conjures the Mexicans and d——s the Texans, which latter refuse to take him seriously and kill him, as they would a "proper" man. Charlie Jim, in return, entertains ideas of Texans which he secretes, except when they dine with Jack, when he may be heard to mutter, "Cake and pie no good for puncher, make him fat and lazy"; and when he crosses the patio and they fling a rope over his foot, he becomes livid; and breaks out, "Da—— puncher; d—— rope; rope man all same horse; d—— puncher; no good that way."

The *patron* has the state apartment, and no one goes there with his hat on; but his relations with his people are those of a father and children. An old gray man approaches; they touch the left arm with the right—an abbreviated hug—say, *"Buenos días, patron!"* *"Buenos días*, Don Sabino!"* and they shake hands. A California saddle stand, on a rack by the desk, and the latter is littered with photographs of men in London clothes and women in French dresses, the latter singularly out of character with their surroundings. The old *criada* squats silently by the fireplace, her head enveloped in her blue *rebozo*, and deftly rolls her cigarette. She alone, and one white bulldog, can come and go without restraint.

The *administrator*, which is Mr. Tom Bailey, of Texas, moves about in the discharge of his responsibilities, and they are universal;

anything and everything is his work, from the negotiation for the sale of five thousand head of cattle to the "busting" of a bronco which no one else can "crawl."

The clerk is in the store, with his pink boy's face, a pencil behind his ear, and a big sombrero, trying to look as though he had lived in these wilds longer than at San Francisco, which he finds an impossible part. He has acquired the language and the disregard of time necessary to one who would sell a *real's* worth of cotton cloth to a Mexican.

The forge in the blacksmith's shop is going, and one puncher is cutting another puncher's hair in the sunlight; ponies are being lugged in on the end of lariats, and thrown down, tied fast, and left in a convulsive heap, ready to be shod at the disposition of their riders.

On the roof of the house are two or three men looking and pointing to the little black specks on the plain far away, which are the cattle going into the *lagunas* to drink.

The second patio, or the larger one, is entered by a narrow passage, and here you find horses and saddle and punchers coming and going, saddling and unsaddling their horses, and being bucked about or dragged on a rope. In the little doorways to the rooms of the men stand women in calico dresses and blue cotton *rebozos*, while the dogs and pigs lie about, and little brown *vaqueros* are ripening in the sun. In the rooms you find pottery, stone *metates* for grinding the corn, a fireplace, a symbol of the Catholic Church, some serapes, some rope, and buckskin. The people sit on a mat on the floor and make cigarettes out of native tobacco and cornhusks, or roll *tortillas;* they laugh and chat in low tones, and altogether occupy the tiniest mental world, hardly larger than the patio, and not venturing beyond the little mud town of Temozachic, forty miles over the hills. Physically the men vacillate between the most intense excitement and a comatose state of idleness, where all is quiet and slothful, in contrast to the mad whirl of the roaring rodeo.

In the haciendas of Old Mexico one will find the law and custom of the feudal days. All the laws of Mexico are in protection of the landowner. The master is without restraint, and the man lives dependent on his caprice. The *patron* of Bavicora, for instance, leases land to a Mexican, and it is one of the arrangements that he shall drive the ranch coach to Chihuahua when it goes. All lessees of land are obliged to follow the *patron* to war, and, indeed, since the common enemy, the Apache, in these parts is as like to harry the little as the great, it is exactly to his interest to wage the war. Then, too, comes the responsibility of the *patron* to his people. He must feed them in the famine, he must arbitrate their disputes, and he must lead them at all times. If, through improvidence, their work cattle die or give out, he must restock them so that they may continue the cultivation of the land, all of which is not . . . profitable in a financial way, as we of the north may think, where all business is done on the "hold you responsible, sir," basis.

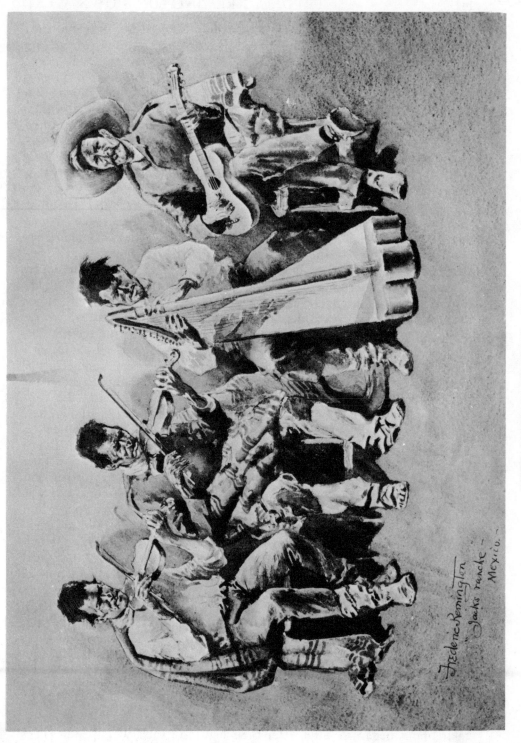

THE MUSIC AT THE "BAILE"

The *vaqueros* make their own saddles and *reatas;* only the iron saddle rings, the rifles, and the knives come from the *patron*, and where he gets them from, God alone knows, and the puncher never cares. No doctor attends the sick or disabled, old women's nursing standing between life and death. The Creator in His province has arranged it so that simple folks are rarely sick, and a sprained ankle, a bad bruise from a steer's horn or a pitching horse, are soon remedied by rest and a good constitution. At times instant and awful death overtakes the puncher—a horse in a gopher hole, a mad steer, a chill with a knife, a blue hole where the .45 went in, a quicksand closing overhead; and a cross on a hillside are all.

Never is a door closed. Why they were put up, I failed to discover. For days I tried faithfully to keep mine shut, but everyone coming or going left it open, so that I gave it up in despair. There are only two windows in the ranch of San José de Bavicora, one in our chamber and one in the blacksmith's shop, both opening into the court. In fact, I found those were the only two windows in the state, outside of the big city. The Mexicans find that their enemies are prone to shoot through these apertures and so they have accustomed themselves to do without them, which is as it should be, since it removes the temptation.

One night the *patron* gave a *baile*. The *vaqueros* all came with their girls, and a string band rendered music with a very dancy swing. I sat in a corner and observed the man who wears the big hat and who throws the rawhide as he cavorted about with his girl, and the way they dug up the dust out of the dirt floor soon put me to coughing. Candles shed their soft luster—and tallow down the backs of our necks— and the band scraped and thrummed away in a most serious manner. One man had a harp, two had primitive fiddles, and one a guitar. One old fiddler was the leader, and as he bowed his head on his instrument, I could not keep my eyes off him. He had come from Sonora, and was very old; he looked as though he had had his share of a very rough life; he was never handsome as a boy, I am sure, but the weather and starvation and time had blown him and crumbled him into a ruin which resembled the pre-existing ape from which the races sprang. If he had never committed murder, it was for lack of opportunity; and Sonora is a long travel from Plymouth Rock.

Tom Bailey, the foreman, came round to me, his eyes dancing and his shock of hair standing up like a Circassian beauty's, and pointing, he said, "Thar's a woman who's prettier than a speckled pup; put your twine on her." Then, as master of ceremonies, he straightened up and sang out over the fiddle and noise, "Dance, thar, you fellers, or you'll git the gout."

In an adjoining room there was a very heavy jug of strong-water, and thither the men repaired to pick up, so that as the night wore on their brains began to whirl after their legs, and they whooped at times in a way to put one's nerves on edge. The band scraped the harder and

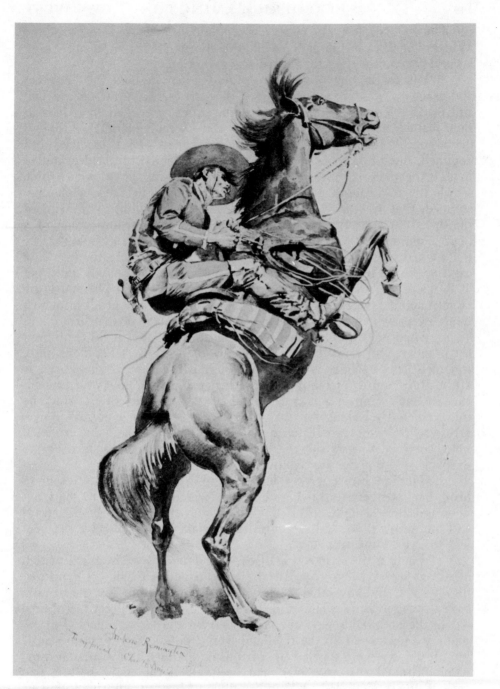

A MEXICAN VAQUERO

the dance waxed fast, the spurs clinked, and *bang bang bang* went the Winchester rifles in the patio, while the chorus, *"Viva el patron,"* rang around the room—the Old Guard was in action.

We sat in our room one evening when in filed the *vaqueros* and asked to be allowed to sing for the *patron*. They sat on my bed and on the floor while we occupied the other; they had their hats in their hands, and their black dreamy eyes were diverted as though overcome by the magnificence of the apartment. They hemmed and coughed, until finally one man, who was evidently the leader, pulled himself together and began, in a high falsetto, to sing; after two or three words the rest caught on, and they got through the line, when they stopped; thus was one leading and the others following to the end of the line. It was strange, wild music—a sort of general impression of a boys' choir with a wild discordance, each man giving up his soul as he felt moved. The refrain always ended, for want of breath, in a low expiring howl, leaving the audience in suspense; but quickly they get at it again, and the rise of the tenor chorus continues. The songs are largely about love and women and doves and flowers, in all of which nonsense punchers take only a perfunctory interest in real life.

These are the amusements—although the puncher is always roping for practice, and everything is fair game for his skill; hence dogs, pigs, and men have become as expert in dodging the rope as the *vaqueros* are in throwing it. A mounted man, in passing, will always throw his rope at one sitting in a doorway, and then try to get away before he can retaliate by jerking his own rope over his head. I have seen a man repair to the roof and watch a doorway through which he expected some comrade to pass shortly, and watch for an hour to be ready to drop his noose about his shoulders.

The ranch fare is very limited, and at intervals men are sent to bring back a steer from the water holes, which is dragged to the front door and there slaughtered. A day of feasting ensues, and the doorways and the gutter pipes and the corral fences are festooned with the beef left to dry in the sun.

There is the serious side of the life. The Apache is an evil which Mexicans have come to regard as they do the meteoric hail, the lightning, the drought, and any other horror not to be averted. They quarrel between themselves over land and stock, and there are a great many men out in the mountains who are proscribed by the Government. Indeed, while we journeyed on the road and were stopping one night in a little mud town, we were startled by a fusillade of shots, and in the morning were informed that two men had been killed the night before, and various others wounded. At another time a Mexican with his followers had invaded our apartment and expressed a disposition to kill Jack, but he found Jack was willing to play his game, and gave up the enterprise. On the ranch the men had discovered some dead stock which had been killed with a knife. Men were detailed to roam the country in search

of fresh trails of these cattle-killers. I asked the foreman what would happen in case they found a trail which could be followed, and he said, "Why, we would follow it until we came up, and then kill them." If a man is to "hold down" a big ranch in northern Mexico, he has got to be "all man," because it is "a man's job," as Mr. Bailey of Los Ojos said—and he knows.

Jack himself is the motive force of the enterprise, and he disturbs the quiet of this waste of sunshine by his presence for about six months in the year. With his strong spirit, the embodiment of generations of pioneers, he faces the Apache, the marauder, the financial risks. He spurs his listless people on to toil, he permeates every detail, he storms, and greater men than he have sworn like troopers under less provocation than he has at times; but he has snatched from the wolf and the Indian the fair land of Bavicora, to make it fruitful for his generation.

There lies the hacienda San José de Bavicora, gray and silent on the great plain, with the mountains standing guard against intruders, and over it the great blue dome of the sky, untroubled by clouds, except little flecks of vapor, which stand, lost in immensity, burning bright like opals, as though discouraged from seeking the mountains or the sea from whence they came. The marvelous color of the country beckons to the painter; its simple natural life entrances the blond barbarian, with his fevered brain; and the gaudy *vaquero* and his trappings and his pony are the actors on this noble stage. But one must be appreciative of it all, or he will find a week of rail and a week of stage and a week of horseback all too far for one to travel to see a shadow across the moon.

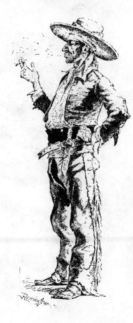

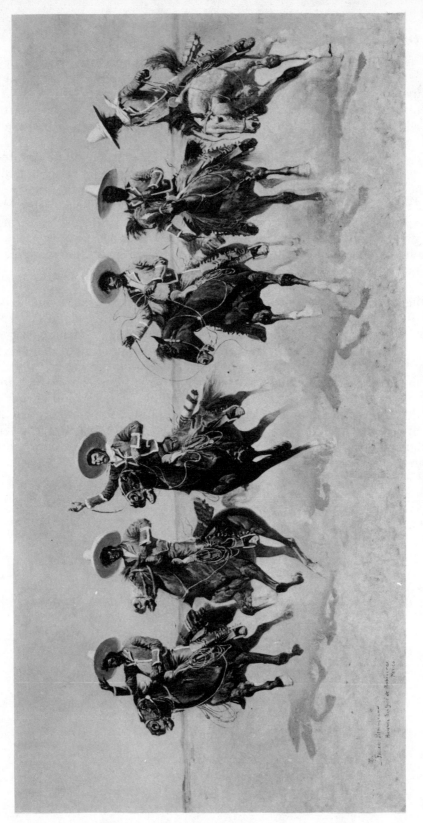

COMING TO THE RODEO

XIII

A Rodeo
at Los Ojos

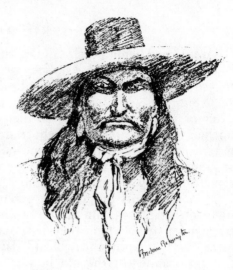

The sun beat down on the dry grass, and the punchers were squatting about in groups in front of the straggling log and adobe buildings which constituted the outlying ranch of Los Ojos, of the hacienda of San José de Bavicora.

Mr. Johnnie Bell, the *capitan* in charge, was walking about in his heavy *chaparajos*, a slouch hat, and a white "biled" shirt. He was chewing his long yellow mustache and gazing across the great plain of Bavicora with set and squinting eyes. He passed us and repassed us, still gazing out, and in his long Texas drawl said, "Thar's them San Miguel fellers."

I looked, but I could not see any San Miguel fellows in the wide expanse of land.

"Hyar, crawl some horses, and we'll go out and meet 'em," continued Mr. Bell; and suiting the action, we mounted our horses and followed him. After a time I made out tiny specks in the atmospheric wave which rises from the heated land, and in half an hour could plainly make out a cavalcade of horsemen. Presently breaking into a gallop, which movement was imitated by the other party, we bore down upon each other, and only stopped when near enough to shake hands, the half-wild ponies darting about and rearing under the excitement. Greetings were exchanged in Spanish, and the peculiar shoulder tap, or abbreviated embrace, was indulged in. Doubtless a part of our outfit was as strange to Governor Terraza's men—for he is the *patron* of San Miguel—as they were to us.

My imagination had never before pictured anything so wild as these leather-clad *vaqueros*. As they removed their hats to greet Jack, their unkempt locks blew over their faces, back off their foreheads, in the greatest disorder. They were clad in terra-cotta buckskin, elaborately trimmed with white leather, and around their lower legs wore heavy cowhide as a sort of legging. They were fully armed, and with their jingling spurs, their flapping ropes and buckskin strings, and with their

147

gay serapes tied behind their saddles, they were as impressive a cavalcade of desert scamperers as it has been my fortune to see. Slowly we rode back to the corrals, where they dismounted.

Shortly, and unobserved by us until at hand, we heard the clatter of hoofs, and leaving in their wake a cloud of dust, a dozen punchers from another outfit bore down upon us as we stood under the ramada of the ranch house, and pulling up with a jerk which threw the ponies on their haunches, the men dismounted and approached, to be welcomed by the master of the rodeo.

A few short orders were given and three mounted men started down to the springs, and after charging about, we could see that they had roped a steer, which they led, bawling and resisting, to the ranch, where it was quickly thrown and slaughtered. Turning it on its back, after the manner of the old buffalo hunters, it was quickly disrobed and cut up into hundreds of small pieces, which is the method practiced by the Mexican butchers, and distributed to the men.

In Mexico it is the custom for the man who gives the roundup to supply fresh beef to the visiting cow men; and on this occasion it seemed that the pigs, chickens, and dogs were also embraced in the bounty of the *patron*, for I noticed one piece which hung immediately in front of my quarters had two chickens roosting on the top of it and a pig and a dog tugging vigorously at the bottom.

The horse herds were moved in from the *llano* and rounded up in the corral, from which the punchers selected their mounts by roping; and as the sun was westering, they disappeared, in obedience to orders, to all points of the compass. The men took positions back in the hills and far out on the plain; there, building a little fire, they cooked their beef, and enveloped in their serapes, spent the night. At early dawn they converged on the ranch, driving before them such stock as they had.

In the morning we could see from the ranch house a great semicircle of gray on the yellow plains. It was the thousands of cattle coming to the rodeo. In an hour more we could plainly see the cattle and behind them the *vaqueros*, dashing about, waving their serapes. Gradually they converged on the rodeo ground, and enveloped in a great cloud of dust and with hollow bellowings like the low pedals of a great organ, they began to mill about a common center, until gradually quieted by the enveloping cloud of horsemen. The *patron* and the captains of the neighboring ranches, after an exchange of long-winded Spanish formalities, and accompanied by ourselves, rode slowly from the ranch to the herd, and entering it, passed through and through and around in solemn procession. The cattle part before the horsemen and the dust rises so as to obscure to unaccustomed eyes all but the silhouettes of the moving thousands. This is an important function in a cow country, since it enables the owners or their men to estimate what numbers of the stock belong to them, to observe the brands and

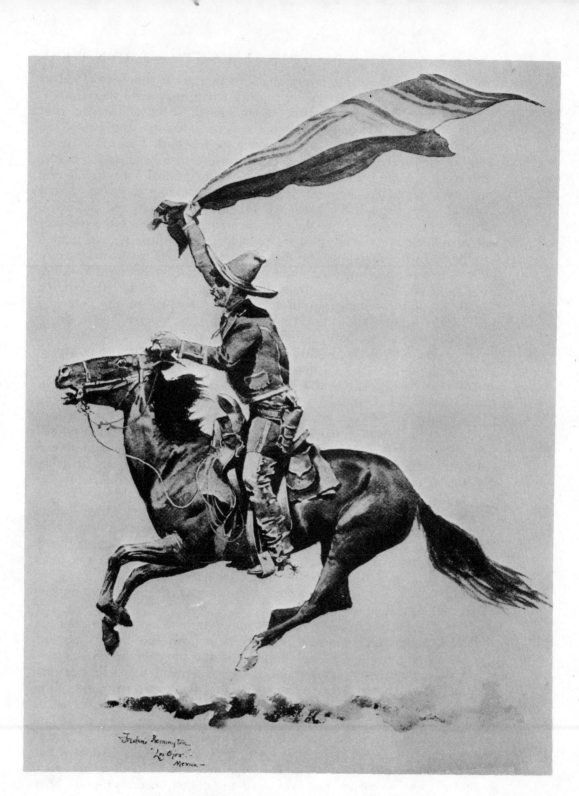

WAVING SERAPE TO DRIVE CATTLE

to inquire as to the condition of the animals and the numbers of calves and mavericks, and to settle any dispute which may arise therefrom.

All controversy, if there be any, having been adjusted, a part of the punchers move slowly into the herd, while the rest patrol the outside and hold it. Then a movement soon begins. You see a figure dash at full speed through an apparently impenetrable mass of cattle; the stock becomes uneasy and moves about, gradually beginning the milling process, but the men select the cattle bearing their brand, and course them through the herd. All becomes confusion, and the cattle simply seek to escape from the ever-recurring horsemen. Here one sees the matchless horsemanship of the punchers. Their little ponies, trained to the business, respond to the slightest pressure. The cattle make every attempt to escape, dodging in and out and crowding among their kind; but right on their quarter, gradually forcing them to the edge of the herd, keeps the puncher, until finally, as a last effort, the cow and calf rush through the supporting line and after a terrific race she is turned into another herd, which is called "the cut."

One who finds pleasure in action can here see the most surprising manifestations of it. A huge bull, wild with fright, breaks from the herd with lowered head and whitened eye and goes charging off, indifferent to what or whom he may encounter, with the little pony pattering in his wake. The cattle run at times with nearly the intensity of action of a deer, and whip and spur are applied mercilessly to the little horse. The process of "tailing" is indulged in, although it is a dangerous practice for the man and reprehensible from its brutality to the cattle. A man will pursue a bull at top speed, will reach over and grasp the tail of the animal, bring it to his saddle, throw his right leg over the tail, and swing his horse suddenly to the left which throws the bull rolling over and over. That this method has its value I have seen in the case of pursuing mavericks, where an unsuccessful throw was made with the rope and the animal was about to enter the thick timber. It would be impossible to coil the rope again, and an escape would follow but for the wonderful dexterity of these men in this accomplishment.

The little calves become separated from their mothers and go bleating about, their mothers respond by bellows, until pandemonium seems to reign. The dust is blinding and the puncher becomes grimy and soiled; the horses lather; and in the excitement the desperate men do deeds which convince you of their faith that a man can't die till his time comes. At times a bull is found so skilled in these contests that he cannot be displaced from the herd; it is then necessary to rope him and drag him to the point desired; and I noticed punchers ride behind recalcitrant bulls, and reaching over, spur them. I also saw two men throw simultaneously for an immense creature, when to my great astonishment he turned tail over head and rolled on the ground. They had both sat back on their ropes together.

The whole scene was inspiring to a degree, and well merited the observation that "it is the sport of kings; the image of war, with twenty-five per cent of its danger."

Fresh horses are saddled from time to time, but before high noon the work is done and the various "cut-offs" are herded in different directions. By this time the dust had risen until lost in the sky above, and as the various bands of cowboys rode slowly back to the ranch, I observed their demoralized condition. The economy *per force* of the Mexican people prompts them to put no more cotton into a shirt than is absolutely necessary, with the consequence that in these cases their shirts had pulled out from their belts and their serapes and were flapping in the wind; their mustaches and their hair were plastered solid with dust; and one could not tell a bay horse from a black.

Now come the cigarettes and the broiling of beef. The bosses were invited to sit at our table, and as the work of cutting and branding had yet to be done, no time was taken for ablutions. Opposite me sat a certain individual who, as he engulfed his food, presented a grimy waste of visage only broken by the rolling of his eyes and the snapping of his teeth.

We then proceeded to the corrals, which were made in stockaded form from gnarled and many-shaped posts set on end. The cows and calves were bunched on one side in fearful expectancy. A fire was built just outside of the bars and the branding irons set on. Into the corrals went the punchers, with their ropes coiled in their hands. Selecting their victims, they threw their ropes, and after pulling and tugging, a bull calf would come out of the bunch, whereat two men would set upon him and "rastle" him to the ground. It is a strange mixture of humor and pathos, this mutilation of calves—humorous when the calf throws the man and pathetic when the man throws the calf. Occasionally an old cow takes an unusual interest in her offspring and charges boldly into their midst. Those men who cannot escape soon enough throw dust in her eyes or put their hats over her horns. In this case there were some big steers which had been "cut out" for purposes of work at the plow and turned in with the young stock. One old grizzled veteran manifested an interest in the proceedings and walked boldly from the bunch with his head in the air and bellowing. A wild scurry ensued, and hats and serapes were thrown to confuse him. But over all this the punchers only laugh, and go at it again. In corral-roping they try to catch the calf by the front feet, and in this they become so expert that they rarely miss. As I sat on the fence, one of the foremen, in play, threw and caught my legs as they dangled.

When the work is done and the cattle are again turned into the herd, the men repair to the *casa* and indulge in games and pranks. We had shooting matches and hundred-yard dashes; but I think no records were broken, since punchers on foot are odd fish. They walk as though they expected every moment to sit down. Their knees work outward

and they have a decided "hitch" in their gait; but once let them get a foot in a stirrup and a grasp on the horn of the saddle, and a dynamite cartridge alone could expel them from their seat. When loping over the plain, the puncher is the epitome of equine grace, and if he desires to look behind him, he simply shifts his whole body to one side and lets the horse go as he pleases. In the pursuit of cattle at a rodeo he leans forward in his saddle, and with his arms elevated to his shoulders, he "plugs" in his spurs and makes his pony fairly sail. While going at this tremendous speed, he turns his pony almost in his stride, and no matter how a bull may twist and swerve about, he is at his tail as true as a magnet to the pole. The Mexican punchers all use the "ring bit," and it is a fearful contrivance. Their saddletrees are very short, and as straight and quite as shapeless as a "sawbuck pack saddle." The horn is as big as a dinner plate, and taken altogether it is inferior to the California tree. It is very hard on horses' backs and not at all comfortable for a rider who is not accustomed to it.

They all use hemp ropes which are imported from some of the southern states of the Republic, and carry a lariat of hair which they make themselves. They work for from eight to twelve dollars a month in Mexican coin and live on the most simple diet imaginable. They are mostly *peoned*, or in hopeless debt to their *patrons*, who go after any man who deserts the range and bring him back by force. On the roundup, which lasts about half of the year, he is furnished beef and also kills game. The balance of the year he is kept in an outlying camp to turn stock back on the range. These camps are often the most simple things, consisting of a pack containing his grub, his saddle, and serape, all lying under a tree which does duty as a house. He carries a flint and steel, and has a piece of sheet-iron for a stove and a piece of pottery for boiling things in. This part of their lives is passed in a long siesta, and a man of the North who has a local reputation as a lazy man should see a Mexican puncher loaf in order to comprehend that he could never achieve distinction in the land where *poco tiempo* means "forever." Such is the life of the *vaquero*, a brave fellow, a fatalist, with less wants than the pony he rides, a rather thoughtless man who lacks many virtues; but when he mounts his horse or casts his *reata*, all men must bow and call him master.

The *baile*, the song, the man with the guitar—and under all this *dolce far niente* are their little hates and bickerings, as thin as cigarette smoke and as enduring as time. They reverence their parents, they honor their *patron*, and love their *compadre*. They are grave, and grave even when gay; they eat little, they think less, they meet death calmly, and it's a terrible scoundrel who goes to hell from Mexico.

The Anglo-American foremen are another type entirely. They have all the rude virtues. The intelligence which is never lacking and the perfect courage which never fails are found in such men as Tom Bailey and Johnnie Bell—two Texans who are the superiors of any cow

men I have ever seen. I have seen them chase the mavericks at top speed over a country so difficult that a man could hardly pass on foot out of a walk. On one occasion Mr. Bailey, in hot pursuit of a bull, leaped a tremendous fallen log at top speed and in the next instant tailed and threw the bull as it was about to enter the timber. Bell can ride a pony at a gallop while standing up on his saddle, and while Cossacks do this trick, they are enabled to accomplish it easily from the superior adaptability of their saddles to the purpose. In my association with these men of the frontier I have come to greatly respect

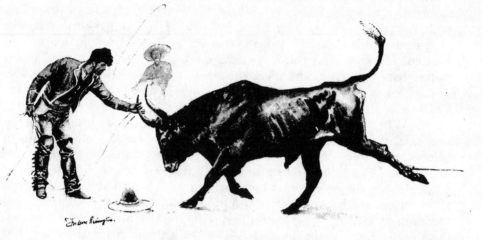

TEASING A MEAN ONE

their moral fiber and their character. Modern civilization, in the process of educating men beyond their capacity, often succeeds in vulgarizing them; but these natural men possess minds which, though lacking all embellishment, are chaste and simple, and utterly devoid of a certain flippancy which passes for smartness in situations where life is not so real. The fact that a man bolts his food or uses his tableknife as though it were a deadly weapon counts very little in the game these men play in their lonely range life. They are not complicated, these children of nature, and they never think one thing and say another. Mr. Bell was wont to squat against a fireplace—*à la* Indian—and dissect the peculiarities of the audience in a most ingenious way. It never gave offense either, because so guileless. Mr. Bailey, after listening carefully to a theological tilt, observed that "he believed he'd be religious if he knowed how."

The jokes and pleasantries of the American puncher are often so close to nature and so generously veneered with heart-rending profanity as to exclude their becoming classic. The cow men are good friends and virulent haters, and if justified in their own minds, would shoot a man instantly, and regret the necessity, but not the shooting, afterward.

Among the dry, saturnine faces of the cow punchers of the Sierra Madre was one which beamed with human instincts, which seemed to say, "Welcome, stranger!" He was the first impression my companion and myself had of Mexico, and as broad as are its plains and as high its mountains, yet William looms up on a higher pinnacle of remembrance.

William was so black that he would make a dark hole in the night, and the top of his head was not over four and a half feet above the soles of his shoes. His legs were all out of drawing, but forty-five winters had not passed over him without leaving a mind which, in its sphere of life, was agile, resourceful, and eminently capable of grappling with any complication which might arise. He had personal relations of various kinds with every man, woman, and child whom we met in Mexico. He had been thirty years a cook in a cow camp, and could evolve banquets from the meat on a bull's tail, and was wont to say, "I don' know so much 'bout dese yar stoves, but gie me a campfire an' I can make de bes' thing yo ever threw your lip ober."

When in camp, with his little cast-off English tourist cap on one side of his head, a short black pipe tipped at the other angle to balance the effect, and two or three stripes of white corn meal across his visage, he would move round the campfire like a cub bear around a huckleberry bush, and in a low authoritative voice have the Mexicans all in action, one hurrying after water, another after wood, some making *tortillas*, or cutting up venison, grinding coffee between two stones, dusting bedding, or anything else. The British field-marshal air was lost in a second when he addressed "Mister Willie" or "Mister Jack," and no fawning courtier of the Grand Monarch could purr so low.

On our coach ride to Bavicora, William would seem to go up to any ranch house on the road, when the sun was getting low, and after ten minutes' conversation with the grave don who owned it he would turn to us with a wink and say, "Come right in, gemmen. Dis ranch is yours." Sure enough, it was. Whether he played us for major generals or governors of states I shall never know, but certainly we were treated as such.

On one occasion William had gotten out to get a hat blown off by the wind, and when he came up to view the wreck of the turn-over of the great Concord coach and saw the mules going off down the hill with the front wheels, the ground littered with boxes and debris, and the men all lying about, groaning or fainting in agony, William scratched his wool, and with just a suspicion of humor on his face, he ventured, "If I'd been hyar, I would be in two places 'fore now, shuah," which was some consolation to William, if not to us.

In Chihuahua we found William was in need of a clean shirt and we had got one for him in a shop. He had selected one with a power of color enough to make the sun stand still, and with great

glass diamonds in it. We admonished him that when he got to the ranch, the punchers would take it away from him.

"No, sah; I'll take it off 'fore I get thar."

William had his commercial instincts developed in a reasonable degree, for he was always trying to trade a "silver" watch with the Mexicans. When asked what time it was, William would look at the sun and then deftly cant the watch around, the hands of which swung like compasses, and he would show you the time within fifteen minutes of right, which little discrepancy could never affect the value of a watch in the land of *mañana*.

That he possessed tact I have shown, for he was the only man at Bavicora whose relations with the *patron* and the smallest, dirtiest Indian "kid" were easy and natural. Jack said of his popularity, "He stands 'way in with the Chinese cook; gets the warm corner behind the stove." He also had courage, for didn't he serve out the ammunition in Texas when his "outfit" was in a life-and-death tussle with the Comanches? did he not hold a starving crowd of Mexican teamsters off the grub wagon until the boys came back?

There was only one feature of Western life with which William could not assimilate, and that was the horse. He had trusted a bronco too far on some remote occasion, which accounted partially for the kinks in his legs; but after he had recovered fully his health, he had pinned his faith to burros and forgotten the glories of the true cavalier.

"No, sah, Mister Jack, I don' care for to ride dat horse. He's a good horse, but I jes' hit de flat for a few miles 'fore I rides him," he was wont to say when the cowboys gave themselves over to an irresponsible desire to see a horse kill a man. He would then go about his duties, uttering gulps of suppressed laughter after the Negro manner, safe in the knowledge that the burro he affected could "pack his freight."

One morning I was taking a bath out of our washbasin, and William, who was watching me and the coffeepot at the same time, observed that "if one of dese people down hyar was to do dat dere, dere'd be a funeral 'fo' twelve o'clock."

William never admitted any social affinity with Mexicans, and as to his own people, he was wont to say, "Never have went with people of my own color." So William lives happily in a small social puddle, and always reckons to "treat any friends of Mister Jack's right."

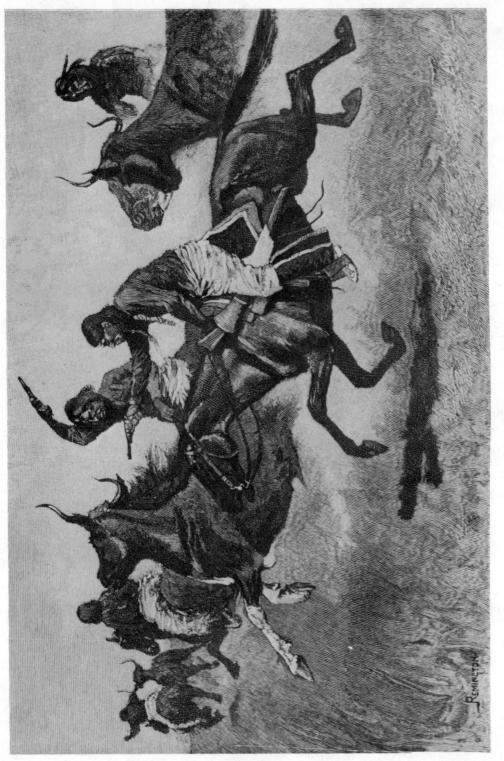

STEER HUNTING

XIV

Artist Wanderings Among the Cheyennes

After a hard pull we came to a beautiful creek heavily timbered with post oak, blackjack, and pecan trees. Taking our well-worn ponies from the pole, we fed and curried them, hoping that by careful nursing they might be gotten through to Fort Reno. I wasted some anxiety on myself, as I discovered that my cowboy driver unrolled from a greasy newspaper the provisions which he had assured me before starting was a matter which had been attended to. It was poor picking enough, and I did not enjoy my after-dinner smoke when I realized that the situation was complicated by the fact that we had eaten everything for dinner and were then miles from Reno with a pair of played-out ponies.

Hooking up again, we started on. On a little hill one jaded beast set back in the breeching, and we dismounted to push the wagon and coax him along. The road was heavy with sand, and we lost a parallel trail made by the passage of the Eighth Cavalry some weeks before. We hoped to discover the "breaks" [the lowering of the land, cut by streams tending toward the basin of a large river] of the South Canadian River before darkness set in; but the land rose steadily away in front, and we realized that something must be done. At last, coming suddenly upon a group of miserable pole cabins, we saw two Caddo Indians reclining on a framework of poles. I conceived the idea of hiring one of these to guide us through in the darkness. The wretches refused to understand us, talk English, sign language or what we would. But after a hard bargain one saddled his pony and consented to lead the way through the darkness.

On we traveled, our valuable guide riding so far ahead that we could not see him, and at last we came suddenly in sight of the bright surface of the South Canadian. The sun was fast sinking, and by the time we had crossed the wide sandbars and the shallow water of the river bottom, a great red gleam was all that remained on the western horizon. About a mile to the left flickered the campfires about a group

157

of lodges of Arapaho tribesmen. We fed our team and then ourselves crunched kernels of "horse-trough corn," which were extracted from the feedbox. Our Caddo sat on his horse while we lay stretched on the grassy bank above the sand flats.

A dark-skinned old Arapaho rode up, and our Caddo saluted him. They began to converse in the sign language as they sat on their ponies, and we watched them with great interest. With graceful gestures they made the signs and seemed immediately and fully to comprehend each other. As the old Arapaho's face cut dark against the sunset, I thought it the finest Indian profile I had ever seen. He was arrayed in the full wild Indian costume of the latter days, with leggings, beaded moccasins, and a sheet wrapped about his waist and thighs. The Caddo, on the contrary, was a progressive man. His hair was cropped in Cossack style; he wore a hat, boots, and a great slicker, or cowboy's oilskin coat. For the space of half an hour they thus interested each other. We speculated on the meaning of the signs and could often follow them; but they abbreviated so much and did it all so fast that we missed the full meaning of their conversation. Among other things, the Caddo told the Arapaho who we were, and also made arrangements to meet him at the same place at about ten o'clock on the following day.

Darkness now set in, and as we plunged into the timber after the disappearing form of our guide, I could not see my companion on the seat beside me. I think horses can make out things better than men can under circumstances like these; and as the land lay flat before us, I had none of the fears which one who journeys in the mountains often feels.

The patter of horses' hoofs in the darkness behind us was followed by a hailing cry in the guttural tone of an Indian. I could just make out a mounted man with a led horse beside the wagon, and we exchanged inquiries in English and found him to be an acquaintance of the morning, in the person of a young Cheyenne scout from Fort Reno who had been down to buy a horse of a Caddo. He had lived at the Carlisle School, and although he had been back in the tribe long enough to let his hair grow, he had not yet forgotten all his English. As he was going through to the post, we dismissed our Caddo and followed him.

Far ahead in the gloom could be seen two of the post lights, and we were encouraged. The little ponies traveled faster and with more spirit in the night, as indeed do all horses. The lights did not come nearer, but kept at the indefinite distance peculiar to lights on a dark night. We plunged into holes, and the old wagon pitched and tipped in a style which insured keeping its sleepy occupants awake. But there is an end to all things, and our tedious trail brought us into Fort Reno at last. A sleepy boy with a lamp came to the door of the post trader's and wanted to know if I was trying to break the house down, which was a natural conclusion on his part, as sundry dents in a certain door of the place will bear witness to this day.

XIV

Artist Wanderings Among the Cheyennes

After a hard pull we came to a beautiful creek heavily timbered with post oak, blackjack, and pecan trees. Taking our well-worn ponies from the pole, we fed and curried them, hoping that by careful nursing they might be gotten through to Fort Reno. I wasted some anxiety on myself, as I discovered that my cowboy driver unrolled from a greasy newspaper the provisions which he had assured me before starting was a matter which had been attended to. It was poor picking enough, and I did not enjoy my after-dinner smoke when I realized that the situation was complicated by the fact that we had eaten everything for dinner and were then miles from Reno with a pair of played-out ponies.

Hooking up again, we started on. On a little hill one jaded beast set back in the breeching, and we dismounted to push the wagon and coax him along. The road was heavy with sand, and we lost a parallel trail made by the passage of the Eighth Cavalry some weeks before. We hoped to discover the "breaks" [the lowering of the land, cut by streams tending toward the basin of a large river] of the South Canadian River before darkness set in; but the land rose steadily away in front, and we realized that something must be done. At last, coming suddenly upon a group of miserable pole cabins, we saw two Caddo Indians reclining on a framework of poles. I conceived the idea of hiring one of these to guide us through in the darkness. The wretches refused to understand us, talk English, sign language or what we would. But after a hard bargain one saddled his pony and consented to lead the way through the darkness.

On we traveled, our valuable guide riding so far ahead that we could not see him, and at last we came suddenly in sight of the bright surface of the South Canadian. The sun was fast sinking, and by the time we had crossed the wide sandbars and the shallow water of the river bottom, a great red gleam was all that remained on the western horizon. About a mile to the left flickered the campfires about a group

157

of lodges of Arapaho tribesmen. We fed our team and then ourselves crunched kernels of "horse-trough corn," which were extracted from the feedbox. Our Caddo sat on his horse while we lay stretched on the grassy bank above the sand flats.

A dark-skinned old Arapaho rode up, and our Caddo saluted him. They began to converse in the sign language as they sat on their ponies, and we watched them with great interest. With graceful gestures they made the signs and seemed immediately and fully to comprehend each other. As the old Arapaho's face cut dark against the sunset, I thought it the finest Indian profile I had ever seen. He was arrayed in the full wild Indian costume of the latter days, with leggings, beaded moccasins, and a sheet wrapped about his waist and thighs. The Caddo, on the contrary, was a progressive man. His hair was cropped in Cossack style; he wore a hat, boots, and a great slicker, or cowboy's oilskin coat. For the space of half an hour they thus interested each other. We speculated on the meaning of the signs and could often follow them; but they abbreviated so much and did it all so fast that we missed the full meaning of their conversation. Among other things, the Caddo told the Arapaho who we were, and also made arrangements to meet him at the same place at about ten o'clock on the following day.

Darkness now set in, and as we plunged into the timber after the disappearing form of our guide, I could not see my companion on the seat beside me. I think horses can make out things better than men can under circumstances like these; and as the land lay flat before us, I had none of the fears which one who journeys in the mountains often feels.

The patter of horses' hoofs in the darkness behind us was followed by a hailing cry in the guttural tone of an Indian. I could just make out a mounted man with a led horse beside the wagon, and we exchanged inquiries in English and found him to be an acquaintance of the morning, in the person of a young Cheyenne scout from Fort Reno who had been down to buy a horse of a Caddo. He had lived at the Carlisle School, and although he had been back in the tribe long enough to let his hair grow, he had not yet forgotten all his English. As he was going through to the post, we dismissed our Caddo and followed him.

Far ahead in the gloom could be seen two of the post lights, and we were encouraged. The little ponies traveled faster and with more spirit in the night, as indeed do all horses. The lights did not come nearer, but kept at the indefinite distance peculiar to lights on a dark night. We plunged into holes, and the old wagon pitched and tipped in a style which insured keeping its sleepy occupants awake. But there is an end to all things, and our tedious trail brought us into Fort Reno at last. A sleepy boy with a lamp came to the door of the post trader's and wanted to know if I was trying to break the house down, which was a natural conclusion on his part, as sundry dents in a certain door of the place will bear witness to this day.

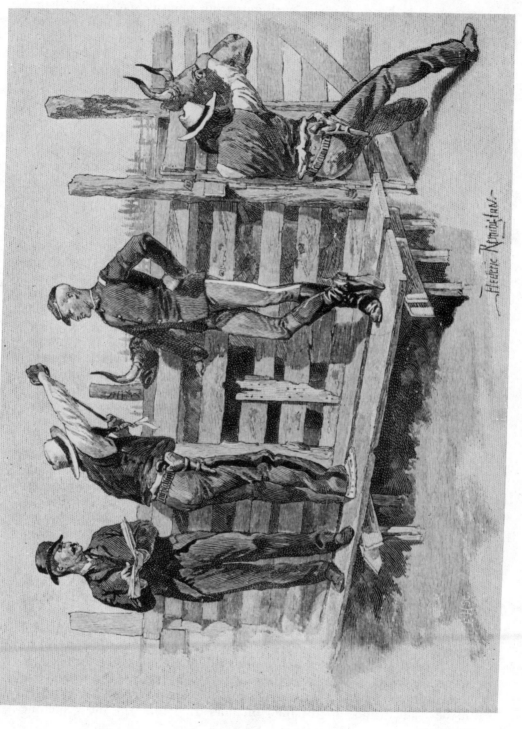

THE BEEF ISSUE

On the following morning I appeared at the headquarters office, credentials in hand. A smart, well-gotten-up noncom gave me a chair and discreetly kept an eye on the articles of value in the room, for the hard usage of my recent travels had so worn and soiled my clothing that I was more picturesque than assuring in appearance. The colonel came soon, and he, too, eyed me with suspicious glances until he made out that I was not a Texas horse thief nor an Oklahoma boomer. After finding that I desired to see his protégés of the prairie, he sent for the interpreter, Mr. Ben Clark, and said, "Seek no farther; here is the best Cheyenne in the country."

Mr. Clark I found to be all that the colonel had recommended, except that he did not look like a Cheyenne, being a perfect type of the frontier scout, only lacking the long hair, which to his practical mind a white man did not seem to require. A pair of mules and a buckboard were provided at the quartermaster's corral, and Mr. Clark and I started on a tour of observation.

We met many Cheyennes riding to some place or another. They were almost invariably tall men with fine Indian features. They wore their hair caught by braids very low on the shoulders, making a black mass about the ears, which at a distance is not unlike the aspect of an Apache. All the Indians now use light cow saddles and ride with the long stirrups peculiar to Western Americans, instead of "trees" of their own construction with the short stirrup of the old days. In summer, instead of a blanket, a white sheet is generally worn, which becomes dirty and assumes a very mellow tone of color. Under the saddle the bright blue or red Government cloth blanket is worn, and the sheet is caught around the waist, giving the appearance of Zouave trousers. The variety of shapes which an Indian can produce with a blanket, the great difference in wearing it, and the grace and naturalism of its adjustment are subjects one never tires of watching. The only criticism of the riding of modern Indians one can make is the incessant thumping of the horse's ribs, as though using a spur. Outside of the far Southwest, I have never seen Indians use spurs. With the awkward old "trees" formerly made by the Indians, and with the abnormally short stirrup, an Indian was anything but graceful on horseback, although I have never heard anyone with enough temerity to question his ability.

I always like to dwell on the subject of riding, and I have an admiration for a really good rider which is altogether beyond his deserts in the light of philosophy. In the Eastern states the European riding master has proselyted to such an extent that it is rather a fashionable fad to question the utility of the Western method. When we consider that for generations these races of men who ride on the Plains and in the Rocky Mountains have been literally bred on a horse's back, it seems reasonable to suppose they ought to be riders; and when one sees an Indian or a cowboy riding up precipices where no horses ought to be made to go, or assuming on horseback some of the grotesque

positions they at times affect, one needs no assurance that they do ride splendidly.

As we rattled along in the buckboard, Mr. Clark proved very interesting. For thirty-odd years he has been in contact with the Cheyennes. He speaks the language fluently, and has discovered in a trip to the far North that the Crees use almost identically the same tongue. Originally the Cheyennes came from the far North, and they are Algonquin in origin. Though their legend of the famous "medicine arrow" is not a recent discovery, I cannot forbear to give it here.

A long time ago, perhaps about the year 1640, the Cheyennes were fighting a race of men who had guns. The fighting was in the vicinity of the Devil's Lake country, and the Cheyennes had been repeatedly worsted in combat and were in dire distress. A young Horatius of the tribe determined to sacrifice himself for the common weal, and so wandered away. After a time he met an old man, a mythical personage, who took pity on him. Together they entered a great cave, and the old man gave him various articles of "medicine" to choose from, and the young man selected the "medicine arrows." After the old man had performed the proper incantations, the hero went forth with his potent fetish and rejoined the tribe. The people regained courage, and in the fight which soon followed they conquered and obtained guns for the first time. Ever since, the tribe has kept the medicine arrows, and they are now in the Indian Territory in the possession of the southern Cheyennes. Years ago the Pawnees captured the arrows, and in ransom got vast numbers of ponies, although they

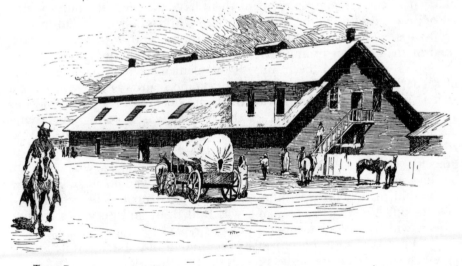

CHEYENNE AGENCY

never gave back all of the arrows; and the Cheyennes attribute all their hard experiences of later days to this loss. Once a year, and oftener should a situation demand it, the ceremony of the arrows takes place. No one has ever witnessed it except the initiated priests.

The tribal traditions are not known thoroughly by all, and of late years only a very few old men can tell the tribal stories perfectly. Why this is so, no one seems to know, unless the Indians have seen and heard so much through the white men that their faith is shaken.

Our buckboard drew gradually nearer the camp of the Cheyennes. A great level prairie of waving green was dotted with the brown-toned white canvas lodges, and standing near them were brush ramadas, or sheds, and also wagons. For about ten years they have owned wagons, and now seldom use the *travaux*. In little groups all over the plain were scattered pony herds, and about the camp could be seen forms wearing bright blankets or wrapped in ghostlike cotton sheets. Little columns of blue smoke rose here and there, and gathered in front of one lodge was squatted a group of men. A young squaw dressed in a bright calico gown stood near a ramada and bandied words with the interpreter while I sketched. Presently she was informed that I had made her picture, when she ran off, laughing at what she considered an unbecoming trick on the part of her entertainer. The women of this tribe are the only squaws I have ever met, except in some of the tribes of the northern Plains, who have any claim to be considered good-looking. Indeed, some of them are quite as I imagine Pocahontas, Minnehaha, and the rest of the heroines of the race appeared. The female names are conventional, and have been borne by the women ever since the oldest man can remember. Some of them have the pleasant sound which we occasionally find in the Indian tongues: "Mut-say-yo," "Wau-hi-yo," "Mo-ka-is," "Jok-ko-ko-me-yo," are examples; and with the soft guttural of their Indian pronunciation, I found them charming.

As we entered the camp, all the elements which make that sort of scene interesting were about. A medicine man was at work over a sick fellow. We watched him through the opening of a lodge and our sympathies were not aroused, as the patient was a young buck who seemed in no need of them. A group of young men were preparing for a clan dance. Two young fellows lay stretched on the grass in graceful attitudes. Children were playing with dogs; women were beading moccasins; a group of men lay under a wagon playing monte; a very old man, who was quite naked, tottered up to our vehicle and talked with Mr. Clark. His name was Bull Bear, and he was a strange object, with his many wrinkles, gray hair, and toothless jaws.

From a passing horseman I procured an old "buck saddle" made of elk horn. They are now very rare. Indian saddlery is interesting, as all the tribes had a different model and the women used one differing from that of the men.

We dismounted at the lodge of Whirlwind, a fine old type who

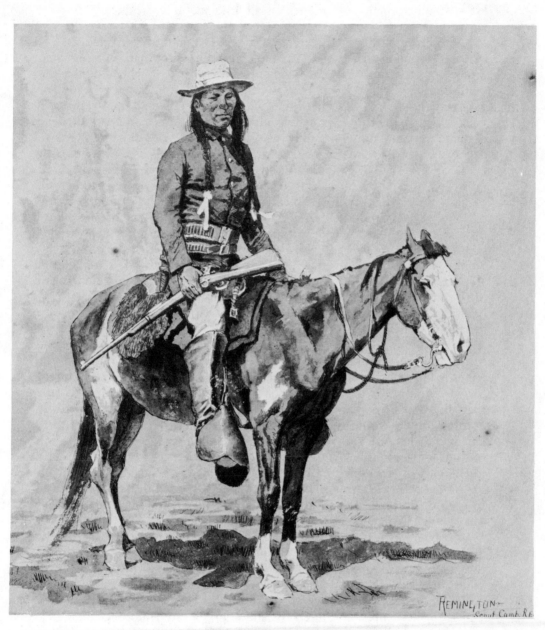

INDIAN SCOUT AT FORT RENO

now enjoys the prestige of head chief. He was dignified and reserved, and greeted us cordially as he invited us to a seat under the ramada. He refused a cigar, as will nearly all Indians, and produced his own cigarettes.

Through the interpreter we were enabled to converse freely. I have a suspicion that the old man had an impression that I was in some way connected with the Government. All Indians somehow divide the white race into three parts. One is either a soldier, a Texas cowboy, or a "big chief from Washington," which latter distinction I enjoyed. I explained that I was not a "big chief," but an artist, the significance of which he did not grasp. He was requested to put on his plumage, and I then proceeded to make a drawing of him. He looked it over in a coldly critical way, grunted several times, and seemed more mystified than ever; but I do not think I diminished in his estimation. In his younger days Whirlwind had been a war chief; but he traveled to Washington, and there saw the power and numbers of the white man. He advised for peace after that, and did not take the warpath in the last great outbreak. His people were defeated, as he said they would be, and confidence in his judgment was restored. I asked him all sorts of questions to draw on his reminiscences of the old Indian life before the conquest, all of which were answered gravely and without boasting. It was on his statesmanlike mind, however, to make clear to me the condition of his people, and I heard him through.

Though not versed in the science of government, I was interested in the old man's talk. He had just returned from a conference of the tribes which had been held in the Cherokee country and was full of the importance of the conclusions there evolved. The Indians all fear that they will lose their land, and the council advised all Indians to do nothing which would interfere with their tenure of the land now held by them. He told with pride of the speech he made while there and of the admiration with which he was regarded as he stood, dressed in the garb of the wild Indian, with his tomahawk in hand. However, he is a very progressive man and explained that while he was too old to give up the methods of life which he had always observed, yet his son would be as the civilized Cherokees are.

The son was squatting near, and I believed his statement, as the boy was large of stature and bright of mind, having enjoyed some three years' schooling at a place which I have now forgotten. He wore white men's clothes and had just been discharged from the corps of scouts at Reno. When I asked the boy why he did not plow and sow and reap, he simply shrugged his shoulders at my ignorance which in justice to myself I must explain was only a leading question, for I know that corn cannot be raised on this reservation with sufficient regularity to warrant the attempt. The rainfall is not enough; and where white men despair, I for one do not expect wild Indians to continue. They have tried it and have failed, and are now very properly discouraged.

Stock-raising is the natural industry of the country, and that is the proper pursuit of these people. They are only now recovering by natural increase from the reverses which they suffered in their last outbreak. It is hard for them to start cattle herds, as their ration is insufficient, and one scarcely can expect a hungry man to herd cattle when he needs the beef to appease his hunger. Nevertheless, some men have respectable herds and can afford to kill an animal occasionally without taking the stock cattle. In this particular they display wonderful forbearance, and were they properly rationed for a time and given stock cattle, there is not a doubt but in time they would become self-supporting. The present scheme of taking a few boys and girls away from the camps to put them in school where they are taught English, morals, and trades has nothing reprehensible about it, except that it is absolutely of no consequence so far as solving the Indian problem is concerned. The few boys return to the camps with their English, their school clothes, and their short hair. They know a trade also, but have no opportunity to be employed in it. They loaf about the forts for a time with nothing to do, and the white men talk pigeon English to them and the wild Indians sneer at them. Their virtues are unappreciated, and as a natural consequence the thousands of years of barbarism which is bred in their nature overcome the three little seasons of school training. They go to the camps, go back to the blanket, let their hair grow, and forget their English. In a year one cannot tell a schoolboy from any other little savage, and in the whole proceeding I see nothing at all strange.

The camp will not rise to the schoolboy and so Mahomet goes to the mountains. If it comes to pass that the white race desires to aid these Indians to become a part of our social system instead of slowly crushing them out of it, there is only one way to do it. The so-called Indian problem is no problem at all in reality, only that it has been made one by a long succession of acts which were masterly in their imbecility and were fostered by political avarice. The sentiment of this nation is in favor of no longer regarding the aborigines of this country as a conquered race; and except that the great body of our citizens are apathetic of things so remote as these wards of the Government, the people who have the administration of their destinies would be called to account. No one not directly interested ever questioned that the Indian Department should have been attached to the War Department; but that is too patent a fact to discuss. Now the Indian affairs are in so hopeless a state of dry rot that practical men, in political or in military circles, hesitate to attempt the role of reformers. The views which I have on the subject are not original, but are very old and very well understood by all men who live in the Indian countries. They are current among Army officers who have spent their whole lives on the Indian frontier of the far West, but are not often spoken, because all men realize the impotency of any attempt to overcome the active work

of certain political circles backed by public apathy and a lot of theoretical Indian regenerators. If anything is done to relieve the condition of the Indian tribes, it must be a scheme which begins at the bottom and takes the "whole outfit" in its scope. If these measures of relief are at all tardy, before we realize it the wild Indian tribes will be, as some writer has said, "loafers and outcasts, contending with the dogs for kitchen scraps in Western villages." They have all raised stock successfully when not interfered with or not forced by insufficient rations to eat up their stock cattle to appease their hunger, and I have never heard that Indians were not made of soldier stuff. A great many Western garrisons have their corps of Indian scouts. In every case they prove efficient. They are naturally the finest irregular cavalry on the face of this globe, and with an organization similar to the Russian Cossacks, they would do the United States great good and become themselves gradually civilized. An irregular cavalry is every year a more and more important branch of the service. Any good cavalry officer, I believe, could take a command of Indians and ride around the world without having a piece of bacon, or a cartridge, or a horse issued by his Government. So far as effective police work in the West is concerned, the corps of Indian scouts do nearly all of that service now. They all like to be enlisted in the service, universally obey orders, and are never disloyal. But nothing will be done; so why continue this?

For hours we sat in the ramada of the old chief and conversed, and when we started to go I was much impressed by the discovery that the old Indian knew more about Indians, Indian policy, and the tendencies and impulses of the white men concerning his race than any other person I had ever met.

The glories of the reign of an Indian chieftain are past. As his people become more and more dependent on the Government, his prestige wanes. For instance, at the time of our visit to this camp the people were at loggerheads regarding the locality where the great annual Sun Dance, or more literally "The Big Medicine," should be held. The men of the camp that I visited wanted it at one place and those of the "upper camp" wanted it at another. The chief could not arrange the matter and so the solution of the difficulty was placed in the hands of the agent.

The Cheyenne agency buildings are situated about a mile and a half from Fort Sill. The great brick building is imposing. A group of stores and little white dwelling-houses surround it, giving much the effect of a New England village. Wagons, saddled ponies, and Indians are generally disposed about the vicinity and give life to the scene. Fifteen native policemen in the employ of the agency do the work and take care of the place. They are uniformed in cadet gray, and with their beaded white moccasins and their revolvers, are neat and soldierly-looking. A son of old Bent, the famous frontiersman, and an educated Indian do the clerical work, so that the agent is about the only white

man in the place. The goods which are issued to the Indians have changed greatly in character as their needs have become more civilized. The hatchets and similar articles of the old traders are not given out, on the ground that they are barbarous. Gay-colored clothes still seem to suit the aesthetic sense of the people, and the general effect of a body of modern Indians is exceeding brilliant.

They receive flour, sugar, and coffee at the great agency building, but the beef is issued from a corral situated out on the plain at some distance away. The distribution is a very thrilling sight, and I made arrangements to see it by procuring a cavalry horse from Colonel Wade at the fort and by following the ambulance containing an Army officer who was detailed as inspector. We left the post in the early morning, and the driver poured his lash into the mules until they scurried along at a speed which kept the old troop horse at a neat pace.

The heavy dew was on the grass and clouds lay in great rolls across the sky, obscuring the sun. From the direction of the target range the *stump* of the Springfields came to our ears, showing that the soldiers were hard at their devotions. In twos, and threes, and groups, and crowds, came Indians, converging on the beef corral. The corral is a great ragged fence made of an assortment of boards, poles, scantling, planks, old wagons, and attached to this is a little house near which the weighing scales are placed. The crowd collected in a great mass near the gate and branding chute. A fire was burning, and the cattle contractors (cowboys) were heating their branding irons to mark *I.D.*, the Indian Department brand, on the cattle distributed, so that any Indian having subsequently a hide in his possession would be enabled to satisfy roving cattle inspectors that they were not to be suspected of killing stock.

The agent came to the corral, and together with the Army officer inspected the cattle to be given out. With loud cries the cowboys in the corral forced the steers into the chute, and crowding and clashing, they came through into the scales. The gate of the scales was opened and a half-dozen frightened steers crowded down the chute and packed themselves in an unyielding mass at the other end. A tall Arapaho policeman seized a branding iron, and mounting the platform of the chute, poised his iron and with a quick motion forced it on the back of the living beast. With a wild but useless plunge and a loud bellow of pain, the steer shrunk from the hot contact; but it was all over, and a long black *I.D.* disfigured the surface of the skin.

Opposite the branding chute were drawn up thirty young bucks on their ponies, with their rifles and revolvers in hand. The agent shouted the Indian names from his book, and a very engaging lot of cognomens they were. A policeman on the platform designated a particular steer which was to the property of each man as his name was called. The Indian came forward and marked his steer by reaching over the fence and cutting off an ear with a sharp knife, by severing the tail,

or by tying some old rag to some part of the animal. The cold-blooded mutilation was perfectly shocking, and I turned away in sickened disgust.

After all had been marked, the terrified brutes found the gate at the end of the chute suddenly opened by the police guard; but before this had been done, a frantic steer had put his head half through the gate and in order to force him back a red-hot branding iron was pushed into his face, burning it horribly. The worst was over; the gates flew wide and the maddened brutes poured forth, charging swiftly away in a wild impulse to escape the vicinity of the crowd of humanity. The young bucks in the group broke away, and each one singling out his steer, followed at top speed with rifle or six-shooter in hand.

I desired to see the whole proceeding, and mounting my cavalry horse, followed two young savages who seemed to have a steer possessed of unusual speed. The lieutenant had previously told me that the shooting at the steers was often wild and reckless and advised me to look sharp or I might have to pack a bullet. Puffs of smoke and the *pop! pop!* of the guns came from all over the plain. Now a steer would drop, stricken by some luck shot. It was buffalo-hunting over again, and was evidently greatly enjoyed by the young men. My two fellows headed their steer up the hill on the right, and when they had gotten him far enough away they turned loose. My old cavalry horse began to exhibit a lively interest in the smell of gunpowder, and plunged away until he had me up and in front of the steer and the Indians, who rode on each side. They blazed away at the steer's head, and I could hear a misdirected bullet "sing" by uncomfortably near. Seeing me in front, the steer dodged off to one side, and the young fellow who was in his way, by a very clever piece of horsemanship, avoided being run over.

The whole affair demonstrated to me that the Indian boys could not handle the revolver well, for they shot a dozen rounds before they killed the poor beast. Under their philosophic outward calm I thought I could see that they were not proud of the exhibition they had made. After the killing, the squaws followed the wagons and proceeded to cut up the meat. After it had been divided among themselves, by some arrangement which they seemed to understand, they cut it into very thin pieces and started back to their camps.

Peace and contentment reign while the beef holds out, which is not long, as the ration is insufficient. This is purposely so, as it is expected that the Indians will seek to increase a scant food supply by raising corn. It does not have that effect, however. By selling ponies, which they have in great numbers, they manage to get money; but the financial future of the Cheyennes is not flattering.

Enlistment in the scouting corps at Reno is a method of obtaining employment much sought after by the young men. The camp is on a hill opposite the post, where the white tepees are arranged in a long line. A wall tent at the end is occupied by two soldiers who do the

clerical work. The scouts wear the uniform of the United States Army, and some of them are strikingly handsome in the garb. They are lithe and naturally well set up. They perform all the duties of soldiers; but at some of the irksome tasks, like standing sentry, they do not come out strong. They are not often used for that purpose, however, it being found that Indians do not appreciate military forms and ceremonies.

Having seen all that I desired, I procured passage in the stage to a station on the Santa Fe Railroad. In the far distance the train came rushing up the track, and as it stopped, I boarded it. As I settled back in the soft cushions of the sleeping car, I looked at my dirty clothes and did not blame the Negro porter for regarding me with the haughty spirit of his class.

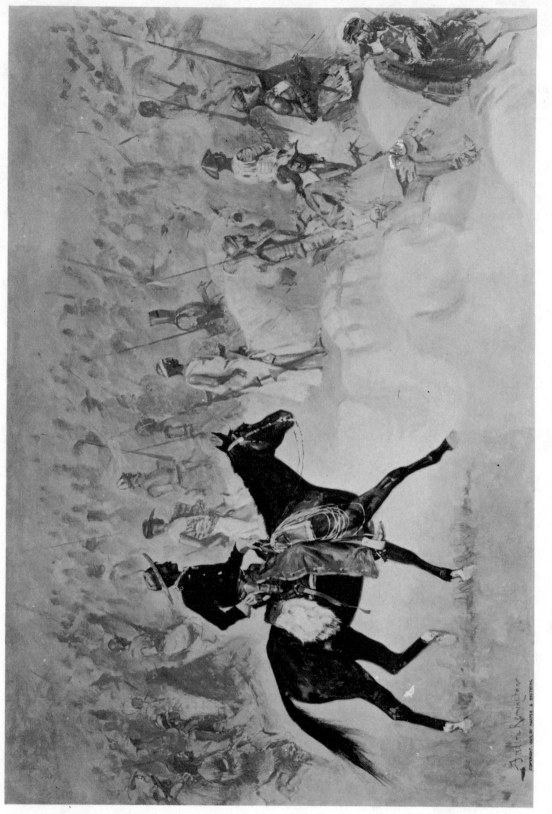

THE LAST CAVALIER

PART TWO

On the Northern Plains

On The
Northern Plains

F rederic Remington's intense interest and intimate experience on the
Northern Plains and adjoining territory closely paralleled that in
the Southwest. It was in the northern region that he had his intro-
duction to early western life and found the inspiration for his career.
This is best told in his own words, written a quarter of a century
afterward for the "Remington Number" of *Collier's Weekly* of March
18, 1905, which was dedicated to him. "Evening overtook me one
night in Montana and I by good luck made the campfire of an old
wagon freighter who shared his bacon and coffee with me. I was
nineteen years of age and he was a very old man . . . during his life
he had followed the receding frontier . . . 'And now,' he said, 'there
is no more West. In a few years the railroad will come along the Yellow-
stone. . . .' I knew the railroad was coming . . . the derby hat, the
smoking chimney, the cord-binder, and the thirty day note . . . I
knew the wild riders and the vacant land were about to vanish forever
. . . Without knowing exactly how to do it I began to try to record
some facts around me, and the more I looked the more the panorama
unfolded . . . The living, breathing end of three American centuries."

Remington pursued everything he did with a restless determina-
tion. In the beginning he scurried about the West, from north to south
and back again, like an ambitious bear-hound with his nose to the ground.
Furthermore, he was blessed with an artist's photographic mind, a
newspaper man's sense of human values, and a scholarly inquisitiveness
for facts—absorbing information rapidly and permanently retaining it.
There were not many travelers in the West during the last two
decades of the nineteenth century who covered more of the back-
country of the old frontiers, and even fewer who gained distinction in
the fields of arts and letters, who had a broader, closer or more earthy ex-
perience among the raw western elements which he documented. When
Remington wrote about the colorful Northern Plains Indians, or the
Army men or cowboys, it was based on long standing personal friend-

172

ships among them. When he told about "The Buffalo Dance" and "Ordeal of the Blackfeet Sun Dance," it was something he had witnessed and not just heard about. The period can be dated between 1880 and the close of the century, and most of what he wrote comes close to being contemporary with his own experiences. In Wyoming and Montana at that time, history was still in the making. The Indians still retained a lot of their proud defiance of the Army, and the name of Sitting Bull was a challenge to that of the Great White Father.

While Remington had a particular devotion to the "little people," whether white or red, he had many close friends among the famous personalities of the West. He was an ardent admirer of Colonel William F. "Buffalo Bill" Cody and was a frequent guest of the glamourous frontiersman at his favorite T E Ranch on the South Fork of the Shoshone River amid the high peaks of the Rockies and near Yellowstone Park. There was invariably on hand a coterie of the old-time characters who figured prominently in the taming of the West. Remington was accepted in these groups as a kindred spirit, and this acceptance provided him with an unusual opportunity to draw from this fountainhead of information. He was welcome, too, in the camps of General Nelson A. Miles and other military leaders. There friendly associations permitted the artist to be an eye-witness and actual participant in the last big engagement of the Indian Wars that climaxed the white man's conquest of the West.

It was against this extraordinary background that these articles and stories were written. Like the stories of the Southwest, they are intimate vignettes of the lives of the white men and red men who made the history of our West—"the living, breathing end of three American centuries."

—H. McM.

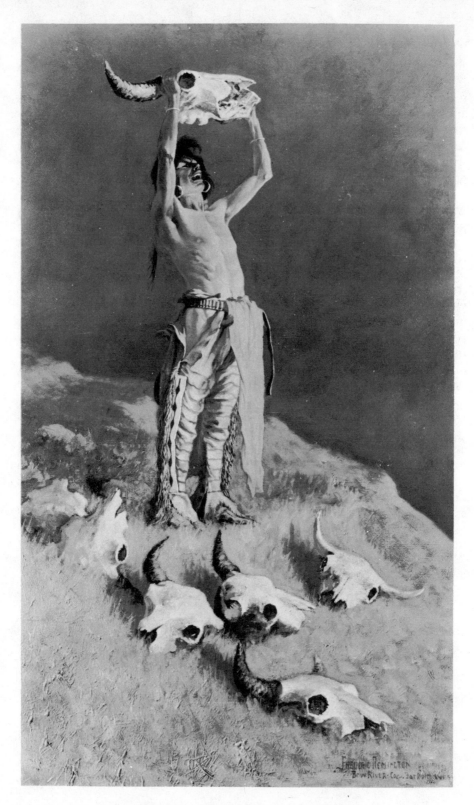

CONJURING BACK THE BUFFALO

XV

The Story of the Dry Leaves

If one loves the earth, he finds a liveliness in walking through the autumn woods: the color, the crackling, and the ripeness of the time appeal to his senses as he kicks his way through the dry leaves with his feet.

It is a wrong thing to dull this harmlessness, but still I must remind him that it was not always so; for such leaves have been the cause of tragedy. How could bad come of such unoffending trifles? Listen.

Long ago a very old Indian—an Ottawa—recalled the sad case of Ah-we-ah from the nearly forgotten past. His case was similar to ours, only more serious, since if we could not approach a deer in the dry forest because of the noise the leaves made, it meant only disappointment; but with Ah-we-ah it meant his utter undoing.

Ah-we-ah grew up, or came up, as all Indian boys do who manage to escape the deadfalls which nature sets in such numbers and variety for them, and was at the time of the story barely a man. His folks lived in the Northwest, in what is now known as Manitoba, and they were of the Ojibway people. As was a very common thing in those days, they were nearly all murdered by the Sioux. The very last kinsmen Ah-we-ah had on earth was dead when Ah-we-ah came in one day from his hunting and saw their bodies lying charred and wolf-eaten about the ashes of his father's lodge.

He found himself utterly alone in the world.

The woods Indians, who followed the moose, the bear, and trapped the small animals for the Fur Company, did not live together in great tribal bodies, as did the buffalo Indians; but scattered out, the better to follow the silent methods of their livelihood.

Ah-we-ah was thus forced to live alone in the forest that winter, and his little bark hut was cold and fireless when he came in at night, tired with the long day's hunting. This condition continued for a time, until grief and a feeling of loneliness determined Ah-we-ah to start in

search of a war party, that he might accompany them against their
enemies and have an opportunity to sacrifice honorably a life which
had become irksome to him.

Leaving his belongings on a *sunjegwun,* or scaffold made of stout
poles, he shouldered his old trade gun, his dry meat, called his wolf-dogs,
and betook himself three days through the forest to the small settlement
made by the hunting camps of his tribesman, old Bent Gun—a settle-
ment lying about a series of ponds, of which no name is saved for his
story; nor does it matter now which particular mudholes they were—so
long ago—out there in the trackless waste of poplar and tamarack.

So the lonely hunter came to the lodge of his friend, and sat
him down on a skin across the fire from Bent Gun; and as he dipped
his hollow buffalo horn into the pot, he talked of his losses, his revenge,
his war ardor, and inquired where he was likely to find a fellow feeling
—yes, even pleaded with the old man that he and his sons, too, might
go forth together with him and slay some other simple savage as a
spiritual relief to themselves. He chanted his war song by the night
fire in the lodge, to the discomfort and disturbance of old Bent Gun,
who had large family interests and was minded to stay in his hunting
grounds, which had yielded well to his traps and stalking; besides which,
the snow was deep and the Sioux were far away. It was not the proper
time of the year for war.

By day Ah-we-ah hunted with old Bent Gun and they killed
moose easily in their yards, while the women cut them up and drew
them to the camps. Thus they were happy in the primeval way, what
with plenty of maple sugar, bears' grease, and the kettle always steaming
full of fresh meat.

But still by night Ah-we-ah continued to exalt the nobleness
of the wearing of the red paint and the shrill screams of battle to his
tribesmen; but old Bent Gun did not succumb to their spirit; there was
meat and his family were many. This finally was understood by Ah-we-
ah, who indeed had come to notice the family, and one of them in
particular—a young girl. Also he was conscious of the abundance of
cheer in the teeming lodge.

In the contemplation of life as it passed before his eyes he found
that his gaze centered more and more on the girl. He watched her cut-
ting up the moose and hauling loads through the woods with her dogs.
She was dutiful. Her smile warmed him. Her voice came softly, and
her form as it cut against the snow was good to look at in the eyes of
the young Indian hunter. He knew, since his mother and sister had
gone, that no man can live happily in a lodge without a woman. And
as the girl passed her dark eyes across his, it left a feeling after their
gaze had gone. He was still glorious with the lust of murder, but a new
impulse had seized him—it swayed him, and it finally overpowered him
altogether.

When one day he had killed a moose early in the morning, he

came back to the camp, asking the women to come out and help him in with the meat; and Mik-kau-bun-o-kwa, or the "Red Light of the Morning," and her old mother accompanied him to his quarry.

As they stalked in procession through the sunlit winter forest, the young savage gazed with glowing eyes upon the girl ahead of him. He was a sturdy man in whom life ran high, and he had much character after his manner and his kind. He forgot the scalps of his tribal enemies; they were crowded out by a higher and more immediate purpose. He wanted the girl, and he wanted her with all the fierce resistlessness of a nature which followed its inclinations as undisturbedly as the wolf— which was his totem.

The little party came presently to the dead moose, and the women, with the heavy skinning knives, dismembered the great mahogany mass of hair, while the crunching snow under the moccasins grew red about it. Some little distance off stood the young man, leaning on his gun, and with his blanket drawn about him to his eyes. He watched the girl while she worked, and his eyes dilated and opened wide under the impulse. The blood surged and bounded through his veins. He was hungry for her.

They packed their sleds and hung the remainder in the trees to await another coming. The old woman, having made her load, passed backward along the trail, tugging at her head-line and ejaculating gutturals at her dogs. Then Ah-we-ah stepped quickly to the girl, who

THE PASSION OF AH-WE-AH

was bent over her sled, and seizing her, he threw his blanket with a
deft sweep over her head. He wrapped it around them both; and they
were alone under its protecting folds. They spoke together until the
old woman called to them, when he released her. The girl followed on,
but Ah-we-ah stood by the bloodstained place quietly, without moving,
for a long time.

That night he did not speak of war to old Bent Gun, but he
begged his daughter of him; and the old man called the girl and set
her down beside Ah-we-ah. An old squaw threw a blanket over them,
and they were man and wife.

In a day or two the young man had washed the red paint from
his face and he had a longing for his own lodge, three days away
through the thickets. It would not be so lonesome now, and his fire
would always be burning.

He called his dogs, and with his wife, they all betook themselves
on the tramp to his hunting grounds. The snow had long since filled up
the tracks Ah-we-ah had made when he came to Bent Gun's camp.

He set up his lodge, hunted successfully, and forgot his past as
he sat by the crackle of the fire; while the woman mended his buck-
skins, dried his moccasins, and lighted his long pipe. Many beaver skins
he had on his *sunjegwun*, and many good buckskins were made by his
wife; and when they packed up in the spring, the big canoe was full
of stuff which would bring powder, lead, beads, tobacco, knives, axes,
and stronding, or squaw-cloth, at the stores of the Northwest Company.

Ah-we-ah would have been destitute if he had not been away
when his family were killed by the Sioux, and as it was, he had little
beyond what any hunter has with him. But he had saved his traps, his
canoe, and his dogs, which in the old days were nearly everything
except the lordly gun and the store of provisions.

At a camp where many of the tribe stopped and made maple
sugar, the young pair tarried and boiled sap along with the others until
they had enough sweets for the Indian year. And when the camp broke
up, they followed on to the post of the big company, where they
traded for the year's supplies—double-battle Sussex gunpowder in
corked bottles, pig-lead, blue and red stronding, hard biscuit, steel traps,
axes, and knives. It is not for us to know if they helped the company's
dividends by the purchase of the villainous "made whisky," as it was
called in the trade parlance, but the story relates that his canoe was
deep-laden when he started away into the wilderness.

The canoe was old and worn out, so Ah-we-ah purposed to
make a new one. He was young, and it is not every old man even who
can make a canoe, but since the mechanical member of his family had
his fire put out by the Sioux on that memorable occasion, it was at least
necessary that he try. So he worked at its building and in due time
launched his bark; but it was "quick" in the water, and one day shortly
it tipped over with him while on his journey to his hunting grounds.

He lost all his provisions, his sugar, biscuits and many things besides, but saved his gun. He was suffering from hunger when he again found the company's store; but having made a good hunt the year before, the factor made him a meager credit of powder, lead and the few necessary things. He found himself very poor.

In due course Ah-we-ah and his family set up their lodge. They were alone in the country, which had already been hunted poor. The other people had gone far away to new grounds, but the young man trusted himself and his old locality. He was not wise like the wolves and the old Indians, who follow ceaselessly, knowing that to stop is to die of hunger. He hunted faithfully, and while he laid by no store, his kettle was kept full, and so the summer passed.

He now directed himself more to the hunting of beaver, of which he knew of the presence of about twenty gangs within working distance of his camp. But when he went to break up their houses, he found nearly all of them empty. He at last discovered that some distemper had seized upon the beaver and that they had died. He recovered one which was dying in the water, and when he cut it up, it had a bloody flux about the heart, and he was afraid to eat it. And so it was with others. This was a vast misfortune to the young hunter; but still there were the elk. He had shot four up to this time, and there was "sign" of moose passing about. The leaves fell, and walking in them he made a great noise, and was forced to run down an elk—a thing which could be done by a young and powerful man, but it was very exhausting.

When an Indian hunts the elk in this manner, after he starts the herd he follows at such a gait as he thinks he can maintain for many hours. The elk, being frightened, outstrip him at first by many miles; but the Indian, following at a steady pace along the trail, at length comes in sight of them; then they make another effort and are no more seen for an hour or two; but the intervals in which the Indian has them in sight grow more and more frequent; and longer and longer, until he ceases to lose sight of them at all. The elk are now so much fatigued that they can only move at a slow trot. At last they can but walk, by which time the strength of the Indian is nearly exhausted; but he is commonly able to get near enough to fire into the rear of the herd. This kind of hunting is what Ah-we-ah was at last compelled to do. He could no longer stalk with success, because the season was dry and the dead leaves rattled under his moccasins.

He found a band, and all day long the hungry Indian strove behind the flying elk; but he did not come up, and night found him weak and starved. He lay down by a little fire, and burned tobacco to the four corners of the world, and chanted softly his medicine song, and devoutly hoped that his young wife might soon have meat. It might be that on his return to his lodge he would hear another voice beside that familar one.

Ah-we-ah slept until the gray came in the east; and girding himself, he sped on through the forest. The sun came and found the buckskinned figure gliding through the woods. Through the dry light of the day he sweated, and in the late afternoon shot a young elk. He cut away what meat he could carry in his weakness, ate the liver raw, and with lagging steps hastened backward to his far-off lodge.

The sun was again high before Ah-we-ah raised the entrance mat at his home, and it was some moments before he could discern in the dusk that his wife was not alone. Hunger had done its work, and the young mother had suffered more than women ought.

Her strength had gone.

The man made broth, and together they rested, these two unfortunates; but on the following day nature again interposed the strain of the tightened belly.

Ah-we-ah went forth through the noisy leaves. If rain or snow would come to soften the noise; but no, the cloudless sky overspread the yellow and red of the earth's carpet. No matter with what care the wary moccasin was set to the ground, the *sweesh-sweesh* of the moving hunter carried terror and warning to all animal kind. He could not go back to the slaughtered elk, it was too far for that; and the wolf and wolverine had been there before. Through the long day no hairy or feathered kind passed before his eye. At nightfall he built his fire and sat crooning his medicine song until nature intervened her demands for repose.

With the early light Ah-we-ah went home and looked on the girl and her baby.

The baby was cold.

The dry breasts of Mis-kau-bun-o-kwa had been of no purpose to this last comer; but the mother resisted Ah-we-ah when he tried to take the dead child away, and he left it. This cut and maddened the hunter's mind, and he cursed aloud his medicine bag and flung it from him. It had not brought him even a squirrel to stay the life of his firstborn. His famished dogs had gone away, hunting for themselves; they would no longer stay by the despairing master and his dreary lodge.

Again he dragged his wretched form into the forest, and before the sun was an hour high, the blue smoke had ceased to curl over the woeful place, and the fainting woman lay quite still on her robe. Through the dry brush and the crackling leaves ranged the starving one, though his legs bent and his head reeled. The moose could hear him an hour before he would sight it.

And again at evening he returned to his bleak refuge; the hut was gray and lifeless. He dropped into his place without making a fire. He knew that the woman was going from him. From the opposite side of the wigwam she moaned weakly—he could scarcely hear her.

Ah-we-ah called once more upon his gods, to the regular *thump-thump* of his tom-tom. It was his last effort—his last rage at fate. If the

spirits did not come now, the life would soon go out of the abode of Ah-we-ah, even as the fire had gone.

He beat and sang through the doleful silence, and from the dark tamaracks the wolves made answer. They, too, were hungry.

The air, the leaves, the trees, were still; they listened to the low moan of the woman, to the dull thump of the tom-tom, to the long piercing howl of the wolf, the low rising and falling voice of the man chanting: *"He-ah neen-gui-o-ho o-ho man-i-to-we-tah-hah gah-neen-qui-o we-i-ah-nah we-he-a."*

The air grew chill and cold. Ah-we-ah was aroused from his deep communion by cold spots on his face. He opened the doormat. He peered into the gray light of the softly falling snow. The spirits had come to him, he had a new energy, and seizing his gun, the half-delirious man tottered into the forest, saying softly to himself, "A bear—I walk like a bear myself—myself I walk like a bear—a beast comes calling—I am loaded—I am ready. Oh, my spirit! Oh, my manitou!"

A black mass crossed the Indian's path—it had not heard the moccasins in the muffle of the snow. The old trade gun boomed through the forest and the manitou had sent at last to Ah-we-ah a black bear. He tore out his knife and cut a small load of meat from the bear, and then he strode on his back track as swiftly as he could in his weakness. He came to the hole in the forest in the middle of which sat the lodge, calling, "Mis-kau-bun-o-kwa! Mis-kau-bun-o-kwa!" but there was no answer.

He quickly lighted a fire—he threw meat upon it, and bending backward from the flame, touched her, saying, "Good bear, Mis-kau-bun-o-kwa; I have a good bear for the *bud-ka-da-win*—for the hunger"; but Mis-kau-bun-o-kwa could not answer Ah-we-ah. The dry leaves had lasted longer than she.

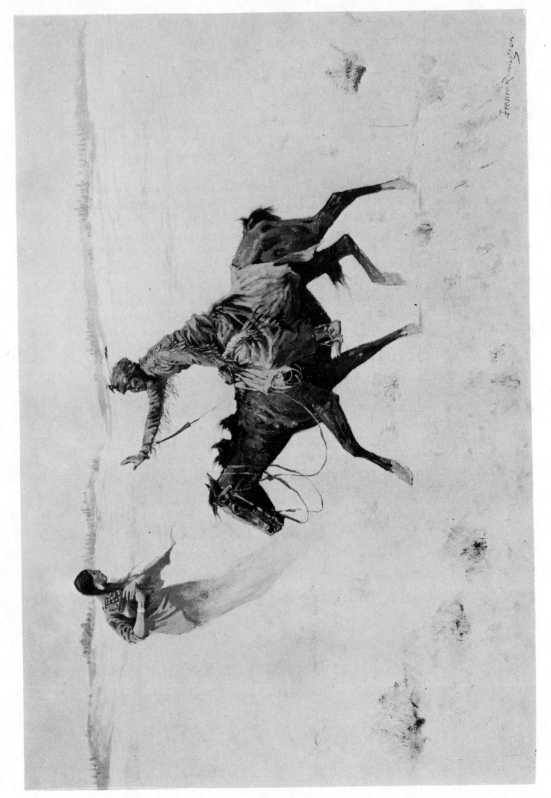

"SHE WAS KEEP OFF JUS' FRONT OF MY PONY"

XVI

How Order No. 6 Went Through

We were full of venison and coffee as we gathered close around the campfire, wiping the fitful smoke out of our eyes alternately as it came our way.

"It's blowing like the devil," said the sportsman as he turned up his face to the pine trees.

"Yees, sair. Maybeso dar be grass fire secon' t'ing we know," coincided Sun-Down Leflare.

Silver-Tip, the one who drove the wagon, stood with his back to us, gazing out across the mountain to an ominous red glare far to the south. "Ef that forest fire gets into Black Canyon, we'll be straddlin' out of yer all sorts of gaits before mornin'," he remarked.

"Cole night," observed Bear-Claw, which having exhausted his stock of English, he spoke further to Fire-Bear, but his conversation was opaque to us.

"Look at the stars!" continued the sportsman.

"Yes—pore critters—they have got to stay out all night; but I am going to turn in. It's dam cold," and Silver-Tip patted and mauled at his blankets.

"What was the coldest night you ever saw?" I asked.

He pulled off his boots, saying, "Seen heap of cold nights—dun'no' what was the coldest—reckon I put in one over on the Bull Mountains, winter of eighty, that I ain't going to forget. If nex' day hadn't been a Chinook, reckon I'd be thar now."

"You have been nearly frozen, I suppose, Sun-Down?" I added.

"Yees, sair—I was cole once all right."

"Ah—the old coffee-cooler, he's been cold plenty of times. Any man what lives in a tepee has been cold, I reckon; they've been that way six months for a stretch," and having made this good-natured contribution, Silver-Tip pulled his blanket over his head.

Sun-Down's French nervousness rose. "Ah—dat mule skinner, what she know 'bout cole?—she freeze on de green grass. I freeze seex

183

day in de middle of de wintar over dar Buford. By gar, dat weare
freeze, too! Come dam near put my light out. Um-m-m!" and I knew
that Sun-Down was my prey.

"How was that?"

"Over Fort Keough—I was scout for Ewers—she was chief scout
for Miles," went on Leflare.

"Yas, I was scout, too—over Keough—same time," put in Ramon,
the club-footed Mexican.

"Yees, Ramon was scout, too. Say—Miles, she beeg man Eas'—
hey? I see her come troo agency—well, fall of ninety. Ah, she ole man;
don' look like she use be sebenty-seben. Good-lookin' den."

"Wall—what you 'spect?" sighed his congener Ramon, in a harsh
interruption. "I was good-lookin' mon myselef—sebenty-seben."

"You weare buy more squaw dan you weare eber steal—you
ole frog. Dat Miles, she was mak heap of trouble up dees way. I was
geet sebenty dollar a month. She not trouble my people, but she was
no good for Cheyenne un Sioux. Dey was nevar have one good night
sleep af'er she was buil' de log house on de Tongue Rivière. Ah, ha,
we was have hell of a time dem day'—don' we, Wolf-Voice?" and that
worthy threw up his head quickly, and said, "Umph!"

"Well—I was wid my ole woman set in de lodge one day. Eet
was cole. Lieuten't Ewers, she send for me. I was know I was got for
tak eet or lose de sebenty. Well, I tak eet. Eet was cole.

"I was t'ink since, it weare dam good t'ing I lose dat sebenty.
I was geet two pony, un was go to log house, where de *officier* she
write all time in de book. Lieuten't was say I go to Buford. I was say
eet dam cole weddar for Buford. Lieuten't was say I dam coffee-cooler.
Well—I was not. Sitts-on-the-Point and Dick, she white man, was
order go Buford wid me. Lieuten't was say, when she han' me beeg
lettair wid de red button, 'You keep eet clean, Leflare, un you go
troo.' I tole heem I was go troo, eef eet was freeze de steamboat.

"We was go out of de fort on our pony—wid de led horse.
We was tak nothin' to eat, 'cause we was eat de buffalo. I was look
lak de leetle buffalo—all skin. Skin hat—skin robe—skin leggin'—you
shoot me eef you see me. Eet was cole. We weare ride lak hell. When
we was geet to Big Dry, Dick she say, 'Your pony no good; your pony
not have de oat; you go back. He says he mak Buford tomorrow night.
I say, 'Yees, we go back tomorrow.'

"We mak leetle sleep, un Sitts-on-the-Point, he go back Keough,
but I geets crazy, un say I brave man; I weel not go back; I weel go
Buford, or give de dinner to de dam coyote. I weel go.

"My pony he was not able for run, un Dick she go over de
keel me, but dey see I was Leflare, so dey rope my pony, tak me een
was watch. I was hungry; dar was nothin' een me. All right, I was go
top of de heel—I was not see a buffalo. All deese while I was head
for de Mountain-Sheep Buttes, where I know Gros Ventre camp up

SUNDOWN LEFLARE, WASHED AND DRESSED UP

by Buford. Eet was blow de snow, un I was walk heap for keep warm.
I was t'ink, eef no buffalo, no Gros Ventre camp for Leflare, by gar.
I was marry Gros Ventre woman once, un eef I was geet dar, I be
all right. De snow, she blow, un I could see not a t'ing. When eet geet
dark, I was not know where I was go, un was lay down een de willow
bush. Oh, de cole—how de hell you 'spect I sleep?—not sleep one wink,
'cept one. Well, my pony was try break away, but I was watch' 'im,
'cept dat one wink. De dam pony what was led horse, she was geet off
een de one wink. I see her track een de mornin', but I was not able
for run him wid de order pony. He was geet clean away. 'Bout dat I
was sorry, for een de daytime I was go keel heem eef no buffalo.

"Een de mornin' de win', she blow; de snow, she blow too. Eet was long time 'fore I untie my lariat, un couldn't get on pony 'tall—all steef—all froze. I walk long—walk long"; and Sun-Down shrugged up his shoulders and eyebrows while he shut down his eyes and mouth in a most forlorn way. He had the quick nervous French delivery of his father, coupled with the harsh voice of his Indian mother. There was also much of the English language employed by this waif of the Plains which, I know, you will forgive me if I do not introduce.

"I deedn't know where I was—I was los'—couldn't see one t'ing. Was keep under cut bank for dodge win'. De snow, she bank up een plass, mak me geet out on de pararie, den de win', she mak me hump. Pony, he was heavy leg for punch troo de snow. All time I was watch out for buffalo, but dar was no buffalo"; and Sun-Down's voice rose in sympathy with the frightful condition which haunted his memory.

"Begin to t'ink my medicin was go plumb back on me. Den I t'ink Ewers—wish she out here wid dam ole order. Eet mak me mad. Order—all time order—by gar, order soldier to change hees shirt—scout go two hundred miles. My belly, she draw up like tom-tom, un my head go roun', roun', lak t'ing Ramon was mak de hair rope wid; my han', she shake lak de leaf de plum tree. I was fall down under cut-bank, wid pony rope tie roun' me. Pony, he stay, or tak me wid heem. How long I lay—well, I dun'no', but I was cole un wak up. Eet was steel—de star she shine; de win' she stop blow. Long time I was geet up slow. I was move leetle—move leetle—den I was move queek—more leetle—move queek. All right—you eat ten deer reebs while I was geet up un stan' on my feet. Pony he was white wid de snow un de fros'. Buffalo robe she steef lak de wagon box. Long time I was move my finger—was try mak fire, un after while she blaze up. Ah, good fire—she steek in my head. Me un pony we geet thaw out one side, den oder side. I was look at pony—pony was look at me. By gar— I t'ink he was 'fraid I eat heem; but I was say no—I eat him by-un-by. I was melt de snow een my tin cup—was drink de hot water—eet mak me strong. Den come light, I was ride to beeg butte, look all roun'—all over, but couldn't tell where I was. Den I was say, no buffalo, I go Missouri Rivière.

"Long time, I was come to de buffalo. Dey was all roun'—oh, everywhere—well, hundred yard. When I was geet up close, I was aim de gun for shoot. I couldn't hole dat gun—she was wabble lak de pony tail een de fly-time. All right, I shoot un shoot at de dam buffalo, but I neber heet eem 'tall—all run off. My head she swim; my han', she shake; my belly, she come up een my neck un go roun' lak she come untie. I almos' cry.

"Well—I dun'no jus' what den. 'Pears lak my head she go plumb off. I was wave my gun; was say I not afraid of de Sioux. Dam de Sioux! —I was fight all de Sioux in de worl'. I was go over de snow fight dem, un I was yell terrible. Eet seem lack all de Sioux, all de Cheyenne, all de Assiniboine, all de bad Engun een de worl', she come out of de sky,

all run dar pony un wave dar gun. I could hear dar pony gallop ovar my head. I was fight 'em all, but dey went 'way.

"A girl what I was use know she come drop—drop out of de sky. She had kettle of boil meat, but she was not come right up—was keep off jus' front of my pony. I was run after de girl, but she was float 'long front of me—I could not catch her. Den I don' know nothin'.

"Black George un Flyin' Medicin was two scout come to Keough from Fort Peck. Dey saw me un follow me—dey was go to keel me, but dey see I was Leflare, so dey rope my pony, talk me een brush, mak fire, un give me leetle meat. By come night I was feel good —was geet strong.

"We was 'fraid of de Assiniboine—'cause de order fellers had seen beeg sign, I sais let us go 'way mile or so un leave fire burn here.

"Black George, he sais he no dam ole woman—he brav' man— fight dem—no care dam for Assiniboine.

"I say to myself, all right—Assiniboine been foller you. I go.

"Flyin' Medicin, he want to go, but George he sais Assiniboine scare woman wid hees pony track—umph! un Flyin' Medicin, she sais she no ole woman. I say, by gar, I am woman; I have got sense. You wan' stay here, you be dead. Den I tak my pony un I go 'way een de dark, but I look back dar un see Medicin, she lie on de robe, Black George she set smoke de pipe, un a gray dog, he set on de order side, all een de firelight. I sais, Dam fools.

"Well, I got for tell what happen. When I was go 'bout mile, I was lay down. 'Bout one hour I hear hell of shootin'. I geet up queek, climb pony, run lak hell. I was ole woman, un I was dam glad for be ole woman. Eet was dark; pony was very thin; all same I mak' heap of trail 'fore mornin' bes' I could."

I asked Sun-Down what made the shooting.

"Oh—Black George camp—course I deedn't know, but I was t'ink strong, eet be hees camp all right, 'nough. Long time after I hear how 'twas. Well—dey lay dar by de fire—Medicin on hees back— George she set up—dog he set up order side—Assiniboine come on dar trail. I was ole woman—eef not, maybeso I was set by de fire too— humph!

"George he geet no chance fight Assiniboine. Dey fire on hees camp, shoot Flyin' Medicin five time—all troo chest, all troo leg, all troo neck—all shoot up. Black George she was shot t'ree time troo lef' arm; un, by gar, gray dog, she keel, too. Black George grab hees gun un was run jump down de cut-bank. Assiniboine was rush de camp un run off de pony, but George she was manage wid her lef' han' to shoot over cut-bank, un dey was not dare tak Medicin's hair. Black George, he was brave man. He was talk beeg, but he was as beeg as hees talk. He was scout roun', un was see no Assiniboine; he was come to Flyin' Medicin, who was go gurgle, gurgle—oh, he was all shot—all blood," and here Sun-Down made a noise which was awfully realistic and quite

unprintable, showing clearly that he had seen men who were past all surgery.

"George, she raise Medicin up, was res' hees head on hees arm, un den Medicin was give heem hell. He was say, 'Deedn't I tole you? By gar, you dam brave man; you dam beeg fool! You do as I tole you, we be 'live, by gar. Now our time has come.' When he could speak again—when he had speet out de blood—he sais, 'Go geet my war bag —geet out my war bonnet—my bead shirt—my bead moccasins—put 'em on me—my time has come'; un Black George, she geet out all de fine war clothes, un she dress Medicin up—all up een de war clothes. 'Put my medicin bag on my breas'—good-by, Black George—keek de fire —good-by'; un Medicin die, all right.

"Course Black George, she put out a foot un mak trail for Keough. He was haf awful time; was seex day geet to buffalo-hunter camp, where she was crawl mos' of de way. De hunter was geeve heem de grub, un was pull heem to Keough een dar wagon. Reckon he was cole—all de blood run out hees arm—nothin' to eat—seez day—reckon dat ole mule skinner, she tink she was cole eef she Black George."

"What became of you meanwhile?"

"Me? Well—I was not stop until come bright day; den my pony was go deese way, was go dat way"—here Sun-Down spread out his fingertips on the ground and imitated the staggering forefeet of a horse.

"I was res' my pony half day, un was try keel buffalo, but I was weak lak leetle baby. My belly was draw up—was go roun'—was turn upside down—was hurt me lak I had wile-cat inside my reebs. De buffalo was roun' dar. One minute I see 'em all right, nex' minute dey go roun' lak dey was all drunk. No use—I could not keel buffalo. Eet was Gros Ventre camp or bus' Leflare wid me den. All time eet very cole; fros' go *pop, pop* under pony feet. Guess I look lak dead man— guess I feel dam sight worse. Dat seez day, she mak me very ole man.

"I was haf go slow—pony he near done—jus' talk 'long. I deedn't care dam for Assiniboine now. De gray wolf, he was follow 'long behin' —two—t'ree—four wolf. I deedn't care dam for wolf. All Sioux, all Assiniboine, all wolf een de worl'—she go to hell now; I no care. I was want geet to Gros Ventre camp 'fore I die. I was walk 'long slow— was feed my pony; my feet, my han's was get cold, hard lak knive-blade. I was haf go to cut-bank for fall on my pony's back—no crawl up no more. I was ride all night, slow, slow. Was sit down; wolf was come up look at me. I was tell wolf to go to hell.

"Nex' day, same t'ing—go 'long slow. Pony, he was dead; he no care for me. I can no more keek heem; I cannot use whip; I was dead.

"You ask me eef I was ever froze—hey, what you t'ink? Dat mule skinner, Silver-Tip, he been dar, by gar, he nevair melt all next summer.

"Jus' dark. I was come een big timber by creek. I was t'ink

I die dar, for I could not mak de fire. I was stan' steel lak de steer een de coulee when de blizzair she blow. Den what you t'ink? I was hear Gros Ventre woman talk 'cross de *rivière*. She was come geet de wattair. I was lead de pony on de hice. I was not know much, but I was wake up by fall een wattair troo crack een hice. My rein was roun' my shoulder; my gun, she cross my two arm. I could not use my han'. When I was fall, gun she catch 'cross hice—pony was pull lak hell, was pull me out. I was wet, but I was wake up. Eef dat bridle she break, een de springtime day fine Leflare een wheat-fiel' down Dakotah.

"De woman was say, 'Go below—you find de ford.' Den he was run. After while I get 'cross ford—all hice. Was come dam near die standin' up. I was see leetle log house, un was go to door un pound wid my elbow. 'Let me een—let me een—I froze,' sais I, een Gros Ventre.

"Dey say, 'Who you are?'

"I sais, 'I am Leflare—I die een 'bout one minute—let me een.'

" 'You talk Gros Ventre; maybeso you bad Engun. How we know you Leflare?' sais de woman.

" 'Eef I not Leflare, shoot when you open de door,' un dey open de door. I t'ink dey was come near shoot me—I was look terrible —dey was 'fraid. I grab de fire, but dey was pull me 'way. Dey was sit on me un tak off my clothes un rub me wid de snow. Well, dey was good; I dun'no' what dey do, but I was eat, eat, leetle at a time, till I was fall 'sleep. When I was wake up, I was say, 'Tak dam ole order to Buford,' un I was tole de man what was tak eet I was keel heem eef he not tak eet.

I was fall 'sleep. When I was wake up, I was say, 'Tak dam ole order Buford. Dey sais de order she was all right. Den dey want me go back Keough wid order. I sais 'Dam glad go back,' for de weddar she was fine den. 'You geeve me pony.'

" 'Why geeve you pony?" sais de *officier*.

" 'By gar, de las' order, she keel my pony,' I sais."

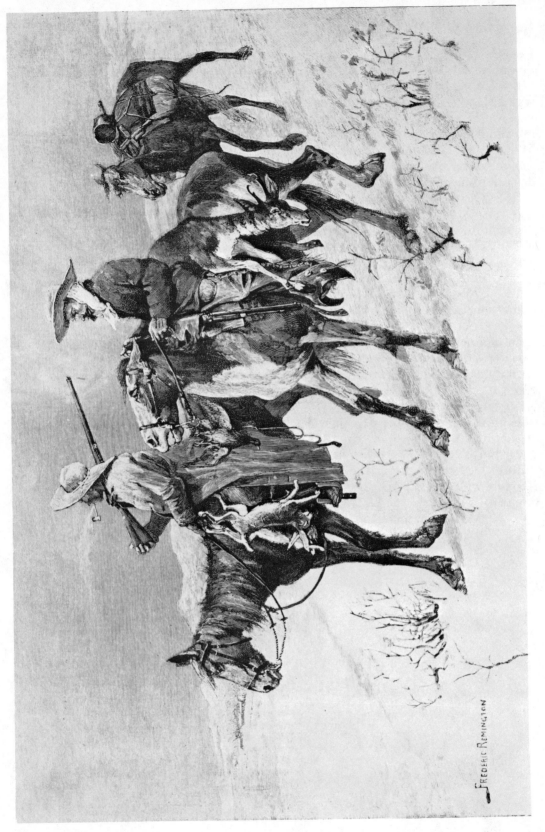

THANKSGIVING DINNER

XVII

Thanksgiving Dinner for the Ranch

The foreman of the ranch had a New England "broughtin'-up," so he expressed it. His first ideas of life had been derived from a lumber camp in the Maine woods. While still a lad he had drifted to Michigan, and been carried on to Montana. There were certain conventionalities which he adhered to. There had to be a good spread for Thanksgiving. Fourth of July! That was a busy time. There were round-ups then, and hard work crowded out patriotism. But Thanksgiving! That was a holiday of quite a different character. It is wonderful in the history of man how retentive is his memory, how conservative he becomes, when there is connection between "the day we celebrate" and the particular food adapted to the situation. That boss had only to hint to the boys "that they had better be looking round for some fresh meat for Thanksgiving." The whole outfit understood what he meant. Of bacon and canned stores there was plenty, and though good for every day, not fitted for Thanksgiving. On a ranch, fresh meat does not always mean flesh of cow or steer. The fact is that only at certain seasons do the boys get their fill of beef. Fresh meat in the far West means game, and elk, deer, and antelope are included in the category.

There is nothing cowboys like better than to hunt, and indefatigable and skillful sportsmen they are. At once three or four small expeditions are organized. The boys know the ground perfectly, for they have ridden over the whole of it looking up stray cattle. As quick to follow a trail as an Indian, every indication of game has been remembered by them. November is a little bit late, for there are occasional snowfalls and the wind is bitter at times; but the fun of the thing makes the boys indifferent to weather.

They could probably find game and be back at the ranch in a couple of hours. But a proper hunting trip has to include at least one night beside a camp fire, out under the stars. On the extra horse that brings up the rear is that most comprehensive thing known as the outfit. It is not in this instance very extensive; a much battered coffeepot, a

rather bumpy frying pan, a little bacon, some flour, and an extra blanket or so. It is just at the time when antelope are hard to get, but they stalk and shoot a good one; and in certain seasons there is no juicier or better-flavored meat than that a prong-horn buck furnishes. Jack rabbits and a bird or so are also included.

Appetites on a ranch are hearty, and though many of the boys have left the outfit for the winter, what these two bring might not satisfy hungers which are of Homeric proportions. What these two cow-boys have bagged is but a quota of the whole, for just as likely as not a royal elk has fallen before another party's Winchesters. It may be depended upon that the rough tables at the ranch on that Thanksgiving Day will be well garnished, and the New England boss fully satisfied.

There is not much sentiment about the cowpuncher. He lives for the day, indifferent about tomorrow. His life is a hard one, and Thanksgiving Day is not more sacred to him than any other day; still, he listens to the boss, who, generally a silent and maybe a taciturn man, unbends for the moment. He tells his following of former New England times, and shows no small pride when he descants on the Puritan blood that runs through his veins, and informs them that for thousands of miles all over the great land on that day, amid good cheer and pleasant company, there will be spoken words of gratitude for the many blessings God has showered on the people of this country.

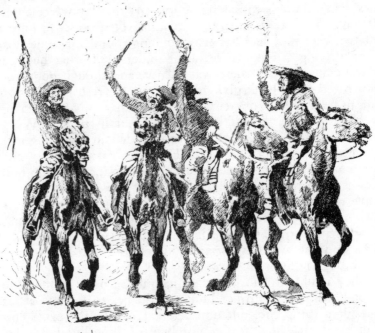

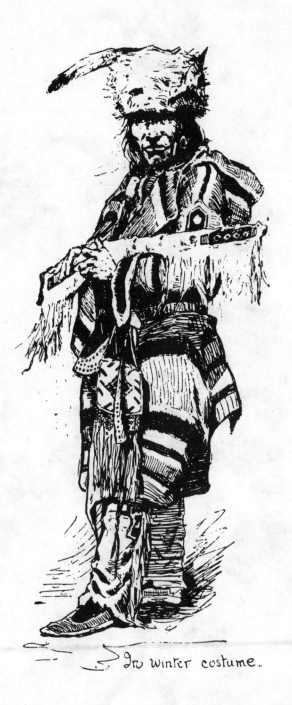

In winter costume.

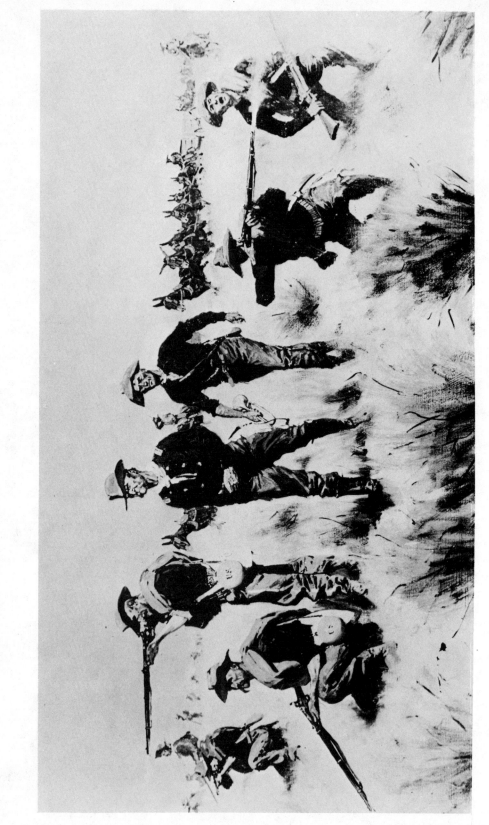

PROTECTING THE WAGONS

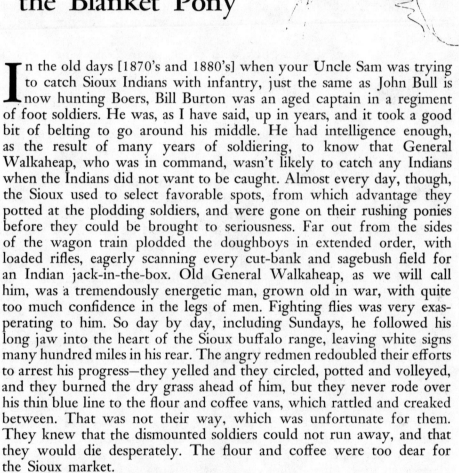

XVIII

The Strategy of
the Blanket Pony

In the old days [1870's and 1880's] when your Uncle Sam was trying to catch Sioux Indians with infantry, just the same as John Bull is now hunting Boers, Bill Burton was an aged captain in a regiment of foot soldiers. He was, as I have said, up in years, and it took a good bit of belting to go around his middle. He had intelligence enough, as the result of many years of soldiering, to know that General Walkaheap, who was in command, wasn't likely to catch any Indians when the Indians did not want to be caught. Almost every day, though, the Sioux used to select favorable spots, from which advantage they potted at the plodding soldiers, and were gone on their rushing ponies before they could be brought to seriousness. Far out from the sides of the wagon train plodded the doughboys in extended order, with loaded rifles, eagerly scanning every cut-bank and sagebush field for an Indian jack-in-the-box. Old General Walkaheap, as we will call him, was a tremendously energetic man, grown old in war, with quite too much confidence in the legs of men. Fighting flies was very exasperating to him. So day by day, including Sundays, he followed his long jaw into the heart of the Sioux buffalo range, leaving white signs many hundred miles in his rear. The angry redmen redoubled their efforts to arrest his progress—they yelled and they circled, potted and volleyed, and they burned the dry grass ahead of him, but they never rode over his thin blue line to the flour and coffee vans, which rattled and creaked between. That was not their way, which was unfortunate for them. They knew that the dismounted soldiers could not run away, and that they would die desperately. The flour and coffee were too dear for the Sioux market.

Well, out in the van rode the general, grim and determined, quite forgetful of men's legs in his purpose to come to close quarters or to at least occupy the heart of their hunting range. Captain Bill Burton had water blisters on his feet, his canteen was always dry, and he longed for a day's letup so he might wash, shave, and lie quietly on his back with his pipe in his mouth, "inviting" his soul.

"There are those d——n Indians now," he said to his trusty lieu-

tenant, Dick Van Nick. "Steady, men! Close up your intervals. Don't fire! Let them come closer."

Down through the dry washes sped the warriors—hovering hawklike, veering before the steady rifles and away. Again the dusty blue line stepped forward.

Captain Burton and General Walkaheap had, in times gone by but not forgotten, had their personal differences, and they were by no means admirers of each other. They seldom came nearer than they officially had to.

"If the old man would stop for a day or so once a month, these Indians might give us an infantry fight. We travel so fast, they can't make up their minds what to do," remarked the vinegary Burton to Van Nick.

"Yes," replied Van Nick with a deep sigh. "Say, Uncle Bill, I wonder if angels have big leather armchairs to sit in? That would pretty near fill my idea of heaven."

"Blow the angels, Dick. If I could only be a major and ride a horse, that would do."

"Well, anyhow, Uncle Bill," spoke Dick, "when we get into camp, we have our little nip while the other fellows are as dry as their belt plates. What?"

"Yes, yes, my son—if only our fellows don't get onto us. If they do, our whisky will last like the Irishman's—pretty d——n quick."

On the start of the expedition against the hostile Indians of the Northwest the old general had, with intent to free his loaded wagons from useless litter, ordered all the whisky left behind. He had made the officers cache their personal belongings, only allowing each one as much as he could hold out in his right hand. But Burton and Van Nick had bought a blanket pony, which did not entrench on the Government transportation, and had more bedding than would otherwise have been possible. At least that was the natural theory, when as a matter of fact in the blanket panniers were two large jugs of rare rye whisky, carefully packed and swaddled. The column had not toiled many days before our worthies became aware that they were the only people in the camp who had any of the encouraging medicine. The blanket pony was tied behind a wagon by day, and at evening halts the captain and lieutenant personally unpacked him. They had by almost superhuman shrewdness and painstaking care managed to conceal the fact that they had a "nightcap" and an "eye opener" at the respective times each day. There were occasional rumors among their comrades in arms to the effect that Captain Bill and his trusted bunkie smelled of the "old thing," but they dissembled and denied. Many weary leagues lay between their cantinas of rye and a further supply, so they did not blame themselves for the selfish protection of their possession. Two jugs were enough for them personally, but among so many officers, if it were known, they would soon be drained.

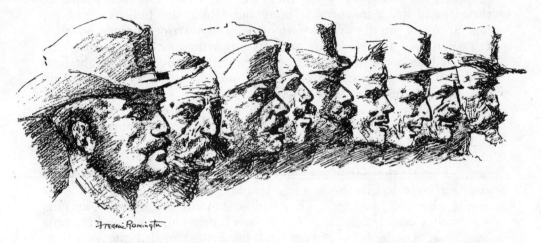

Along through the buffalo grass and the gray sage tramped the soldiers—bearded and dusty and bored. Far out on the plains they could see at times their wolfish following, but they did not come near enough to give them the relaxation of a fight. At night, to be sure, they came to shoot into the camps and wagons, keeping the men awake. They made very delicate work for the pickets in the darkness, also for the officer of the guard, who had to go, stumbling about in the gloom. All of this exasperated the men, and particularly the old general, whose ideas of war had been gathered at such places as Chapultepec and the Death Angle. He longed to get at them; he yearned for contact with these desert hawks, and he pressed them as hard as his men could leg it or his mules be whacked along, but to no purpose. He left ambuscades for them which they never fell into. He hunted them in the darkness and the rain; but they were hunters themselves. It became utterly discouraging, so he mentally gave it up and just marched. He ceased to be interested in his own strategy.

Everyone else felt the same way. Everyone had ceased to expect that the regiment would get any credit out of this cheerless war, and one day Van Nick said to Uncle Billy, "It does seem kind of low-down of us to husband that rum when we could use it in the interest of the regiment—don't it, now?"

"What do you mean, Dick? You don't dream of springing it on the fellows?"

"Oh no, Captain, that isn't my idea; my idea is to use it strategically."

"Use whisky strategically?"

"Yes—give it to the Indians. It might make them fight."

"Ho, ho! I see. That's not a bad idea; but how? It's against orders to have it with us at all."

Dick thought awhile, and future general that he was to be, finally

proposed that someday when they were in camp and well prepared, they should drive the blanket pony out where the Indians could get him and rely on the whisky to make the warriors brave. So their campaign was arranged, not without misgivings as to the possibilities of so sudden a conjunction of red men and red liquor. It might be a powerful combination, or a weak one, but experience of the past said Yes. Shortly the train made a day's resting halt. The mules had come in from grazing and were safe within the wagon corral. Well out on each four sides of the camp lay a battalion of infantry—deployed—loaded and tired of the monotony which their shifting enemies enforced. They could put no salt on the Sioux bird's tail.

Out to the north, on some low bluffs not five hundred yards away, a considerable body of warriors were squatting beside their ponies, observing the camp. They had no desire to come nearer; keeping watch, they could both see and understand. Being all ready and the time propitious, Uncle Billy Burton and his lieutenant led the poor old blanket pony outside the line of soldiers.

"Where the hell are you going with that pony, Burton?" sang out one of a group of officers who sat playing poker on the grass.

"Oh, I am going to exercise him. He don't get work enough," responded our merry strategist with a wink.

The game stopped. Some soldier lark ahead possibly. They might be amused, they hoped.

The two officers borrowed rifles and belts as they passed through the line. Leading the loaded pony, they marched forth toward the row of grotesque figures sitting on the bluffs. When this curious trio had advanced a hundred and fifty yards, the warriors out in the distance began to gird and mount. Neither did they understand. The troops had never so maneuvered before. Was it a talk which was wanted, were the soldiers sick of the long-drawn game, or was it some deep-seated thoughtfulness? The Indians did not make it out. Neither did the waiting troops. They had never before seen two men leading a simple pony out into the open between two forces bent on each other's destruction. It was not in the books; it had never been told around the winter fires.

With the alert willingness to take advantage of the chances, the Sioux quirted and kicked their ponies into a proper state of anticipation of the game. The regulars sat up, spread their faces cheerfully, and fingered their rifle sights up to the possible distances. Steadily the officers advanced on their curious adventure.

"Say, Uncle Bill, I think we had better stop; when they come, we won't have much the best of a race back to the lines."

"All right—I think we are about right; but, Dick, I don't want this whisky to come back on us. It won't do us a damn bit of good and may do us harm if the general gets onto it, and the boys would never let us hear the last of it. No! wait. Get your horseshoes ready. Tie

them on, but hold up his tail, and for —— sake, Dick, don't get him started the wrong way or we are dirt."

Lieutenant Van Nick proceeded quickly to tie a string of mule shoes, which he had strung on some "whang" leather, to the blanket pony's tail. He wove it in tight and strong. Meanwhile the anxious Sioux had begun to circle and hover in their bird-of-prey fashion, confident of their mobility.

"Hurry up, Dick! The damn whelps will come soon. They will scare the pony back into the lines."

"All right, Uncle—I have him fixed. Are you ready?"

"Yes—turn him loose."

This was one of those battles which had been thought out before it was begun, which seldom happens outside books. It was the soldier ideal—the real military ideal; it was what the boys at West Point had studied when they tried their simple strategy on the Academy staff, that being, in cadet theory, the way to apply talent. The captain had the thin old calico pony, loaded with his two panniers, turned toward the enemy. Dick raised the consecrated animal's tail and made a quick pass under it; he dropped the same suddenly; the string of mule shoes clattered about its hocks; with his rifle he gave the beast a big whack and fired a cartridge over its back. The blanket pony's memories of patient treatment were all forgotten in this sudden movement of his ganglions. He made off toward the rushing Sioux.

Turning toward their lines, the two officers ran for it—only looking back occasionally to see what the blanket pony was doing. He had run away about a hundred yards, but upon seeing the charging Indian line, had stopped.

"Keep between the pony and our line so they won't shoot," called out the lieutenant.

This they did. The line held its fire, and the Indians rounded up the pony and bore it away.

Coming among their comrades, they were greeted with amazement. "What the —— are you doing?" "Burton, you must be crazy," etc.

"They certainly did get our pony," said Burton, grinning.

"Why didn't you lie down and let us fire over you?" was asked; but the pony strategists shed no light, and walked away to speculate in quiet.

Again the soldiers lay down in groups along the line, and the poker game was resumed amid wild conjectures as to Bill Burton's sanity. They could see a possible joke in giving up the old pony, though why sacrifice all those blankets now that winter was approaching? But mostly they gave it up.

The Indians had gone out of sight beyond the bluffs. "It won't take long before we will see what our combination of reds will produce. Chemically speaking, we ought to get a wild scrap in twenty minutes or a half hour," speculated Van Nick.

"See Bill—looking at the horizon through his glasses. Guess he's making medicine for the lost bronc," observed a poker player.

Time passed, when suddenly Captain Bill took down his glasses. "They are coming, Dick," and he ran forward. "Attention! Get ready! Now we'll have the fight of our lives, boys. Make no mistake now— they are coming home this time!" he yelled.

The line sprang to its knees; the officers drew their swords and stood to their places. Down the bluff and over the plain came the wild, charging line of warriors—scintillating bright reds and yellows and whites—revolvers and rifles going in the air—their shrill "yips" even reaching at his distance, and the ponies beating madly. Now and then a warrior fell from his pony, and yet not a shot had been fired.

"Ready!—aim!—fire!" The gray lead sped; the blue smoke eddied out along the grass "Load!—ready!—aim!—fire!" and again sped the deadly volley. Faintly through the smoke the soldiers saw the swift line come. In fierce nervousness they picked at their belts, threw up and down the breechblocks, and poured it in. Ponies lay kicking all along behind the Indian squadron, but on they came. Many soldiers jammed their bayonets into the sockets, many clubbed their rifles, and some lay flat on the ground.

"They are coming home!" was yelled in the captain's ear as he threw himself on the ground. The beating crowd of ponies rode over the skirmish line, but it did not fire or stop. The soldiers punched and belted with their guns. Warriors reeled and rolled like sacks of flour along the ground. There were many riderless ponies. These continued on, while the mounted ones were twisted and turned about in aimless fashion to renew the attack. Warriors were seen to roll about on the

ponies' backs, some were hanging on by an eyelid, others had their arms around their ponies' necks, not seeking to control them. The soldiers ran to catch them, but found the Indians not inclined to resist. They saw others sitting on the grass, waving their arms aimlessly. They stopped to regard them wonderingly. The entire absence of offensiveness on the part of the reds was slowly understood, until men began to call, "They are drunk!" "They are all drunk!" and then they pulled what few were left from their ponies and sat on their chests.

As things began to clear, it was seen that there were no casualties among the soldiers, and they were amazed to see Burton and Van Nick slapping their thighs and each other's backs while they roared and screamed with laughter. The others, comprehending, began to howl, until the whole battalion, so lately grim before death, yelled in happy chorus.

"Say, Bill, why didn't you give us a drop before you got rid of that whisky, you old villain?"

"Well, boys, you got a fight, and that's better than a drink—ain't it? You fellows would kick anyway."

The general came galloping and stood staring at his successor, but did not understand the laughter. "What was on that pony, Captain?" he demanded at last.

"That was a medicine pony, General—he was loaded with the Great Spirit," returned our strategist with cheerful innocence.

The general rode away, smiling. The men walked out, gathered up the drunk and wounded and the empty blanket pony, shot the downed horses, and congratulated each other on the good fortunes of the S'teenth Foot, which would get ample credit, even if it was accomplished by "shrewdness and force and by deeds unknown."

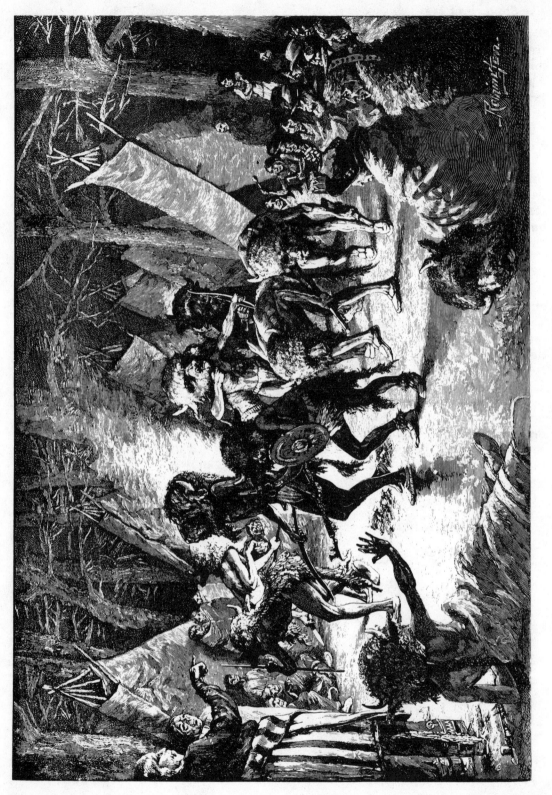

THE BUFFALO DANCE

XIX

The Buffalo Dance

Among the Indians of the northern Plains is a custom called "dancing the buffalo." It is resorted to when the hunters have great difficulty in finding buffalo—a difficulty which has been growing more pronounced every year, until of late the poor Indian finds his "buffalo medicine dance" fails universally, and he has all but lost faith in it. And yet it has but rarely failed before, for the peculiar strength of the "medicine" lies in the fact that when the medicine dance is once started, it is kept up religiously night and day until the outriders discover buffalo, and as the Indian reasons, the dance brought them.

The Crows had a dance in which they believed that the Great Spirit had secluded the buffalo temporarily, but that as soon as he recovered from his sulk, he would send them back again. The Crow dance did bring a half-dozen old bulls to the Crow hunters; not much meat, to be sure, but a sure sign of the strength of the medicine.

Ten or a dozen men dance at a time, and as they grow weary and leave their places, others take them, and so keep up the ceremony. They wear the head or mask of a buffalo, which each warrior is supposed to keep in his outfit; the tails are often attached to these by a long piece of hide. Drums are beaten, rattles shaken, and the usual Indian yelling is kept up. The hunters all have their arms ready and the outlying hills are patrolled. These dances have been kept up in certain villages for two or three weeks on a stretch without stopping an instant. When a man becomes fatigued, he signifies it by bending quite low, when another draws a bow and hits him with a blunt arrow. He falls to the ground and is dragged off by the spectators, who proceed to butcher him in pantomine, much after the fashion of children; for the Indian in his moods is for all the world like an overgrown boy. . . . Alas for the buffalo, and alas for the poor Indian, too, the buffalo dance will no more bring the countless thousands of bison to the sight of the hunter, and the only meat he will ever eat ranges between Government steers and sage hens.

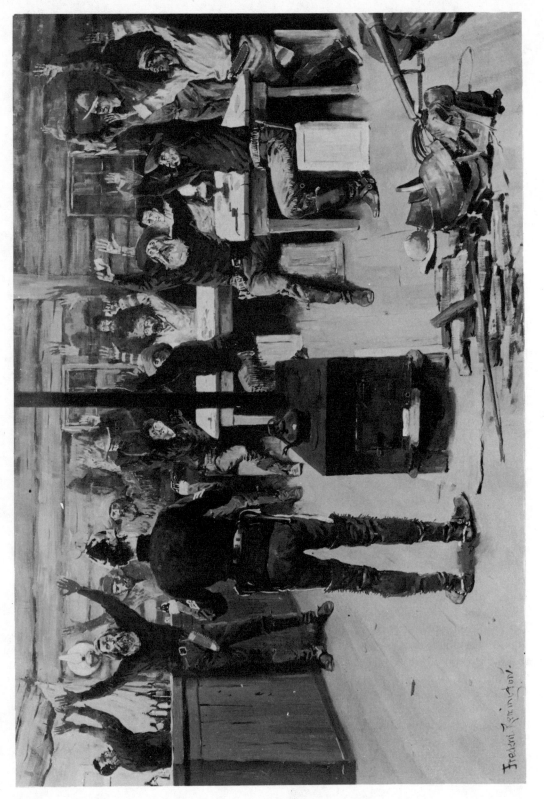

"NO, I AM NOT LOCO"

XX

When a Document
is Official

William or "Billy" Burling had for these last four years worn three yellow stripes on his coat sleeve with credit to the insignia. Leading up to this distinction were two years he had only worn two, and back of that were yet other annums when his blue blouse had been severely plain except for five brass buttons down the front. This matter was of no consequence in all the world to anyone except Burling; but the nine freezing, grilling, famishing years which he had so successfully contributed to the cavalry service of the United States were the "clean-up" of his assets. He had gained distinction in several pounding finishes with the Indians; he was liked in barracks and respected on the line; and he had wrestled so sturdily with the books that when his name came up for promotion to an officer's commission, he had passed the examinations. On the very morning of which I speak, a lieutenant of his company had quietly said to him, "You need not say anything about it, but I heard this morning that your commission has been signed and is now on the way from Washington. I want to congratulate you."

"Thank you," replied William Burling as the officer passed on. The sergeant sat down on his bunk and said mentally, "It was a damn long time coming."

There is nothing so strong in human nature as the observance of custom, especially when all humanity practices it; and the best men in America and Europe, living or dead, have approved of this one. It has, in cases like the sergeant's, been called "wetting a new commission." I suppose in Mohammedan Asia they buy a new wife. Something outrageous must be done when a military man celebrates his step; but be that as it may, William Burling was oppressed by a desire to blow off steam. Here is where the four years of the three stripes stood by this hesitating mortal and overpowered the exposed human nature. Discipline had nearly throttled custom, and before this last could catch its breath again, the orderly came in to tell Burling that the colonel wanted him up at headquarters.

It was early winter at Fort Adobe and the lonely plains were white with a new snow. It certainly looked lonely enough out beyond the last buildings, but in those days one could not trust the plains to be as lonely as they looked. Mr. Sitting-Bull or Mr. Crazy-Horse might pop out of any coulee with a goodly following, and then life would not be worth living for a wayfarer. Some of these high-flavored romanticists had but lately removed the hair from sundry buffalo hunters in Adobe's vicinity, and troops were out in the field trying to "kill, capture, or destroy" them, according to the ancient and honorable form. All this was well known to Sergeant Burling when he stiffened up before the colonel.

"Sergeant, all my scouts are out with the commands and I am short of officers in post. I have an order here for Captain Morestead, whom I suppose to be at the juncture of Old Woman's Fork and Lightning Creek, and I want you to deliver it. You can easily find their trail. The order is important and must go through. How many men do you want?"

Burling had not put in nine years on the Plains without knowing a scout's answer to that question. "Colonel, I prefer to go alone." There was yet another reason than "he travels fastest who travels alone" in Burling's mind. He knew it would be a very desirable thing if he could take that new commission into the officers' mess with the prestige of soldierly devotion upon it. Then, too, nothing short of twenty-five men could hope to stand off a band of Indians.

Burling had flipped a mental coin. It came down heads for him, for the colonel said, "All right, sergeant. Dress warm and travel nights. There is a moon. Destroy that order if you have bad luck. Understand?"

"Very well, sir," and he took the order from the colonel's hand.

The old man noticed the figure of the young cavalryman and felt proud to command such a man. He knew Burling was an officer, and he thought he knew that Burling did not know it. He did not like to send him out in such weather through such a country, but needs must.

As a man, Burling was at the ripe age of thirty, which is the middle distance of usefulness for one who rides a Government horse. He was a light man, trim in his figure, quiet in manner, serious in mind. His nose, eyes, and mouth denoted strong character, and also that there had been little laughter in his life. He had a mustache, and beyond this, nothing can be said, because cavalrymen are primitive men, weighing no more than one hundred and sixty pounds. The horse is responsible for this, because he cannot carry more, and that weight even then must be pretty much on the same ancient lines. You never see long, short, or odd curves on top of a cavalry horse—not with nine years of field service.

Marching down to the stables, he gave his good bay horse quite as many oats as were good for him. Then, going to his quarters, he

dressed himself warmly in buffalo coat, buffalo moccasins, fur cap and gloves, and he made one saddle pocket bulge with coffee, sugar, crackers, and bacon, intending to fill the opposite side with grain for his horse. Borrowing an extra six-shooter from Sergeant McAvoy, he returned to the stables and saddled up. He felt all over his person for a place to put the precious order, but the regulations are dead set against pockets in soldiers' clothes. He concluded that the upper side of the saddlebags, where the extra horseshoes go, was a fit place. Strapping it down, he mounted, waved his hand at the fellow-soldiers, and trotted off up the road.

It was getting toward evening, there was a fine brisk air, and his horse was going strong and free. There was no danger until he passed the Frenchman's ranch where the buffalo hunters lived; and he had timed to leave there after dark and be well out before the moon should discover him to any Indians who might be viewing that log house with little schemes of murder in expectance.

He got there in the failing light, and tying his horse to the rail in front of the long log house, he entered the big room where the buffalo hunters ate, drank, and exchanged the results of their hard labor with each other as the pasteboards should indicate. There were about fifteen men in the room, some inviting the bar, but mostly at various tables guessing at cards. The room was hot, full of tobacco smoke and many democratic smells, while the voices of the men were as hard as the pounding of two boards together. What they said, for the most part, can never be put in your library; neither would it interest if it was. Men with the bark on do not say things in their lighter moods which go for much; but when these were behind a sagebrush handling a Sharps, or skinning among the tailing buffaloes on a strong pony, what grunts were got out of them had meaning!

Buffalo hunters were men of iron endeavor for gain. They were adventurers; they were not nice. Three buckets of blood was four dollars to them. They had thews, strong-smelling bodies, and eager minds. Life was red on the buffalo range in its day. There was an intellectual life—a scientific turn—but it related to flying lead, wolfish knowledge of animals, and methods of hide-stripping.

The sergeant knew many of them and was greeted accordingly. He was feeling well. The new commission, the dangerous errand, the fine air, and the ride had set his blood bounding through a healthy frame. A young man with an increased heart action is going to do something besides standing on one foot leaning against a wall: nature arranged that long ago.

Without saying what he meant, which was, "Let us wet the new commission," he sang out, "Have a drink on the Army. Kem up, all you hide-jerkers," and they rallied around the young soldier and "wet." He talked with them a few minutes and then stepped out into the air—partly to look at his horse and partly to escape the encores

which were sure to follow. The horse stood quietly. Instinctively he started to unbuckle the saddle pocket. He wanted to see how the "official document" was riding, that being the only thing that oppressed Burling's mind. But the pocket was unbuckled and a glance showed that the paper was gone.

His bowels were in tremolo. His heart lost three beats; and then, as though to adjust matters, it sent a gust of blood into his head. He pawed at his saddlebags; he unbuttoned his coat and searched with nervous fingers everywhere through his clothes; and then he stood still, looking with fixed eyes at the nigh front foot of the cavalry horse. He did not stand mooning long; but he thought through those nine years, every day of them, every minute of them; he thought of the disgrace both at home and in the Army; he thought of the lost commission, which would only go back the same route it came. He took off his overcoat and threw it across the saddle. He untied his horse and threw the loose rein over a post. He tugged at a big sheath knife until it came from the back side of his belt to the front side, then he drew two big Army revolvers and looked at the cylinders—they were full of gray lead. He cocked both, laid them across his left arm, and stepped quickly to the door of the Frenchman's log house. As he backed into the room, he turned the key in the lock and put it under his belt. Raising the revolvers breast high in front of him, he shouted, "Attention!" after the loud, harsh habit of the Army. An officer might talk to a battalion on parade that way.

No one had paid any attention to him as he entered. They had not noticed him in the preoccupation of the room, but everyone quickly turned at the strange word.

"Throw up your hands instantly, every man in the room!" And with added vigor, "Don't move!"

Slowly, in a surprised way, each man began to elevate his hands —some more slowly than others. In settled communities this order would make men act like a covey of quail, but at that time at Fort Adobe the six-shooter was understood both in theory and in practice.

"You there, bartender, be quick! I'm watching you." And the bartender exalted his hands like a practiced saint.

"Now, gentlemen," began the soldier, "the first man that bats an eye or twitches a finger or moves a boot in this room will get shot just that second. *Sabe?*"

"What's the matter, Mr. Soldier? Be you loco?" sang out one.

"No, I am not loco. I'll tell you why I am not." Turning one gun slightly to the left, he went on: "You fellow with the long red hair over there, you sit still if you are not hunting for what's in this gun. I rode up to this shack, tied my horse outside the door, came in here, and bought the drinks. While I was in here someone stepped out and stole a paper—official document—from my saddle pockets; and unless that paper is returned to me, I am going to turn both of these

guns loose on this crowd. I know you will kill me, but unless I get the paper, I want to be killed. So, gentlemen, you keep your hands up. You can talk it over; but remember, if that paper is not handed me in a few minutes, I shall begin to shoot." Thus having delivered himself, the sergeant stood by the door with his guns leveled. A hum of voices filled the room.

"The soldier is right," said someone.

"Don't point that gun at me; I hain't got any paper, pardner. I can't even read paper, pard. Take it off; you might git narvous."

"That sojer's out fer blood. Don't hold his paper out on him."

"Yes, give him the paper," answered others. "The man what took that papers wants to fork it over. This soldier means business. Be quick."

"Who's got the paper?" sang a dozen voices. The bartender expostulated with the determined man—argued a mistake—but from the compressed lips of desperation came the word, "Remember!"

From a near table a big man with a gray beard said, "Sergeant I am going to stand up and make a speech. Don't shoot. I am with you." And he rose quietly, keeping an inquisitive eye on the Burling guns, and began:

"This soldier is going to kill a bunch of people here; anyone can see that. That paper ain't of no account. What ever did any fool want to steal it for? I have been a soldier myself, and I know what an officer's paper means to a despatch-bearer. Now, men, I say, after we get through with this mess, what men is alive ought to take the doggone paper thief, stake the feller out, and build a slow fire on him, if he can be ridden down. If the man what took the paper will hand it up, we all agree not to do anything about it. Is that agreed?"

"Yes, yes, that's agreed," sang the chorus.

"Say, boss, can't I put my arms down?" asked a man who had become weary.

"If you do, it will be forever," came the simple reply.

Said one man, who had assembled his logistics, "There was some stompin' around yar after we had that drink on the sojer. Whoever went out that door is the feller what got yer document; and ef he'd atooken yer horse, I wouldn't think much—I'd be lookin' fer that play, stranger. But to go *cincha* a piece of paper! Well, I think you must be plumb loco to shoot up a lot of men like we be fer that yar."

"Say," remarked a natural observer—one of those minds which would in other places have been a head waiter or some other highly sensitive plant—"I reckon that Injun over thar went out of this room. I seen him go out."

A little French half-breed on Burling's right said, "Maybe as you keel de man what 'ave 'and you de *papier*—hey?"

"No, on my word I will not," was the promise; and the half-breed continued, "Well, the *papier* ees een ma pocket. Don't shoot."

The sergeant walked over to the abomination of a man, and putting one pistol to his left ear, said, "Give it up to me with one fist only—mind, now!" But the half-breed had no need to be admonished, and he handed the paper to Burling, who gathered it into the grip of his pistol hand, crushing it against the butt.

Sidling to the door, the soldier said, "Now I am going out, and I will shoot anyone who follows me." He returned one gun to its holster, and while covering the crowd, fumbled for the keyhole which he found. He backed out into the night, keeping one gun at the crack of the door until the last, when with a quick spring, he dodged to the right, slamming the door.

The room was filled with a thunderous roar and a dozen balls crashed through the door.

He untied his horse, mounted quickly with the overcoat underneath him and galloped away. The hoofbeats reassured the buffalo hunters; they ran outside and blazed and popped away at the fast-receding horseman, but to no purpose. Then there was a scurrying for ponies and a pursuit was instituted; but the grain-fed cavalry horse was soon lost in the darkness. And this was the real end of Sergeant William Burling.

The buffalo hunters followed the trail next day. All night long galloped and trotted the trooper over the crunching snow, and there was no sound except when the moon-stricken wolves barked at his horse from the gray distance.

The sergeant thought of the recent occurrence. The reaction weakened him. His face flushed with disgrace; but he knew the commission was safe and did not worry about the vengeance of the buffalo hunters, which was sure to come.

At daylight he rested in a thick timbered bottom near a cut-bank, which in Plains strategy was a proper place to make a fight. He fed himself and his horse and tried to straighten and smooth the crumpled order on his knee; and wondered if the people at Adobe would hear of the unfortunate occurrence. His mind troubled him as he sat gazing at the official envelope. He could not get the little sleep he needed, even after three hours' halt. Being thus preoccupied, he did not notice that his picketed horse from time to time raised his head and pricked his ears toward his back track. But finally, with a start and a loud snort, the horse stood eagerly watching the bushes across the little opening through which he had come.

Burling got on his feet, and untying his lariat, led his horse directly under the cut-bank in some thick brush. As he was in the act of crawling up the bank to have a look at the flat plains beyond, a couple of rifles cracked and a ball passed through the soldier's hips. He dropped and rolled down the bank, and then dragged himself into the brush.

From all sides apparently came Indians' "ki-yis" and "coyote

yelps." The cavalry horse trembled and stood snorting, but did not know which way to run. A great silence settled over the snow, lasting for minutes. The Sioux crawled closer, and presently saw a bright little flare of fire from the courier's position, and they poured in their bullets; and again there was quiet. This the buffalo hunters knew later by the "sign" on the trail. To an old hunter there is no book so plain to read as footprints in the snow.

And long afterward, in telling about it, an old Indian declared to me that when they reached the dead body they found the ashes of some paper which the soldier had burned, and which had revealed his position. "Was it his medicine which had gone back on him?"

"No," I explained, "it wasn't his medicine, but the great medicine of the white man, which bothered the soldier so."

"Hump! The great Washington medicine maybeso. It make dam fool of soldiers lots of time I know 'bout," concluded the old Indian as he hitched up his blanket around his waist.

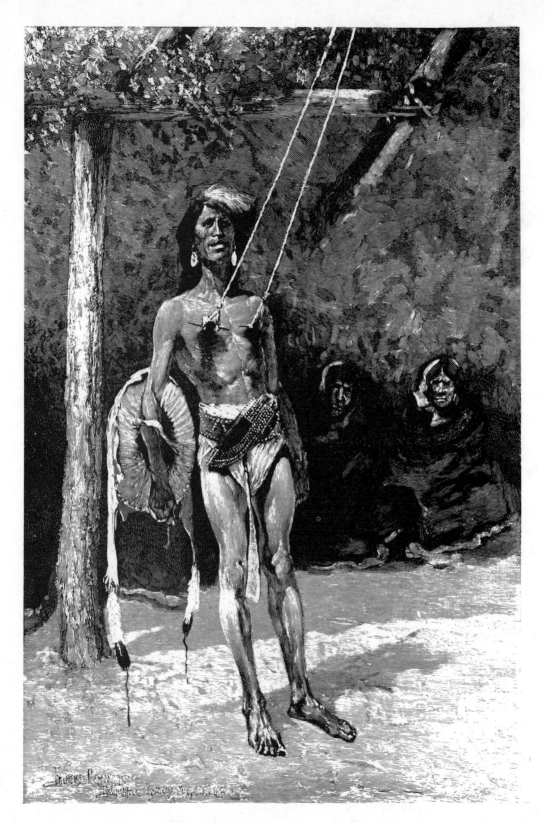

ORDEAL OF THE SUN DANCE

XXI

Ordeal of the Blackfeet Sun Dance

The primary object in life of a young American Indian once was to be a warrior. Thus the testing of the young man's courage and endurance by an ordeal of torture in the presence of his people has ever been a characteristic practice among the savage tribes of this continent. In a life beset, as was that of the American Indian in his native condition, with perils attending the pursuit of game, and with the greater danger presented in the perpetual warfare with environing hostile tribes—a warfare in which no mercy was shown, and capture meant to the prisoner a lingering death under every torment that savage ingenuity could invent—it was necessary that the warrior be at all times ready to incur unshrinkingly the risk of death or captivity by venturousness in battle or in plundering raids.

To establish for the young man an honorable position among the warriors of his tribe, a proof of his ability to endure pain unflinchingly must be given. This test of the young aspirant's bravery varies among the different peoples. Of all ordeals, the most savage and painful is that of the northwesterly tribes of the Northern Plains—the Western Sioux or Dakota tribes and the Blackfeet, whose homes are near the easterly base of the Rocky Mountains. Those aboriginal tribes of North America found between the forty-second and the fifty-second parallels of latitude exceed the Indians to the south or north of them in stature, energy, courage, and dignity of character. The Tarratines, Iroquois, Chippewas, Sioux, and Cheyennes have represented the highest type of the savage Indian, and ranking with the foremost of these are the Blackfeet, whose original domain upon the arid plains of the central plateau included the country drained by the Saskatchewan and extended southerly to the Missouri and the Yellowstone. Their country was the favorite home of the buffalo, and up to the time of the discovery of gold in Idaho and Montana the Blackfeet had little to do with the whites. At that date they constituted one of the purest types of the aboriginal Indians, with a nature fierce and unsubdued, and their native virtue uncorrupted.

213

In person the Blackfeet possess unusual beauty and symmetry of the Indian type. They are tall and well made, with intelligent faces, aquiline noses, clear and lustrous eyes, with less prominent cheekbones and thinner lips than are usual among other tribes. Their costume is the ordinary dress of the Northern Plains Indians, and the faces of the men and women are often painted with vermilion. The primitive costume of the women is a long gown of buffalo skin, dressed beautifully soft and edged with yellow ocher. It is confined at the waist by a broad belt of the same material, thickly studded with brightly polished round metal plates the size of a silver half-dollar or larger.

The Blackfeet are of a livelier temperament than most other tribes. When under the influence of liquor, instead of being quarrelsome and eager to take the warpath, as is the case with many Indians, they are jolly and good-tempered. Their form of government is simple. Each tribe has a head chief, and each band, a subordinate chief, whose authority in time of peace is nominal, but who exercise absolute control in time of war. A few chiefs are hereditary leaders, but usually they are elevated to their position by prowess in war or by their gifts as orators and statesmen, and an uncompromising assertion of their rights alone sustains them in their office. The form of religion of this people is sun worship. Their name of god is Na-pi-en, or the Venerable Old Man; but him they regard as unfriendly to mankind, and bestow their worship upon the especial friend of their people, Na-tush, or the Man-in-the-Sun, whom they regard as a good human form of surpassing grandeur and beauty. He is the bestower of buffalo and other game and good, gives succor in war, cures diseases, and governs in the land of spirits. He it was who bound the rain spirits with the rainbow, and who fights the spirits of evil. To propitiate the Man-in-the-Sun, they offer religious sacrifices and proffer votive offerings of cloth, warlike implements, robes, and other Indian valuables, which they hang to trees in such position that the sunbeams may fall upon them.

The small boy among the Indian tribes has his games in which he hunts and practices mimic warfare with toy bows and short arrows. He is taught to dance, his teacher usually being his mother's brother. In the winter he snowballs, slides downhill on blocks of ice, or standing on flat sticks, coasts swiftly, balancing himself with a pole. As he approaches manhood, he is filled with the ambition to become a warrior, and is eager for the trial of courage that shall install him among the men of the tribe. The ordeal is the same at all times as to the torture inflicted, but the chosen occasion on which to display his heroic endurance under pain is in the great annual ceremony of the tribes of the Northwest known as the "sun dance." This savage ceremonial, which exhibits that highest form of sacrificial self-immolation, is called "vision-seeking." At this time it is determined whether the young men participating in it are worthy to become warriors of the tribe.

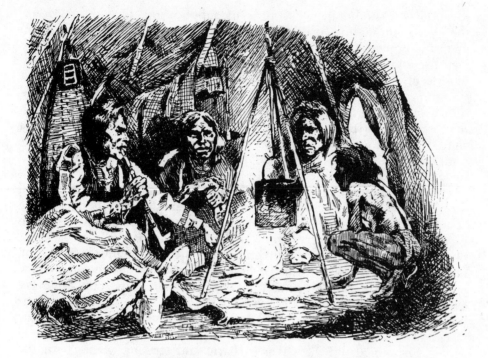

BLACKFEET AT HOME

The sun dance takes place during the hottest period of the summer—July or August—and lasts three or four days. But long before that time, at a period late in the spring, the Indians have begun to beat the tom-tom, the sound of which goes a long distance and is heard through the different camps. This noise is kept up during most of the nights and is accompanied by dancing. The drumming and dancing culminate in the putting up of a large medicine lodge near the ground chosen for the grand dance, and the exposing of valuable presents as an offering to the sun.

The young men who are to undergo the ordeal generally fast for some time previous to the sun dance. At the beginning of the ceremonies they repair to the lodge of the medicine man, who makes four incisions in each aspirant's chest—two at each side—and passes a knife under the muscles of the breast, so that a short stick can be passed underneath the flesh intervening between each pair of incisions. They then repair to the dance ground, where a stout pole about twenty feet in length has been set upright. Suspended from the top of the pole are a half-dozen rawhide ropes, the loose ends of which are made fast to the sticks in the young men's chests. The young men then throw their weight on the ropes and begin to dance around the pole. They hang suspended only by these cords, without food or drink, while

the head and body, in an attitude of supplication, face the sun, and the eye is unflinchingly bent upon it. Their minds are intently fixed upon the object in which they wish to be assisted by the deity, as they wait for a vision from above. Swinging by the rope, they blow a bone whistle or shout and sing in bravado, boasting of past exploits and of the brave actions that they intend to accomplish, until the sticks are torn away through the flesh and tendons or the dancers fall, fainting, on the ground. If they hesitate to join the dance or show the least signs of cowardice in bearing pain, they are regarded as unfit to associate with warriors, and henceforth rank as "squaw men," and are not allowed to take part in the tribe councils, war parties, and dances.

Occasionally, as a greater display of courage, individuals will have corresponding incisions made in their shoulders and backs, and attach to these by hair ropes one or more saddles, shields, or buffalo or ox heads, so that every time the body moves as the dancer keeps time with the music, a jerk is given to the objects dragging behind him, until the sticks are torn from the flesh. This greater display of courage is rewarded by more prestige as a "brave" and more important privileges among his tribe in afterlife. Sometimes the stick is set so deeply in the flesh that two men have to press on the performer's shoulders to tear it away.

The sun dance affords a barbaric and striking scene, with the great crowd of gaily attired onlookers watching with eager and sympathetic interest the tortured braves who, betraying no sign of the pain they endure, dance wildly amid the continued songs of admiration and encouragement by the spectators, accompanied by the loud and violent beating of the tom-tom. The tortured warrior is the epitome of the religion, the ambition, and the heroic character of this Spartan-like people. The young aspirants, weakened by the previous fast, often fall faint and senseless to the ground; but they are lifted up, and continue their dance until the flesh tears loose or it is manifest that they can endure no more, in which case they are honorably released. The ordeal sometimes endures for three or four days, but one by one they break away, and each, after his release from torture, receives the attentions of his relatives, who usually have prepared a feast for him. In after-years the Indians show the scars of the ordeal with pride.

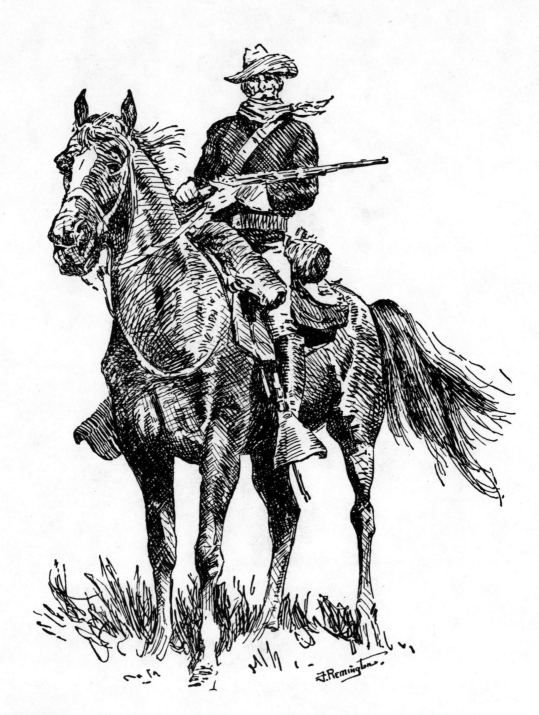

THE CAVALRY MAN

XXII

The Trouble Brothers

Madness comes when we think of how long ago things happened. Let us not bother ourselves about time, though we cannot cease to remember that it took youth to sit up all night in the club and ride all next day, or sleep twenty-four hours on a stretch, as the situation demanded. The scene, as I recall it, demanded exactly that. The ambulances of Fort Adobe brought a party of ranking military men, sundry persons of substance, lesser mortals of much enthusiasm, and Colonel William Cody—up the long thirty miles of dusty plains from the railroad. The yellow country in the autumn is dry riding and hard work. The officers stationed at the post took a brotherly interest in the newcomers because they were also sportsmen. You could not drive an iron wedge between the Plains type of officer and a sportsman without killing both. There were dinners of custom and such a gathering at the club as was unusual, where the hunting plans were keenly discussed—so keenly, in fact, that it was nearer morning than midnight when it was considered desirable to go to bed.

There were dogs which the sportsmen had brought along—fierce wolfhounds from Russia—and Buffalo Bill had two malignant pups in which he took a fine interest. The officers at Adobe were possessed of a pack of rough Scotch hounds, besides which, if every individual soldier at the post did not have his individual doggie, I must have made a miscount. It was arranged that we consolidate the collection and run a wolf on the morrow.

When sport was in prospect, reveille was the usual hour, regardless of bedtime. Morning found us all mounted, and the throng of horses started up the road. The dogs were kept together; the morning was of the golden, frosty Adobe type, and the horses could feel the run which was coming to them.

Everything was ready but the wolf. It was easy to find wolves in that country, however. We had slow dogs to trail them with. But our wolf came to us in the way money comes to a modern politician.

Bill, the chief of sports, as we called him, was riding ahead when we saw him stop a wagon. It was driven by an old "prairie dog," and on the bed of the wagon was a box made of poles and slats. Inside of this was a big gray wolf, which the man had caught in a trap without injuring it in the least. He hoped to be able to sell it at the post, but he realized his hope and his price right there. "Now, boys, we'll have a wolf hunt; but let us go back to the post, where the ladies and the men can see it."

We could not agree whether it was the colonel's gallantry or his circus habits which prompted this move, but it was the thing which brought a blighting sorrow to Fort Adobe. We turned back, bundling Mr. Wolf down the road. He sat behind the slats, gazing far away across his native hills, silent and dignified as an Indian warrior in captivity.

The ladies were notified, and came out in traps. The soldiers joined us on horseback and on foot, some hundred of them, each with his pet mongrel at his heels.

The domestic servants of the line came down back of the stables. The sentries on post even walked sidewise, that they might miss no details. Adobe was out for a race. I had never supposed there were so many dogs in the world. As pent-up canine animosities displayed themselves, they fell to taking bites at each other in the dense gathering; but their owners policed and soothed them.

Everyone lined up. The dogs were arranged as best might be. The wagon was driven well out in front, and Colonel William Cody helped the driver to turn the wolf loose, a matter which gave no trouble at all. They removed two slats, and if there had been a charge of melinite behind that wolf, he could not have hit that valley any harder.

The old hounds, which had scented and had seen the wolf, straightway started on his course. With a wild yell the cavalcade sprang forward. Many cur dogs were ridden, screaming, under foot. The two bronco ponies of the man who had brought the wolf turned before the rush and were borne along with the charge. Everything was going smoothly.

Of the garrison curs many were left behind. They knew nothing about wolves or field sports, but addled by the excitement, fell into the old garrison feuds.

At a ravine we were checked. I looked behind, and the intervening half-mile was dotted here and there with dog-fights of various proportions. Some places there were as high as ten in a bunch, and at others, only couples. The infantry soldiers came running out to separate them, and to my infinite surprise, I saw several of the doughboys circling each other in the well-known attitudes of the prize ring. Officers started back to pull them apart. Our dogs were highly excited. Two of them flew at each other; more sprang into the jangle. The men yelled at them and got off their horses. One man kicked another man's

dog, whereat the aggrieved party promptly swatted him on the eye. This is the way it began. While you read, over a hundred and fifty men were pounding each other with virility, while around and underfoot fought each doggie with all possible vim. Greyhounds cut red slices on quarter-bred bulls; fox terriers hung on to the hind legs of such big dogs as were fully engaged in front. Fangs glistened; they yelled and bawled and growled, while over them struggled and tripped the men as they swung for the knock-out blow. If a man went down, he was covered with biting and tearing dogs. The carnage became awful —a variegated foreground was becoming rapidly red. The officers yelled at the men, trying to assert their authority, but no officer could yell as loud as the acre of dogs. By this time the men were so frenzied that they could not tell a shoulder strap from a bale of hay. One might as well have attempted to stop the battle of Gettysburg.

Naturally this could not last forever, and gradually the men were torn apart and the dogs unhooked their fangs from their adversaries. During the war I looked toward the fort, hoping for some relief, but the half-mile was dotted here and there with individuals thumping and pounding each other while their dogs fought at their heels. Where, where had I seen this before, thought came. Yes, yes—in Caesar's *Commentaries*. They did things just this way in his time. Bare legs and short swords only were needed here.

Things gradually quieted, and the men started slowly back to the post, nursing their wounds. Most of the horses had run away during the engagement. It was clear to be seen that plaster and liniment would run short at Adobe that day.

Colonel Cody sat on his horse, thinking of the destruction he had wrought.

The commanding officer gathered himself and sang out, "Say, Bill, there is your doggoned old wolf sitting there on the hill looking at you. What do you reckon he thinks?"

"I reckon he thinks we have made trouble enough for today. Next time we go hunting, Colonel, I think you had better leave your warriors at home," was Bill's last comment as he turned his horse's tail toward the wolf.

"IT'S A PERFECTLY SQUARE GAME...."

XXIII

A Quarrel Over Cards

It is more than likely that in Montana, Arizona, and New Mexico, where cards are played for money by ranchmen, horse rustlers, teamsters and cowboys, kites and hawks are numerous, while pigeons to be plucked are comparatively rare birds. Near every Government post gamblers settle and games are opened. The seductive influences of draw-poker or monte are irresistible. After months of hard service comes pay day, and the soldiers and noncommissioned officers, along with the teamsters and roustabouts, are sure to part with their money in these gambling dens.

Apart from the individual skill of the professional and his perfect knowledge of the ways of playing the game, long practice has enabled him to increase his chances by the cleverest tricks of legerdemain. He does not generally "work his crowd" single-handed, but has a confederate. If monte is the game, "short cards" are used. If it is draw-poker, by means of a clever confederate the game invariably beats the novices. Nimble fingers pass the cards, and flushes and straights upset all the calculations of chances. A hidden card, produced at the exact nick of time, makes "four of a kind," and the pot is raked in. The blandness of the "heathen Chinee" would find itself entirely out of place among such talented performers. There is a coolness, a quiet deliberateness, about this knavery which is of the most defiant kind.

Sometimes, however, there comes a player who has "stacked his chips" on every "lay out" from Bangor to Brazos. He knows all those ways which are crooked. It even adds to his zest to play not only against the luck of cards, but the talents of the crooked gamblers. He is quite prepared for the double stake—his life and his dollars—and of the two, holds the former as of lesser value. Of course he has his gun. Before he went into the nest of thieves, he saw that his revolver was in prime order, sweet of pull, and with no hitch about it. There would be little excitement about the game without drawing of cards and revolvers. There is always bad liquor, and in abundance, in such

gambling places, but those who run these establishments do but little of the drinking. Newcomers are urged to drink long and hearty, while the professionals are singularly abstemious. When play begins, the inevitable result is that the tipsy men lose all their money.

The phlegmatic Chinaman is not very much disturbed. He has been there before; nor does he cease his culinary operations when the revolvers speak. There is the furious man who has sprung to his feet. His thumb is on the hammer of his gun. He has "the drop," so to speak. Perhaps the three aces which beat his three kings, or the four treys which beat his ace full, have become a trifle too monotonous. Then there is the steady, thoroughgoing desperado who has been dealing. In one stretched palm of the other hand he seems to say, "It's all perfectly square, gentlemen." That stolid-looking man to his right is his confederate. It was his deal before, and then the trick was done. The party to the left, seated on the soapbox, has a shrewd suspicion that in the "muss" the table might be overturned; so he wants to make his money safe, and covers his chips with his hands. The old stager, who has been long in service still smokes his pipe; he is used to such things. The noncommissioned man toys with his pistol. He seems to think that all has not been lovely, and that if there is to be any general shooting, "promiscuous-like," he will know whom his pistol will cover. Above the table the lamp throws its bright glare and emphasizes the play of human features.

It is something that happens somewhere or other every day in the territories. The papers tell of it briefly: "A teamster killed a gambler over a game of draw." Or it may be: "A gambler shot a cowboy dead at poker." You can pack in a whole drama and the end of a life easily enough in eight or ten words.

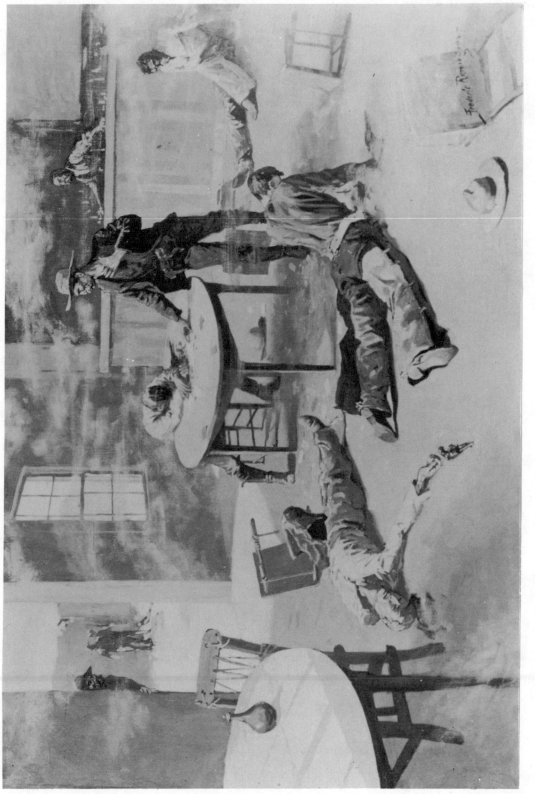

A MIS-DEAL

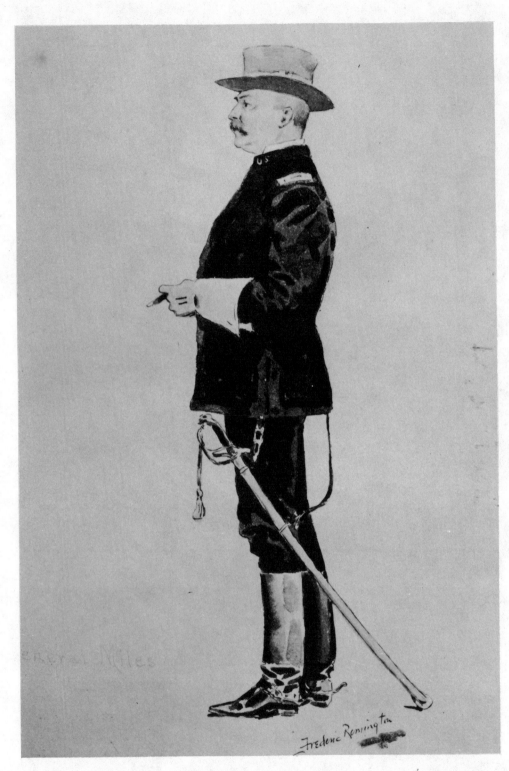

GENERAL MILES

XXIV

Chasing a
Major General

The car had been sidetracked at Fort Keough, and on the following morning the porter shook me and announced that it was five o'clock. An hour later I stepped out on the rear platform and observed that the sun would rise shortly, but that meanwhile the air was chill and that the bald, square-topped hills of the badlands cut rather hard against the gray of the morning. Presently a trooper galloped up with three horses, which he tied to a stake. I inspected them, and saw that one had a "cow saddle," which I recognized as an experiment suggested by the general. The animal bearing it had a threatening look, and I expected a repetition of a performance of a few days before, when I had chased the general for over three hours, making in all twenty-eight miles.

Before accepting an invitation to accompany an Indian commission into the Northwest, I had asked the general quietly if this was a "horseback" or a "wagon outfit." He had assured me that he was not a "wagon man," and I indeed had heard before that he was not. There is always a distinction in the Army between wagon men and men who go without wagons by transporting their supplies on pack animals. The wagon men have always acquired more reputation as travelers than Indian fighters. In a trip to the Pine Ridge Agency I had discovered that General Miles was not committed to any strained theory of how mounted men should be moved. Any settled purpose he might have about his movements were all locked up in a desperate desire to "get thar." Being a little late in leaving a point on the railroad, I rode along with Lieutenant Guilfoil, of the Ninth, and we moved at a gentle trot. Presently we met a citizen in a wagon, and upon observing the lieutenant in uniform, he pulled up his team and excitedly inquired, "What's the matter, Mr. Soldier?"

Guilfoil said nothing was the matter that he knew of.

"Who be you uns after?"

"No one," replied the lieutenant.

227

"Well, I just saw a man go whirling up this 'ere valley with a soldier tearin' after him fit to kill" (that was the general's orderly), "and than comes a lot more soldiers just asmokin', and I sort of wondered what the man had done."

We laughed, and remarked that the general must be riding pretty hard. Other citizens we met inquired if that man was a lunatic or a criminal. The idea of the soldiers pursuing a man in citizen's clothes furthered the idea, but we assured them that it was only General Miles going somewhere.

All of these episodes opened my eyes to the fact that if I followed General Miles, I would have to do some riding such as I had rarely done before. In coming back to the railroad, we left the Pine Ridge agency in the evening without supper, and I was careful to get an even start. My horse teetered and wanted to gallop, but I knew that the twenty-eight miles would have to be done at full speed, so I tried to get him down to a fast trot, which gait I knew would last better; but in the process of calming him down to a trot I lost sight of the general and his orderly as they went tearing like mad over a hill against the last gleam of sunset. I rode at a very rapid trot over the hills in the moonlight for over three hours, but I never saw the general again until I met him at dinner. Then I further concluded that if I followed the general, I would have no time to regait my horses, but must take them as I found them, gallop or trot. So on the cool morning at Keough I took observations of the horses which were tied to the post, with my mind full of misgivings.

Patter, patter, patter—clank, clank, clank; up comes the company of Cheyenne scouts who are to escort the general—fine-looking tall young men, with long hair, and mounted on small Indian ponies. They were dressed and accoutered as United States soldiers, and they fill the eye of a military man until nothing is lacking. Now the general steps out of the railroad car and hands the commission into a six-mile ambulance. I am given a horse, and mounting, we move off over the plain and into the hills. The sun comes streaming over the landscape, and the general is thinking about this old trail and how years before he had plowed his way through the blinding snow to the Lame Deer fight. I am secretly wishing that it would occupy his mind more fully, so that my breakfast might settle at the gentle gait we are going. But shortly he says "It's sixty miles, and we must move along." We break into a gallop.

The landscape is gilded by the morning sun and the cool of the October air makes it a perfect thing, but there are elements in the affair which complicate its perfection. The badlands are rough, and the general goes down a hill with even more rapidity than up it.

General Miles has acquired his knowledge of riding from wild Indians, and wild Indians go uphill and downhill as a matter of course at whatever gait they happen to be traveling. He would make his horse

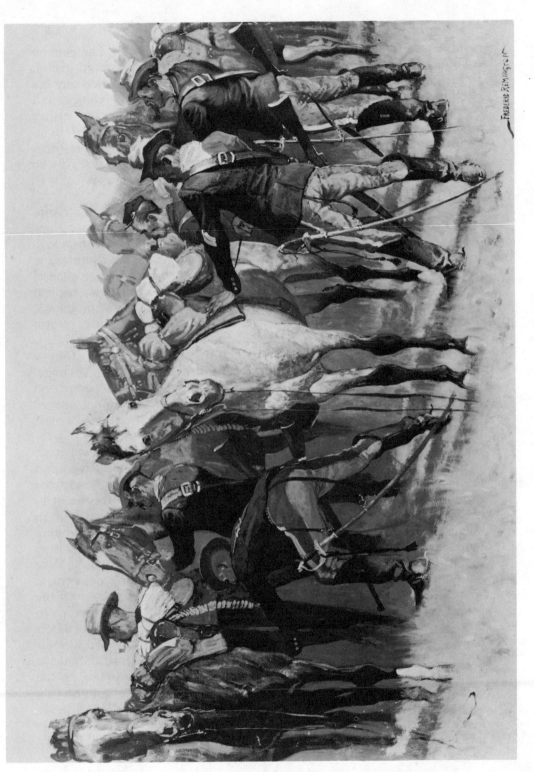

BOOTS AND SADDLES

climb a tree with equal gravity if he was bound that way. The general has known Indians to ride for two days and a night at a rapid gallop, and it never occurs to him that he cannot do anything which anyone else can; so he spurs along, and we go cutting around the coulees and bluffs like frightened antelopes or mad creatures. The escort strings out behind. This is observed with grim humor by the general, who desires nothing so much as to leave his escort far in the rear. He turns in his saddle, and seeing the dust of the escort far behind, says, "Shake up the young men a little; do 'em good. They get sleepy." Away we go.

It is over thirty miles to the first relay station, or courier's camp, and another problem looms up. The general's weight is over two hundred pounds, and I confess to two hundred and fifteen avoirdupois, and, as I have before remarked, my horse was not an Irish hunter, so my mustang took a serious vein. It is all very well for a major general to ride down a cavalry horse, but if such an accident were to happen to me, then my friends in the cavalry would crown me with thorns. Two hundred and fifteen pounds requires a great deal more careful attention than a one-hundred-and-forty-pound wasp-waisted cavalry-man. What the latter can do with impunity would put me on foot—a thing that happened some ten years since in this very state of Montana, and a thing I have treasured in mind but will not have repeated. So I brought the old horse down to a trot, and a good round trot eats up a road in short order. Your galloper draws away from you, but if the road is long enough, you find that you are at his heels.

After a good day's ride of something like sixty miles, we meet a troop of the Eighth Cavalry near its camp on the Tongue River, and the general is escorted in. The escorts draw into line, salute, and the general is duly deposited in a big Sibley tent. I go away on the arms of some "cavalry kids" (as young lieutenants are called) to a hole in the ground (a dugout) where they are quartered. On the following morning I am duly admonished that if my whereabouts could have been ascertained on the previous evening, the expedition would have continued to the camp of the First Cavalry. I do not think the general was unduly severe, desiring simply to shift the responsibility of the procrastination on to other shoulders, and meanwhile being content to have things as they were. I was privately thanked by the citizen members of the commission for the delay I had caused, since they had a well-grounded conviction that sixty miles a day on an Army ambulance was trouble enough. After some sarcasm by a jolly young sub, to the effect that "if one wants to call a citizen out of a tent, one must ring a dinner bell," we were again mounted and on the way. I was badly mounted that day, but able to participate in the wild charge of forty-five miles to the Lame Deer camp, near the Cheyenne agency. The fifty Cheyenne scouts and a troop of the Eighth were in escort.

By a happy combination I was able to add greatly to my equestrian knowledge on this ride. It happened in this way; but I must

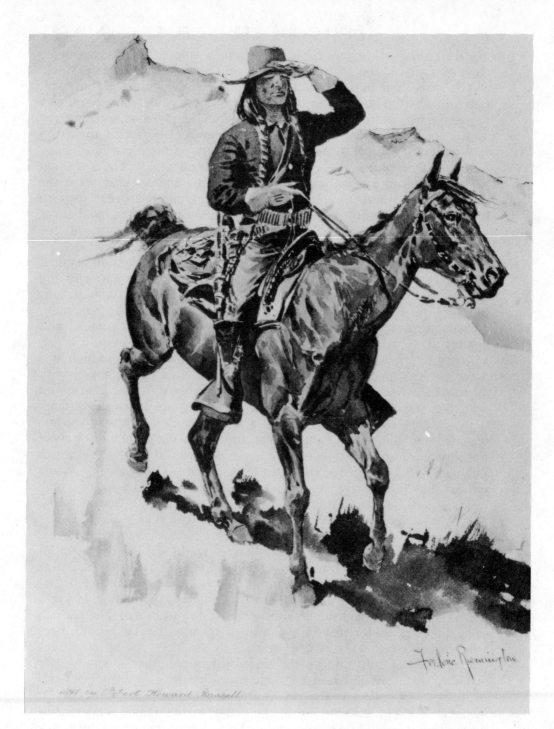

A CHEYENNE SCOUT

explain. Some years ago I had occasion to ride a stock saddle (the cowboy article), and with all the positiveness of immature years, I held all other trees and all other methods of riding in a magnificent contempt. Later on I had to be convinced that a great many young cavalry officers in our service were the most daring and perfect riders, and that the McClelland saddle was the proper thing. I even elaborated a theory in explanation of all this, which I had duly shattered for me when I came East and frequented a New York riding academy, where a smiling professor of the art assured me that cowboys and soldiers were the worst possible riders. Indeed, the sneers of the polite European were so superlative that I dared not even doubt his statements. Of course I never quite understood how my old champions of the cattle range and the war trail could pick things off the ground while in full career, or ride like mad over the cut-banks and boulders, if they were such desperately bad riders; and I never was able completely to understand why my European master could hardly turn in his saddle without tumbling off. But still, he reduced me to submission and I ceased even to doubt. I changed my style of riding, in deference to a public sentiment, and got my legs tucked up under my chin and learned to loose my seat at every alternate footfall, and in time acquired a balance which was as secure as a pumpkin on the side of a barrel. Thus equipped with all this knowledge and my own saddle, I went out to the Northwest with the purpose of introducing a little revolution in cavalry riding.

Things went swimmingly for a time. The interpreters and scouts watched my riding with mingled pity and scorn, but I knew they were unenlightened and in no way to be regarded seriously. The general was duly amused by my teetering, and suggested to the smiling escort officers that "he has lived so long abroad, you know," etc., all of which I did not mind, for my faith in the eternal art of the thing was complete.

Now to tell how I discovered that I was riding a seat which was no seat at all, and was only retained by a series of happy accidents. While at the head of the column, where I could see the deep ruts in the road and the boulders and could dodge the prairie-dog holes, it was simple enough; but my horse being a very clumsy galloper and beginning to blow under the pace, I began to pull up, calculating to get a sharp trot and overhaul the column when it slowed down. The column of soldiers dashed by and the great cloud of dust rose up behind them which always follows a herd of animals in the West. Being no longer able to see, the only thing to do under the circumstances was to give my horse his head and resign myself to the chances of a gopher hole, if it was foreordained that my horse should find one. True to his instincts, my old cavalry horse plunged into the ranks. You cannot keep a troop horse out of the ranks. They know their place and seek it with the exactitude of water. If the cavalry tactics are ever changed, the present race of horses will have to be sold, because while you can teach a horse anything, you cannot unteach him.

In front I could see two silhouettes of soldiers tearing along,

and behind could hear the heavy pounding of the troop horses, the clank of arms, the snorts and heavy breathings. I could hardly see my horse's head, to say nothing of the ground in front. Here is where the perfect grip with the thighs is wanted, and here is where the man who is bundled up like a ball on his horse's back is in imminent danger of breaking his neck. I felt like a pack on a Government mule, and only wished I had someone to "throw the diamond hitch over me." The inequalities of the road make your horse plunge and go staggering side-wise, or down on his knees, and it is not at all an unusual thing for a cavalryman to upset entirely, though nothing short of a total turn-over will separate a veteran soldier from his horse. After a few miles of these vicissitudes I gained the head of the column, and when the pace slackened, I turned the whole thing over in my mind, and a great light seemed to shine through the whole subject. For a smooth road and a trotting horse, that European riding master was right; but when you put a man in the dust or smoke, over the rocks and cut-banks, on the bucking horse, or where he must handle his weapons or his lasso, he must have a seat on his mount as tight as a stamp on an envelope, and not go washing around like a shot in a bottle. An Indian or a cow-boy could take the average park rider off from his horse, scalp him, hang him on a bush, and never break a gallop.

With a repetition of the military forms, we reached the cavalry camp on the Lame Deer Creek. This is an old battleground of the general's—his last fight with the Cheyennes, where, as the general puts it, we "kicked them out of their blankets in the early morning." These Indians recognize him as their conqueror, and were allied with him in the Nez Percé campaign. One old chief pointed to the stars on his shoulder strap and charged him to remember that they helped to put them there.

That night was very cold, and I slept badly, so at an early hour I rolled out of my tent and saw that the stars were yet visible and the light of the morning warming up to chase the gray shadows over the western hills. Three tight little cavalry soldiers came out on parade and blew three bugles as hard as ever they could to an unap-preciative audience of sleepy soldiers and solemn hills. I walked down past the officers' row and shook the kinks out of my stiffened knees. Everything was as quietly dismal as only a sleeping camp can be. The Sibley containing General Miles showed no signs of life, and until he arose, this little military solar system would not revolve. I bethought me of the irregulars. They were down in the river bottom—Lieutenant Casey and his Indian scouts. I knew that Casey had commanded Indian scouts until his temper was as refined as beaten gold, so I thought it safer to arouse him than anyone else, and walking down, I scratched at his tent—which is equivalent to knocking—and received a rather loud and surly inquiry as to what I wanted. My sensitive nature was so shocked by this that, like the bad actor, I had hopes for no more generous gift than a cigarette.

I was let into the Sibley and saw the ground covered with blanketed forms. One of the swathed forms sat up, and the captain allowed he wanted to get up in the night, but that ever since Lieutenant Blank had shot at the orderly, he was afraid to move about in the gloom. Lieutenant B. sat up and denied the impeachment. Another officer arose and made some extended remarks on the unseemly disturbance at this unseasonable hour. To pass over these inequalities of life, I will say that the military process of stiffening a man's backbone and reducing his mind to a logarithm breeds a homogeneous class whom we all know. They have small waists and their clothes fit them; they are punctilious; they respect forms, and always do the dignified and proper thing at the particular instant, and never display their individuality except on two occasions; one is the field of battle and the other is before breakfast. Some bright fellow will one day tell in print the droll stock anecdotes of the United States Army, and you'll agree that they are good. They are better, though, if you sit in a Sibley on a cold morning while the orderly boils the coffee; and are more fortunate if you have Ned Casey to embellish what he calls the international complications which arose from the bombardment of Canada with paving-stones by a drunken recruit at Detroit.

After the commission had talked to a ring of drowsy old chiefs, and the general had reminded them that he had thrashed them once and was perfectly willing to do it again if they did not keep in the middle of the big road, the commission was loaded into the ambulances. The driver clucked and whistled and snapped his whip as a preliminary which always precedes the concerted movement of six mules, and we started. This time I found that I had a mount that was "a horse from the ground up," as they phrase it in the West. Well it was so, for at the relay camp I had issued to me a sorrel ruin which in the pristine vigor of its fifth year would not have commanded the value of a tin cup. After doing a mile of song and dance on this poor beast, I dismounted, and shifting my saddle back to my led horse of the morning, which was led by a Crow scout, made the sixty-mile march of that day on the noble animal. Poor old chap, fit for a king, good for all day and the next, but condemned to pack a trooper in the ranks until a penurious government condemns and sells him to a man who, nine times out of ten, by the law of God, ought not to be entrusted with the keeping of the meanest of his creatures, to say nothing of his noblest work—a horse. "Such is life" is the salve a good soldier puts on his wounds.

During the day we went all over the battlefield of the Little Big Horn [scene of the Custer fight]. I heard a good deal of professional criticism, and it is my settled conviction that had Reno and his support gone in and fought as hard as they were commanded to do, Custer would have won his fight and become a major general. The military moral of that affair for young soldiers is that when in doubt about

what to do, it is always safe to go in and fight "till you drop," remembering that, however a citizen may regard the proposition, a soldier cannot afford to be anything else than a "dead lion."

We were nearing the Crow agency and Fort Custer, and it is against all my better impulses and with trepidation at the impropriety of unveiling the truth that I disclose the fact that the general would halt the column at a convenient distance from a post, and would then exchange his travel-worn garb for glittering niceties of a major-general's uniform. The command then advanced into the fort. The guns bellowed and the cavalry swung into line, while numerous officers gathered, in all the perfection of neat-fitting uniforms, to receive him. At this time the writer eliminated himself from the ceremonial, and from some point of vantage proceeded to pull up his boots so as to cover as much as possible the gaping wounds in his riding trousers, and tried vainly to make a shooting jacket fit like an officer's blouse while he dealt his hat sundry thumps in a vain endeavor to give it a more rakish appearance. He was then introduced and apologized for in turn. To this day he hopes the mantle of charity was broad enough to cover his case. . . .

The last stage from Custer to the railroad is thirty-five miles and a half, which we did with two relays, the latter half of it in the night. There was no escort—only two orderlies and the general—and I pattered along through the gloom. The clouds hung over the earth in a dense blanket and the road was as dim as a Florentine fresco; but night nor cold nor heat can bring General Miles to a walk, and the wild charge in the dark was, as an experience, a complete thing. You cannot see; you whirl through a canyon cut in the mud; you plow through the sagebrush and over the rocks clatter and bang. The general is certainly a grim old fellow—one of the kind that make sparks fly when he strikes an obstacle. I could well believe the old Fifth infantryman who said, "He's put many a corn on a doughboy's foot," and it's a red-letter day for anyone else that keeps at his horse's heels. You may ride into a hole, over a precipice, to perdition, if it's your luck on this night, but is not the general in front? You follow the general—that's the grand idea—that is the military idea. If the United States Army was strung out in line with its general ahead, and if he should ride out into the broad Atlantic and swim to sea, the whole United States Army would follow along, for that's the idea, you know.

But for the headlong plunge of an orderly, we passed through all right, with due thankfulness on my part, and got to our car at the siding, much to the gratification of the Chicago colored man in charge, who found life at Custer station a horrid blank. Two hundred and forty-eight miles in thirty-six hours and a half, and sixty miles of it on one horse, was not bad riding, considering everything. Not enough to make a man famous or lame, but enough for the time being.

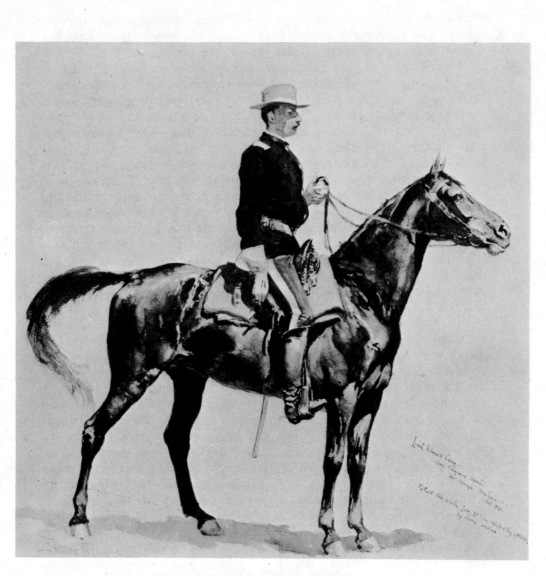

LIEUTENANT EDWARD CASEY

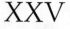

XXV

Lieutenant Casey's
Last Scout

The train bearing the Cheyenne scout corps pulled into Rapid City somewhat late. It was a freight train, with the horses in tight boxcars, the bacon and *Chis-chis-chash* [the name the Cheyennes apply to themselves] on flat gravel cars, and Lieutenants Casey and Getty in the caboose. We were glad to meet again. Expansive smiles lit up the brown features of the Indian scouts as they recognized me. Old Wolf-Voice came around in his large, patronizing way and said, "How?—what you do out here?" Wolf-Voice was a magnificent type of the Indian, with a grand face, a tremendous physique, and enough self-containment for a High Church bishop. High-Walking nudged Stump-Horn and whispered in his ear, and they both smiled as they looked at me. Lieutenant Casey walked out in the road and talked with General Miles, who sat on his beautiful sorrel horse, while two scouts and a young "horse pusher" [boy who travels with horses on the cars] from St. Louis helped me to load one strawberry roan horse, branded 52 on the nigh front foot, into a boxcar with a scrawny lot of little ponies, who showed the hard scouting of the last month in their lank quarters.

The quartermaster came down and asked Lieutenant Casey for a memorandum of his outfit, which was "70 horses, 49 Indian scouts, 1 interpreter, 2 white officers, 1000 pounds of bacon, so many crackers, 2000 pounds forage, 5 Sibley tents, and 1 citizen," all of which the quartermaster put down in a little book. You are not allowed by United States quartermasters to have an exaggerated estimate of your own importance. Bacon and forage and citizens all go down in the same column, with the only distinction that the bacon and forage outnumber you.

We were pulled down the road a few miles to the town of Hermoso, and there, in the moonlight, the baggage was unloaded and the wild little ponies frightened out of the cars, down a chute, and into the stock corrals. The Sibleys were pitched, and a crowd of curious citizens who came down to feast their eyes on the *Chis-chis-chash* were

dissipated when a rather frugal dinner was prepared. This was Christmas night, and rather a cheerless one, since in the haste of departure the Sibley stoves had been forgotten. We never had stoves again until the gallant Leavenworth battalion came to the rescue with their surplus, and in the cold, frosty nights in the foothills there can be no personal happiness where there are no stoves. We brewed a little mess of hot stuff in a soldier's tin cup, and in the words of Private Mulvaney we drank to the occasion, "Three fingers—standing up!"

The good that comes in the ill wind where stoves are lacking is that you can get men up in the morning. Sun worship must have originated in circumstances of this kind. The feeling of thankfulness at the sight of the golden rays permeates your soul, and your very bones are made glad.

A few ounces of bacon, some of those accursed crackers which are made to withstand fire, water, and weevil, a quart of coffee blacker than evil, then down come the Sibleys, the blankets are rolled and the saddles adjusted, and bidding *adios* to the First Infantry (which came in during the night), we trot off down the road.

These, then, are the Cheyenne scouts. I am glad I know the fact, but I never can reconcile the trim-looking scout corps of Fort Keogh with these strange-looking objects. Erstwhile their ponies were fat and cavorted around when falling in ranks; now they paddle along in the humblest kind of a businesslike jog trot. The new overcoats of the corps metamorphose the scouts into something between Russian Cossacks and Black Crooks. Saddle pockets bulge out, and a thousand and one little alterations in accouterment grow up in the field which are frowned down in garrison. The men have scouted hard for a month and have lost two nights' sleep, so at the halts for the wagons they flop down in the dust of the road and sleep, while the little ponies stand over them, ears down, heads hanging, eyes shut, and one hind foot drawn up on its toe. Nothing can look so dejected as a pony, and doubtless few things have more reason to feel so. A short march of twenty-five miles passes us through the Seventeenth Infantry camp under Colonel Offley and down to the Cheyenne River, where we camp for the night. There is another corps of Cheyenne scouts somewhere here on the river, under Lieutenant L. H. Struthers, of the First Infantry, and we expect to join them. On the other side of the Cheyenne rise the tangled masses of the famous Bad Lands—seamed and serrated, gray here, the golden sunset flashing there, with dark recesses giving back a frightful gloom—a place for stratagem and murder, with nothing to witness its mysteries but the cold blue winter sky. Yet we are going there. It is full of savage Sioux. The sun goes down. I am glad to cease thinking about it.

The next day we passed down the river, and soon saw what to inexperienced eyes might be dark gray rocks on the top of yellow hills They were the pickets of the Cheyennes. Presently we saw the tepees

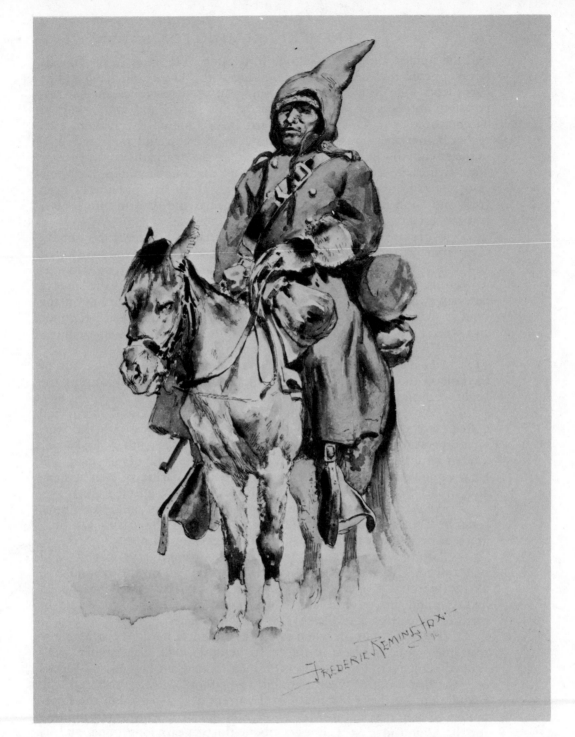

A CHEYENNE SCOUT IN WINTER RIG

and the ponies, and then we rode into camp. The men from Tongue River greeted the men from Pine Ridge with "ki-yis" of delight. The corps from Pine Ridge was organized from the Cheyennes on that reservation, and was as yet only partially disciplined and in no way to be compared with Casey's Old Guard from Tongue River. Some two nights before the Sioux had fired into their camp and they had skirmished with the enemy. The virmilion of the warpath was on every countenance, and through sympathy I saw that our men, too, had gone into this type of decorative art; for faces which had previously been fresh and clean now passed my vision streaked and daubed into preternatural ferocity.

It grew later and later, and yet Lieutenant Struthers did not return from his scouting of the day. We were alarmed, and wondered and hoped; for scouting through the Bad Lands to the stronghold was dangerous, to state it mildly. A few shots would not be heard twelve miles away in the hills. We pictured black objects lying prone on the sand as we scouted next day—little masses of clay which had been men and horses, but would then be as silent as the bare hillocks about them.

"Ki-yi-yip—a-ou!" and a patter in the gloom.

"That's Struthers." We fall over each other as we pile out of the hole in the Sibley, and find Struthers and Lieutenant Byrom of the Eighth Cavalry, all safe and sound.

"We go on the stronghold in the morning," says Casey; "and coffee," are words in the darkness; and we crawl back into the tent, where presently the big, honest, jolly eyes of Mr. Struthers look over a quart cup, and we are happy. Byrom was a fine little cavalryman, and I have good reason to know that for impudent daring of that desperately quiet kind, he is distinguished in places where all men are brave.

Away goes the courier to the colonel for orders, and after a time, back he comes—a wild dash of twelve miles in the dark. Of little moment here, but a life memory to an unaccustomed one.

"We go on the stronghold in the morning," says Casey; "and now to bed." A bed consists of two blankets spread on the ground, and all the personal property not otherwise appropriated piled on top. A luxury, mind you, is this; later it was much more simple, consisting of earth for a mattress and the sky for a counterpane.

The sun is not up when in comes the horse herd. My strawberry roan goes sneaking about in the frosty willows, and after sundry well-studied maneuvers I get a grip on the lariat, and am lugged and jerked over the brush until "52 on the nigh front foot" consents to stand still. I saddle up, but have lost my gun. I entreat Mr. Thompson, the interpreter, to help me find it. Mr. Thompson is a man who began fighting for the Union in East Tennessee about thirty years long gone, and he has continued to engage in that work up to date Mr. Thompson has formed a character which is not as round as a ball, but much more the shape of horn-silver in its native state. He is humorous by turns, and

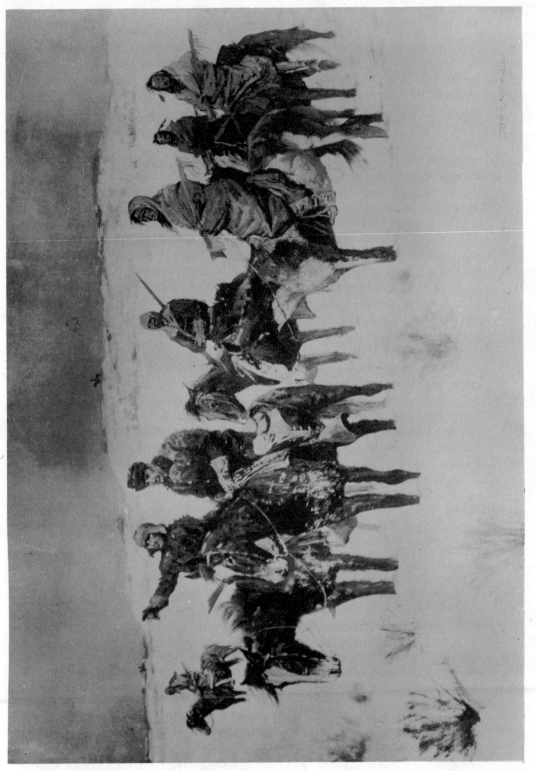

HUNTING THE HOSTILE CAMP

early in my acquaintance he undertook the cultivation of my mind in the art of war as practiced on the frontier. On this occasion he at last found my Springfield, and handed it to me with the admonition "that in times like these one warrior can't look after another warrior's gun."

The wagons were to go—I never knew where, but they went off over the hills and I never saw them again for some miserable days and dreary nights. Five Pine Ridge Cheyennes and Mr. Wolf-Voice were my party, and we filed away. At Battle Creek we watered, and crossed the Cheyenne a mile above. My horse was smooth shod and the river frozen halfway over, so we slid around on the ice, jumped into the icy waters, got wet, crawled out, slid around some more, and finally landed. Mr. Wolf-Voice looked me over and smilingly said, "Me think you no like 'em"; wherein his conclusion was eminently correct. Who does like to have a mass of ice freeze on him when naturally the weather is cold enough to satisfy a walrus?

It was twelve miles through the defiles of the Bad Lands to the blue ridge of the high mesa where the hostiles had lived. The trail was strewn with dead cattle, some of them having never been touched with a knife. Here and there a dead pony, ridden to a stand-still and left nerveless on the trail. No words of mine can describe these Bad Lands. They are somewhat as Doré pictured hell. One set of buttes, with cones and minarets, gives place in the next mile to natural freaks of a different variety, never dreamed of by mortal man. It is the action of water on clay; there are ashes, or what looks like them. The painter's whole palette is in one bluff. A year's study of these colors by Mr. [Albert] Bierstadt [and other artists] might possibly convey to the Eastern mind an idea; so we'll amble along after Mr. Wolf-Voice and leave that subject intact.

"Hark!" My little party stops suddenly and we all listen. I feel stupid.

"You hear 'em?" says Wolf-Voice in a stage whisper.

"Hear what?" I say.

"Shots."

Then we all get out our guns and go galloping like mad. I can't imagine why, but I spur my horse and perform equestrian feats which in an ordinary frame of mind I should regard as insane. Down a narrow trail we go, with the gravel flying, and through a coulee, up a little hill, on top of which we stop to listen, and then away we go again. The blue wall grows nearer, and at last we are under it. A few cottonwood trees, some frozen water, a little cleft on the bluffs, and I see a trail winding upward. I know these warriors are going up there, but I can't understand precisely how. It is not the first perilous trail I have contemplated; but there are dead cattle lying at the bottom which had fallen off and been killed in the ascent. We dismount and start up. It tells on your wind and tries the leg muscles. Up a steep place a horse wants to go fast, and you have to keep him from running over you. A bend in the trail where the running water has frozen seems impass-

able. I jump across it, and then pull the bridle and say, "Come on, boy!"
If I were the horse I would balk, but the noble animal will try it. A
leap, a plunging, and with a terrible scramble we are all right. Farther
up, and the incline is certainly eighty-five degrees. My horse looses his
front feet, but a jerk at the headstall brings him down, and he plunges
past me to be caught by an Indian at the top of the trail. For a moment
we breathe, and then mount.

Before us is a great flat plain blackened by fire and with the
grass still burning. Away in the distance in the shimmer of the air
waves are figures.

"Maybeso dey Sioux," says Wolf-Voice. And we gallop toward
them.

"What will you do if they are?" I ask.

"Stand 'em off," replies the war dog.

Half an hour's ride showed them to be some of our Cheyennes.
All about the plain were strewn the remains of dead cattle (heads and
horns, half-butchered carcasses, and withal a rather impressive smell),
coyotes, and ravens—all very like war. These Brûlés [Sioux] must have
lived well. There were lodge poles, old fires, and a series of rifle pits
across the neck of land which the Sioux had proposed to defend; medi-
cine poles, and near them the sacrifices, among which was food dedi-
cated to the Great Spirit, but eventually consumed by the less exalted
members of Casey's command. I vandalized a stone pipe and a rawhide
stirrup.

The less curious members of our band had gone south, and Wolf-
Voice and I rode along together. We discussed war, and I remember
two of Wolf-Voice's opinions. Speaking of infantry and their method
of fighting, he said, "Dese walk-a-heap soldiers, dey dig hole—get in—
shoot heap—Injun can't do nothin' wid 'em—can't kill 'em—can't do
nothin' but jes' go 'way."

Then, explaining why the Sioux had shown bad generalship in
selecting their position, he turned in his saddle and said, "De big guns
he knock 'em rifle pit, den de cavalry lun pas' in colum—Injun no stop
calavy—kill 'em heap, but no stop 'em—den de walk-a-heap dey come,
too, and de Sioux dey go ober de bluffs." And with wild enthusiasm
he added, "De Sioux dey go to hell!" That prospect seemed to delight
Mr. Wolf-Voice immensely.

It was a weary ride over the black and smoking plain. A queer
mirage was said by my Indian to be the Cheyenne scouts coming after
us. Black figures of animals walking slowly along were "starving bron-
cos abandoned by the hostiles."

"Cowboy, he catch 'em," said Wolf-Voice.

I explained that Colonel Offley had orders not to allow any
citizens to cross the Cheyenne River.

"Cowboy, he not give um dam; he come alle samee."

I thought Wolf-Voice was probably right.

On the southern edge of the bluffs of the mesa we halted and

found water for man and beast. The command gradually concentrated, and for half an hour we stood on the high points, scanning the great flats below, and located the dust of the retiring hostile column and the back-lying scouts. Lieutenant Casey had positive orders not to bring on an engagement, and only desired to hang on their flanks so as to keep Miles familiar with the hostile movements. A courier started on his lonely ride back with a note for the major general. Our scouts were flying about far down the valley, and we filed off after them. Presently a little column of dust follows a flying horseman toward us. On, on he comes. The scouts grow uneasy; wild creatures they are, with the suspicion of a red deer and the stealth of a panther.

The Sioux have fired on our scouts. Off we go at a trot, scattering out, unslinging our guns, and the air full of fight. I ride by Casey and see he is troubled. The orders in his pocket do not call for a fight. Can he hold these wild warriors?

"Struthers, we have got to hold these men," said Casey, in a tone of voice which was full of meaning. To shorten the story, our men were at last gotten into ranks and details made to cover the advance. The hostiles were evidently much excited. Little clouds of dust whirling hither and thither showed where the opposing scouts were shadowing each other. The sun was waning, and yet we spurred our weary horses on toward the enemy. Poor beasts! no food and too much exercise since daylight.

The Cheyennes were uneasy and not at all pleased with this scheme of action. What could they know about the orders in Lieutenant Casey's pocket, prompted by a commanding general thinking of a thousand and one interests, and with telegrams from Washington directing the avoidance of an Indian war?

Old-soldier Thompson even, with all his intelligence and knowledge of things, felt the wild battle valor, which he smothered with difficulty, and confined himself to potent remarks and spurring of old Piegan. He said, "This is a new kind of war. Them Injuns don't understand it, and to tell you the truth, I don't nuther. The Injuns say they have come all the way from Tongue River, and are going back poor. Can't get Sioux horses, can't kill Sioux," and in peroration he confirmed his old impression that "this is a new kind of war"; and then relapsed into reveries of what things used to be before General Miles invented this new kind of war.

In our immediate front was a heavy body of Sioux scouts. Lieutenant Casey was ahead. Men broke from our ranks, but were held with difficulty by Struthers and Getty. Back comes Casey at a gallop. He sees the crisis, and with his hand on his six-shooter, says, "I will shoot the first man through the head who falls out of the ranks." A mutiny is imminent in the Pine Ridge contingent, but the diplomat Struthers brings order at last. We file off down the hills to the left, and stop by a stream while Casey goes back and meets a body of Sioux on a high

WHEN WINTER IS CRUEL

hill for a powwow. I watched through a glass, and the sun went down as they talked. We had orders not to remove our saddles, and stood in the line nervously expecting anything imaginable to happen. The daring of Casey in this case is simply an instance of a hundred such, and the last one cost him his life. By his prompt measures with his own men and by his courage in going among the Sioux to powwow, he averted a bloody battle and obeyed his orders. There was one man between two banks of savage warriors who were fairly frothing at the mouth— a soldier; the sun will never shine upon a better.

At last, after an interminable time, he came away. Far away to the right are two of our scouts driving two beeves. We see the bright blaze of the six-shooters, the steers tumble, and hunger is no longer one of our woes.

The tired horses are unsaddled to eat and drink and roll. We lay dry cottonwood limbs on the fires, heavy pickets are told off, and our "bull meat" is cooked in the primitive style. Old Wolf-Voice and another scout are swinging six ribs on a piece of rawhide over a fire, and later he brings me a rib and a little bit of coffee from a roll in his handkerchief.

Three or four Brûlés are let in through our pickets, and come "wagging their tails," as Two-Moons says, but adding, "Don't you trust the Sioux." They protest their good intentions, borrow tobacco, and say Lieutenant Casey can send in a wagon for commissaries to Pine Ridge, and also that I can go through their lines with it. Were there ever greater liars on earth?

I sat near the fire and looked intently at one human brute opposite, a perfect animal, so far as I could see. Never was there a face so replete with human depravity, stolid, ferocious, arrogant; and all the rest—ghost shirt, warpaint, feathers, and arms. As a picture, perfect; as a reality, horrible. Presently they go away and we prepare for the night. This preparing for the night is a rather simple process. I have stolen my saddle blanket from my poor horse, and with this laid on the ground, I try my saddle in four or five different positions in its capacity of pillow. The inventor of the Whitman tree never considered this possible use of his handiwork, or he might have done better. I next button the lower three buttons of my overcoat, and thus wrapped, I lie down to pleasant dreams—of rheumatism.

An hour later and the fires go down. Black forms pass like uneasy spirits, and presently you find yourself thrashing around in the underbrush across the river after branches to feed that insatiable fire. One comrade breaks through the ice and gets wet, and inelegant remarks come from the shadowy blackness under the riverbanks. A chilling wind now adds to the misery of the situation, and the heat of the fire goes off in a cloud of sparks to the No Man's Land across the river. After smoking a pipe for two hours your mouth is raw and your nervous system shattered, so nothing is left but to sit calmly down and just suffer.

And morning finds you in the saddle. It always does. I don't know how it is—a habit of life, I suppose. Morning ought to find me cosily ensconced in a good bed, but in retrospect they always seem to be in the saddle, with a good prospect of all day ahead, and evening finds me with a chunk of bull meat and without blankets, until one fine day we come to our wagons, our Sibleys, and the little luxuries of the mess chest.

The next morning I announced my intention of going to the Pine Ridge agency, which is twenty-five miles away. Mr. Thompson, two scouts, and a Swedish teamster are to go in for provisions and messages. Mr. Thompson got in the wagon. I expressed my astonishment at this and the fact that he had no carbines, as we expected to go through the hostile pickets and camp. He said, "If I can't talk them Injuns out of killin' me, I reckon I'll have to go." I trotted along with Red-Bear and Hairy-Arm, and a mile and a half ahead went the courier, Wells. Poor man! in two hours he lay bleeding in the road with a bullet through the hips, and called two days for water before he struck the long trail to the kingdom come.

We could see two black columns of smoke, which we did not understand. After we had gone eight or ten miles and were just crossing a ravine, we saw a Sioux buck on a little hill just ahead, out of pistol shot. He immediately rode the "danger signal." Red-Bear turned his horse in the "peace sign," and advanced. We drove over the ravine and halted. I dismounted. Six young Brûlé Sioux rose out of the ground and rode up to Red-Bear. The hills were full of pickets to the right and left. We waited to hear the result of Red-Bear's conversation, when he presently came back and spoke to Thompson in Cheyenne. His eyes were snapping and his facial muscles twitched frightfully.

"Red-Bear says we will have to go back," explained Thompson; and turning to Red-Bear, he requested that the two Sioux might come closer and talk with us. Things looked ominous.

Hairy-Arm's face was impassive, but his dark eyes wandered from Brûlé to Brûlé with devilish calculation. Two young bucks came up and one asked Thompson for tobacco, whereat he was handed a package of Durham. "It's lucky for me that tobacco ain't a million dollars," he sighed.

Another little buck slipped up behind me, whereat Mr. Thompson gave me a warning look. Turning, I advanced on him quickly (I wanted to be as near as possible, not being armed), and holding out my hand, said, *"How, colah?"* He did not like to take it, but he did, and I was saved the trouble of further action.

"We'll never get this wagon turned around," suggested Mr. Thompson, as the teamster whipped up; but we did. As we commenced our movement on Casey's camp, he added, "Go slow; don't run, or they'll sure shoot."

"Gemme gun," said the little scout Red-Bear, and we all got our arms from the wagon.

There was no suspense now. Things had begun to happen. A little faster, we go up the little banks of the coulee, and, ye gods! what! —five fully armed, well-mounted cowboys—a regular rescue scene from Buffalo Bill's show.

"Go back!" shouted Thompson.

Bang! bang! bang! and the bullets whistle around and kick up the dust. Away we go.

Four bucks start over the hills to our right to flank us. Red-Bear talked loudly in Cheyenne.

Thompson repeated, "Red-Bear says if anyone is hit, get off in the grass and lie down; we must all hang together."

A well-mounted man rode like mad ahead of the laboring team horses to carry the news to the scout camp. The cowboys, being well mounted, could easily have gotten away, but they stuck with us.

Here is the great beauty of American character. Nothing can be taken seriously by men used to danger. Above the pounding of the horses and the rattle of the wagon and through the dust came the cowboy song from the lips of Mr. Thompson:

> "Roll your tail,
> And roll her high;
> We'll all be angels
> By-and-by."

We deployed on the flanks of the wagon so that the team horses might not be shot, which would have stopped the whole outfit, and we did ten miles at a record-breaking gallop. We struck the scout camp in a blaze of excitement. The Cheyennes were in warpaint and the ponies' tails were tied up and full of feathers. Had the Sioux materialized at that time, Mr. Casey would have had his orders broken right there.

After a lull in the proceedings, Mr. Thompson confided to me that "the next time I go to war in a wagon it will put the drinks on me"; and he saddled Piegan and patted his neck in a way which showed his gratification at the change in transport. We pulled out again for the lower country, and as our scouts had seen the dust of Colonel Sanford's command, we presently joined them.

We awoke next morning with the sleet freezing in our faces, made camp in a blizzard, and borrowed Sibley stoves of the soldiers. We were at last comfortable, and spent New Year's Eve in a proper manner.

I was awakened at a late hour that night by Captain Baldwin, of General Miles's staff, and told to saddle up for a night's ride to Pine Ridge. This was the end of my experience with Lieutenant Casey and his gallant corps. We shook hands cheerily in the dim candlelight of the tepee, and agreeing to meet in New York at some not distant day,

I stepped out from the Sibley, mounted, and rode away in the night.

Three days later I had eaten my breakfast on the dining car and had settled down to a cigar and a Chicago morning paper. The big leads at the top of the column said: "LIEUTENANT E. W. CASEY SHOT." Casey shot! I look again. Yes; dispatches from headquarters—a fact beyond question.

A nasty little Brûlé Sioux had made his coup, and shot away the life of a man who would have gained his stars in modern war as naturally as most of his fellows would their eagles. He had shot away the life of an accomplished man; the best friend the Indians had; a man who did not know fear; a young man beloved by his comrades and respected by his generals. The squaws of another race will sing the death song of their benefactor, and woe to the Sioux if the northern Cheyennes get a chance to coup!

"Try to avoid bloodshed," comes over the wires from Washington. "Poor savages!" comes the plaintive wail of the sentimentalist from his place of security. American soldiers of our frontier days have learned not to expect sympathy in the East, but where one like Casey goes down there are many places where Sorrow will spread her dusky pinions.

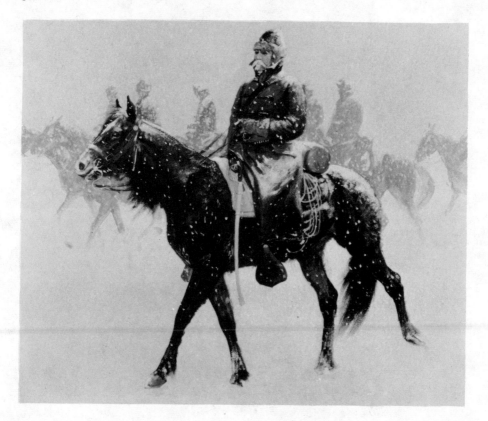

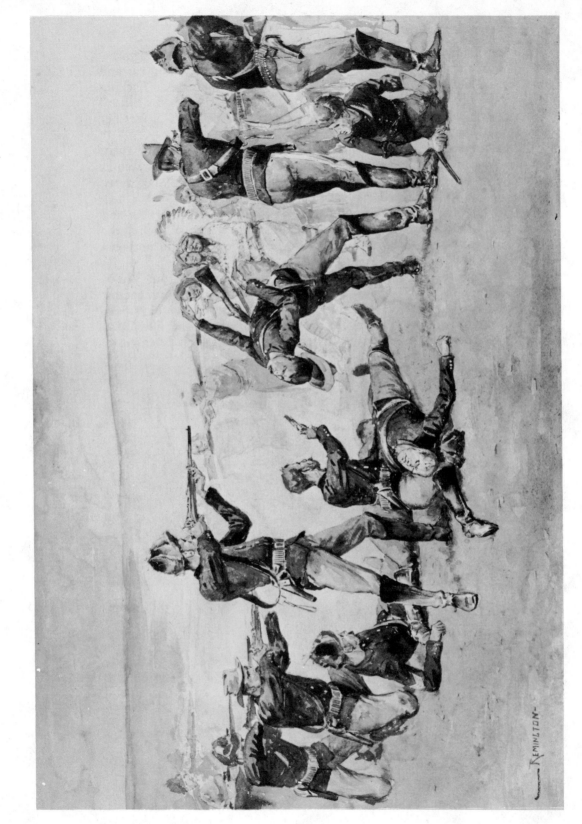

THE WOUNDED KNEE FIGHT

XXVI

The Sioux Outbreak in South Dakota

We discussed the vague reports of the Wounded Knee fight in the upper camps of the cordon, and old hands said it could be no ordinary affair because of the large casualty. Two days after I rode into the Pine Ridge agency, very hungry and nearly frozen to death, having ridden with Captain Baldwin, of the staff, and a Mr. Miller all night long. I had to look after a poor horse, and see that he was groomed and fed, which require considerable tact and hustling in a busy camp. Then came my breakfast. That struck me as a serious matter at the time. There were wagons and soldiers—the burial party going to the Wounded Knee to do its solemn duty. I wanted to go very much. I stopped to think; in short, I hesitated, and of course the opportunity was lost, for after breakfast they had gone. Why did I not follow them? Well, my natural prudence had been considerably strengthened a few days previously by a half hour's interview with six painted Brûlé Sioux who seemed to be in command of the situation. To briefly end the matter, the burial party was fired on, and my confidence in my own good judgment was vindicated to my own satisfaction.

I rode over to the camp of the Seventh United States Cavalry and met all the officers both wounded and well, and a great many of the men. They told me their stories in that inimitable way which is studied art with warriors. To appreciate brevity, you must go to a soldier. He shrugs his shoulders and points to the bridge of his nose, which has had a piece cut out by a bullet, and says, "Rather close, but don't amount to much." An inch more and some youngster would have had his promotion.

I shall not here tell the story of the Seventh Cavalry fight with Big Foot's band of Sioux on the Wounded Knee; but I will recount some small talk current in the Sibley tepees, or the "white man's war tents," as the Indians call them.

Lying on his back, with a bullet through the body, Lieutenant

251

Mann grew stern when he got to the critical point in his story. "I saw three or four young bucks drop their blankets, and I saw that they were armed. 'Be ready to fire, men; there is trouble.' There was an instant, and then we heard sounds of firing. . . . 'Fire!' I shouted, and we poured it into them."

"Oh yes, Mann, but the trouble began when the old medicine man threw the dust in the air. That is the old Indian signal of 'defiance'; and no sooner had he done that act than those bucks stripped and went into action. Just before that someone told me that if we didn't stop that old man's talk, he would make trouble. He said that the white men's bullets would not go through the ghost shirts."

Said another officer, "The way those Sioux worked those Winchesters was beautiful." The criticism was strictly professional.

Added another man, "One man was hit early in the firing, but he continued to pump his Winchester; but growing weaker and weaker, and sinking down gradually, his shots went higher and higher, until his last went straight up in the air."

"Those Indians were plumb crazy. Now, for instance, did you notice that before they fired, they raised their arms to heaven? That was devotional."

"Yes, Captain, but they got over their devotional mood after the shooting was over," remonstrated a cynic. "When I passed over the field after the fight, one young warrior who was near to his death asked me to take him over to the medicine man's side, that he might die with his knife in the old conjurer's heart. He had seen that the medicine was bad, and his faith in the ghost shirt had vanished. There was no doubt but that every buck there thought that no bullet could touch him."

"Well," said an officer, whose pipe was working into a reflective mood, "there is one thing which I learned, and that is that you can bet that the private soldier in the United States Army will fight. He'll fight from the drop of the hat anywhere and in any place, and he'll fight till you call 'time.' I never in my life saw Springfield carbines worked so industriously as at that place. I noticed one young fellow, and his gun seemed to just blaze all the while. Poor chap! he's mustered out for good."

I saw the scout who had his nose cut off. He came in to get shaved. His face was covered with strips of court-plaster, and when informed that it would be better for him to forego the pleasure of a shave, he reluctantly consented. He had ridden all day and been in the second day's fight with his nose held on by a few strips of plaster; and he did not see just why he could not be shaved; but after being talked to earnestly by a half-dozen friends, he succumbed.

"What became of the man who did that?" I asked of him.

He tapped his Winchester and said, "Oh, I got him all right!"

I went into the hospital tents and saw the poor fellows lying on

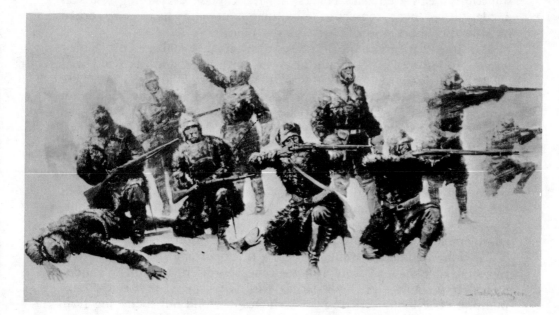

THE END OF OUR INDIAN WARS

the cots, a little pale in the face, and with a drawn look about the mouth and eyes. This is the serious part of soldiering. No excitement, no crowd of cheering comrades, no shots and yells and din of battle. A few watchful doctors and Red Cross stewards with bottles and bandages, and the grim specter of the universal enemy hovering over all, and ready to dart down on any man on the cots who lay quieter and whose face was more pale than his fellows'.

I saw the Red Cross ambulances draw up in line, and watched the wounded being loaded into them. I saw poor Garlington. His blond mustache twitched under the process of moving, and he looked like a man whose mustache wouldn't twitch unnecessarily. Lieutenant Hawthorne, who was desperately shot in the groin while working the little Hotchkiss cannon, turned his eyes as they moved Garlington from the next cot, and then waited patiently for his own turn.

I was talking with old Captain Capron, who commanded the battery at the fight—a grim old fellow, with a red-lined cape overcoat and nerve enough for a hundred-ton gun. He said, "When Hawthorne was shot, the gun was worked by Corporal Weimert, while Private Hertzog carried Hawthorne from the field and then returned to his gun. The Indians redoubled their fire on the men at the gun, but it seemed only to inspire the corporal to renewed efforts. Oh, my battery was well served," continued the captain, as he put his hands behind his back and looked far away.

This professional interest in the military process of killing men

sometimes rasps a citizen's nerves. To the captain everything else was a side note of little consequence so long as his guns had been worked to his entire satisfaction. That was the point.

At the mention of the name of Captain Wallace, the Sibley became so quiet that you could hear the stove draw and the wind wail about the little canvas town. It was always "Poor Wallace!" and, "He died like a soldier, with his empty six-shooter in his right hand, shot through the body, and with two jagged wounds in his head."

I accosted a soldier who was leaning on a crutch while he carried a little bundle in his right hand. "You bet I'm glad to get out in the sunlight; that old hospital tent was getting mighty tiresome."

"Where was I shot?" He pointed to his hip. "Only a flesh wound; this is my third wound. My time is out in a few days; but I'm going to re-enlist, and I hope I'll get back here before this trouble is over. I want to get square with these Injuns." You see, there was considerable human nature in this man's composition.

The ambulance went off down the road, and the burial party came back. The dead were for the time forgotten, and the wounded were left to fight their own battles with stitches and fevers and suppuration. The living toiled in the trenches or stood out their long term on the pickets, where the moon looked down on the frosty landscape, and the cold wind from the north searched for the crevices in their blankets.

[Thus literally ended the Indian wars for the United States Army. Thus came to a close the epoch of our history, which will long be remembered as the "Old West."]

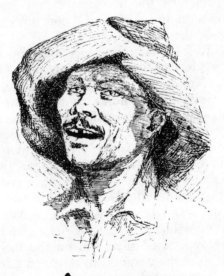

Adios.